CHICAGO MODERN 1893–1945

Pursuit of the New

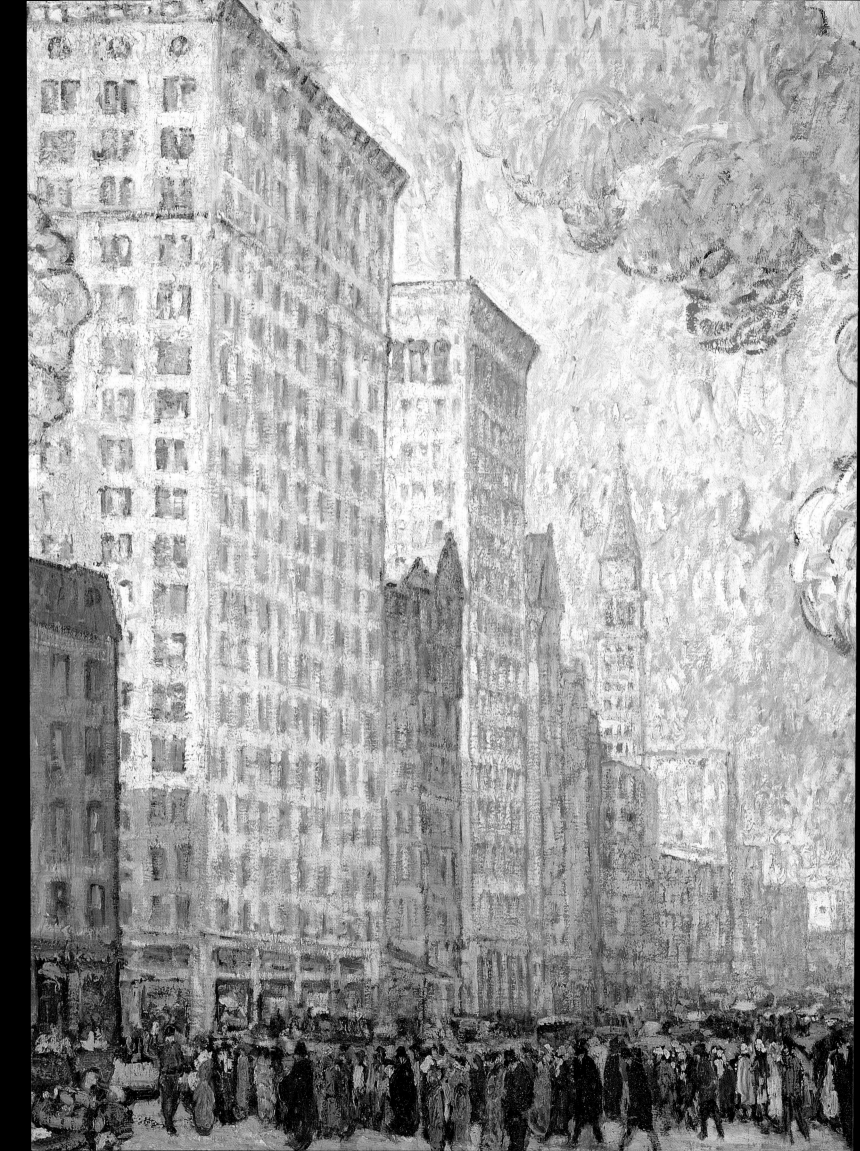

CHICAGO MODERN
1893–1945

Pursuit of the New

Edited by Elizabeth Kennedy

ESSAYS BY

Wendy Greenhouse, Daniel Schulman, and Susan S. Weininger

Terra Museum of American Art and
Terra Foundation for the Arts, Chicago

Distributed by The University of Chicago Press, Chicago

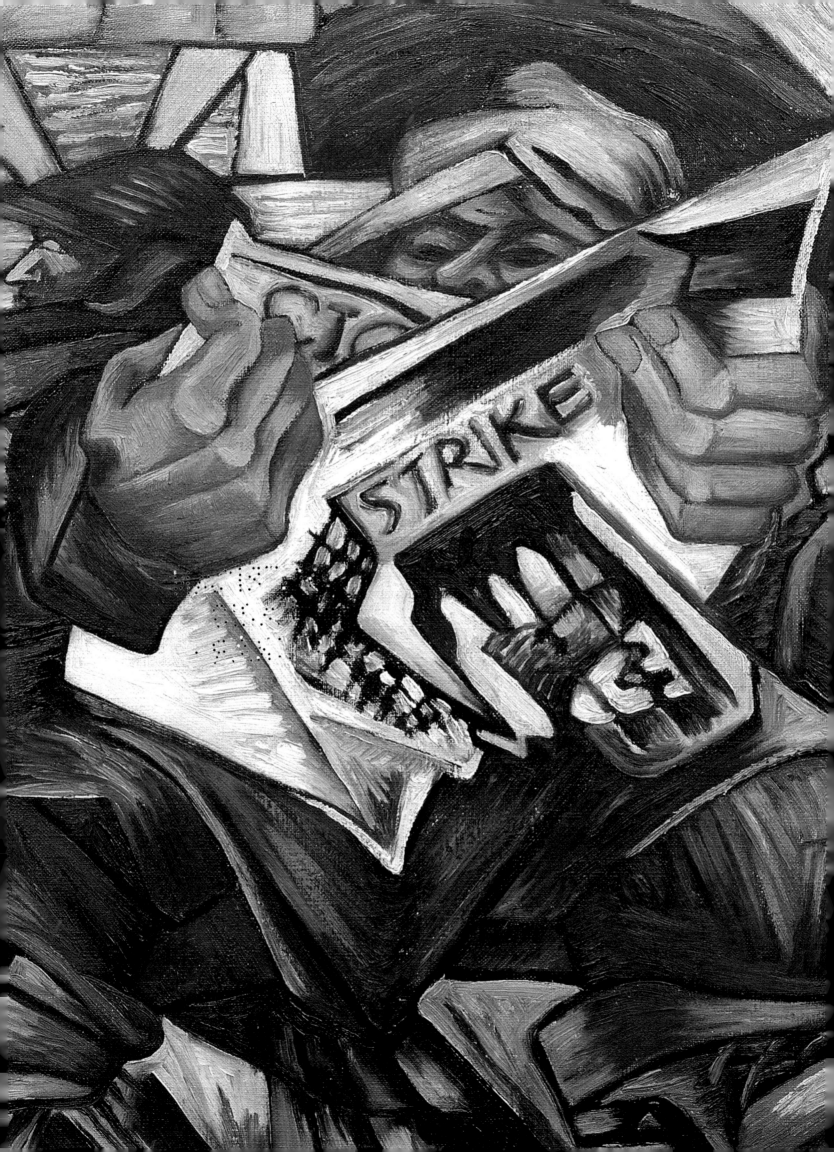

CONTENTS

FOREWORD

CHICAGO MODERN, 1893–1945: PURSUIT OF THE NEW is an unprecedented survey of early modernism by Chicago artists. It is the culminating exhibition in Modern Matters, the Terra Museum of American Art's ground-breaking series that explores the dynamism of modernism in American art in the first half of the twentieth century. During this era of artistic ferment, the sites of experiments and debates were extremely critical in forging a shared definition of what it meant to be modern. The six exhibitions within Modern Matters allow for the comparison of the artistic dialogues that occurred in New York City during World War I; in Paris between the world wars; and, for the first time, in Chicago from the 1890s through the 1940s.

Through its examination of Chicago's art of this period and the ideas and events that shaped it, *Chicago Modern* proposes to add a chapter to the reconsideration of the history and tradition of American modernism. For nearly a century, many influential art critics and scholars have narrowed the once-inclusive boundaries of modern art to a select canon of high modernism that favors the tenets of formalism through pure abstraction. Such a reshuffling and reshaping of what once was a rich and varied history has created a narrative informed strictly by style without consideration of cultural context. This exhibition and publication join recent scholarly efforts to remedy such historic oversimplification by recovering and reassessing the cultural complexities of modernism as it surfaced in America's artistic centers.

Modern art garnered popular attention in the Midwest with the debut of the impressionist style in Chicago at the 1893 World's Columbian Exposition. Just as debates occurred in New York and Paris, Chicago's painters critically examined and experimented with the latest movements in art, from the ultra-modern European imports to the homegrown expressions of regionalism, social realism, and surrealism in the 1920s, '30s, and '40s. *Chicago Modern* explores the multiple points of view that were present in this city's art of the late nineteenth and early twentieth centuries in order to acknowledge its vitally modern art scene. Such a consideration also deepens our understanding of American regional art styles and the larger national developments of which they were a part.

From the beginning, the exhibition's organizers held an ambitious and inclusive vision to reconstruct the breadth of early modern expression within Chicago, an urban community that, during the period discussed, boasted America's second largest population and one of its most prestigious art schools. Special thanks are owed to the guest curators who have been dedicated to unearthing and retelling Chicago's rich history of art: Dr. Wendy Greenhouse, independent art scholar; Daniel Schulman, Associate Curator in the Department of Modern and Contemporary Art at the Art Institute of Chicago; and Susan Weininger, Professor of Art History and Director of the School of Liberal Studies at Roosevelt University, Chicago. Thanks also to David Sokol, Professor Emeritus and Director of Museum Studies at the University of Illinois at Chicago, who contributed to the early planning of the exhibition. These scholars' distinct topics of specialization have been united to give audiences the fullest and most comprehensive representation of Chicago's artistic legacy. Collaborating closely with them, Elizabeth Kennedy, Curator at the Terra Museum, organized this exhibition and publication project with the hope that its scholarly contributions will inspire further investigations into the critical achievements of individual artists and works of art that have been ignored or deleted from the historical record. In the four years she has been associated with the Terra Museum, Dr. Kennedy has consistently proposed and addressed deeper questions that have inspired the museum to present the art of our nation in all its complexity. Indeed, American art has a formidable champion in Dr. Kennedy, and I would like to thank her for her insight, vision, and scholarship.

An exhibition of such scope and quality is only made possible through the generosity of institutions and collectors. Without the extraordinary cooperation of the Art Institute of Chicago, the Chicago Historical Society, and the Union League Club of Chicago—James N. Wood, Director; Lonnie G. Bunch, President; and Nina Owen, Chair, Art Committee, respectively—among others, *Chicago Modern* would not have been able to bring together this exceptional presentation of the city's early modern art. We offer our most sincere thanks to all of the lenders

who responded so enthusiastically to the exhibition's mission and without whose loans we would have been unable to realize this ambitious project.

The Terra Foundation for the Arts takes special pleasure in a partnership with a Chicago community leader, LaSalle Bank. We appreciate their support for this exhibition that unveils a previously neglected aspect of Chicago's art. Thanks and appreciation are also extended to Thom Gianetto, Don Merrill, and Daniel Nicodemo of Edenhurst Gallery, Los Angeles and Palm Desert, California; and Mr. and Mrs. Harlan J. Berk, Chicago, for their generous subventions that provided additional resources for initiatives and contributed to this project's success.

From its inception in 1980, the Terra Museum of American Art has showcased close to 200 exhibitions, both those conceived of and organized by the museum staff as well as those offered by other art organizations. Yet it is particularly appropriate that *Chicago Modern* serves not only as the culmination of the Modern Matters series but also as the final exhibition presented by the Terra Museum. In its tradition of presenting American art from the colonial era through the 1940s in its intimate galleries on North Michigan Avenue and in homage to the city it has called home for over fifteen years, the Terra Museum offers this groundbreaking exhibition and publication in celebration of Chicago's artists and vibrant art scene of the early modern era. The Terra Foundation for the Arts, the museum's parent institution founded by Daniel J. Terra, will continue to operate in Chicago to fulfill its mission of promoting a greater understanding and appreciation of this nation's rich artistic and cultural heritage among diverse national and international audiences. *Chicago Modern, 1893–1945: Pursuit of the New* is a proud achievement in that ongoing effort.

Elizabeth Glassman
Director, Terra Museums
President and Chief Executive Officer, Terra Foundation for the Arts

LENDERS TO THE EXHIBITION

Anonymous lenders

The Art Institute of Chicago

Mr. and Mrs. Harlan J. Berk

Powell and Barbara Bridges

Chicago Historical Society

Collection of Clifford Law Offices

Davis Museum and Cultural Center, Wellesley College

Edenhurst Gallery

Barton Faist

John Norton Garrett

Greenwich Gallery of American Art

Barry and Merle K. Gross

Molly Day and John D. Himmelfarb

Howard University Gallery of Art

Huntington Museum of Art

Illinois Historical Art Project

Illinois State Museum

Jane Addams Hull-House Museum, University of Illinois at Chicago

Jonson Gallery of the University Art Museums, The University of New Mexico

The Keys Collection

Kresge Art Museum Collection, Michigan State University

Jeanne D. Lutz

The Marshall Collection, Peoria, Illinois

Michael Rosenfeld Gallery

Milwaukee Art Museum

National Portrait Gallery, Smithsonian Institution

Mr. and Mrs. Kenneth Probst

Shane Qualls

Laurie and Alan Reinstein

Robert Henry Adams Fine Art

Rockford Art Museum

Jim Romano

San Diego Historical Society Museum

Smithsonian American Art Museum

The Snite Museum of Art, University of Notre Dame

South Side Community Art Center

Rick Strilky

Tuskegee University Archives and Collections

Union League Club of Chicago

The Walter O. Evans Collection of African American Art

Weatherspoon Art Museum, The University of North Carolina at Greensboro

West and Velma Weisenborn

Western Illinois University Art Gallery

Jim and Randi Williams

ACKNOWLEDGEMENTS

A LOAN EXHIBITION of this magnitude requires the expertise and dedication of numerous individuals. We would like to thank the following at the Terra museums for their invaluable assistance, without which this project would not have materialized: Kristina Bottomley, Leo Kelly, Janice McNeill, Catherine Ricciardelli, Shelly Roman, Francesca Rose, and Tom Wawzenek. As curatorial interns for the Terra Museum of American Art, Lauren Hinkle, Donna Kovey, Nicole Kovski, Katharine Raff, and Maryanna Ramirez provided invaluable research support. Amy Galpin, University of Illinois at Chicago Research Fellow, and Caroline Schloss deserve special recognition for their research and writing contributions to this catalogue. Rachael Arauz, Garry Henderson, Laura Hensley, and Joan Sommers have our gratitude for making this publication read and look as it does.

Always supportive of curatorial endeavors, the staff at the Terra Museum has developed programs and other specialized initiatives for this exhibition of Chicago art and artists. Thank you to Lenard Adams, Kiran Advani, Molly Carter, Fraser Coffeen, Tim Duncan, Elaine Holzman, Dori Jacobsohn, Laura Kalas, Ann Meehan, Jennifer Messier, Harries Nicholson, Rochelle Robinson, Elizabeth Rossi, Stefanie Shanebrook, Jennifer Siegenthaler, Tom Skwerski, Barbara Voss, Elizabeth Whiting, and Caren Yusem.

The exhibition curators would also like to express their gratitude to the following individuals for their invaluable support and expert skills: Andrea Barnwell; Derrick Joshua Beard; Paul Benisek; Thomas Branchick; Valerie Carberry; Diane Dillon; Joel Dryer; Paul Fairchild; Sandra Farrow and William McKnight Farrow III; Jan Harmer; Noah Hoffman; Roberta Gray Katz; Marjorie Albright Lins; George J. Mavigliano; Paula F. Peyraud; Robert F. Peyraud, Jr.; Michael Rosenfeld; Don Ryan; Leone Schmidt; Elizabeth Seaton; Julie Simek; Arielle Weininger; Jeffrey Bergen, ACA Gallery; Matt Cook, Sarah Kelly, Kristin Lister, Mary Solt, Garnet C. Thorne, and Greg Williams, the Art Institute of Chicago; Rob Kent and Sam Plourde, Chicago Historical Society; staff of the Chicago Historical Society Research Center; staff of the Chicago Public Library; David Mickenberg, Davis Museum and Cultural Center, Wellesley College; Theresa Christopher, Angela Rivers, and E. Selene Holmes, DuSable Museum of African American History; Thom Gianetto, Edenhurst Gallery; Sylvia Yount, High Museum of Art; Tritobia Hayes Benjamin, Howard University; Sue D'Auria, Huntington Museum, West Virginia; Carole Peterson, Illinois State Museum; Harriet Warkel, Indianapolis Museum of Art; Carol Cheh, Jonson Gallery of the University Art Museums, The University of New Mexico; Kenneth A. Probst, Kenneth Probst Galleries; Kristan H. McKinsey, Lakeview Museum of Arts and Sciences, Peoria, Illinois; Flora Doody, Lane Tech High School; Jim Zimmer, Lockport Gallery, Illinois State Museum; Andrew Walker, Missouri Historical Society; Carolyn Kinder Carr and Brandon Fortune, National Portrait Gallery; Beth McCormick, Oregon (Illinois) Public Library; Patti Gilford, Patti Gilford Fine Arts; Tom Hosier, R. H. Love Galleries; Richard Norton, Richard Norton Gallery; Sandra Adams and David Lusenhop, Robert Henry Adams Fine Art; Matthew Herbig, Nancy Sauer, and Scott Snyder, Rockford Art Museum; Stephen Good, Rosenstock Arts; Jack Perry Brown, Susan Perry, Bart Ryckbosch, and Deborah Webb, Ryerson and Burnham Libraries, the Art Institute of Chicago; Roy Saper, Saper Galleries; Kymberly Pinder, School of the Art Institute of Chicago; George Gurney, Smithsonian American Art Museum; Dean F. Porter, Snite Museum of Art, University of Notre Dame; Diane Dinkins Carr, South Side Community Art Center; Ellery Howard Kurtz, Spanierman Gallery; Nicole Rivette, Toledo Museum of Art; Cynthia Wilson, Tuskegee University; Nina Owen, Marianne Richter, and Philip Wicklander, Union League Club of Chicago; Michael Flug, Vivian G. Harsh Collection of Afro-American History and Literature, Chicago Public Library; and Jill Whitten, Whitten & Proctor Fine Art Conservation.

We offer our sincere thanks and gratitude to the trustees and staff of the Terra Foundation for the Arts. Promoting American art in the United States and abroad offers many options and opportunities. We are very pleased that this project on Chicago's early modern art and artists received such enthusiastic and generous support.

Finally, we dedicate this project on Chicago art to the memory of Archibald J. Motley III and Robert Henry Adams. Almost every aspect of this publication and exhibition has been enriched by the contributions of Archie and Rob, who devoted their lives to the understanding and documentation of artists in Chicago. We, along with inspired generations to come, are in their debt.

PREFACE | Elizabeth Kennedy

MODERN OR MODERNIST? After 1910, critics and scholars began to devise a schema or genealogy of modern art to differentiate the many visual strategies of contemporary artists. The term "modern" was used to characterize non-academic art produced within a specific historical moment; in art history, the "modern era" was frequently identified as the 1850s through the 1970s. "Modernist," in contrast, implied that a work of art was the embodiment of an aesthetic theory whose ultimate ideal was abstraction.

A canon of "pure" modernist art was advanced in the 1930s through the establishment of the Museum of Modern Art in New York. The status of modernism among American intellectuals and artists was further bolstered by the repudiation of modern and modernist art by totalitarian regimes in Germany and the Soviet Union and by the rise of formalist art criticism. Modernist critic extraordinaire Clement Greenberg advanced a theory of formalism in which "pure" painting, or painting that expresses the medium's essential two-dimensional quality, is celebrated. A selective modernist art historiography, satisfying the era's optimistic evolutionary progressivism, developed based on such ideals; this trajectory nurtured an international art movement whose *raison d'être* was freedom of expression, culminating in abstraction, or totally non-objective art. (Ironically, however, modernist critics were exceedingly dictatorial in selecting a roster of art that satisfied the modernist mandate of artistic "purity."[1])

Until late in the twentieth century, modernist critical dogma championed abstraction, distaining other attitudes and styles of modern art from the 1910s and '20s. In the 1970s, however, Marxist and feminist critics challenged the primacy of formalism as the constituting principal in the formation of the modernist canon. The notion of the avant-garde, a military expression applied to artists creating art ahead of their time, was reclaimed as a critical component of modern art. Marxist art historian T. J. Clark, for example, championed the relationship of modern art to social experience in his examination of French painter Gustave Courbet's polemical realism, which was indeed perceived as political commentary by the artist's contemporaries.[2] Feminist theory, by confronting the absolutism of modernist assumptions, recovered the divergent but unequivocal modernity of individual practitioners, particularly women and minority artists. Reinstating the legacy of political avant-gardism—aesthetic diversity and individualism, historically both fundamental tenets of modernism—situates modernism in a regional as well as an international context.

The Individual and Modernity

The linkage of individuality and freedom of expression was a legacy of the eighteenth-century Age of Enlightenment. As the product of rational thought and scientific objectivity, the notion of "progress" was inextricably associated with democracy, capitalism, industrialization, science, and urbanization—although the obvious shortcomings of such manifestations of modernity drew the criticism of Karl Marx, among others.[3] Nevertheless, an ideology of freedom encouraged both the notion of objectivity in scientific investigation of the material world and a belief in the essential subjectivity of art.

The artistic styles and ideologies we recognize as "modern" surfaced in the mid-nineteenth century, when the rise of an independent art market intersected with the cult of individual genius, the latter a product of romanticism. Originally the purview of conservative institutional sponsors—notably state, church, and aristocracy—whose artistic programs aimed to enhance their ideological agendas, art patronage shifted to a radically different clientele that prized artistic individuality as a reflection of its own sensibilities and that sought an art appropriate for private, domestic spaces.[4]

Artistic freedom meant not only experimentation in the studio but also innovation in attempting to win acclaim. Rebelling from the exhibition protocols of the French art establishment in 1850, Courbet and later the impres-

sionists demonstrated their anti-authoritarian individualism in a flurry of independent, entrepreneurial exhibitions that sanctioned the diversity and eclecticism of modern art. Their emphasis on individualism neutralized the political ramifications of modern art as polemic. In effect, the banner of individual freedom of expression, a means of distinguishing oneself from others in the art market, also diluted modern political ideologies of individual self-determination.

French realism's breakthrough in the representation of nature evolved toward modern stylistic innovations, notably impressionism as developed by Claude Monet. Both realism, as the "honest" depiction of the material world, and impressionism, the recording of the visible effects of sunlight on surfaces, were deeply informed by a quasi-scientific premise of objectivity. In the *fin-de-siècle* avant-garde art world, many artists rejected this for a more personalized artistic expression. Symbolism became the darling of modern art: it valorized artistic individuality while engaging the viewer in an interpretive dialogue. With its roots in eighteenth-century romanticism, symbolism emphasized the subjectivity of painting, the directness of personal experience, and the originality of creative imagination. As a reaction against realism or the primacy of scientific objectivity in art, symbolist representation deviated from the colors and forms of the natural world. Symbolism's effects range from a distorted representation of reality that mediates between physical and spiritual realms to a totally non-objective art of pure color, shape, and line. Symbolism thus represents an expressive strand of modernism that has been minimized in the modernist canon—one that is nonetheless vital to reconstructing the development of early modern art in the United States.

Modernism's commitment to the emotional and spiritual authenticity of the individual artist distinguishes it from the traditional, academic ideal of art as a vehicle of moral instruction. By downplaying recognizable subjects in his paintings, American expatriate artist James McNeill Whistler, among others, drew attention to artistic process and to the formal qualities of painting—the composition of colors and shapes on the flat surface of the canvas—that embody the philosophy of "art for art's sake." In the first two decades of the twentieth century, British critics Clive Bell and Roger Fry introduced the theory of formalism as a foundation for modernist art. They allied it to a modern philosophical belief in absolutes, neither personal nor relative, that premised artistic quality as independent of critical subjective judgment. At the same time, however, American art critics were repeatedly employing the expression "the latest tendencies" to characterize modern art, an indication not only of the notion of a multiplicity of styles but also the acceptance of this plurality when speaking of modern art. The lack of a consensus as to what defined modern art underscored authentic individual expression as modernism's most salient "characteristic."[5]

Early American Modernism

As historians of American art reevaluate the early decades of modern art in the United States, the authority of formalist criteria lingers. Alfred Stieglitz and his circle of American artists have long been acclaimed as the true representatives of early American modernism because of their commitment to abstraction.[6] Recently, however, the avant-gardism of Robert Henri's rebellious mission in New York's art world has been reclaimed as part of the historical context of American modernism, as has the dedication to innovation demonstrated by George Bellows, his favorite pupil.[7] Henri and his circle preached the primacy of personal experience. He wrote: "Painting is the expression of ideas in their permanent form. . . . It is the study of our lives, our environment. The American who is useful as an artist is one who studies his own life and records his experiences."[8]

The doctrine of individualism prized by both Stieglitz and Henri traces its American roots to Ralph Waldo Emerson's "unity-in-diversity" paradigm, a symbolic interpretation of the world associated with the early nineteenth-century revolutionary movements of democracy and nationalism. A generation later, Walt Whitman's individualism, translated into the sensual poetry of his autobiographical *Leaves of Grass* (1855), scandalized his Victorian contemporaries, but it was embraced by 1900 as the founding philosophy of an American cultural identity. Not only was the Brooklyn poet and newspaperman a spiritual guide for the Ashcan school, validating their dynamically realistic depictions of a transitory urban scene, but his demand for personal freedom also authenticated the formal innovations of Stieglitz's artists. While Henri quoted Whitman to his students, photographers Paul Strand and Charles Sheeler juxtaposed Whitman's poetry with images of the harbor and streets of New York in their pioneering motion picture *Manhatta* (1920), named after a poem by Whitman.[9]

The Eight's 1908 Macbeth Gallery show and the 1910 Exhibition of Independent Artists (a prologue to the 1917 organization of the Society of Independent Artists) were the products of Henri's leadership in defiance of New York's art hierarchy. These renegade art exhibitions won public recognition of Henri's avant-garde role; more importantly, however, his articulation of individualism inspired countless students to take up the mantle of mod-

ernism. A critical review of the 1908 Macbeth show reiterates Henri's assertion that freedom of expression is the foundation of modernism: "[The Eight] have been working for years developing and producing on the same lines in which they are now found, each from the other in his different way—no unity to any cult of painting—similar only in that they all agree that life is the subject and that view and expression must be individual."[10] Tarred with the brush of realism, however, Henri and his associates were expelled from the long-dominant formalist account of modern American art, their rebellious avant-gardism minimized in accounts of its history.

The rhetoric of freedom was very important in the 1910s. Immigrants were settling in unprecedented numbers in America's urban centers, supplying unstinting cheap labor to an entrepreneurial capitalist system that viciously struggled against the successful unionization of workers. After years of contentious haranguing by determined suffragettes, the Nineteenth Amendment was ratified in 1920, and women gained a formal political voice. Tarnishing its avowal of political freedom, however, was America's history of racial exclusion of its African American citizens, who were increasingly demanding to be part of the political and social dialogue. Henri and his followers politicized their individual artistic efforts as an act of freedom and their independent, jury-free exhibitions as a democratic exercise. These artists, along with their critics and patrons, embraced an inclusionary vision of modern art: not only were diverse artistic styles accepted, but artists from outside the mainstream— women, African Americans, Jews, and immigrants of every conceivable nationality—exhibited in a democratic venue that celebrated equality of opportunity. (The association between political and artistic freedom that pervaded the discourse of modernism in its early years prefigured the politicizing of abstract expressionism after the Second World War, when it became a part of the Cold War debate between communism and democracy.)

East Coast Modernism

The evaluation of modern art in the 1910s and '20s outside of New York City is critical to a full understanding of American modernism. Art audiences in America's hinterlands were conservative, but probably no more so than the majority of art lovers in East Coast metropolitan areas. Boston and Philadelphia, both with nationally acclaimed art academies, were notoriously conservative. Lilla Cabot Perry had championed Monet's radical impressionism in the 1890s in Boston, but in 1914 she joined with many illustrious alumni from the School of the Museum of Fine Arts to found the Guild Society of the Boston Artists, an ultra-conservative, anti-modern art society, in response to what they considered to be extreme radicalism in contemporary art.[11] Yet the staid Pennsylvania Academy of the Fine Arts (PAFA) in Philadelphia, America's oldest art school, officially sanctioned American modernism with the first comprehensive display in an American museum, the "Exhibition of Paintings and Drawings Showing the Later Tendencies in Art," in the spring of 1921. Organized by Stieglitz and others, the exhibition's checklist reveals a mixture of artistic styles from representational to abstract, with much of the art dating to the previous decade. As PAFA curator Sylvia Yount has noted from her study of the show's critical reviews, it presented modernism as "more of a cultural attitude than a coherent movement," a turning away from the old to embrace the new.[12]

Critics in America's major cities, New York included, apparently accepted a plurality of artistic styles in their definition of modern art; museum trustees, however, generally shunned it for their permanent collections.[13] The Société Anonyme, Inc., organized by Katherine Dreier with Marcel Duchamp and Man Ray in 1920, was intended to fill the void of exhibition sites for modern art. After her colleagues' departure for Europe the following year, Dreier assumed sole responsibility for the organization, whose collection lacked both a permanent home and adequate funding, and valiantly struggled to promote modern art for the next twenty years. On the eve of the Depression in 1929, however, two museums dedicated to modern art were founded in New York. When the Metropolitan Museum of Art rejected her collection of contemporary American art, Gertrude Vanderbilt Whitney created the Whitney Museum of American Art, which won acclaim from critics for the diversity of its art and for its support of living artists. Remarkably, the enthusiasm of three women collectors of American and European modern art—Abby Aldrich Rockefeller, Lillie Bliss, and Mary Quinn Sullivan—led to the establishment of the Museum of Modern Art. As historian Kathleen D. McCarthy has argued, these women's leadership in organizing the first museums of modern art in the United States constituted a form of rebellion. The eclecticism of their collections reaffirms the breadth of modern art in the 1920s and '30s.[14]

Regional Modernism

Acceptance of modern and modernist art was still marginal in America's most sophisticated cities in the 1920s, and a new competing mantra for art was evolving: localism. The avant-garde journal *The Dial* published articles that touted the "local" as the source of genuine American culture. Progressive educator John Dewey's 1920 article

"Americanism and Localism" encouraged artists to exploit the local to express universal values, while Harvard professor George Santayana declared that, in any culture, art springs from everyday life. Thomas Craven, *The Dial*'s art critic, advocated the rejection of experimentation for its own sake while validating individual expression, especially as it revealed distinctly American characteristics. The emphasis on self-expression remained a vital aspect of artistic modernism, but its connection to a local audience began to resonate with a growing political conservatism, manifested in a national retrenchment of liberalism that was intensified by the economic disaster of the 1930s.[15]

Rick Stewart, one of the first art historians to examine modern American art in a regional context, thoughtfully distinguished it from the historically narrow construction of the American scene movement. He noted that "a group of local artists who came to national prominence by forging an artistic expression on the values of regional character, tradition, self-reliance, and opportunity" represented a regionalism that expressed diverse systems of beliefs and individual modernity.[16] Just as modernism in Philadelphia and New York was interpreted as more an attitude than a style, modernism in a regional context was validated as a cultural outlook in which a local environment inspired artists to pursue universal ideals.

Paradoxically, the rise of a spirit of regionalism was aligned with nationalism, an international phenomenon in the 1920s and '30s. Regionalism adopted a modern openness to a variety of styles as a means of achieving freedom of artistic expression. American scene painting, a form of aesthetic populism that was officially identified in 1928, is now acknowledged as only one strain of the broader movement known as regionalism. Another strain was social realism—again, not a particular style but an approach that grew out of avant-gardism's sense of the relationship between art and society. Social-realist art focused on specific communities and issues; however, American artists were often leery of producing art with a political subject—afraid that it would be dismissed as illustration or, worse, rejected as propaganda. As a philosophical movement of the 1930s, American scene painting, decried by modernist sympathizers as nationalistic cant, invited a blanket condemnation of regionalism as worse than merely a provincial flowering of contemporary art.

The conflation of regionalism and American scene values has been challenged in recent years: regionalism is increasingly understood as both a geographical construction and an artistic philosophy. Attributing modernist expression to American scene painters is a far more recent endeavor, but one that is expanding the understanding of modernism. In his critique of the one-dimensional, formalist definition of modernism, art historian James M. Dennis ironically noted the anti-modernism of Stieglitz-circle artists Charles Demuth and Charles Sheeler, the regionalism of Marsden Hartley and Georgia O'Keeffe, and the formalist aesthetic of Thomas Hart Benton. Benton's democratic urge to eliminate traditional divisions between elite and popular subject matter is linked to the avant-gardism of social realism. Critics who interpreted his figures in terms of themes of social intolerance and class bias often ignored contemporary critical interest in Benton's formal preoccupations, particularly his use of color theory and his expressive abstraction through distortion and exaggeration.[17]

By the late 1920s and '30s, individual expressions of modern art were in crisis. As democracy was threatened by totalitarian regimes and a world-wide economic crisis, some American art critics called on painters to abandon mere technical experimentation and create art of social relevance. They critiqued representational art in a modernist style for its purported message rather than for its avant-garde innovations. Others pointed to freedom of expression as the ultimate validation of democracy and a capitalist economic system; thus, by painting their "inner necessity," artists validated America's ideology of individualism by expressing themselves in an original, personal artistic style. Modern art was recognized as not only the result of formal stylistic experiments, but also as a sympathetic expression of political freedom that upheld ideals of social activism and individualism. By reclaiming this interpretation of modernism, scholars are beginning to comprehend the expansive perception of modernism that existed in its early years in the United States.

Chicago Modernism

The irony of showcasing technological innovations amidst the traditionalist Beaux-Arts architecture of Chicago's World's Columbian Exposition highlights the ironic contradictions of modernity in 1893. In architecture, engineering, retail marketing, and other practical matters, America's Second City was leading the nation into the future, but in the cultural sphere, the civic elite clung to the cosmopolitan sureties of past generations. But, is it reasonable to castigate the art establishment as reactionary or, worse, as hopelessly provincial? Chicago was no more conservative than eastern cities with established art schools, including New York, where avant-garde art circles were a sensational novelty. When farsighted writer Hamlin Garland optimistically declared in 1893 that "art to be vital, must be local," he was not merely a midwestern booster.[18] His advocacy of regionalism acknowl-

edged not only the subjective nature of creativity but also the transformative agency of the artwork as the means of dialogue between artist and viewer. Nothing could be more modern than this notion of aesthetic experience as a process of interaction between artist, subject, and viewer.

To be modern in Chicago, as well as in America, was, as the Windy City's art critic C. J. Bulliet declared in 1935, to celebrate "'individualism' as opposed to 'regimentation.'"[19] Being a modernist might mean cloistering oneself within an art environment devoted to expressing one's "inner necessity" through formal experimentation. A greater number of Chicago artists, however, struggled to claim an artistic identity within a local setting in which art mattered as both a personal expression and as an engagement with an audience of one or more. These unacknowledged Chicago artists "pursued the new," some in open defiance of convention, others while winning acclaim that accrued not only personally but also to the larger community they represented. They constitute an artistic avant-garde whose commitment to individual expression as a democratic ideal unequivocally belongs to the story of American artistic modernism.

NOTES

1. For a clear and comprehensive presentation of the history of modernism that includes both the contextual narrative of modern art as well as its theoretical discourse, see Francis Frascina et al., *Modernity and Modernism: French Painting in the Nineteenth Century* (New Haven: Yale University Press, in association with the Open University, 1993).

2. T. J. Clark, *Images of the People: Gustave Courbet and the 1848 Revolution* (London: Thames and Hudson, 1973).

3. My summary of the history of the philosophical underpinnings of modern art is informed by Terry Barrett, *Criticizing Art: Understanding the Contemporary* (Mountain View, Calif.: Mayfield Publishing, 1994); and Johanna Drucker, *Theorizing Modernism: Visual Art and the Critical Tradition* (New York: Columbia University Press, 1994). See also Clement Greenberg, *The Collected Essays and Criticism*. 2 vols. Ed. J. O'Brian (1968; Chicago: University of Chicago Press, 1988).

4. Robert Jensen, *Marketing Modernism in Fin-de-Siècle Europe* (Princeton, N.J.: Princeton University Press, 1994).

5 Identifying the broad notion of modernism in early American modernism began in the 1990s, and the scholarship continues to expand. The following are a few important examples: Ilene Susan Fort, *The Figure in American Sculpture: A Question of Modernity* (Seattle: University of Washington Press with Los Angeles County Museum of Art, 1995); *Precisionism in America 1915–1941: Reordering Reality* (New York: Harry N. Abrams, in association with the Montclair Art Museum, 1995); Kirsten Swinth, *Painting Professionals: Women Artists and the Development of Modern American Art, 1870–1930* (Chapel Hill: University of North Carolina Press, 2001); and Erika Doss, *Benton, Pollock, and the Politics of Modernism: From Regionalism to Abstract Expressionism* (Chicago: University of Chicago Press, 1991).

6. Wanda M. Corn, *The Great American Thing: Modern Art and National Identity, 1915–1935* (Berkeley: University of California Press, 1999), helpfully reminds us that the notion of American exceptionalism—the "Americanness" of American art—was the ideological impetus behind attempts to connect historic American art to the ascendancy of American modernist art in the 1950s. By examining the adherence to abstraction by the Stieglitz circle of writers and artists, Corn is validating their placement in the modernist canon. For the Stieglitz circle, scholarship has richly expanded through Marcia Brennan, *Painting Gender, Constructing Theory: The Alfred Stieglitz Circle and American Formalist Aesthetics* (Cambridge, Mass.: MIT Press, 2001); and Celeste Conner, *Democratic Visions: Art and the Theory of the Stieglitz Circle, 1924–1934* (Berkeley: University of California Press, 2001).

7. Ronald Netsky, "George Bellows's Woodstock Landscapes and the Question of Modernism," and Mark Andrew White, "A 'Native American Genius' or Errant Modernist? George Bellows's Late Work and the Critics," in Marjorie B. Searl and Ronald Netsky, *Leaving for the Country: George Bellows at Woodstock* (Rochester, N.Y.: Memorial Art Gallery of the University of Rochester, 2003), are in the forefront of scholars who are rightfully recapturing Bellows's individual modernism.

8. Robert Henri, *The Art Spirit* (1923; Boulder, Colo.: Westview Press, 1984), 116.

9. Henri's quotations from Whitman were recorded in a compilation of his writings published as *The Art Spirit* (see note 8), 85. On *Manhatta*, see Corn, *The Great American Thing*, 183.

10. As quoted in Allan Antliff, *Anarchist Modernism: Art, Politics, and the First American Avant-Garde* (Chicago: University of Chicago Press, 2001), 15.

11. Meredith Martindale, *Lilla Cabot Perry: An American Impressionist* (Washington, D.C.: National Museum of Women in the Arts, 1990), 82.

12. Sylvia Yount and Elizabeth Johns, *To Be Modern: American Encounters with Cézanne and Company* (Philadelphia: Pennsylvania Academy of the Fine Arts and University of Pennsylvania Press, 1996), 9.

13. As Andrew Martinez noted in "A Mixed Reception for Modernism: The 1913 Armory Show at The Art Institute of Chicago," *The Art Institute of Chicago Museum Studies* 19, 1 (1993): 55, "The rate at which it [The Art Institute of Chicago] accepted modern art was not much different than that of other American museums." The Arthur Jerome Eddy Collection of modern art was not accepted until 1931, eleven years after Eddy's death. My thanks to Wendy Greenhouse for this reference, which acknowledges the lack of enthusiasm by the trustees of the Art Institute in accessioning gifts of modern art.

14. Kathleen D. McCarthy, *Women's Culture: American Philanthropy and Art, 1830–1930* (Chicago: University of Chicago Press, 1991), discusses the founding of the first museums of modern art in the United States.

15. Rick Stewart, *Lone Star Regionalism: The Dallas Nine and Their Circle 1928–1945* (Dallas: Texas Monthly Press and Dallas Museum of Art, 1985), 22.

16. Ibid., 11.

17. James M. Dennis, *Renegade Regionalists: The Modern Independence of Grant Wood, Thomas Hart Benton, and John Steuart Curry* (Madison: University of Wisconsin Press, 1998).

18. Hamlin Garland, "Impressionism," in *Crumbling Idols* (1894; Cambridge, Mass.: Belknap Press of Harvard University Press, 1960), 104.

19. C. J. Bulliet, "Around the Galleries: Our Leading Modernists," *Chicago Daily News*, 9 February 1935.

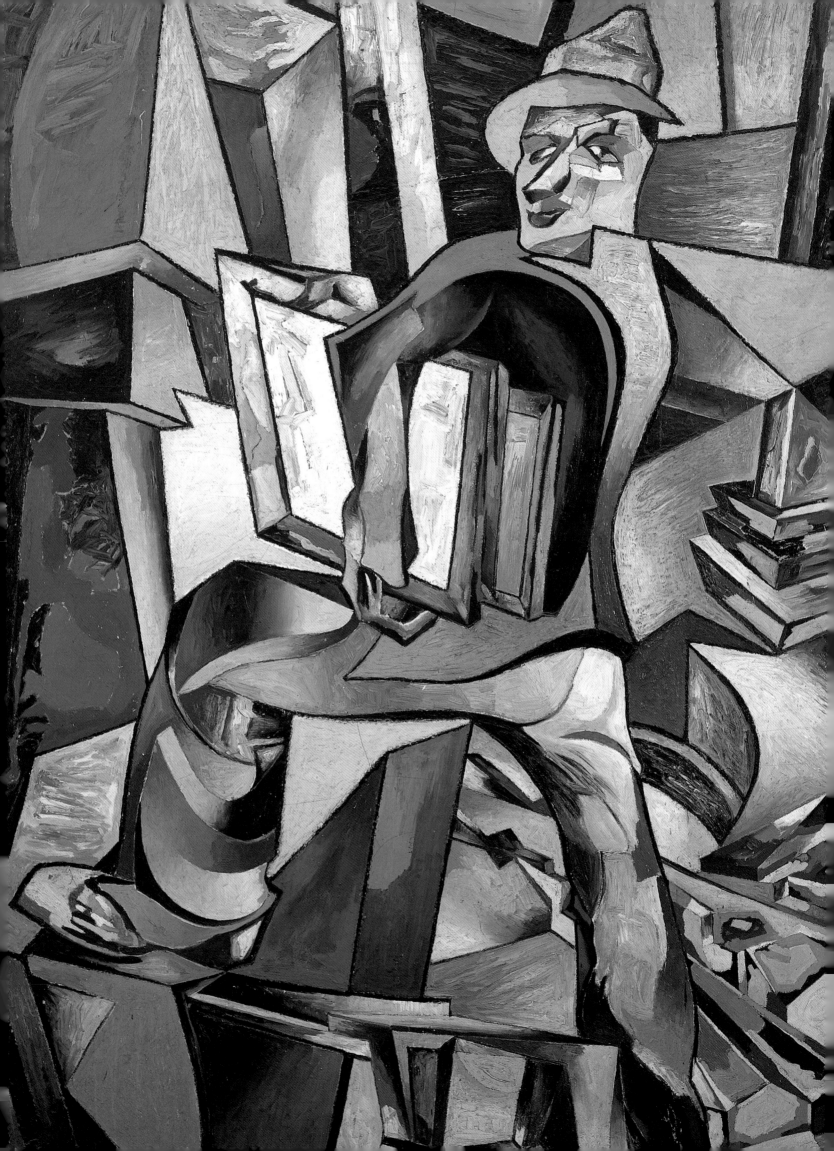

INTRODUCTION | WENDY GREENHOUSE

BETWEEN ITS TWO GREAT world's fairs of 1893 and 1933, Chicago experienced a cultural vitality that has been called a "renaissance." Although the term implies a revival of the glories of a past age, Chicago's renaissance was characterized by a fascination with the new and a drive "to be first in everything," according to historian Thomas J. Schlereth.[1] Culturally, the city has long been famous for its innovations in literature, the performing arts, architecture, and design, but its modernism in the fine arts is far less acknowledged. *Chicago Modern, 1893–1945: Pursuit of the New* presents an unprecedented assemblage of paintings by Chicago-based artists, a cross-section of a variegated artistic response to contemporary life and ideas of the new from the dynamic half-century in which Chicago matured as the quintessential modern American metropolis.

This book and the exhibition it accompanies represent a first effort to characterize the "pursuit of the new" in Chicago painting between the World's Columbian Exposition of 1893 and the outbreak of the Second World War. By exploring four distinct "chapters" in that history, the essays that follow offer glimpses into different ways in which this city's artists grappled with the new through innovative styles, subject matter, definitions of art and its function, and ideas about artistic identity and the role of the artist in society.

This project joins two intertwined strands of inquiry, both of which have recently emerged in the scholarship of American art of the late nineteenth and early twentieth centuries. The first is a regional approach that acknowledges the variety and value of art activity and achievement in many locales throughout the United States. Thus, New York's traditional dominance as *the* national art center need not simply be challenged so much as understood as a phenomenon that has shaped, even distorted, the canonical narrative of American art history. We can begin to understand American art as a series of dialogues not only between the United States and Europe but also within this country—between perceived "centers" and a wider periphery whose dimensions are only now beginning to be mapped.[2] With such acknowledgement of the rich art communities that flourished independently in many American art centers—from major cities to rural, seasonal colonies—comes a new understanding of distinct regional expressions of the major movements that shaped the history of art in this country. Cities such as Chicago, which boasted their own exhibitions, patrons, dealers, artists' organizations, and critics, are important not only for the indigenous creativity they nurtured but also for their national influence and position.

The rewriting of the history of modernism is a second, related important enterprise in our evolving understanding of the history of American art. Recent scholarship has broadened the meaning of modernism to embrace many forms, including a new emphasis on subject matter as an expression of modernity and a greater appreciation of modernist precedents and their sources.[3] Studies of regional manifestations have introduced alternate "modernisms"; some are variant applications of familiar ideas and influences, while others reflect altogether new ways of being modern.[4] Viewed in its broadest sense, modernism can be seen as not just a stylistic break with precedent, but also as a concern for expressing contemporary experience, from the psychological or spiritual conditions it fosters to the urban physical environment that has long symbolized modernity. It can involve style, subject matter, or even simply artistic intention. Indeed, modernism for many Chicago artists was a function of "thinking modern" rather than necessarily painting in a "modern" style, as defined by an art-historical canon largely based on developments in Europe and New York.[5]

Chicago Modern examines a variety of "modernisms" and changing meanings of "the new" among Chicago painters during a crucial half-century of artistic achievement. In the 1890s, impressionism represented a radical break with such time-honored academic values as finish and idealism—as much because of its legitimization of local, contemporary subject matter as for its preoccupation with pure color and light. By the 1910s, however, representational art itself was under siege: self-styled modernist artists questioned the very nature of objective "picturing" by radically distorting, fragmenting, and flattening their ostensible subjects; even many self-defined

CAT. 87 (DETAIL)

conservatives stressed formal elements of structure, pattern, and color in works of "decorative impressionism." For many artists in the 1920s and '30s, modernism meant a new dedication of art to social purpose and the application of a new realism to polemical stances on contemporary issues of social and economic justice.

Not all Chicago artists endorsed challenges to standards, ideals, and time-honored techniques, but even the most conservative were concerned about being modern in the sense of creating an art for the day—even within the framework of inherited standards. To today's viewers, the quietly revolutionary nature of Frank Peyraud's modified impressionist imagery of the prairie or the dignified formality of Archibald J. Motley Jr.'s Bronzeville portraits may be less obvious than Rudolph Weisenborn's cubism or Bernece Berkman's timely political thrust. But all, in their individual ways, were inspired by contemporary life and experience near at hand. The works presented in this exhibition are *modern* in this sense, if not *modernist*, expressing a consciousness of contemporaneity as well as innovation.

Chicago and the New

As a relative latecomer among the great urban centers of the United States, Chicago from the first seemed to embody the new.[6] As late as 1934, it could be considered "a vigorous pioneer city in its fundamental character," one marked not only by youth but also by explosive growth.[7] Indeed, its citizens were said to be so accustomed to change as to be insulted if they could recognize their city after any absence; hence, "the real Chicago is always a little in the future."[8] It was specifically in contrast to this whirlwind of change that Chicagoans in the nineteenth century established a conservative tradition of art, founding such institutions as the Art Institute of Chicago as islands of permanence, idealism, and universal values amidst the flux of the industrial and commercial city.[9] Craftsmanship, beauty, and moral truth would remain the defining attributes of art for many artists and art consumers.

Art-minded Chicagoans prided themselves on their cosmopolitan and progressive outlook. The Art Institute's school, the most important art academy in the Midwest, made Chicago a vital nexus between the American hinterland and the great American art world centered on the East Coast and Europe. (Indeed, until World War I, study and work abroad were the culmination of professional training for the school's ambitious graduates.) Chicago claimed some of America's most adventurous collectors of modernist art from the 1890s through the 1930s, and the city's dynamic industry of art journalism kept Chicagoans in touch with happenings elsewhere. From the late 1910s through the 1930s, in particular, Chicago boasted a number of small but lively avant-garde groups whose members produced unconventional work and defied the jury system governing the Art Institute's influential annual salons.

In its eagerness to be "in the know" with new developments in art, Chicago also positioned itself early on as an internationally important exhibition venue. Founded as both a school and a museum, the Art Institute aspired to serve as a "university" of art for the Midwest, a forum or clearing-house that would keep the public "constantly informed of current achievement and thought in the art world"—particularly through a busy program of temporary exhibitions.[10] Thus the museum was ahead of comparable institutions in offering, for example, the impressionist-dominated Society of American Artists exhibition in 1890; the 1908 show of realist works by The Eight first mounted by New York's Macbeth Gallery; and the groundbreaking International Exhibition of Modern Art, commonly referred to as the Armory Show, in 1913. Indeed, painter Ralph Clarkson asserted in 1914 that the "best and latest" art trends he witnessed in Europe had already had their exposure in recent Art Institute exhibitions.[11] Where the Art Institute feared to tread, the Arts Club and the Renaissance Society of the University of Chicago organized exhibitions of cutting-edge work in the 1920s. Even earlier, a handful of farsighted art dealers in Chicago also boldly introduced the work of some of America's most innovative artists.

Despite such progressive views and exhibitions, Chicago was branded as largely resistant to new styles and movements. Scandalized local reaction to the Armory Show has long epitomized a seemingly intractable conservatism: the show's airing of the latest trends in European art shocked many viewers in New York before the show opened at the Art Institute, but it was Chicago's outrage—climaxing in the infamous burning of an effigy of Henri Matisse on the museum's steps—that provoked organizer Walt Kuhn's famous dismissal: "It's a Rube Town!"[12] Many Chicagoans found the work of artists such as Matisse, Marcel Duchamp, and Pablo Picasso so remote from anything they recognized as art as to be ludicrous—offering a choice between "madness and humbug," according to conservative painter Charles Francis Browne.[13] Like New Yorkers during the show's first venue, however, they couldn't stay away.

The story of the Armory Show in Chicago illuminates more than simple parochialism, however. The Art Institute was the only museum to host the Armory Show on its three-city tour, an expression of its liberal policy

of giving "a hearing to strange and even heretical doctrines, relying upon the inherent ability of the truth ultimately to prevail."[14] Museum director William M. R. French had been repelled by the "extreme" work of the cubists, futurists, post-impressionists, and other radicals he saw at the Armory Show in New York, but he insisted they be fully represented in Chicago so that Chicagoans could witness firsthand the radical art that was causing such a stir. With such exhibitions the museum demonstrated its commitment to "the theory that its members and the public have the right to see and judge for themselves everything that is new and interesting in art," according to trustee and modernist sympathizer Arthur Jerome Eddy.[15] Yet it was not until well into the 1920s, when the modernism of the Armory Show had become acceptable, that the Art Institute began to admit examples into its permanent collection.

The Art Institute's ambivalent early relationship with modernism epitomizes Chicago's "pursuit of the new," which blended passion and caution, fascination with innovation and an impulse to accommodate the new to certain established fundamentals. Such a cautious outlook was consistent with Chicago's cultural tradition of what has been called "process and progress," a belief in evolution rather than revolution as the mechanism of artistic innovation. This mindset contributed to Chicago's position as something of a battleground between conservative and modern, "old guard" and "avant-garde,"[16] and marked the peculiar brand of artistic modernism, characterized by a spirit of inclusion and compromise, that emerged locally in the wake of the Armory Show. In 1925 Ramon Shiva expressed this spirit in his preference for the term *progressive* over *modernist*, rejecting the latter as denoting mere freakishness.[17]

The artistic experiments of Shiva and other Chicagoans in the 1910s and '20s demonstrate a complex, even ambiguous relationship to pure abstraction. Many were encouraged to pursue pure, sensual beauty as the ultimate end of art by widely popular analogies between painting and music, the "purest" art form. The example of James McNeill Whistler was championed by Chicago collector Eddy and reinterpreted in the popular theories of Arthur Wesley Dow. Equally influential in Chicago were the theories of Russian artist Wassily Kandinsky, whose ideas about the "inner necessity of art" inspired Chicagoans, as they did artists nationally, in their search for a new kind of art to replace the materialism of conventional representational painting.[18]

At the same time, even Chicago's self-described modernists rarely challenged the notion of the painting as a window into an imagined space, however distorted or unreal. For most, disassociating art and objective representation led not so much to abstraction as to fantasy: their works balance a decorative sensibility for shapes, forms, and colors arranged on a flat surface with a powerful sense of escapism that is charged with narrative undertones or even political allegory.

Thus a certain idealism underlies the strong penchant for the decorative that is evident in the work both of artists associated with Chicago's avant-garde and those who claimed to uphold tradition. As they looked to the city for subjects, for example, both tended to use formal means to euphemize its calamitous chaos and visual brutality, continuing a pattern established in the earliest impressionist portrayals of this city, created just after the turn of the twentieth century.

Chicago modern painting thus shares some fundamental values with the city's mainstream artistic tradition. The city's self-proclaimed modernist artists defined themselves, in fact, less by how and what they painted than by their political banner of individual freedom. To be a modern in Chicago in the 1910s and '20s meant above all to express oneself with complete sincerity and individuality, whether or not the effort to do so involved radical artistic experimentation. The diversity of work produced in this particular environment for modernism reflects the inclusive, if qualified, liberalism on which Chicagoans prided themselves. Thus the most prominent, influential, and long-lived manifestation of native Chicago modernism was the No-Jury Society, founded in 1922, whose sole non-monetary requirement for membership was adherence to the principle of openness to any exhibitor, defying the jury system that ruled the important annual exhibitions at the Art Institute and established institutions.[19] The group's truly democratic campaign to champion individual self-expression had its roots in the "process and progress" agenda long established by the city's civic leaders, based in the belief that art in the city benefited all.

Chicago's liberal receptivity to the new was appropriate to a metropolis that itself embodied the new; this openness was qualified, however, by persistent ideals of craftsmanship, beauty, moral uplift, and social amelioration. From their earliest experiments in impressionism, the modernism of the 1890s, through the politically charged art of the Depression era, painters working in Chicago brought the influence of new styles and artistic ideas to bear on the issue of expressing—directly or obliquely—the life and identity of their most modern of cities.

1. Thomas J. Schlereth, "A Robin's Egg Renaissance: Chicago Culture, 1893–1933," *Chicago History* 8 (Fall 1979): 144. The term "renaissance" to describe Chicago's cultural life in this period was used by Sherwood Anderson in his memoirs (quoted in idem, 144).

2. The publication in 1990 of William H. Gerdts's monumental, three-volume *Art Across America: Two Centuries of Regional Painting, 1710–1920* (New York: Abbeville Press) symbolized, as much as it has catalyzed, the recent shift toward the study of American art in its regional manifestations.

3. See, for example, H. Barbara Weinberg, Doreen Bolger, and David Park Curry, *American Impressionism and Realism: The Painting of Modern Life, 1885–1915* (New York: Metropolitan Museum of Art, distributed by Harry N. Abrams, 1994); and Ilene Susan Fort et al., *The Figure in American Sculpture: A Question of Modernity* (Los Angeles: Los Angeles County Museum of Art, in association with University of Washington Press, 1995).

4. Modernism in its regional manifestations was the subject of a session at the 1992 annual meeting of the College Art Association, held in Chicago, and again at the 2004 meeting.

5. The idea of "thinking modern"—rather than necessarily painting modern—as the defining attribute of Chicago's progressive artists in the period between 1910 and 1940 was first articulated by Susan Weininger in the exhibition "Thinking Modern: Painting in Chicago 1910–1940," which she curated for the Mary and Leigh Block Gallery at Northwestern University in 1992.

6. When Chicago was incorporated in 1837, with a mere 4,170 inhabitants, New York was more than two centuries old and boasted a population of 270,000; the acknowledged capital of the West was St. Louis, with 16,000 citizens, founded in 1764.

7. Clara McGowan, "Old and New Chicago Used as a Design Inspiration," *Design* 35 (April 1934): 23.

8. Harrison Rhodes, "The Portrait of Chicago," *Harper's Magazine* 135 (June 1917): 80.

9. Helen Lefkowitz Horowitz's pioneering study of attitudes toward culture in turn-of-the-century Chicago, *Culture & the City: Cultural Philanthropy in Chicago from the 1880s to 1917* (reprint, Chicago: University of Chicago Press, 1976), remains an invaluable guide for understanding the nature of Chicago's "conservative" artistic tradition.

10. Clarence A. Hough, "The Art Institute of Chicago," *Art & Archaeology* 12 (Sept.–Oct. 1921): 153. The Art Institute was described as a university, forum, and clearing-house for art in the *Annual Report of the Art Institute of Chicago, 1910–11*, 29; as quoted in Eugenia Remelin Whitridge, "Art in Chicago: The Structure of the Art World in a Metropolitan Community" (Ph.D. diss., University of Chicago, 1946), 111.

11. Ralph Clarkson, "Chicago Painters, Past and Present," *Art & Archaeology* 12 (Sept.–Oct 1921): 138.

12. Walt Kuhn as quoted in Milton W. Brown, *The Story of the Armory Show* (New York: Abbeville Press, 1988), 196.

13. Charles Francis Browne as quoted in ibid., 208. This quote has also been attributed to William M. R. French; see Andrew Martinez, "A Mixed Reception for Modernism: The 1913 Armory Show at The Art Institute of Chicago," *The Art Institute of Chicago Museum Studies* 19,1 (1993): 38. Martinez provides a useful overview of the Art Institute's progressive tradition of exhibiting cutting-edge art.

14. "Exhibition of Modern Art," *Bulletin of the Art Institute of Chicago* 6 (April 1913): 51.

15. Eddy as quoted in Martinez, "A Mixed Reception for Modernism," 56.

16. Kenneth Hey, "Five Artists and the Chicago Modernist Movement, 1909–1928" (Ph.D. diss., Emory University, 1973), ch. 1. For an example of the evolutionary model of artistic progress, see James Spencer Dickerson, "A Chicago Renaissance?" *Brush and Pencil* 1 (March 1898): 185–86.

17. Ramon Shiva as quoted in Samuel Putnam, "Ramon Shiva," *The Palette & Chisel* (April 1925): 1–2. I am indebted to Susan Weininger for this reference.

18. Susan Weininger, "Kandinsky and Modernism in Chicago," *BlockPoints: The Annual Journal and Report of the Mary and Leigh Block Museum of Art* 3/4 (1996/1998): 58–75.

19. For an excellent overview of the history of the No-Jury and other radical art organizations of the period in Chicago, see Paul Kruty, "Chicago's Alternate Art Groups of the 1920s," in *The Old Guard and the Avant-Garde: Modernism in Chicago, 1910–1940*, ed. Sue Ann Prince (Chicago: University of Chicago Press, 1990), 77–93.

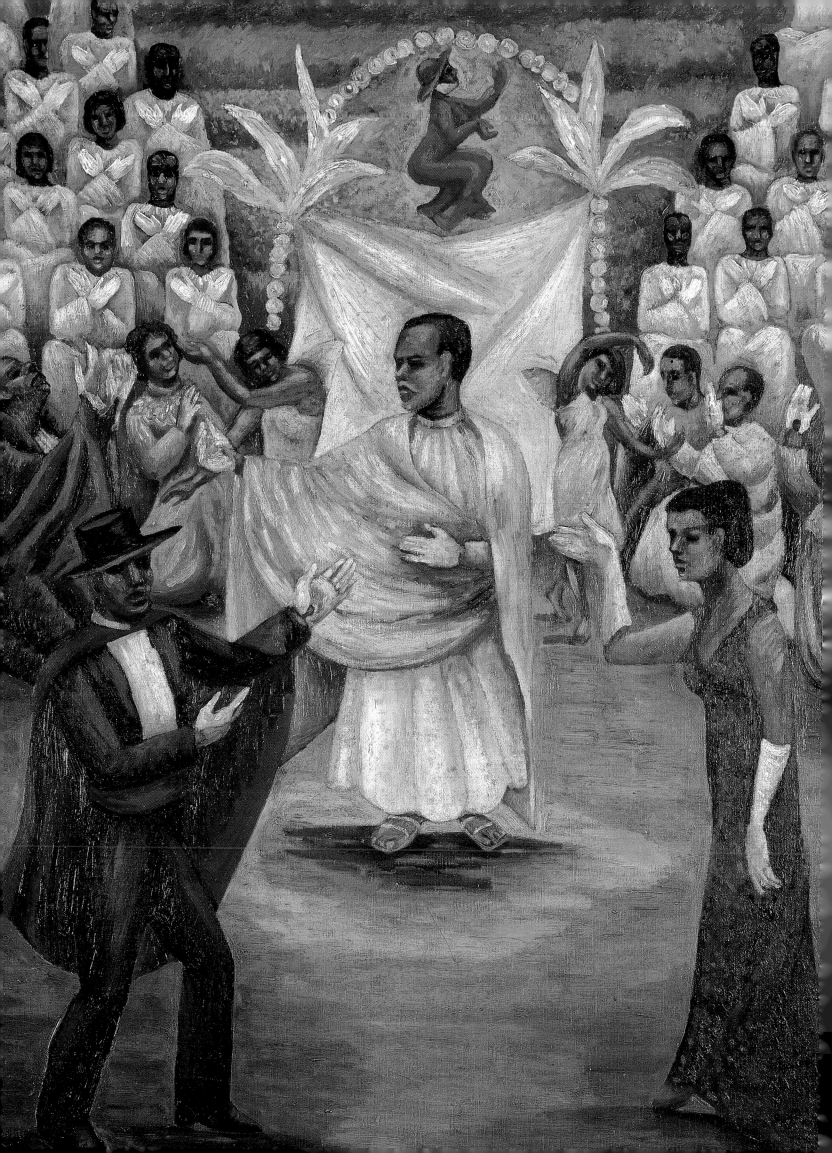

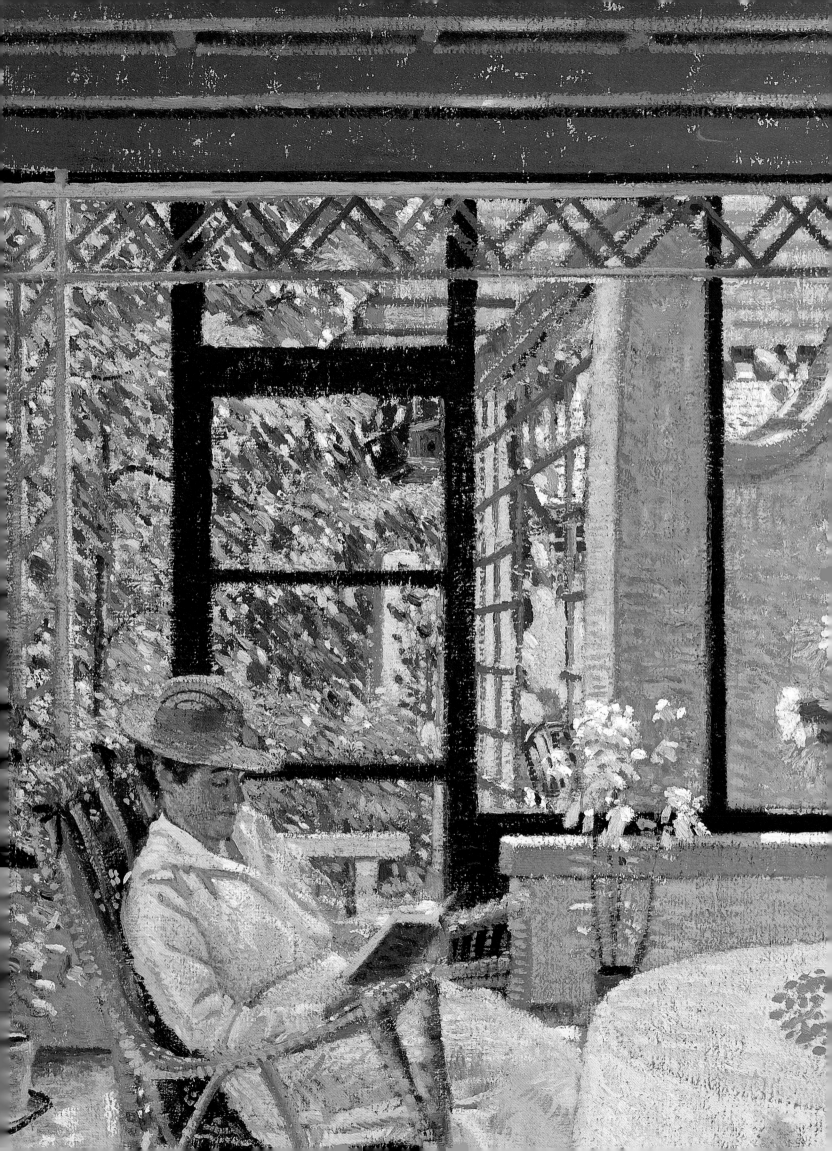

WENDY GREENHOUSE

LOCAL COLOR:
Impressionism Comes to Chicago

CHICAGO HAS ALWAYS HAD a special rela-
tionship with impressionism. More than a century ago,
Chicago's World's Columbian Exposition marked
what scholars agree was a turning point for American
acceptance of this new approach to art. Today, the
international renown of the Art Institute of Chicago
and the Terra Foundation for the Arts rests largely on
their beloved collections of impressionist paintings by
familiar European and American masters. Far less
known is the story of how progressive elements in
Chicago's own art community received and assimilated
the new style during the first decade of its widespread
acceptance in America, beginning with the 1893
world's fair. Impressionism then was as thoroughly
equated with artistic radicalism as, within a few short
decades, it would be with conservatism. Chicagoans'
early critical and artistic engagement with impression-
ism constitutes the opening chapter in their "pursuit of
the new"—the first conscious gesture of modernism
among local artists.

American Impressionism

Impressionism became a dominant trend in American
painting between the late 1880s and the 1920s.
Initially inspired by the work of Claude Monet and
the French impressionists in his circle, American
impressionism developed along less radical lines.
Where French exponents subjugated the illusion of
form to the optical effects of light on colored surfaces,
American painters retained their notions of represen-
tation and of idealism, albeit within the context of a
new concern with the painterly portrayal of natural
light and atmosphere and contemporary, out-of-doors
subject matter. Relatively reluctant to "dissolve" the
solid forms of the subject in a shimmering surface of
broken flecks of pure color, they selected correspond-
ingly safe subjects and themes that were modern with-
out being disturbing or challenging. The result was a
cautious impressionism that has been described as an
art of "euphemism, optimism, nationalism, and nostal-
gia."[1] In Chicago, this reconciliation of modernism
and conventional artistic values legitimized the forging
of local cultural identity.

"Invigorating" and "Inspiring:" Impressionism Comes to Chicago

With the exhibition and collecting of impressionist
art, Chicago took its place as one of the nation's most
progressive art centers. Impressionism arrived in
Chicago as the city struggled to define itself both as
the quintessential modern metropolis and as a mature
city distinct, in its relationship to the hinterland and in
its youth, from established cities to the east and south.
In the 1890s the city seemed poised to realize a cul-
tural greatness, even leadership, comparable to its
achievements in more practical realms of commerce
and industry.

While a progressive outlook in art might be expected
of a young, up-and-coming metropolis apparently
destined to lead the West, the artistic taste of late
nineteenth-century Chicago manifested a latecomer's
insecurity, the impress of still-vital notions of high cul-
ture as the expression of maturer civilizations. The
host of cultural institutions founded in the 1880s and
1890s —from the Art Institute of Chicago and the
Chicago Symphony Orchestra to the Newberry
Library and the University of Chicago embodied
local philanthropists' belief in the power of high cul-
ture to temper, even to redeem, the life of a city dedi-
cated to practical concerns.[2] Art was not only the
reward for but the essential complement to material
wealth, an antidote to Chicago's native brutality, com-
mercial aggressiveness, and industrial ugliness. The
much-prized paintings of the French Barbizon school,
for example, transported the viewer "to a region where
noise has ceased, where dirt and grime are absent,
where the soul sports in beauty, a delicious rest pos-
sesses us, and we feel that life is worth the living after
all," in the words of one Chicagoan in 1898.[3] In their
choices, Chicago collectors typically were guided by
both moral idealism and ardent cosmopolitanism, a
combination that would inform Chicago's critical
reception and artistic assimilation of the next new
thing, impressionism.[4]

Chicagoans' fundamentally conservative cultural out-
look was tempered by eagerness to be exposed to, if

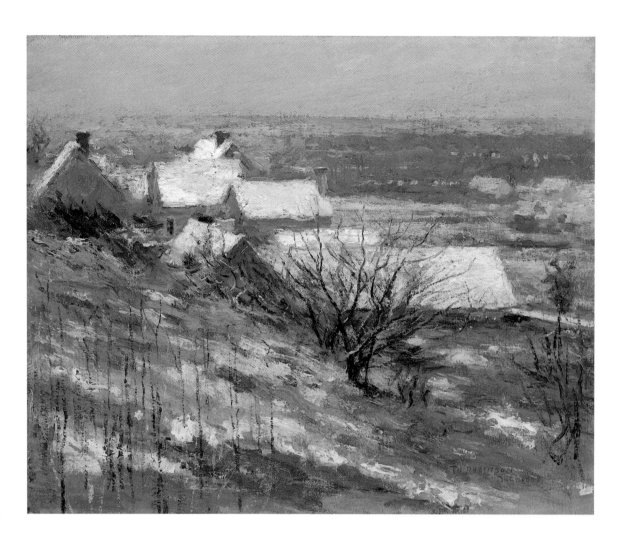

FIG. 1
Theodore Robinson (1852–1896)
Winter Landscape, 1889
Oil on canvas, 18 ¼ x 22 in.
Terra Foundation for the Arts,
Daniel J. Terra Collection, 1999.28

not to endorse, the latest trends in art. In its rapid recovery from the Great Fire of 1871, the city reinvented itself as the city of "the new" in matters both cultural and practical. Fittingly, given the city's commercial character, French impressionist works were first displayed there not in the select confines of a museum but rather amidst the market atmosphere of the annual trade show known as the Interstate Industrial Exposition.[5] There, from 1873 to 1890, eclectic exhibitions of modern European and American art from private collections and dealers' stock could be seen under the same cavernous glass roof as the latest in consumer goods, industrial equipment, and agricultural machinery. These mammoth art shows were organized by Sarah Tyson Hallowell, who would also serve as advisor to Chicago collectors of impressionist art.[6] Recognized both by contemporaries and by art historians today as among the most important art exhibitions of their era held in the United States, Chicago's Interstate Industrial Expositions brought the work of contemporary resident and expatriate American as well as European artists before the national and local art publics.[7] The last of these shows, in 1890, astounded Chicagoans with a selection of French impressionist paintings, including works by Monet, Camille Pissarro, August Renoir, and Alfred Sisley. Local critics echoed reaction elsewhere as they found

themselves alternately elated by these paintings' freedom of color and brushwork and offended by their rawness of technique. Particularly noteworthy is one reviewer's prophesy that the impressionists, while perhaps a fringe movement, would be hailed as "liberators" of art from its contemporary tendency toward "hard, dull, soulless exactness," an assessment redolent of Chicagoans' own yearnings for an art of elision, evocation, and idealism.[8]

This 1890 exhibition was by no means the first for impressionism in America, but it signaled Chicago's coming leadership as a national center for appreciation of the new mode.[9] The year before, the city's most progressive art collectors, wealthy businessman Potter Palmer and his wife, the cultivated Bertha Honoré Palmer, were among the first Americans to collect French impressionist works when they purchased a pastel by Edgar Degas. The new works such Chicago collectors saw at the 1890 Interstate Industrial Exposition shaped their taste in impressionist painting but, according to the pattern typical of Chicago collectors, they made their purchases abroad. On numerous visits to Paris, with the guidance of Hallowell and expatriate American artist Mary Cassatt, the Palmers amassed their considerable collection with astonishing speed. They purchased twenty-two works by

Claude Monet alone in 1892, the year that Chicago streetcar magnate Charles Yerkes turned his attention from Dutch old master and Barbizon works to paintings by masters of French impressionism. Collectors Arthur Jerome Eddy and Martin A. Ryerson would follow suit in the wake of the world's fair. Several important private collections, including those of Yerkes and the Palmers, were open to the public.[10]

The year 1890 was also marked by the Art Institute's presentation of works by members of the New York-based Society of American Artists.[11] This was Chicago's first serious exposure to the work of American painters in the process of adopting the new strategies of impressionism. Three times as many viewers saw the exhibition in Chicago as in New York, and it generated excitement in proportion. The overall effect of the show was "invigorating" and "inspiring."[12] Critics lauded the works' emphatically contemporary subject matter; even more striking was the accompanying abandonment of narrative in favor of "artistic arrangements in pure color" presenting "spiritual interpretation[s] of nature and nature's life"[13] Art for art's sake, such a comment paradoxically implied, could be redeemed if it in fact actually communicated a deeper spiritual truth.

The obverse of such enthusiasm was outrage at the seeming moral emptiness of the new art, whose technical innovation might be nothing more than an empty "seeking for effect." "Artists Who Try to Paint with Palette Knives Are Not Always Geniuses in Disguise" was the subtitle of one critique, which condemned Theodore Robinson's *Winter Landscape* (fig. 1) as a "fitful and erratic dabbling in pigments."[14] Similar concerns informed negative reaction to the two prize-winners, Dennis Miller Bunker's *The Mirror* (fig. 2) and John Singer Sargent's striking *La Carmencita*, although critics failed to distinguish these dark-toned, indoor works from the truer impressionism of much of the landscape paintings on display. The mere technical skill and manual cleverness of Sargent's and Bunker's paintings failed to disguise a "lack of motive" and the absence of the "deep and subtle significance which is to painting what vitality is to the human frame."[15] For Chicagoans, as for American critics in general, the separation of these artistic means from a "deep and subtle significance" would remain a particular concern.

Impressionism at the Columbian Exposition

The turning point in American artists' engagement with impressionism, contemporaries and historians agree, was Chicago's World's Columbian Exposition of 1893.[16] The fair itself offered a dramatic contrast between tradition and innovation, embodied in the juxtaposition of the White City's stately monochrome classicism and the futuristic technology of electric

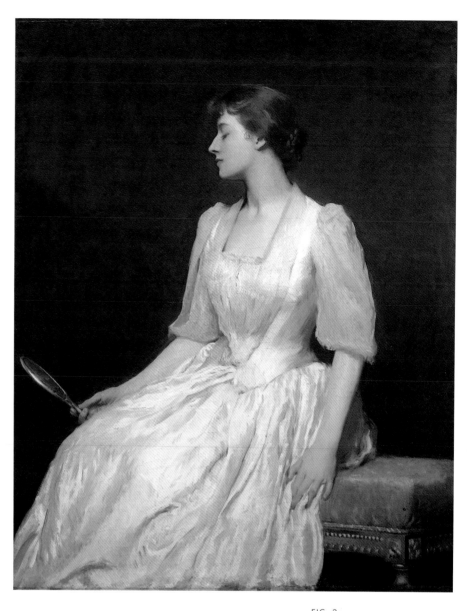

lighting and the Ferris wheel. Visiting artist Childe Hassam captured this dichotomy when he rendered the exposition's retrospective, formal architecture in a thoroughly up-to-date impressionist manner emphasizing movement and transience (fig. 3). Similar contrast could be found within the fair's gargantuan Palace of Fine Arts where, organized into a series of official national displays, the extremes of academic, narrative, and sentimental art were sometimes countered by modernist works gleaming with impressionist light and color. In the midst of these national sections, a special loan exhibition, organized by the indefatigable Miss Hallowell, presented a striking group of French impressionist paintings from American private collections, dominated by that of Chicago's own Mr. and Mrs. Potter Palmer.

Local critical reaction to impressionism at the world's fair was as diverse as the national response, with enthusiasm for its freedom and freshness again tempered by concern over its violation of artistic standards.[17] "The gratifying advance toward representations of

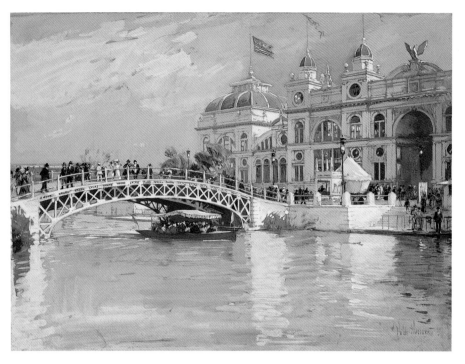

FIG. 3
Childe Hassam (1859–1935)
Columbian Exposition, Chicago, 1892
Gouache "en grisaille" on paper,
10⅝ x 14 in.
Terra Foundation for the Arts,
Daniel J. Terra Collection, 1992.38

light and sunshine must be accompanied by a firmer hold on the verities," opined a writer for *The Graphic.* Impressionism's flaunting of finish and sound technique, according to this critic, indicated more important deficiencies: "There must be the substance, the inspiring theme, the moving story, as well as the technique, which is so daring, so gratifying, and, in most cases, so true to nature."[18] While even the most enthusiastic American champions of impressionism could be deterred by its evident deliberate lack of "purpose," however, observers at the world's fair agreed that impressionism, "whether for good or bad, for long or short, . . . is the active influence in the art of today," in the words of Indiana painter William Forsyth, a convert to the movement.[19] Juxtaposed in the loan exhibition with examples of progressive movements that preceded it, impressionism seemed, indeed, historically inevitable.

The issue of national identity preoccupied both the varied response to the American section of the Columbian art exhibition and critical discussion of American impressionism throughout the 1890s. To some, American artists' adoption of impressionism, understood as yet one more manner imitated from the French, merely underscored their inability to develop a distinctly American artistic voice—a failure reiterated in the derivative, historicist architecture of the White City itself and magnified in the setting of Chicago, a quintessentially American city perpetually aping inherited culture. For supporters, however, impressionism, despite its foreign roots, offered itself as a vehicle of national expression, as demonstrated in the uniqueness of its various foreign manifestations. Scandinavian impressionist works exhibited at the

world's fair, for example, demonstrated the adaptability of impressionism to the expression of nationality beyond the borders of France; the French impressionists' celebration of pure nature and validation of intimate, quotidian localism offered an example to be emulated elsewhere.[20] Moreover, impressionism's emphasis on everyday modern life offered a fresh alternative to the high finish and exotic, historical, and sentimental themes characteristic of what is commonly called cosmopolitanism, the Europe-oriented trend of much late nineteenth-century academic American art. Impressionism, by contrast, offered a vehicle for a new art that was thoroughly American in its stylistic freshness and distinctly native subject matter.[21]

Chicago Artists and Impressionism

Along with the growing attention to impressionism among Chicago art collectors, the sanction of impressionism implied in its presentation at the world's fair seems to have catalyzed its acceptance locally. In the years surrounding the World's Columbian Exposition, impressionism was termed "the influence of the hour" among some Chicago painters, although little of what was produced in this vein has survived.[22] Even prior to the fair, some local artists seem to have been experimenting with impressionism's sketchy execution, bright color, and broken brushwork, for as early as 1892, in response to what it regarded as impressionism's seductive allure, the conservative Chicago Society of Artists offered two generous prizes in its annual exhibition for works untainted by the baleful influence of Monet, Pissarro, Sisley, and company— paintings "in which a summary treatment and eccentricities in drawing and color take the place of intelligent selection or arrangement and conscientious study."[23] While the exposition was in full swing, a small group of painters and sculptors who had come to Chicago to work on decorations for the fair formed the short-lived Vibrant Club, which admitted only those sculptors and painters who could prove an allegiance to "the new school by painting in spots and iridescent color or modeling 'à la boulette.'"[24]

Chicagoans' growing interest in impressionism was fed by the international art press and by exhibitions locally; in the 1890s the Art Institute presented exhibitions of the paintings of Edouard Manet and Monet, for example, as well as such variants as the work of contemporary Swedish artists led by impressionist figure painter Anders Zorn and the sunlit landscapes of broad Long Island vistas by William Merritt Chase and students at his Shinnecock Summer School. Local artists' own travel and study outside Chicago brought many under impressionist influence, which came directly to Chicago in the figure of Chase, a popular instructor at the Art Institute in 1894 and 1897, where Pauline Palmer (see

cat. 67) was one of his students. Chase's classes in New York and in Europe attracted such Chicagoans as Alson Skinner Clark (see cat. 23) and Frank Russell Wadsworth, whose *A River Lavadero, Madrid* (cat. 86) clearly indicates the master's influence in its slashing brushwork and unconventional viewpoint.

In the mid-1890s, many among Chicago's native community of young and progressive artists clearly took up impressionism, at least in their landscape and outdoor figural painting. In 1896 a group of female Art Institute students, including Palmer and several others with professional aspirations, showed impressionist paintings in the annual exhibition of the Art Students' League at the Art Institute, according to descriptions of these now-lost works in a review of the show.[25] In contrast to their dark-toned interior figural paintings that often nodded to contemporary fashion for nostalgia or *japonisme*, these artists' outdoor scenes were described in terms of light, color, atmosphere, and natural landscape elements. Palmer, for example, "successfully presents her thorn trees casting long blue and purple shadows on a shady walk through the woods, which teems with lovely atmosphere"; she also exhibited a genre scene of a woman reading before a window open to a sun-drenched landscape, perhaps the prototype for her favorite theme. Martha Baker's landscapes, including views of the picturesque Chicago suburb of Riverside in strong morning light and in the rosy glow of twilight, were "impressionistic" as well as "true in tone and line," and a landscape by Clara L. Powers, the most "impressionistic" member of the group, was "rife with sunshine and strong color." The description of Karl Buehr's work (see cat. 19) in this exhibition indicates that he was already working *en plein air* to render brilliant light in high-keyed color in his "blithe and joyous" landscapes.

Concurrent with and adjacent to the Art Students' League's 1896 exhibition at the Art Institute was the first annual show of the newly formed Society of Western Artists. This cooperative artists' organization, founded in Chicago, claimed members in states west of the Alleghenies and circulated its annual exhibitions to six midwestern cities.[26] Its inaugural exhibition, dominated by landscapes, announced the society's progressive tenor, for the effect of the whole show, enthused *The Inter Ocean*, was "broad, aimed to record an appearance of nature rather than to represent objects by the painstaking detail, that now seems in part to have gone out of fashion. In other words, impressionism is the rule rather than the exception."[27]

It is no accident that Chicago artists' early experimentation in impressionist painting occurred in landscape painting, the genre freest from academic dictates regarding drawing as the foundation of painting and the primacy of the carefully modeled human figure.

Their figural paintings typified the cautious, academic American approach to impressionism in admitting only a subtle influence from the new mode, which they grafted cautiously onto an armature of convention. Oliver Dennett Grover (see cat. 38–40), one of Chicago's most successful academic mural painters, for example, had come under the influence of James McNeill Whistler during his years in Venice as a member of American expatriate painter Frank Duveneck's circle. His 1899 full-length formal portrait of his wife (fig. 4), elegant in profile, is an Whistlerian essay in "tonal sentiment" that yet retains a strong academic emphasis on outline and drawing.[28] However, it marks a striking departure from his earlier masterpiece, *Thy Will Be Done* (fig. 5), exhibited at the World's Columbian Exposition, a work heavy with sentiment and dark Munich-school tonalities. Similarly, Pauline Dohn (Rudolph)'s *Village Belle* of 1899 (cat. 29) demonstrates a studied informality of subject and brushwork in harmony with its overtones of rural nostalgia, in contrast to her usual "painstaking, earnest" and sometimes "pretentious" manner.[29] In both cases, the artists were working in modes that perhaps lent themselves to less conventional means: Grover's portrait is of his wife, not a client sitter, while Dohn's work is a genre portrait on a small scale.

Portrait and figure painter Alice Kellogg Tyler was similarly selective in her experiments in impressionism in the mid- to late 1890s. The acknowledged

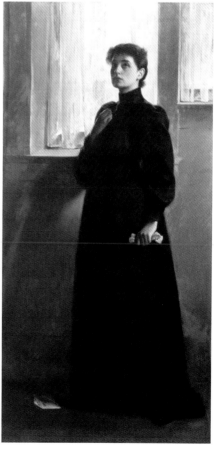

FIG. 4

Oliver Dennett Grover (1861–1927)
Portrait of Mrs. O. D. Grover, 1899
Oil on canvas, 79 x 40¼ in.
Courtesy of the Chicago Historical Society

FIG. 5

Oliver Dennett Grover
Thy Will Be Done, c. 1892
Oil on canvas, 71 x 34 in.
Illinois Historical Art Project

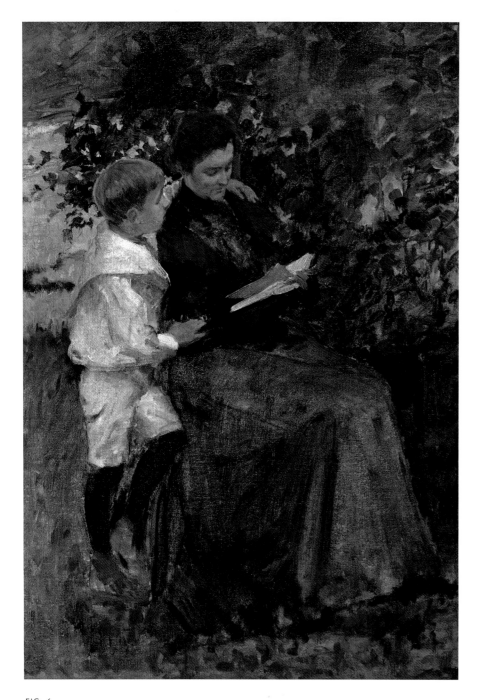

FIG. 6
Alice Kellogg Tyler (1862–1900)
Mabel and John in the Garden, c. 1898
Oil on canvas, 27 x 19½ in.
Powell and Barbara Bridges Collection

Even with few such examples of Chicago "impressionist" painting of the 1890s to study, it is clear that here as elsewhere the term was used loosely and inclusively by critics. Some described as impressionist the works of Whistler and the French Barbizon painter Camille Corot, for example, on the basis of their evocative works' disdain for detail and high finish and for their emphasis on overall effect.[32] Others proposed that any artist who worked directly from nature might be called an impressionist.[33] The tonalist painter Alexander Harrison was termed "a believer in the much-maligned and misunderstood principle of impressionism" because through his *plein-air* execution he realized an honest, direct "impression" of nature untrammeled by sentiment or convention, in the view of painter and art writer Charles Francis Browne, a critic of "extreme" impressionism.[34] Despite growing awareness of impressionism's historical development, which pointed to Manet, Monet, Pissarro, and Sisley as the defining practitioners of the movement, the term continued to be used with considerable latitude among Chicago critics. For local landscape painters and their public, it might indicate not only broad paint application and conception and heightened color but also a local sense of place and even the element of mood, the projection of emotion onto the landscape.

Such was the case with the "perilously popular," brilliantly colored snow scenes of Swedish-born landscapist Svend Svendsen, a follower of Swedish impressionist Fritz Thaulow. Svenden's pink snows and purple shadows struck one reviewer as "garish as well as impossible," but his work also was praised as "essentially modern."[35] *Winter Sunset Shadows* of 1895, an unlocated work apparently very similar to his strongly tinted 1897 *Winter Scene in Norway* (cat. 81), was judged "half impressionistic and half realistic, but wholly true . . . laden with the poetry of Corot and the truth of today."[36] Academic in its literal truthfulness and restrained paint handling, *Winter Scene* hardly fits a conventional definition of impressionism; it was "impressionistic," in the reviewer's sense, in its presentation of an intimate, unpeopled, rural scene in which "natural" or casually ordinary elements—carefully placed tree trunks set against gently rising land, frozen atmosphere, a surreal glow cast by sunset light on snow, tracks left by sleigh, horse, and man—are presented with seeming detachment for evocative effect.

"Impressionist" was also used to describe the very different paintings of Harry Wallace Methven, which were "individual in composition and personal in color," according to the *Chicago Tribune's* review of the 1895 Chicago artists' annual exhibition at the Art Institute. Judging by a poor reproduction in *Arts for America*, the painter's unlocated *The Lone Fisherman* (fig. 7), which hung in that exhibition, was distinguished by a

leader among Chicago's women artists, Tyler loosened her technique and freshened her color only in works whose small scale and subjects—family members portrayed with genrelike intimacy—admitted informal treatment; her major works, meanwhile, reflected her careful academic training in Paris in the late 1880s.[30] Tyler's image of her sister and nephew reading outdoors (fig. 6) has a snapshot quality that conveys the idea of the instantly perceived "impression" of real, modern life; indeed, it seems almost a painter's response to the unposed portraits made by a unidentified contemporary "impressionist" photographer whose candid technique should be emulated by portrait painters, according to the progressive Chicago journal *The Arts*.[31] Tyler's figures remain solid, three-dimensional forms in space, while the natural setting surrounding them is only sketchily suggested.

high horizon and a focus on shimmering water rendered in broken, patterned, presumably brilliantly colored brushstrokes. Another work by Methven, his unlocated *Evening*, was "presumably the most insanely impressionistic picture" in the exhibition, according to the *Inter Ocean*, which conceded nonetheless that this apparent "blotch of purple and rose tint" really did capture the feel of the landscape at sunset.[37]

Such "extreme" impressionism seems to have had few other practitioners in Chicago, where, as we have seen, there was little tolerance for such challenges to artistic verities as disdain for "finish," eccentric technique and garish colors, and above all lack of "motive." Stylistic radicalism or mere affectation was dispatched with humor in the tongue-and-cheek "Salon de Refuse." Named with self-deprecating reference to the mid-nineteenth-century Salon de Refusés, or exhibition of the rejected, staged by radical French painters whose works met official rebuff, this series of parodies of the current Chicago artists' exhibition at the Art Institute was held in the late 1890s by members of the Palette and Chisel Club, a professional artists' group. Begun in 1895, the club's founding membership consisted mainly of professional illustrators with higher aspirations, attendees at the Art Institute's "life class," where students drew from the living model. The club's parody exhibitions, ostensibly provoked by the rejection of some members' work from the Art Institute's exhibition, were partly a function of the important role of "high jinks" in the life of the organization, and they skewered the pretensions of a wide range of works. Impressionism came in for particular attention, however, perhaps because its sidelining of drawing, anecdote, and the figure ran counter to the artistic practice and aspirations of the club's illustrator-members. The 1898 Salon spoofed William Merritt Chase (whose work and that of his Shinnecock School students had been exhibited recently at the Art Institute) by offering "A Shinnecock Hills cigar" as the prize for "the painting showing the dizziest results of the pink and blue impressionist movement."[38] Paintings entitled "Chunks" and "Blobs" poked fun at impressionism's impasto and broken brushwork as subjects in themselves, while art for art's sake was lampooned in works with such titles as "A Portrait in Six Printings and a Gray Tint" and "A Knockturn in Prussian Blue." The star of the group was a reinterpretation of Methven's moonlight study as "a symphony in tar and barn paint, the effect being produced by a lighted candle behind glazed paper . . . executed with a shovel by permission of the board of health."[39]

While the "Salon de Refuse" took aim at the visual eccentricities of radical impressionism as practiced locally, the very popularity of the new mode provoked the concern of conservative Chicago painter, writer, and teacher Charles Francis Browne, an adherent of

Barbizon-style landscape painting. Condemning impressionism as mere faddishness, Browne admonished fellow-artists to "think beyond our tools," for the exaltation of method over "motive," the lack of higher purpose, were only a short way from the dangerous amorality embodied in French impressionism's baldly realist take on modern life.[40] Even collector Eddy admitted that his much-admired Manet "painted things as he saw and felt them, but he never saw and never felt the best side of things."[41] As a fresh way to capture both the appearance and the essence of modern life, impressionism seems to have alternately compelled and appalled such observers. Grounded in a traditionalist conviction of the relationship between art and morality, they were unprepared to accept its ultimate challenge to their understanding of art as a language of higher truths.

Local Color: Impressionism and Regionalism

The problem of accommodating modernism to morality preoccupied writer Hamlin Garland, one of America's most eloquent champions of impressionism in the 1890s. Garland was a native Midwesterner who moved from his adopted hometown of Boston to Chicago after visiting the World's Columbian Exposition, where the impressionist works on exhibit struck him with the force of a revelation.[42] Garland validated Midwesterners' growing assertion of regional cultural identity in his promotion of the heartland, with Chicago as its capital, as the coming leader and wellspring of modern American culture. He worked to spread the gospel of art in America's central region through the Chicago-based Central Art Association, founded in 1894 with progressive sculptor Lorado Taft

and patron Mrs. T. Vernette Morse, and through the organization's journal *The Arts* (later *Arts for America*), an important forum for discussion of impressionism.[43]

For Garland, as for Eddy, the quality of the artist's impression, as well as his choice of subject, reflected his spiritual health.[44] Garland's solution to the pitfalls of the modernist mode was to set its means—fresh color and light and *plein-air* naturalism—to the service of a wholesome nationalism, for "Art, to be vital, must be local."[45] He found his ideal of heartland impressionism in the work of a group of Indiana landscape painters he dubbed the "Hoosier school," which he presented in Chicago in 1894 under the auspices of the Central Art Association. It was not the artistic radicalism of their low-keyed, modified impressionism he admired so much as their celebration of the modest charm of the rural Indiana landscape, validated by the use of a recognizably modern style. Garland defined impressionism not in terms of color, light, and brushwork, but as a function of spontaneity, individuality, and especially authenticity. For Garland the impressionist rendering of a local, modern subject was the artistic equivalent of his own literary specialty, the local color sketch.[46]

Garland's redefinition of impressionism fell on receptive ground in Chicago in the 1890s. His emphasis on local subject matter, echoed by such influential art advocates as Browne and Taft, belonged to a larger drive for regional self-identity centering on the Midwest, manifested in the movement in literature, architecture, and the decorative arts later dubbed the Prairie school.[47] In Chicago, growing appreciation for the city's unique character, fed by international attention during the World's Columbian Exposition, had begun partly to counter local cultural insecurity. Although a perennial exodus of artistic talent eastward and major collectors' habit of buying abroad would continue to draw anxious protest, Chicagoans could also point with pride to a growing community of resident artists, the establishment of permanent organizations dedicated to their interests and to the elevation of the city's cultural life, generous local and national press coverage of art events in the city, and the national prestige of the Art Institute's exhibitions and school. New patronage and influence came from middle-class women's and civic clubs: such organizations as the Chicago Woman's Club, the Arché Club, the Young Fortnightly Club, and the Union League Club of Chicago funded prizes in and purchased art from exhibitions of local artists' work, particularly the Art Institute's Chicago artists' annual, inaugurated in 1897.[48] The following year, these patron groups coordinated their efforts through the newly founded Chicago Art Association and collectively committed a princely $12,000 to the purchase of works from the Chicago annual for their individual organizations.[49]

New interest in local subject matter among painters, then, reflected not only national reaction against American art's apparent slavishness to European subjects and styles, but a compatible civic and cultural climate within Chicago itself. Several resident artists, notably Browne, Grover, and Frank Peyraud, were painting Illinois and Indiana scenes as early as the World's Columbian Exposition (fig. 8).[50] Access was facilitated by the growth of local summer art colonies and club camps, promoted as homegrown "Barbizons" and "Givernys."[51] The local summer sketching excursions and exercises in *plein-air* painting undertaken by such artists' organizations as the Palette and Chisel Club in the 1890s indicates, if not an allegiance to impressionism itself, similar interest in direct, spontaneous execution, natural light, and, perhaps, appreciation for nearby locales as artistic subjects.

For some figural artists, the practice of painting out-of-doors led naturally to the consideration of local rural life, if not to the practice of orthodox impressionism. As early as 1889, two important Art Institute instructors, John Vanderpoel and Charles E. Boutwood, began teaching annual summer classes in *plein-air* figure and landscape painting in locales ranging from Delavan, Wisconsin, to St. Joseph, Michigan. Both artists were traditionalists dedicated to the supremacy of the figure, but their endeavors to render the human subject outdoors suggests a new concern for natural light; moreover, their *plein-air* instruction, according to one student, offered opportunities to study not only the posed model in a sylvan setting but picturesque rural subjects suggesting "open-air occupation"—a farmer resting on a hay mound, a girl picking cherries, or a boy fishing.[52] Such subjects answered current fashion for themes of idyllic European peasant life just as the classes themselves echoed expatriate artists' popular summer excursions to rustic spots in France and Holland.

As the tide turned against cosmopolitan exoticism and finish, the rural children portrayed in Winslow Homer's paintings and the poetry of John Greenleaf Whittier assumed new value for artists seeking a contemporary expression of wholly native themes. In Chicago they were led by Adam Emory Albright. Albright began his career painting portraits and moralizing allegories, but by 1899 abandoned them entirely for outdoor scenes of "wholesome country lads" or actual "Cook county children" (including his own three sons) that proved to one reviewer that the American boy could be as interesting a subject as any French peasant.[53] These loosely painted works were executed *en plein air*—as proven by the gnats allegedly embedded in the paint—near the artist's Edison Park, Illinois, studio, although he also used photographs to freeze his child-models' seemingly spontaneous poses.[54] Little of Albright's turn-of-the-century work

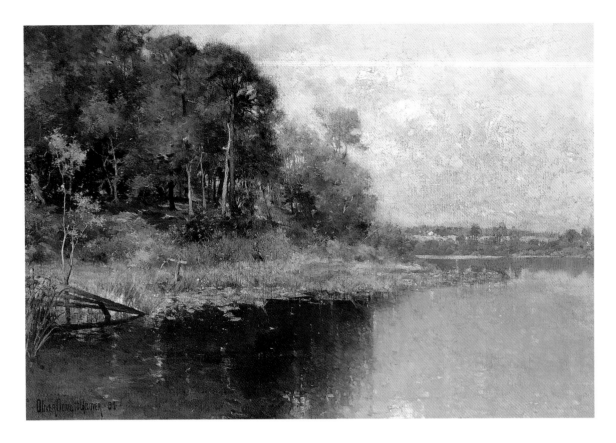

FIG. 8
Oliver Dennett Grover
Untitled (River Landscape)
Oil on canvas, 26¾ x 29 in.
Powell and Barbara Bridges
Collection

survives, but it was abundantly reviewed. Critics noted the paintings' "summary treatment" and praised their abundant sunlight and "luminous" color, partly the result of the painter's use of only three, bright colors. *Home From the Fields* of 1901 (fig. 9), reproduced in the artist's 1953 autobiography, indicates his free execution and patchy, tactile paint application in the rendering of highlights. Albright's impressionist approach was acceptable even to the conservative journal *Brush and Pencil*, however, because of his paintings' "strong native quality" uncorrupted by European influence and their status as "pictures with a meaning." Their cheerily nostalgic themes, which recalled in rosy tones the rural childhood of many a Chicago businessman, captured the public immediately and made the "farmer-artist" consistently the most popular exhibitor at the Art Institute for several decades.[55]

Although Albright did not commit himself wholly to the *plein-air* portrayal of rural children until 1899, he was already associated with a group of "progressive local artists" who formed the Cosmopolitan Art Club in 1893.[56] Founding members Kellogg (Tyler), Methven, Peyraud, Alfred Juergens, Hardesty Maratta, and Albright were sympathetic to new artistic trends and inspired by a sense of regional spirit. The club's annual exhibition of 1896 was conspicuous for "scenes of nature peculiar to America" and a welcome "dearth of wooden shoes, and the picturesque, toil-bowed, blue-garmented people of the mist" (that is, Dutch peasant subjects).[57] This exhibition was also the occasion of a regional convocation that gave birth to the Society of

Western Artists, whose inaugural exhibition that same year (already noted) was "ruled" by impressionism. The founding of the society expressed local convictions that, with sufficient exposure and support, the West would soon realize its destined leadership of American art.

The leader among Chicago's progressive landscape artists was Peyraud. His 1896 winter landscape (see cat. 68) may exemplify Garland's notion of impressionism in its combination of evocatively rendered

FIG. 9
Adam Emory Albright (1862–1957)
Home from the Fields, original in private collection; reproduced in Adam Emory Albright, *For Art's Sake* (Chicago: Lakeside Press, R. D. Donnelly and Sons Company, 1953), opposite 56

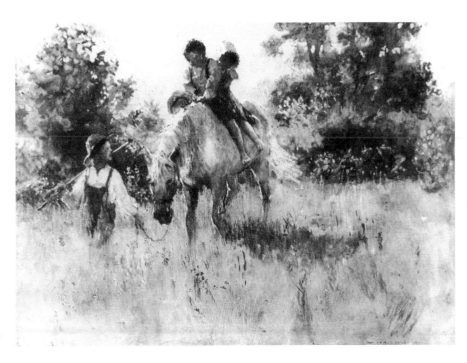

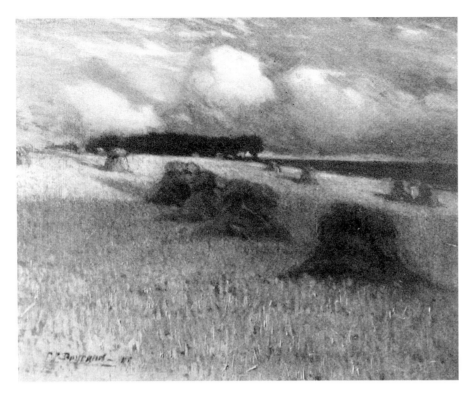

winter light and free brushwork with poetic feeling and a modest midwestern subject. The work retains a strong allegiance to traditional ideals of pictorial unity and integrity; although it exalts the flat rural landscape of the region, the careful massing of farm buildings in the distance seems designed to relieve that setting of its characteristic monotony. For such an accessible and cautious approach, applying aestheticizing strategies of painterly technique and evocative color to a solidly modeled subject, Peyraud's works earned the encomium of "valid impressionism."[58] His prize-winning painting *The Last Glow* (fig. 10) was the star of the 1899 Chicago artists' annual exhibition at the Art Institute among a collection evincing fresher, brighter, more spontaneous color.[59] Winner of the Young Fortnightly prize, *The Last Glow* was much parodied in the Palette and Chisel Club's "Salon de Refuse"; the original, however, won numerous plaudits as a work of "delicacy and poetry" that exemplified the painter's "elusive spirit" as well as his "suave brush."[60] These qualities were echoed in the evocative title, which (like that of his 1894 painting *The Dying Day*) reinforces the interpretive dimension of this treatment of nature as a vehicle for imposed sentiment in an manner quite alien to orthodox impressionism. Like Albright, Peyraud favored the mellow light and long shadows of day's end.[61]

Peyraud's melding of "poetical" overtones with ostensibly local subject matter made him a darling of the Central Art Association. His commitment to the midwestern landscape and his characteristic breadth of treatment appealed to Garland, who mentioned the artist favorably, if briefly, in *Impressions on*

Impressionism, his influential pamphlet championing the new mode.[62] The Central Art Association, he wrote to Peyraud in 1894, liked to send his paintings on exhibition tour because they demonstrated an ideal of buoyant color and free brushwork; "Mr. Taft joins me in reckoning you among our most powerful and lucid painters of sunlit landscape."[63] With Garland's encouragement, Peyraud and fellow artist Hardesty Maratta arranged to teach art at various branch "leagues" associated with Garland's organization, including at Peoria, where the two had already begun spending their summers painting in the Illinois River valley.[64] Both were hailed as "painters of western landscape, fresh and sweet, full of vitality and strong in color."[65] Peyraud used his lecture series in Peoria as an opportunity to promote impressionism as the painting of nature's "moods" and to advocate American subjects for American artists.[66]

As redefined by Garland, Peyraud, and other practitioners of "local color," then, impressionism was the modernist idiom by which midwestern landscape artists embraced their native setting. They were motivated by the same regionalist impulse that stimulated the experiments of the progressive architects and writers later dubbed the Prairie school, and they shared the latter's peculiar blending of modernism, nostalgic escapism, and a solid footing in technical fundamentals. When Peyraud, Browne, and other artists dedicated to the depiction of local landscape collaborated directly with these architects, the resulting mural and decorative painting could be incongruously academic and stylized.[67] Yet the sense of common enterprise is suggested by Frank Lloyd Wright's acquisition, by 1896, of impressionist easel works of midwestern landscape scenes by William Wendt and by Charles Corwin (fig. 11), brother of Wright's close friend and fellow architect Cecil Corwin. Installed in Wright's own Chicago suburban home, a showpiece of his evolving design aesthetic, these demonstrated a harmonious interplay of reference to the native landscape—in informal artistic imagery and in the intimate middle-class domestic space, equally inspired by the local natural setting, in which it was displayed.

Urban Impressionism

The qualified impressionism by which Chicago-based artists embraced the midwestern rural landscape also abetted a tentative growing interest in the artistic interpretation of their city.[68] This was perhaps more remarkable than it sounds, for despite the obvious pride felt for Chicago's astounding economic development, the ugliness of the city, with its industrial character, often eccentric architecture, and notorious congestion, was "an admitted fact."[69] It would not be until the 1910s that William Clusmann and

FIG. 11

Charles Abel Corwin (1857–1938)
Untitled Landscape, undated
Pastel and gesso on linen, 14 x 36 in.
Collection of Frank Lloyd Wright
Preservation Trust. Gift of Catherine
Baxter, 1977.10.01

Alfred Juergens (fig. 12), among others, created their celebratory impressionist images of the grandeur of the Loop's commercial architecture and busy thoroughfares. In the 1890s, as in New York and Boston a decade earlier, artists began to tame their unruly urban subject through the portrayal of metropolitan parks, laid out in Chicago in the 1880s with a deliberate naturalism in defiance of the city's relentless grid and monotonous flatness. Clusmann, who would make impressionist images of Chicago parks his specialty, began painting them in the mid-1890s. H. Leon Roecker sent "impressionist" scenes of Washington Park to the Art Institute's 1895 American art annual exhibition; influenced by his study of Manet and Monet, according to one critic, the painter "has come out boldly for sunlight and outdoor effects." Roecker "wisely" called his two canvases "impressions—and as such they can be understood."[70] The necessarily selective nature of "impressions" could reinforce the ethos of the parks themselves as idyllic pastoral refuges remote in spirit if not in space from urban reality.[71] The artistic interpretation of Chicago's more characteristic industrial and commercial landscape, however, was still problematical at the turn of the century. Artists typically took advantage of the ubiquitous smoke and steam of the city's industrial environs as a screen or filter for the ugliness of utilitarian architecture. When a reviewer of the Cosmopolitan Art Club's 1896 exhibition praised Harry Aiken Vincent's watercolor view of the industrial South Branch, for example, he noted the image's emphasis on overhanging smoke to create "a poetical illusion, through which the mind is led to believe that the beautiful is ever present, even under the most adverse conditions."[72] The river was notoriously filthy and congested, but the expanse of rippling water and billows of industrial vapor kept bridges, warehouses, shipping, and other utilitarian elements at a genteel remove. James Bolivar Needham, a relative outsider in Chicago's art world, was perhaps

the first painter seriously to envision the downtown riverscape as artistic subject (see cat. 54–61). Needham's diminutive paintings were exhibited by the Central Art Association in 1895 as part of its program to encourage western artists.[73] In both Needham's and Vincent's paintings, small scale and evident rapidity of execution on the spot underscored the "impression"-like character of the work, a validation of their necessarily selective, interpretive approach to a fundamentally unpicturesque subject.

By 1897 the ability to perceive poetry in the city's utilitarian ugliness was enough of a stereotypical attribute of the modern artist to be parodied. "Isn't it delightful to gaze with half-closed eyes at a building nearly hid by Chicago soot and tell each other that it is 'mighty decorative,' when we know that a dozen people are watching our antics?" queried *Brush and Pencil* rhetorically.[74] One such interpreter was the French-born, academically trained painter Albert Fleury, whose Chicago street images appeared in 1900 in a solo exhibition at the Art Institute pointedly titled "Picturesque Chicago." In such works as *A Winter Day in Chicago* (fig. 13), showing the office tower of the Auditorium Building and the "El" shadowing Wabash Avenue, Fleury, too, harnessed the softening atmospheric effects of swirling smoke, fog, or snow to capture the texture of the familiar while erasing its crudity; he "idealized" the grimy city, stated reviewer Maude Oliver frankly but approvingly, and "through the medium of an exceptionally sensitive touch, has happily recorded beauties and even poetry itself, which native artists have failed to discover."[75]

Native artists soon corrected this deficiency, however. In 1904 the Art Students' League's annual exhibition at the Art Institute featured one wall hung exclusively with "sketches of 'picturesque Chicago'"; the following year members of the Palette and Chisel Club took their sketching expedition in the city rather than to

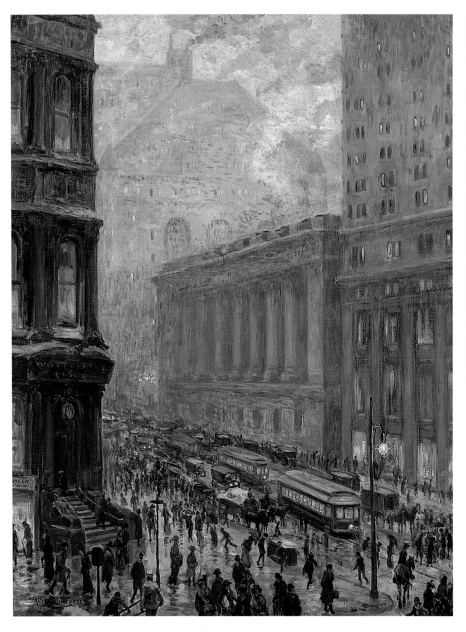

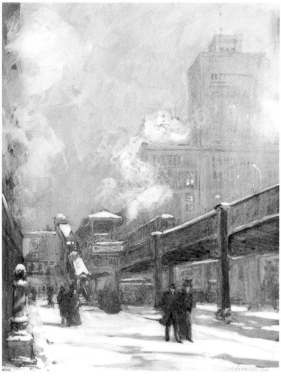

FIG. 12
Alfred Juergens (1866–1934)
La Salle Street at Close of Day, 1915
Oil on canvas, 40 x 30 in.
Powell and Barbara Bridges
Collection

FIG. 13
Albert Fleury (1848–1924)
A Winter Day in Chicago, 1901
Watercolor and gouache on paper,
23 x 17 in.
Roosevelt University, Chicago

their usual rural spot and attempted "to catch the local color of the diverse sides of city life."[76] About this time, Alson Clark returned to his native Chicago to paint *The Coffee House* (cat. 23), in which the view south across the State Street bridge is blurred by weak winter sunlight diffused through industrial smoke. Praised by a contemporary reviewer as a thoroughly "twentieth-century" work, *The Coffee House* approached its urban theme with a modernist sensibility embodied in the composition's ambiguous viewpoint, the slashing diagonal of the bridge, which leads the eye into the middle distance, and the focus on light effects rather than discrete objects. Clark's painting anticipated a host of celebratory, decorative portrayals of Chicago in the late 1910s and 20s, such as George Demont Otis's playfully tinted *Grain Elevators, Goose Island* (cat. 66) and George Ames Aldrich's brooding *The Melting Pot, Chicago* (cat. 4).

Conclusion

In 1900 Fleury's "Picturesque Chicago" exhibition took place at the Art Institute concurrently with Albright's first one-man show of his "barefoot boys." The two exhibitions' common theme of midwestern archetypes represented a remarkable ascension of the local in the mere half-dozen years since Garland, among others, called on American artists to embrace their native landscape.[77] The expression of regional spirit through local rural and urban subject matter was only one of many ways in which Chicago painters applied aspects of impressionism, but the one that most clearly demonstrates their particular redefinition of the new in terms of local conditions.

As the expression of "local color," impressionism was an important means by which some of Chicago's progressive painters of the 1890s and 1900s tackled the very problem of what it meant to be a modern artist of and in their city. In defiance of what many Americans regarded as the amoral materialism of French impressionism, they redefined the modern mode in terms of purpose and intention rather than technique; they were preoccupied with how this modern way of representing nature on its own terms, liberated from narrative and from photographic detail, could yield a truer interpretation of nature's own poetry, "those deeper meanings. . . [and] closer relations of nature with the heart of man which are strong to soothe and console and inspire."[78] Rapid, on-the-spot execution, a selective elimination of detail, an attention to light, atmosphere, and expressive color, the elimination of obvious narrative, the exaltation of the landscape—

some or all of these came into play, but only as means to such transcendent ends. These strategies validated the subject by transforming it into an aesthetic object—not simply as a source of reflected colored light but as a vehicle of meaning.

This brief moment of modernist experimentation in Chicago offers an opportunity to deepen our understanding of what makes American impressionism American: here, at least, it was not just an "academic" reluctance to surrender pictorial illusion to optical effects but a driving search for meaning and signifi-cance in the representation of "local color" and the expression of native artistic self-identity. "Technical dexterity, strength of handling and feeling for color are very necessary qualities in a painter, but surely these are not the all of art," wrote a commentator in *Arts for America*, Chicago's progressive voice of the decade; "The idea, the sentiment, the theme, the soul-truth and soul-beauty are equally important matters of consideration; and these are, perhaps, the points which are finally to differentiate and give national distinction and impress to our own work."[79]

NOTES

1. H. Barbara Weinberg, Doreen Bolger, and David Park Curry, *American Impressionism and Realism: The Painting of Modern Life, 1885–1915* (New York: Metropolitan Museum of Art, in association with Harry N. Abrams, 1994), 8.

2. For a thorough discussion of the ideas and sense of mission that motivated the founding of Chicago's major institutions of culture in the 1890s, see Helen Lefkowitz Horowitz, *Culture & the City: Cultural Philanthropy in Chicago from the 1880s to 1917* (reprint, Chicago: University of Chicago Press, 1976). See also Robert I. Goler, "Visions of a Better Chicago," in Susan E. Hirsch and Robert I. Goler, *A City Comes of Age: Chicago in the 1890s* (Chicago: Chicago Historical Society, 1990), 90–153.

3. C. F. Browne, "The Permanent Collections of the Museum of the Art Institute of Chicago. IV.—The Henry Field Memorial Collection," *Brush and Pencil* 2 (April 1898): 3.

4. For an overview of late nineteenth and early twentieth-century collecting in Chicago, see Lena M. McCauley, "Some Collectors of Paintings," *Art & Archaeology* 12 (September–October 1921): 155–72; see also Stefan Germer, "Traditions and Trends: Taste Patterns in Chicago Collecting" in *The Old Guard and the Avant-Garde: Modernism in Chicago, 1910–1940*, ed. Sue Ann Prince (Chicago: University of Chicago Press, 1990), 171–86.

5. A selection of works chosen by Paul Durand-Ruel, the most important Paris dealer in impressionist art, was exhibited at Thurber's Art Gallery in Chicago in 1888, to little notice. Leslie Goldstein, "Art in Chicago and the World's Columbian Exposition" (M. A. thesis, University of Iowa, 1970), 34. On the Interstate Industrial Exposition art shows, see T. Vernette Morse, "Looking Backward," *The Arts 4* (August 1895): 39–42; John D. Kysela, "Sara Hallowell Brings 'Modern Art' to the Midwest, " *Art Quarterly* 27 (1964): 150–67; Joseph W. Faulkner, "Painters at the Hall of Expositions: 1890," *Chicago History* 2 (Spring 1972): 14–16; and Stefan Germer, "Pictures at an Exhibition," *Chicago History* 16 (Spring 1987): 5–21. For an overview of the early exhibition of impressionist painting in Chicago, see also Daniel Catton Rich, "Half a Century of American Exhibitions," in *Annual Exhibition Record of the Art Institute of Chicago, 1888–1950*, ed. Peter Hastings Falk (Madison, Conn.: Sound View Press, 1990), 9–12.

6. On Hallowell, see *Revisiting the White City: American Art at the 1893 World's Fair* (Washington, D. C.: National Museum of American Art and National Portrait Gallery, Smithsonian Institution, 1993), 65–7, 114 n. 8.

7. On the national importance of the Interstate Industrial Exposition art exhibitions, see Germer, "Pictures at an Exhibition," 10–12, and Kysela, "Sara Hallowell," 154–55.

8. *Chicago Evening Post*, 3 September 1890; as quoted in Faulkner, "Painters at the Hall of Expositions," 16. See also Kysela, "Sara Hallowell," 155.

9. French impressionist art had been seen in New York and in Boston in several important exhibitions in the 1880s; see William H. Gerdts, *American Impressionism* (New York: Abbeville Press, 1984), 48–53.

10. These private collections are mentioned as open to the public in *Chicago Tribune*, 10 March 1887 and 30 November 1890; cited in Leslie Goldstein, "Art in Chicago and the World's Columbian Exposition," 18, 21, 29; see also McCauley, "Some Collectors of Paintings," 166. On Eddy's collecting of Manet and Whistler, see Paul Kruty, "Arthur Jerome Eddy and His Collection: Prelude and Postscript to the Armory Show," *Arts Magazine* 61 (February 1987): 41.

11. The works, recently exhibited in New York City as the annual show of the Society of American Artists, were brought as a group to Chicago with the exception of seventeen canvases; these were partly replaced by works mostly by local painters, including Oliver Dennett Grover, Walter McEwan, and Jules Guerin; see "At the Art Institute," *Inter Ocean*, 10 June 1890.

12. "Fine Works in Oil," illegibly dated newspaper clipping marked *Chicago Evening Post*, in the Art Institute of Chicago Scrapbooks, vol. 4, the Art Institute of Chicago, microfilmed; "Wafted from the Sea," *Chicago Times*, 9 June 1890. *Chicago Tribune* quoted in "Art Notes," *New York Times*, 23 July 1890, reported that 15,000 people attended the exhibition at the Art Institute, compared to 5,000 at the National Academy of Design, although only one work was sold during the exhibition's five weeks in Chicago. The *Tribune* pointed out that this was undoubtedly due to the lateness of the exhibition season and the absence of many picture-buyers from the city.

13. "Homemade Paintings," *Chicago Herald*, 9 June 1890.

14. "Pointers on Paintings," clipping from unidentified newspaper, dated 21 June 1890, in the Art Institute of Chicago Scrapbooks, vol. 4. See also "At the Art Institute," *Inter Ocean*, 10 June 1890.

15. "Fine Works in Oil." This article was subtitled "American Painters Have Great Manual Cleverness—THEY LACK ONLY MOTIVE."

16. Gerdts, *American Impressionism*, 141–42; Weinberg, Bolger, and Curry, *American Impressionism and Realism*, 22, 32.

17. See "Fine Arts at the Fair," *Chicago Tribune*, 20 August 1893; Gerdts, *American Impressionism*, 142; *Revisiting the White City*, 99–106. I am grateful to Diane Dillon for bringing the *Tribune* review to my attention.

18. "The Fine Arts Department of the Columbian Exposition," *The Graphic*, 27 May 1893, 351.

19. W. Forsyth, "Some Impressions of the Art Exhibit at the Fair.—II," and "Some Impressions of the Art Exhibit at the Fair.—III," *Modern Art*, unnumbered (Autumn 1893): n.p. *Modern Art* was a progressive journal published in Indianapolis at the time of the fair.

20. For typical comments on the Scandinavian paintings, see for example Martha C. Thurber, "Impressionism in Art—Its Origin and Influence," *Arts for America* 5 (June 1896): 183.

21. For more on these views of impressionism, see Weinberg, Bolger, and Curry, *American Impressionism and Realism*, especially 25, 32–33, and 55–66.

22. T. Vernette Morse, "The Text-books of Modern Art," *The Arts* 4 (Oct. 1895): 103.

23. *Chicago Tribune*, 27 March 1892; as quoted in Goldstein, 67, note 133. One of the two $300 prizes, ironically, was offered by collector Charles Yerkes, who that very year had begun collecting French impressionist paintings.

24. The only reference to the Vibrant Club is in *Chicago Tribune*, 20 August 1893. The membership consisted of a handful of sculptors only temporarily in the city as creators of decorative sculpture at the World's Columbian Exposition and a few, unidentified painters. The French word *boulette* translates as "pellet," suggesting, in the context of sculpture, rough modeling by the accretion of small blobs of clay.

25. The following quotes are all taken from "Art Students' League Exhibition," *Chicago Times-Herald*, 13 December 1896.

26. On the origins of the Society of Western Artists, see "Pictures at the Cosmopolitan Club Exhibition," *Chicago Tribune*, 8 March 1896; see also William H. Gerdts, *Art Across America. The South, Near Midwest* (New York: Abbeville Press, 1990), 175–77.

27. Newspaper clipping inscribed *Inter Ocean*, 16 December 1896, in the Art Institute of Chicago Scrapbooks, vol. 8, microfilmed. See also "Artists Are Hosts," newspaper clipping inscribed *Inter Ocean*, 15 December 1896, in the Art Institute of Chicago Scrapbooks, vol. 8, microfilmed.

28. "Art," *Chicago Times-Herald*, 26 February 1899.

29. "Chicago Women in Art," *Chicago Times-Herald*, 12 February 1899; "Exhibit by Chicago Artists," *Chicago Chronicle*, 5 March 1899.

30. Annette Blaugrund with Joanne W. Bowie, "Alice D. Kellogg: Letters From Paris, 1887–1889," *Archives of American Art Journal* 28 (1988): 18. See also Annette Blaugrund et al, *Paris 1889: American Artists at the Universal Exposition* (Philadelphia: Pennsylvania Academy of the Fine Arts in association with Harry N. Abrams, 1989), 177–78.

31. Editorial, *The Arts* 4 (October 1895): 117.

32. *Chicago Tribune*, 27 April 1890 and 20 May, 1888; quoted in Goldstein, "Art in Chicago," 41.

33. "The Fine Arts, *Chicago Tribune*, 27 March 1892.

34. Charles Francis Browne, "Alexander Harrison—Painter," *Brush and Pencil* 4 (June, 1899): 133.

35. "Art," *Chicago Times-Herald*, 19 March 1899.

36. See "Svend Svendsen," *The Arts* 4 (December 1895): 183, where *Winter Sunset Shadows* is described in detail.

37. *Chicago Tribune* and *Inter Ocean*; as quoted in "American Artists and Their Critics," *The Arts* 4 (November 1895): 141.

38. Theodore Leonard Phillips, "The Salon de Refuse," *Brush and Pencil* 1 (March 1898): 208.

39. "Burlesque on Art Prizes," *Chicago News*, 12 February 1898.

40. A Critical Triumvirate [pseud.], *Impressions on Impressionism* (Chicago: The Central Art Association, 1894), 24; see also page 17 of idem and C. F. Browne, "The Permanent Collections," 7, and T. Vernette Morse, "The Text-Books of Modern Art," *The Arts* 4 (October 1895): 103–4.

41. Arthur J. Eddy, "Edouard Manet, Painter," *Brush and Pencil* 1 (February 1898): 139–40.

42. Gerdts, *American Impressionism*, 142–48.

43. On the Central Art Association and its journal see Gerdts, *Art Across America*, 302–3.

44. See Jane Johnson, introduction to Hamlin Garland, *Crumbling Idols* (1894; Cambridge, Mass.: Belknap Press of Harvard University Press, 1960), xvii–xxii, which provides a thorough discussion of Garland's philosophy and its sources.

45. Garland, "Impressionism" in *Crumbling Idols*, 104. Garland's argument closely follows that of Alma G. White in "Paint What You See," published in the Indianapolis journal *Modern Art*, (Summer 1893): n.p. On the development of Garland's literary theory of "veritism" and local color, see Donald Pizer, "A Summer Campaign in Chicago: Hamlin Garland Defends a Native Art," *Western Humanities Review* 13 (Autumn 1959): 375–82.

46. On the Hoosier school, see Gerdts, "The Golden Age of Indiana Landscape Painting," in *Indiana Influence* (Fort Wayne, Ind.: Fort Wayne Museum of Art, 1984), 14–59. See also Gerdts, *Art Across America*, 266–75, and bibliography, 368–69. The work of the Hoosier artists continued to be held up as an example by the Central Art Association: see O. Public Occurrent [pseud.], "C.A.A. Exhibition in Fort Wayne," *Arts for America* 5 (June 1896): 197–98. For Garland's views of the Hoosier school, see Gerdts, "The Golden Age of Indiana Landscape Painting," 25–26. See Johnson, *Crumbling Idols*, xxi–xii, for a discussion of Garland's local-color writings.

47. A Critical Triumvirate [pseud.], "Impressions on Impressionism," 22–3; Lorado Taft, "Picturesque Illinois," *Brush and Pencil* 2 (July 1898): 184. For an introduction to the flowering of midwestern culture in Chicago beginning in the aftermath of the World's Columbian Exposition, see Thomas J. Schlereth, "A Robin's Egg Renaissance: Chicago Culture, 1893–1933," *Chicago History* 8 (Fall 1979), 144–54.

48. On the role of the women's clubs, see for example Ida M. Condit, "Art Conditions in Chicago and Other Western Cities," *Brush and Pencil* 4 (April 1899): 8.

49. "Art," *Chicago Tribune*, 30 January 1898. In 1899 the association was absorbed by the Municipal Art League, which had broader objectives to improve the city's appearance, elevate public taste, and encourage local artists. The league assembled a public art collection, the bulk of which is now owned by the Union League Club of Chicago, that includes important later impressionist works by Chicago-based painters.

50. Peyraud exhibited a prairie scene at the World's Columbian Exposition, reproduced in *The Graphic* with the title *Evening—Creek near Rockford, Ill.*; in the Art Institute's American annuals, Brown was exhibiting scenes painted around Bass Lake, Indiana, as early as 1894.

51. Browne's Bass Lake, Indiana, scenes, for example, were painted while he summered there as a member of the art colony. Grover painted the area around the Rock River, near his native Earlville, and later joined Eagle's Nest, an exclusive seasonal gathering of artists and literary figures founded in nearby Oregon, Illinois, in 1898.

52. Louise Riedel, "Student Life at Delavan," *Brush and Pencil* 2 (June 1898): 116. The year 1898 was described as the ninth season that Vanderpoel and Boutwood had conducted these summer classes ("Art Notes," *Brush and Pencil* 2 [June 1898]: 137).

53. G. D. B., "Art and Artists," *Chicago Journal*, 3 October 1900.

54. Marianne Richter, "Adam Emory Albright" (paper written for the Illinois Historical Art Project, 2000), 3. I am grateful to Marianne Richter for access to this paper and for permission to cite it.

55. The comments are from Lorado Taft, "Two Interesting Exhibits," *Chicago Record*, 16 October 1900, and "Exhibitions of the Week," *Chicago Record-Herald*, 5 October 1902.

Reproductions of Albright's work from this early period of his painting children may be found in William Vernon, "Fine Exhibits Are Shown at the Art Institute," *Chicago American*, 3 October 1902, and "Reception at Art Institute," *Chicago News*, 3 October 1902. Albright claimed to use only rose-madder, cobalt blue, and chrome yellow (Henry E. Willard, "Adam Emory Albright, Painter of Children," *Brush and Pencil* 12 [April 1903] 11). For the critical reception of Albright's outdoor paintings of children see Willard, "Adam Emory Albright," 11–12; Vernon, "Fine Exhibits"; G. D. B., "Art and Artists," *Chicago Journal*, 13 October 1900; and "He Portrays the Children," *Chicago News*, 11 October 1900. On Albright's turn to this subject, see Adam Emory Albright, *For Art's Sake* (Chicago: Lakeside Press, R. R. Donnelly and Sons Company, 1953), 108–9.

56. On the formation of the Cosmopolitan Club, see "Art and Artists," *The Graphic*, 5 March 1892, and Richard W. Bock, *Memoirs of an American Sculptor*, ed. Dorathi Bock Pierre (Los Angeles: C.C. Publishing Co., 1991), 50. According to William H. Gerdts, Albright began painting more colorful and light-filled works in the 1890s after exposure to impressionist painting at the World's Columbian Exposition; see Gerdts, *Art Across America. The South, Near Midwest*, 301.

57. "Art and Artists," *Chicago Evening Journal*, 12 March 1896.

58. "Art," *Chicago Times-Herald*, 26 February 1899.

59. "The Exhibition of Chicago Artists," *Brush and Pencil* 4 (April 1899): 46–47.

60. "Art," *Chicago Times-Herald*, 26 February 1899; "Art Institute Exhibitions," *Chicago Record*, 28 February 1899.

61. "Exhibitions of the Week," *Chicago Record-Herald*, 5 October 1902.

62. A Critical Triumvirate [pseud.], *Impressions on Impressionism*, 21. This important pamphlet, probably Garland's work, was a review of the Art Institute's 1894 American art annual in the form of a discussion between the "Novelist" (Garland), the "Sculptor" (Taft), the "Conservative Painter" (Charles Francis Browne), and an unidentified "Eminent Painter." Peyraud's *Evening* was reproduced in *The Graphic*, 27 May 1893, 349.

63. Garland to Peyraud, Oct. 7, 1895, collection of Paula Peyraud. I am grateful to Paula Peyraud for access to this letter and for permission to quote from it. See also "Juries of Selection," *Arts for America* 5 (July 1896): 234.

64. "C.A.A. League Notes," *Arts for America* 5 (February 1896): 30; Janice Harmer and Miriam Lorimer, *Frank C. Peyraud: Dean of Chicago Landscape Painters* (Peoria, Ill.: Lakeview Museum of Arts and Sciences, 1985), n. p.

65. Isabel McDougal, "Art and Artists," *Chicago Post*, 5 June 1896.

66. "Realists and Impressionists," *Peoria Evening Star*, 12 November 1897, and "American Art and Artists," *Peoria Journal*, 19 November 1897, both quoted in Harmer and Lorimer, *Frank C. Peyraud*, n. p. But by the turn of the century, Peyraud had begun to downplay the evocation of locality in favor of bolder, more stylized forms and strong color for dramatic or lyrical effect; see for instance Peyraud's *Twilight* of 1900, reproduced in Gerdts, *Art Across America. The South, Near Midwest*, 300.

67. Paul Kruty, "Art for Architecture: Mural Painting in the Prairie School," *BlockPoints: The Annual Journal and Report of the Mary and Leigh Block Museum of Art* 3/4 (1996/1998): 8–31.

68. For an overview of Chicago as an artistic subject see Wendy Greenhouse, "Picturing the City: Chicago Artists and the Urban Theme," *BlockPoints: The Annual Journal and Report of the Mary and Leigh Block Museum of Art* 3/4 (1996/1998): 77–97.

69. Elia W. Peattie, "The Artistic Side of Chicago," *The Atlantic Monthly* 84 (December 1899): 831.

70. *Inter Ocean* as quoted in "American Artists and Their Critics," *The Arts* 4 (November 1895): 141. The following year, more of Roecker's park views appeared in the Cosmopolitan Art Club's fifth annual exhibition, where they were commended as "charming expressions of our own time and place" by the reviewer for *Arts for America*; see "Cosmopolitan Art Club," *Arts for America* 5 (April 1896): 88.

71. For an overview of Chicago park design and its cultural construction in the late nineteenth century, see Daniel Bluestone, *Constructing Chicago* (New Haven: Yale University Press, 1991), ch. 2.

72. "Cosmopolitan Art Club," *Arts for America* 5 (April 1896): 88–90; Vincent's watercolor is reproduced on page 101.

73. Needham's exhibition is mentioned in Hamlin Garland, "Successful Efforts to Teach Art to the Masses," *The Forum* 19 (July 1895): 609.

74. Me [pseud.], "Concerning Freaks," *Brush and Pencil* 1 (November 1897): 26–27.

75. Maude I. G. Oliver, "Chicago Painter: The Work of Albert Fleury," *International Studio* 22 (March 1904): 21; see also Lorado Taft, "Two Interesting Exhibits," *Chicago Record*, 16 October 1900.

76. "The Art Students' League of Chicago Annual Exhibition, Art Institute," *The Sketch Book* 3 (March 1904): 183; "Art," *Chicago Evening Post*, 14 January 1905 (the article is illustrated with examples of the league members' work, mostly works on paper).

77. A Critical Triumvirate [pseud.], *Impressions on Impressionism*, 21–23.

78. Harriet Monroe, "Wendt's Landscapes," *Chicago Examiner*, 11 March 1905.

79. Nannie Seawall Boyd, "American Art and Artists," *Arts for America* 5 (March 1896): 47.

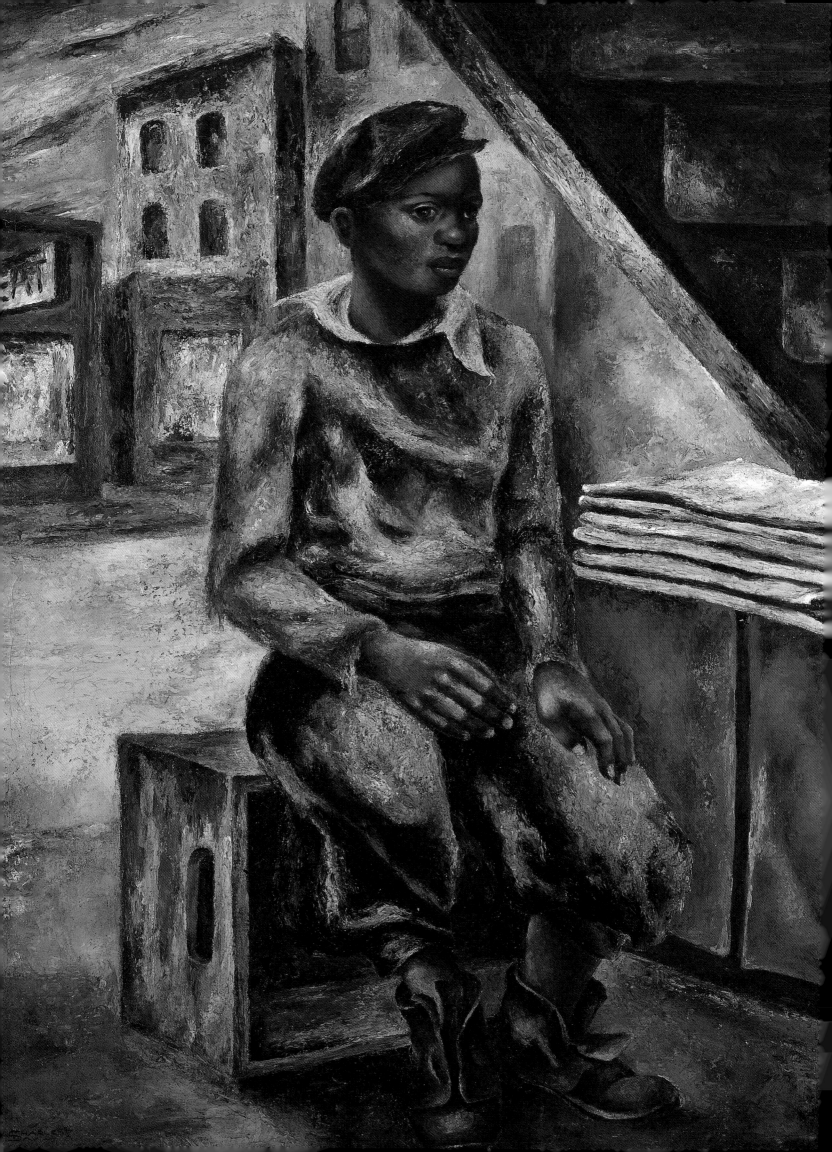

Daniel Schulman

"WHITE CITY" AND "BLACK METROPOLIS":
African American Painters in Chicago, 1893–1945

AFRICAN AMERICAN ARTISTS in Chicago faced a variety of challenges during the period from the World's Columbian Exposition of 1893 to the early 1940s. As citizens, they were subjected to a rising tide of discrimination and hostility by their white neighbors. As artists, their works and aspirations were judged through a filter of conflicting expectations and agendas. In spite of this adversity, black artists found training, opportunity, and an audience in Chicago. Indeed, by the late 1930s African American artists in Chicago were among the most celebrated in the country—although still thought of by mainstream critics as "separate." As many historians have noted, the exclusion of black artists from opportunity, as well as from art history, has strongly influenced the interpretation and reception of their work.[1] In addition to coping with the complexities of modernism and its impact on the formation of cultural identity, black artists were engaged in a basic struggle for inclusion. In the case of Chicago artists of color, a comprehensive survey has yet to be written. The goal of this essay is to lay the groundwork for a more accurate history of the work and experience of black artists in Chicago before World War II.

The historical record of the work and lives of black artists in Chicago, especially before World War I, is still quite fragmentary. Part of the reason for this is that early in the period under consideration, the black population was relatively small. In 1890 there were only 15,000 black residents in Chicago, about 1 percent of the city's population.[2] Even after the war and the rapid influx of southern blacks during the 1910s and '20s, the community of black men and women making a living as artists or illustrators was so small that making broad generalizations about their work and careers is difficult. While we may be able to recognize some working black artists by name, often little remains of their work.

Although the identification of unifying or common threads in this history can be elusive, two factors stand out. The first is the city itself, which, as a result of increasing migration from the South, came to have the second largest black population of any American city.

Chicago responded to these changes by subjecting African Americans to an unofficial but consistent regime of discrimination and segregation—a new form of Jim Crow as unjust as any that had been devised in the South. Blacks were forced to live in a constricted zone of settlement on the South Side that came to be known as Bronzeville. Despite such harsh origins, a vibrant and distinctive culture grew out of this community, and, as a result, Chicago was home to some of the most extraordinary artistic talent to emerge during the interwar period in America.[3] The second factor influencing the development of African American artists in the city was the Art Institute of Chicago. Founded in 1879, as a combined museum and school, the Art Institute has long been known as the dominant visual arts institution in the Midwest.[4] Less known is that it was also one of the few private art academies in the country to admit and actively encourage African American students. Its faculty and staff gave black students noteworthy and, in some cases, exceptional support.

From 1893 to the Great Migration

Alternatively known as the "White City," the World's Columbian Exposition of 1893 was both a complex projection of Chicago's power, ambition, and idealism and an expression of its slightly insecure identity as a cultural center. It was also a fascinating setting for developments revolving around issues of race and national identity. Prominent African Americans who sought to have the aspirations and accomplishments of blacks represented in this national celebration of American achievement were consistently denied a role by the fair's organizers. Nevertheless, many African Americans attended and participated in the fair, including several who would have a hand in shaping black life in Chicago and beyond for years to come. The marginalization (and denigration) of blacks at the fair was a defining moment for a number of activists—including the aging Frederick Douglass, who served as the official representative of Haiti, and the young anti-lynching crusader Ida B. Wells, who collaborated on the pamphlet entitled "The Reasons Why the Colored

CAT. 26 (DETAIL)

American is Not in the World's Columbian Exposition." A number of other prominent (or soon to be prominent) African Americans were present as well, including Wells's future husband, the publisher and lawyer Ferdinand L. Barnett; Robert S. Abbott, future publisher of the great black weekly, the *Chicago Defender*; and two young poets: James Weldon Johnson, who was visiting as a college student from Atlanta University, and Ohioan Paul Laurence Dunbar, whom Douglass took under his wing.[5]

Although not represented in the enormous exhibition of American art at the World's Fair—no black artists were—expatriate African American artist Henry Ossawa Tanner participated in other ways. Trained at the Pennsylvania Academy of the Fine Arts, where he was severely ostracized for being black, Tanner spent most of his career in France. At the fair's congress session on Africa, held in the building that would become the home of the Art Institute, Tanner delivered an address on "The American Negro in Art."[6] In the next twenty years, Tanner would become well known in Chicago, largely through his successes at the Art

Institute's annual exhibitions of American art. By 1913 he was represented in the museum's permanent collection by two major works, *Two Disciples at the Tomb* of 1905 (fig. 1), awarded the Norman Waite Harris Prize and purchased at the eighteenth annual American exhibition, and the *Three Marys* of 1910, acquired in 1913.[7]

Tanner's successes at the Art Institute and his presence in what must have been numerous private collections in the city made him a revered figure to aspiring African American art students.[8] The prominent artist and organizer Charles Dawson (fig. 2), who paid his way through the School of the Art Institute as a waiter at Chicago's premier artistic and literary club, the Cliff Dwellers, recalled with enormous pride the occasion of Tanner's visit to the club in early 1913:

> We waiters were all aligned in front of the buffet one noon. The dining room was loaded with "stars" [members such as Frank Lloyd Wright, James Henry Breasted, Hamlin Garland, and Ralph Clarkson]. All at once everyone arose and stood like privates in the armed forces when a superior enters or is expected to enter. We looked toward the entrance, and there came the superior, a man of my race, about my color or a bit lighter, with a very neat Van Dyck beard; the only American known to me except Whistler who had achieved the honor of the award of the "Gold Medal" of the "Paris Salon" and who had in his lifetime two works purchased by the French Government and placed in the Luxembourg Museum in Paris . . . ; and there was Henry Ossawa Tanner, escorted by Charles Francis Browne and Oliver Dennett Grover, painters of renown. He was seated. Only then did the others assume theirs after much most sincere applause.[9]

Despite the recognition accorded Tanner by museums and collectors in the United States, his experience of racism here led the artist to spend almost his entire career in Europe.

The earliest Chicago-based African American artists to have left a record of their work are James Bolivar Needham and William A. Harper. Both must have sought what Tanner was looking for: the freedom to work and to show without either discrimination or condescension based upon their race. In contrast to Tanner, however, the limited careers and life records of these two artists are obstacles to a deep understanding of their feelings about their work and audience. While Needham and Harper were different in many ways, both found support and encouragement in the circle of Chicago artists around the Beaux-Arts-trained sculptor and Art Institute professor Lorado Taft and the writer Hamlin Garland.[10]

The work of Needham has only recently come to light. What we know of his life comes to us exclusively through a profile that appeared in the *Chicago Daily*

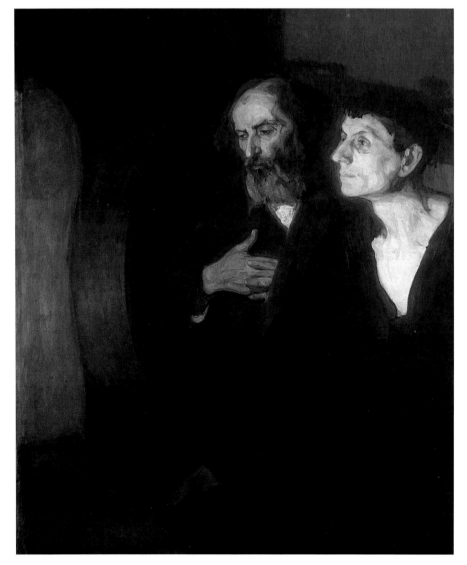

FIG. 1
Henry Ossawa Tanner (1859–1937)
Two Disciples at the Tomb, 1905
Oil on canvas, 51 x 41 ¹³⁄₁₆ in.
The Art Institute of Chicago,
Robert A. Waller Fund, 1906.300

FIG. 2
Charles Dawson (back row, fourth from left) and class at the School of the Art Institute of Chicago, c. 1916. Standing to Dawson's right is Archibald J. Motley Jr. Seated at center is professor Karl Buehr, and to Buehr's left, student William Schwartz.

News shortly after his death in 1931.[11] (Between his death and an exhibition of his work in 1997, he seems to have been almost entirely forgotten.) Needham was born in 1850 in Chatham, Ontario, a town well known as a northern terminus for the Underground Railroad. Before coming to Chicago in 1867, Needham ran cattle in Manitoba and worked on lumber-carrying schooners that sailed the Great Lakes from ports in Detroit and Saginaw, Michigan. In Chicago he worked in hotels and department stores, and he was also employed as a decorator and painter. Throughout the years that he was working at such jobs to earn a living, the *Daily News* article states:

> Jim Needham was painting Chicago. Painting the water and the boats and the boisterous human beings who worked around them. The old Mackinac ketches, the little schooners, the solid three-masters, the water under them; the gingerbread architecture in Chicago buildings; the horse cars crossing the bridges; the swamp at the foot of Randolph Street; horses hitched to garbage wagons or to surreys or to light driving gigs; women with bustles and men with beards and tall hats—this was what Jim Needham painted. This was the Chicago he loved.[12]

Needham's intimately scaled views of activity on the Chicago River, the commercial heart of the city in the nineteenth century, are small marvels of freshly observed detail and atmosphere (fig. 3, see cat. 54–61). Over the course of his career, Needham must have produced hundreds of these works, most no larger than 6 by 8 inches. They are rapidly executed in oil on meticulously crafted supports of linen and mounted on cradled boards. Many are inscribed on the reverse with a diamond shape painted in orange on a black field—presumably a personal symbol that brings to mind the shape and colors of nautical insignia.

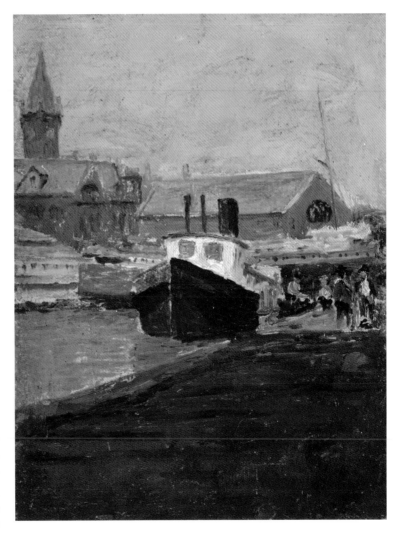

FIG. 3
James B. Needham (1850–1931)
Chicago River, Chicago and Northwestern Railroad Station, 1902
Oil on canvas on board, 8 x 6 in.
Chicago Historical Society,
Gift of Mrs. Joseph Du Canto

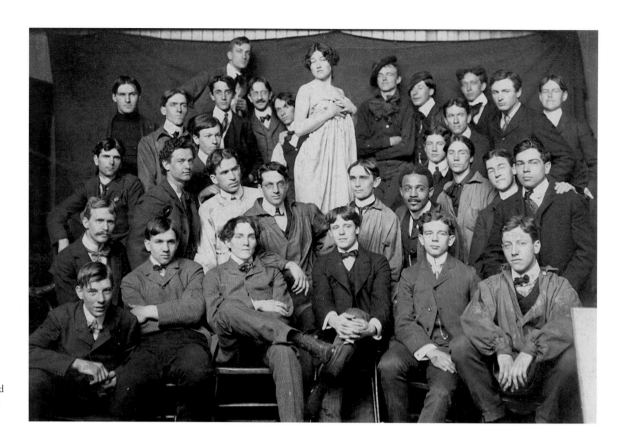

FIG. 4
William A. Harper and fellow
student Albert Krehbiel (fourth and
sixth from right, second row) at the
Académie Julian, Paris, 1904

According to the *Daily News* profile, Needham routinely destroyed works that did not meet his standards. A fire that swept through his loft/studio—the indirect cause of the eighty-year-old artist's death—destroyed many more.

Needham's unassuming river scenes show great sensitivity to the mutability and hidden beauty in subject matter that might be considered inherently vulgar or ugly. They faithfully and unpretentiously record the times of day, the effects of smoke, steam, and moisture upon the atmosphere, and reflections in water in a style of open, loose brushstrokes and a rich and sophisticated palette. The striking similarities between Needham's work and that of Albert Fleury (see Greenhouse, fig. 13), who showed a large number of river scenes at the Art Institute in 1900, suggests that Needham may have studied with the academically trained landscapist—either at the Art Institute or in Fleury's private sketch class. Needham's brother is on record as saying that Needham took classes at the Art Institute and knew Taft. We also know of one exhibition of Needham's work, mentioned in an 1895 article by Garland, one of the founders of the Central Art Association (see Greenhouse essay).[13] All of these factors indicate that Needham was accepted and encouraged by leading figures of the Chicago art establishment. Still, there is no question that Needham was his own man. His works are less "picturesque" and formulaic than those of Fleury; they give us the sensation of being "in" the landscape, rather than "before" it. Given the small portion of Needham's work that has

been recovered, however, the temptation to make sweeping generalizations about his work should be avoided. In the years to come, more information about the artist is likely to surface.[14]

Whereas Needham seems to have avoided the institutional and economic trappings of the art world, William Harper (fig. 4) was deeply involved in the academy and the ritual of public exhibition. Born in 1873 in Cayuga, Ontario, above the northern shore of Lake Superior, Harper moved to Illinois in 1885 and began studies at the Art Institute in 1895. He earned his tuition by working in the building as a janitor and night watchman, a fact rarely neglected in contemporary references to the artist. Harper's academic progress can be traced through school circulars and glowing press accounts as well as in issues of the school's periodical, *Brush and Pencil*.[15] After graduating in 1901, Harper taught drawing in the public high schools of Houston, Texas, and he worked in Paris during 1903–5 and again in 1907–8, when he studied with Tanner and painted with Chicago artists William Wendt and Charles Francis Browne. One of the leading landscapists of the time in Chicago, Browne was, with his brother-in-law Taft and Ralph Elmer Clarkson, one of the principal leaders of the Central Art Association. They maintained a celebrated summer colony at Eagle's Nest Bluff in western Illinois, where Harper served as a kind of assistant at the colony and was known as a talented "colored protégé."[16]

As Harper discovered, working in France did not guarantee refuge from racial discrimination. His mem-

bership to the American Art Association of Paris, which was sponsored by his Chicago colleague and fellow student at the Académie Julian, Albert Krehbiel, was opposed by a group of American painters from the South.[17]

Harper exhibited forty-eight paintings in eleven American and Chicago and Vicinity exhibitions from 1903 to 1910.[18] His critical success in the 1905 show, where a group of his works was awarded a prize by the Municipal Art League, was remarkable. The Chicago *Inter Ocean* of February 9, 1905, notes: "He has studied in Paris and his sympathies are decidedly French, which perhaps accounts for his abundance of poetry, commonly called by women of the clubs as 'temperament.'"[19] The article continues, with a mixture of admiration and condescension:

> He is one of the handsomest chaps I ever saw," said the woman I happened to overhear, and her companion, a man of enlightenment, gravely offered to introduce the artist. She enthused and instinctively straightened her hat. Harper incidentally is a great favorite at the Eagle's Nest in summer, where he goes each summer as "assistant" in a general work sense. "He is so handsome and well mannered," said one of the artists to me yesterday as we talked over the exhibit "that we scarcely have the face to ask him for service; though, for that matter, he is perfect in manner, and never intrudes his admirable personality. His self-effacement is a part of his personal charm. But it is his work that has commanded our genuine admiration and respect.[20]

Harper was so strikingly gifted in looks, manner, and talent that his color and class almost caused embarrassment.

There can be no doubt as to Harper's talent. Critics sometimes quibbled with his use of heavy impasto, but they enthusiastically praised his restrained palette of warm earth tones and his highly poetic evocations of the French and English countryside. Harper's sometimes heavy handling of paint signals the strong influence of Tanner's symbolist manner, but his bold contrasts of light and dark, active impasto, and the shimmering quality of light in a work such as *August in France*, c. 1908–9 (cat. 41) clearly reflects his interest in Barbizon-School painting. By 1909 Harper had clearly gained a mastery of contemporary modes of traditional landscape painting and was beginning to find his own style.[21]

Harper's present obscurity is due largely to his untimely death from tuberculosis in 1910. The high regard for Harper in Chicago art circles is reflected in the speakers at his memorial service: Taft and William M. R. French, the director of the Art Institute. Four months after his death in July of 1910, the museum honored him with a large, one-person exhibition—certainly the first major museum show for a black artist in Chicago, if not anywhere in the United States.[22] His death left a large void for those who were supportive of the efforts of young African American artists to receive academic training in Chicago.

This gap, however, was filled by increasing numbers of black students entering the School of the Art Institute. By the 1890s the Art Institute had become the nation's largest art school. It did not keep track of the number of African American artists that attended classes, but it is clear that black enrollment increased in the 1910s. In addition to Charles Dawson, William McKnight Farrow, and Archibald J. Motley Jr.—all of whom are discussed in this essay—other African American artists attending the school in the years around 1920 included Richmond Barthé, Robert Pious, Dox Thrash, and Ellis Wilson. According to Dawson, "the policy of the Art Institute was entirely free of bias."[23]

Why did the Art Institute maintain such a liberal attitude at a time when other art academies barred blacks or tolerated their harassment? One explanation may be that principles of inclusiveness and democracy were built into the institution by design. The members of Chicago's business and cultural elite who founded the Art Institute firmly believed in the usefulness of art as an instrument of social uplift and civic improvement. Charles Hutchinson, who served as president of the Art Institute from 1882 until his death in 1924, saw art as "a universal language" that "speaks alike to every man of every tongue; to bound and free alike." Hutchinson, fully supported by his board and staff, envisioned the museum as a temple of art that doubled as a community open house.[24] In addition to its school and extraordinary collections, the museum offered concerts, space for exhibitions and meetings of various local art associations, and lectures and classes intended for people of all ages and backgrounds. The museum was also free on Sunday, the only day that most working-class people could visit, and in the 1890s the public came at a rate of up to six thousand per day.[25] Impeding access of any particular group would have been inimical to the museum's principles and practices.[26]

An important student from the school during this period was William Edouard Scott, a young painter from Indianapolis who was already making a name for himself at the Art Institute in 1909, when he shared a prize in the mural-painting competition. His vigorously brushed and inventively staged 18-foot long mural, *Commerce* (fig. 5)—purchased for the Public School Art Society by Art Institute patron Kate Buckingham—was a brilliant debut for Scott, who would become one of Chicago's most prolific mural painters.[27] After study in France with Tanner and at the Académie Julian in Paris from 1909 to 1914, the

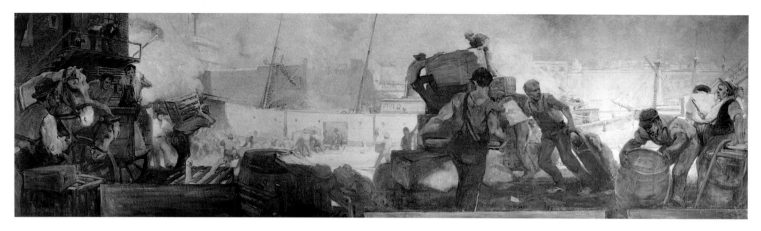

artist established himself as heir to the promise that was lost with Harper's untimely death. Unlike Harper, however, Scott made African Americans the focus of his work.

The task of counteracting decades of stereotypical or degrading images of blacks was an established priority of civil-rights leaders early in the century. In 1915 Scott traveled to Alabama's Tuskegee Institute, founded in 1881, as the guest of Booker T. Washington, becoming one of the first African American artists to make black life in the South his principle study. Scott also received support from W. E. B. Du Bois, National Association for the Advancement of Colored People founder and editor of its journal, *The Crisis*. Du Bois championed African American artists by commissioning illustrations and cover art for *The Crisis. Traveling (Lead Kindly Light)* (cat. 75), used for the cover of the Easter 1918 issue, is one of many works that Du Bois commissioned from Scott.[28] For Du Bois, art was a form of propaganda: he believed that proving accomplishment in the fine arts was one important way of debunking old myths of racial inferiority.[29]

The New Negro Movement: Chicago in the 1920s

World War I had the effect of dramatically increasing an already substantial flow of southern blacks to cities in the North in order to take advantage of employment in wartime industries. In Chicago, where the black population increased by 50 percent during the war, reaction to black migration came in the form of race riots in 1919 and the restriction of black settlement to a narrow strip of territory on the South Side.[30] The next generation of artists was deeply influenced by these events, and many contributed to the new atmosphere of black cultural awareness that emerged in the 1920s and that permeated Jazz-Age America. Given this atmosphere, it makes sense that Scott's immediate followers studying at the Art Institute, William McKnight Farrow and Charles Dawson, are better known for their activism than for the works of art they produced. This is partly due to the fact that few of their

paintings survive. Also, unlike Scott, neither made his career from painting alone. However, their careers and their tireless efforts to organize exhibition opportunities and to cultivate an audience in the African American community are well worth consideration.

Farrow was born in Dayton, Ohio, in 1885, and he moved to Indianapolis when he was in high school. It was there that he met Scott, whose career at the Art Institute he followed with great interest. While working a series of odd jobs, Farrow attended classes at the Art Institute, first part-time (1909–14) and then full-time (1914–18). In addition to selling paintings and graphic works, Farrow earned income as a commercial illustrator for various Chicago companies, and in the late 1910s and '20s he held a variety of posts at the Art Institute, including assistant to the curator for temporary exhibitions and head of the printing shop. He was also given the task of reinstalling the museum's Egyptian collections. Despite Farrow's long association with the Art Institute, the artist may have hit a color barrier. He left the Art Institute to teach an evening course for adults in commercial art at Carl Schurz High School from 1926 to 1948. Scrapbooks in the possession of Farrow's family expose the artist's bitter feelings about the Art Institute. In the margins of a 1935 article profiling the artist in the *Dayton Journal*, next to a reference to his job at Schurz High School, Farrow typed the following: "Any success I may have had as an art instructor has been achieved there. The Art Institute is a different story altogether. (The fact that I have given gallery lectures and was on its museum staff has led to the mistaken conclusion that I am an instructor at The Art Institute of Chicago.)"[31]

In addition to earning a livelihood through his art, Farrow, as president of the Chicago Art League, dedicated himself to the cause of his fellow African American artists. Founded in 1923, the Chicago Art League was the first group of black artists in Chicago (perhaps anywhere) to present regular exhibitions, lectures, and public demonstrations—most of which took place at the Wabash Avenue YMCA in Bronzeville (fig. 6). In one of his occasional columns of art criti-

cism and news written for the *Chicago Defender* in the mid-twenties, entitled "Art and the Home," Farrow described a lively meeting of the Art League. Farrow reports that he presented a talk illustrated with lantern slides on "primitive," "prehistoric," and Egyptian art in order to show "the direct connection between the later African work and that of Egypt and to indicate by that means the historical background from which the Negro of today may draw much inspiration." According to Farrow, another speaker, Francis L. Holmes, "did not believe in harking back to an uncertain past but, instead, one should draw his inspiration from present surroundings and his imagination, and only look forward to the brilliant future which is ours for the striving."[32] The account demonstrates that Chicago's African American artists were completely current with the aesthetic and political discourse that would soon become nationally heralded with the publication, later in 1925, of the *New Negro* anthology. Edited by Howard University professor of philosophy Alain Locke, this collection of fiction, poetry, and essays represented the new generation's efforts to redefine the cultural identity of black Americans in the modern age.[33]

Farrow's portrait of poet Paul Laurence Dunbar (see cat. 31), a 1934 version of a 1923 painting, has a restraint that is fully characteristic of most of the artist's work. Modeled on a photograph of Dunbar posed officially, it has a haunting, vulnerable quality that many images of the young poet convey (fig. 7). It is an attribute that photographs of Farrow disclose as well. As a high-school student in Dayton in the 1890s, Farrow heard Dunbar recite from his works in person, and he obviously identified with the tragic poet: "I had an opportunity to see with my own eyes one whose genius, almost submerged amid many prejudices, gradually pushed ajar the gates of immortality; and then I knew that I had a chance."[34]

Farrow's classmate at the Art Institute, Charles Dawson, was temperamentally the opposite of his reserved and most dignified colleague. The corny title of his unpublished, 536-page typed autobiography, "Touching the Fringes of Greatness," instantly gives away Dawson's penchant for hyperbole. What it lacks in literary style, however, it more than makes up for as a remarkable historical document. Furthermore, Dawson's overwhelming ambition, as a promoter of both himself and the larger cause of redressing the long history of white oppression and devaluation of blacks in America, exemplifies the boisterous spirit of black self-confidence that emerged in the 1920s. In its own quirky way, "Touching the Fringes of Greatness" provides a uniquely detailed chronicle of the life and aspirations of an artist living at a time of momentous transformation in the status of blacks in the United States. The document takes us from Dawson's youth in

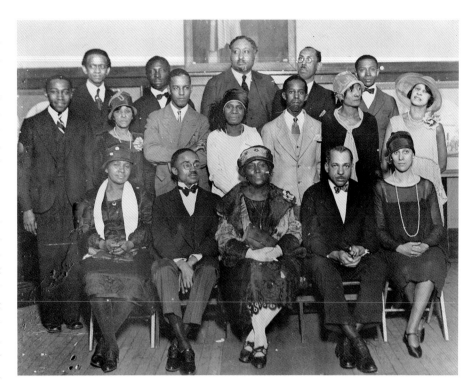

FIG. 6
The Chicago Art League, c. 1927, including William Edouard Scott (top row, center), Arthur Diggs (top row, far right), Ellis Wilson (second row, left), Richmond Barthé (second row, second from left), Charles Dawson (seated, first row, second from left), and William McKnight Farrow (seated, first row, second from right)

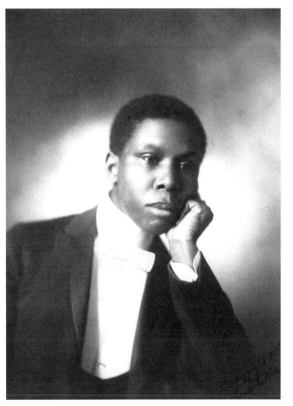

FIG. 7
Photograph of Paul Laurence Dunbar, c. 1900

Brunswick, Georgia, in the 1890s to his college years at Tuskegee; as an art student in New York City (he claims to have been the first black student at the Art Students' League; see fig. 8) and Chicago before 1917; his service in World War I; and his career as an artist, entrepreneur, and curator from 1920 to 1945.[35]

While working as a commercial artist and illustrator for both white clients downtown and a burgeoning black clientele in 1920s Bronzeville, Dawson played a

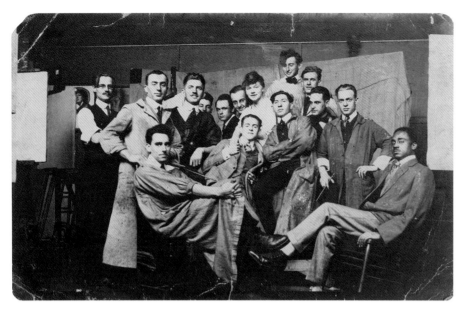

key role in the most important manifestation of the "New Negro" movement in Chicago: the 1927 "Negro in Art Week" exhibition, sponsored by the Chicago Woman's Club and presented at the Art Institute. Conceived by Locke as a demonstration of his argument that black artists could reclaim their heritage and create a truly "racial art," the show included the nineteenth-century artists Edward Mitchell Bannister and Edmonia Lewis; contemporaries of an older generation, Meta Warrick Fuller and Tanner; the Chicagoans Harper, Scott, Farrow, and Dawson; John Wesley Hardrick and Hale Woodruff, who were trained in Indiana; Richmond Barthé, the Art Institute student

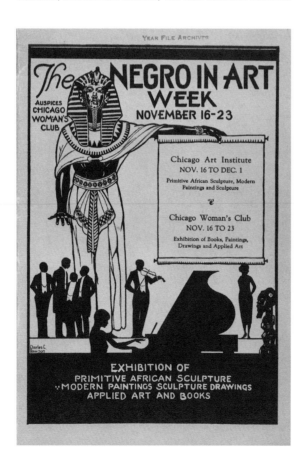

whose sculptures were premiered at the Woman's Club headquarters; and a selection of African sculpture. Dawson's design for the catalog cover (fig. 9) perfectly illustrates Locke's influential polemic: it features an Egyptian pharaoh and a West African sculpture sharing a performance stage with formally attired modern men and women.[36]

Dawson's memoirs reveal much about the artist's furious behind-the-scenes activities in connection with the exhibition. If we are to believe him, it might not have succeeded at all without his efforts. He reports that Scott was initially opposed to the exhibition because he felt that "the Negro artists were not yet producing work of sufficient quality to meet the demands of this occasion." Dawson also claims to have gone above the head of the museum director, Robert Harshe, to the board president, Arthur Aldis, to get the show into the museum.[37] The responsiveness of the Art Institute to such initiatives from the community was remarkable. The earliest exhibition of work by African American artists to be hosted by a major museum, the "Negro in Art Week" show also preceded by several months the Harmon Foundation's series of exhibitions of African American art.[38]

Conspicuously absent from the "Negro in Art Week" show was Archibald J. Motley Jr., one of the most interesting figures in the history of art in Chicago. By the time of the landmark show, Motley was the most well-known black artist in Chicago and well on his way to gaining national attention. To Farrow and Dawson—his slightly senior colleagues who were deeply invested in promoting the image of a successful and skilled black artist—Motley was both very impressive and very irritating. Widely considered to be the first artist to create an enduring image of black life in a modern, urban environment, the independent-minded Motley resisted being identified primarily as a "black artist." He refused to join the Chicago Art League and ignored invitations to show in the "Negro in Art Week" exhibition.[39] Also, while he crafted brilliant and indelible images of black entertainment and street life in Bronzeville, his depictions of African Americans are not completely positive. Even today, Motley's use of caricature and his ambiguous approach to his subject is still a matter of lively debate.[40]

A native of Chicago, the light-skinned Motley lived in the largely white, middle-class neighborhood of Englewood. As a young man, he immersed himself in the vibrant spectacle and atmosphere of Bronzeville. A talented draftsman by the time he graduated from high school, Motley was introduced to the Reverend Frank Gunsaulus by his father, who came to know the great Chicago preacher and educator as a client on his Pullman car route. The president of the Armour Institute, Gunsaulus was also a trustee of the Art

Institute and a collector and friend of Tanner.[41] Although his father wanted the young Motley to study architecture at Armour, Gunsaulus was so impressed with the aspiring artist that he agreed to pay for Motley's first year at the Art Institute, rather than at Armour. Motley soon also gained the attention of another powerful patron, Art Institute director Harshe, who made many efforts to promote his work, including placing Motley's paintings in museum and gallery exhibitions on the East Coast. Motley's successes continued with both Harmon Foundation awards and a Guggenheim Foundation grant, which allowed the artist to work in Paris in 1929.

After his return from Paris, Motley concentrated on scenes of life in Chicago's Black Belt. His paintings of the 1930s and '40s celebrate, stylize, and romanticize the lowbrow entertainments of Bronzeville: tawdry cabarets and clubs, back-room card games and gangsters, and electrically charged street life at night. His paintings represent a highly artificial and fictive construct that is wonderfully seductive. *The Plotters* of 1933 (cat. 53), with its lush orchestration of velvety blacks, saturated cobalt blue, and warm browns, is typical of Motley's spectacular palette. His use of caricature and a kind of stock company of performers suggests that the picture refers to reality but also is made to be taken for what it is—a concoction and a bit of a dream. The indispensable black artist of his time, Motley was the only African American artist besides Tanner to be represented at the Art Institute's important exhibition of American painting that accompanied the 1933 "Century of Progress" fair.

The Great Depression and the Era of the WPA

In contrast to the preceding decades, the 1930s witnessed an explosion of talent. The sheer growth in the black population of Chicago was one reason. Another was the collective spirit of the Great Depression and the New Deal programs of the Roosevelt administration.[42] Social service and settlement-house activity increased dramatically in Bronzeville, and art training for children and young adults became widespread. Dozens of talented young African American artists in Chicago discovered a sense of collective identity while taking part in Works Progress Administration Federal Art Project (1934–43) initiatives that supported training, apprenticeship, and employment. The Federal Art Project also expanded contacts between black and white artists: experienced white artists such as Morris Topchevsky (see cat. 84), Carl Hoeckner (see cat. 44), Mitchell Siporin (see cat. 78), Edward Millman (see cat. 52), and Si Gordon taught at various settlement houses and exposed young black artists to progressive and radical political philosophies. And for the first time, Michigan Avenue gallerists, notably

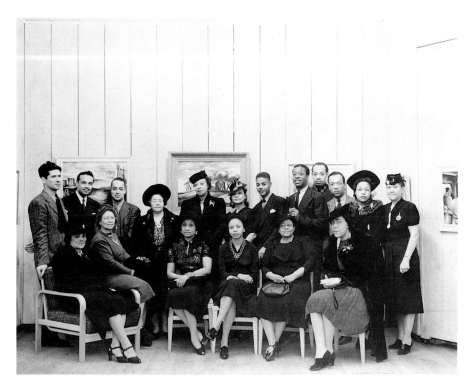

FIG. 10
Personnel of the South Side Community Art Center, 1940–41, including Peter Pollack, Director (standing, at left), Henry Avery (standing, fifth from right), Charles White (standing, third from right), and Margaret Goss Burroughs (seated, third from right)

Peter Pollack and Katharine Kuh, both future Art Institute of Chicago staff members, showed the work of black artists.

President Franklin D. Roosevelt's courtship of the black vote in northern cities through WPA programs reinforced support of black artists at the Art Institute, and the museum and school were strongly supportive of the work of black artists through exhibitions, outreach, and staff support.[43] Margaret Burroughs, who would become one of the most energetic artist-organizers in the city, was one of many elementary- and high-school students who attended evening and Saturday lecture classes at the museum prior to entering the School of the Art Institute.[44] Academic lessons from the Art Institute filtered into the black community as well through artist George Neal, who held informal classes in his coach house studio at 32nd and Michigan Avenue. An organization called the Arts Crafts League formed around Neal, which included Burroughs, Charles White, Eldzier Cortor, Charles Davis, Joseph Kersey, Charles Sebree, and many others who later formed the nucleus of the South Side Community Art Center.[45] A public/private partnership of the Federal Art Project, the center opened its doors in 1941, and it is the only surviving example of the one hundred original community art centers opened during the WPA period (fig. 10).[46] In retrospect, the 1930s, which expanded horizons and opportunities and created coalitions of black and white artists and groups, was a golden age for artists in Chicago.

For some artists in Chicago who came of age in this atmosphere, Motley's focus on black subjects and local settings was a starting point. In their search for

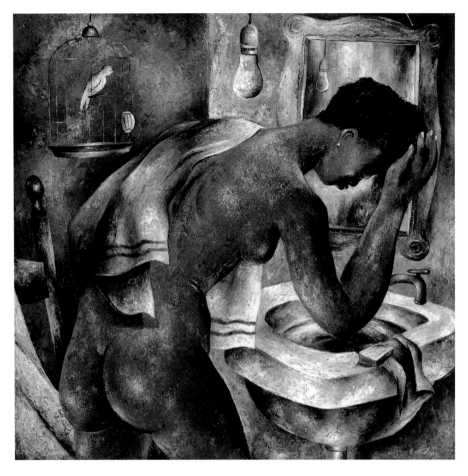

FIG. 11
Eldzier Cortor (b. 1916)
Girl Washing Her Hair, 1941
Oil on canvas, 28 x 28 in.
Private collection, courtesy Michael
Rosenfeld Gallery, New York

authenticity, however, White and Cortor dispensed with Motley's artificial refinement and sense of satire. The politically radical White focused on the latent revolutionary potential of the black workers—his style has been termed, not without justice, "proletarian grotesque."[47] The monumental and heroic figure in White's *Spiritual* of 1941 (cat. 88) exemplifies the artist's interest in black folk roots, a widespread preoccupation among African American artists and writers at the time.

Like White, who traveled to the American South in search of a mythic black past, Cortor was also interested in researching sources of contemporary black identity that had connections with the past, either in the American South or in Africa. In 1944 Cortor was awarded a Julius Rosenwald Grant to paint in the coastal Sea Islands region of Georgia, whose residents had long been geographically and culturally isolated from white southerners. In contrast to White's highly masculinized imagery, Cortor's emphasis was on the expressive potential of the black female nude—a highly charged and rarely treated subject. *Girl Washing Her Hair*, shown at the 1941 Chicago and Vicinity exhibition at the Art Institute (fig. 11), is an updated version of a classical Venus absorbed in her modern toilet in a Bronzeville kitchenette apartment.

White and Cortor were the strongest artists of the group, and their careers are still in need of more inten-

sive scholarship. They were also only two among many. The variety of artistic styles and personalities among the black artists who came of age in the 1930s is remarkable. Several artists worked in a primitivizing or folk-inspired mode, including Walter Ellison, whose *Train Station* (cat. 30) is a small masterpiece of acute social observation, and Henry Avery, a master of meticulous execution and naïve vision (see cat. 7). Charles V. Davis's American scene approach is evident in his affecting portrayal of a *Newspaper Boy (The Negro Boy)* (cat. 26). Charles Sebree, who showed with the Katharine Kuh Gallery, and who was especially close to Gertrude Abercrombie (see Weininger realism essay) represented a kind of neo-romantic strain in American painting (see cat. 76). As impressive as this roster is, the easel painting of this generation of Chicago artists only scratches the surface of a more significant achievement. The drawings and mural paintings of White, or the sculpture produced by Joseph Kersey and Marion Perkins, for example, lie beyond the scope of this essay.

The collective spirit of idealism and optimism during the WPA era in Chicago culminated in the largest exhibition of work by black artists ever mounted before World War II. The "Exhibition of The Art of the American Negro" was a component of a larger show, the "American Negro Exposition," held during the summer of 1940 at the Chicago Coliseum, a huge hall at 15th Street and Wabash. Intended to commemorate seventy-five years of black progress since the end of the Civil War, the exposition was a private initiative supported by the state and federal governments. It was a kind of "World's Fair of the Black Metropolis," intended to counter a string of American world's fairs (including those in Chicago in 1893 and 1933) that had excluded the representation of African Americans. Although the attempt would never have been successful without the Roosevelt administration—which badly needed to retain the black vote on the eve of World War II—the fair was an extraordinary demonstration of black artistic and literary excellence.[49] The brainchild of Alain Locke, the exhibition contained over twice as many works as the 1927 "Negro in Art Week" show and was seen by over 250,000 visitors. It was also the national debut of the Chicago artists who had launched the South Side Community Art Center. The distance traveled by artists in that thirteen-year period was nothing short of phenomenal. However, with World War II and the collapse of the New Deal and popular front alliances that did so much to advance the training and careers of black artists in Chicago during the 1930s, the postwar agenda for artists of color would be completely revised.

1. For a succinct overview of the critical issues surrounding race and national identity in art during the period, as well as a review of the literature on African American art, see Mary Ann Calo, "African American Art and Critical Discourse Between World Wars," *American Quarterly* 51, 3 (September 1999): 580–621.

2. U.S. Census figures cited in Alan H. Spear, *Black Chicago: The Making of a Negro Ghetto, 1890–1920* (Chicago: University of Chicago Press, 1967), 12.

3. At mid-century, Chicago came to be thought of in the popular imagination as the most "American" city—distinct from New York, the largest and most cosmopolitan city in the United States. Chicago was also considered the greatest "black" city. Not only was it home to the second largest concentration of black citizens, it was also the most active point of dispersal for blacks migrating from the South in the period between the 1910s and the 1950s. Thus, the use of the term "Black Metropolis" was used to stand in for Chicago in the epic 1945 sociological and historical study of Chicago's Black Belt in St. Clair Drake and Horace Cayton, *Black Metropolis: A Study of Negro Life in a Northern City* (1945; reprint, Chicago: University of Chicago Press, 1993).

4. The most useful sources for information on the early history of the Art Institute of Chicago are Helen Lefkowitz Horowitz, *Culture and the City: Cultural Philanthropy in Chicago from the 1880s to 1917* (Lexington: University Press of Kentucky, 1976); Peter C. Marzio, "A Museum and a School: An Uneasy but Creative Union," *Chicago History* 8, 1 (Spring 1979): 20–23, 44–52; and Roger Gilmore (ed.), *Over a Century: A History of the School of the Art Institute of Chicago, 1866–1981* (Chicago: School of the Art Institute of Chicago, 1982).

5. The literature on the World's Columbian Exposition is extensive, but the issue of the exclusion of blacks at the fair has been examined closely by Robert W. Rydell in the introduction to Ida B. Wells, Frederick Douglass, Irvine Garland Penn, and Ferdinand L. Barnett, *The Reason Why the Colored American Is Not in the World's Columbian Exposition* (Urbana/Chicago: University of Illinois Press, 1999). See also Christopher Robert Reed, *"All the World Is Here!" The Black Presence at White City* (Bloomington: Indiana University Press, 2000). The confluence of these great African American figures at the fair was first considered in Arna Bontemps and Pat Conroy, *Anywhere But Here* (originally published as *They Seek a City* [1945]; reprint, Columbia/London: University of Missouri Press, 1966), 88–110).

6. The text of Tanner's speech has not been preserved, but press accounts of its content are noted in Dewey F. Mosby and Darrell Sewell, *Henry Ossawa Tanner* (Philadelphia: Philadelphia Museum of Art, 1991), 116, 294. According to Mosby (idem, 299), Tanner also showed a painting, *The Bagpipe Lesson* (1892–93; Hampton University Museum, Virginia), at an exhibition of "student work" at the fair, but I have been unable to confirm this.

7. *The Three Marys* was given by the Art Institute of Chicago to Fisk University in Nashville in 1950. Fisk was founded for the education of southern black students in 1866 by the American Missionary Association.

8. An area of critical importance to the study of African American art that has yet to be fully examined by scholars is that of private patronage. The number of works by Tanner in Chicago collections would be worthy of a study. One private buyer of particular note is Frank Wakely Gunsaulus (see note 41), one of the most important figures in Chicago's cultural and educational history, and an early patron of painter Archibald J. Motley Jr.

9. Charles Dawson's unpublished autobiography, written in the early 1960s, is owned by the DuSable Museum of African American History, Chicago. It is available on microfilm in the Archives of American Art, Washington, D.C. See the Charles C. Dawson Papers, DuSable Museum of African American History, Chicago, 210–11. Tanner would have been visiting on the occasion of his second one-person exhibition at the Thurber Galleries in Chicago, which took place in February 1913.

10. To promote the education of artists and the appreciation of contemporary art throughout the Midwest, Taft and Garland founded the Central Art Association in 1894. See Horowitz, *Culture and the City*, 172–73; and William Gerdts, *Art Across America. The South, Near Midwest* (New York: Abbeville Press, 1990), 302–3.

11. Jerome Beam, "This Man Loved Chicago: Portrait of a Dreamer," *Chicago Daily News*, 18 March 1931, "Midweek" supplement, 14. The article is transcribed in *James Bolivar Needham* (Chicago: Robert Henry Adams Fine Art, 1997).

12. Beam, "This Man Loved Chicago," 14.

13. Hamlin Garland, "Successful Efforts to Teach Art to the Masses," *The Forum* 19 (July 1895): 609. I am indebted to Wendy Greenhouse for the citation of Garland's article, which mentions Needham's exhibition.

14. An examination of Needham's death certificate suggests further avenues of research. Dated January 30, 1931, it indicates that the artist was a caretaker at the Lambert Tree Estate. If Needham worked at Tree Studios, the historic Chicago artists' studio and residence erected by Judge Lambert Tree in 1894 and 1912–13, it seems quite likely that many artists who worked there would have been aware of Needham's work.

15. *Circulars of Instruction* and *Catalogues of Students of the Art Institute*, preserved in the Ryerson and Burnham Libraries, permit us to follow Harper's progress as a student from an "Antique Class" in 1895–96, to a "Life Class" of 1896–97, 1898–99, to an "Advanced Life Class" of 1899–1900, in which one of his academic figure studies is reproduced; see *Circular of Instruction* and *Catalogue of Students, Academic Year 1899–1900*, 87. I wish to thank Sarah Kelly for referring me to *Brush and Pencil*, where three of Harper's works are reproduced: 7, 6 (1901): 369; 9, 6 (1902): 339; and 19, 12 (1907): opp. 45.

16. From an article in the *Ogle County Reporter* describing the opening of the Oregon, Illinois, Public Library Art Room, where one of Harper's paintings, *Normandy Pines* 1903/8, was donated by members of the colony on July 10, 1918. My thanks to Beth McCormick of the Oregon Public Library for bringing this article to my attention.

17. Robert Guinan, *Krehbiel: Life and Works of an American Artist* (Washington, D.C.: Regnery Gateway, 1991), 9.

18. The record of Harper's inclusion in the annual American and Chicago and Vicinity exhibitions can be found in Peter Hastings Falk (ed.), *The Annual Exhibition Record of the Art Institute of Chicago, 1888–1950* (Madison, Conn.: Sound View Press, 1990), 408–9.

19. The Art Institute of Chicago Scrapbooks.

20. Ibid.

21. Even Alain Locke, the chief polemicist of the Harlem Renaissance—who was hostile to the academicism of Harper's informal teacher, Tanner—referred to Harper as "one of the real talents of his generation. . . . His premature death was a major loss to Negro art in that generation, for critics judged him of great promise, and many thought him more creatively original than Tanner." See Alain Locke, *The Negro in Art* (New York: Associates in Negro Folk Education, 1940), 132.

22. For Harper's obituary, including a description of his memorial service at Bethesda Baptist Church of Chicago, see *Art Institute of Chicago Bulletin* 4, 4 (July 1910): 11. For his one-person exhibition, see *Exhibition of Paintings by William A. Harper* (Chicago: Art Institute of Chicago, 1910).

23. Charles C. Dawson Papers, 220. Archibald J. Motley Jr., also commented on the absence of racial discrimination towards students at the Art Institute; see Elaine D. Woodall, "Looking Backward: Archibald J. Motley and The Art Institute of Chicago: 1914–1930," *Chicago History* 8, 1 (Spring 1979): 53. I am indebted to Kymberly Pinder for sharing her unpublished research on African American students at the School of the Art Institute of Chicago.

24. Charles L. Hutchinson, "Art, Its Influence and Excellence in Modern Times" (lecture delivered before the Art Institute); reprinted in the *Saturday Evening Herald*, 31 March 1888, and excerpted in Kathleen D. McCarthy, *Noblesse Oblige: Charity & Cultural Philanthropy in Chicago, 1849–1929* (Chicago: University of Chicago Press, 1982), 87.

25. Horowitz, *Culture and the City*, 88. The museum took careful count of attendance. It gave Hutchinson great satisfaction that the Art Institute regularly outdrew the Boston Museum of Fine Arts and the Metropolitan Museum of Art in New York.

26. According to historian Donald L. Miller, idealism was not the only motive driving Hutchinson's devotion to social uplift through support of cultural institutions. "For Chicago's capitalists, promotion of the arts was part of an effort to maintain control of their city. Frightened by the direction of urban change but unable to shape it through direct political action because they had withdrawn from active engagement in city government, they sought to augment their economic power through privately managed boards and committees dedicated to civic causes, organizations born in the cigar-scented parlors of their downtown clubs." See Donald L. Miller, *City of the Century: The Epic of Chicago and the Making of America* (New York: Simon & Schuster, 1996), 387.

27. Scott's mural, along with those of his classmates Margaret Hittle and Gordon Stevenson, was originally installed at the first Albert G. Lane Technical High School at Division and Sedgwick streets in Chicago. The mural was moved in 1934 when Lane Tech moved to a new building at 2501 West Addison Street. For this and other murals by Scott, see Mary Lackritz Gray, *A Guide to Chicago's Murals* (Chicago: University of Chicago Press, 2001); and Heather Becker, *Art for the People: The Rediscovery and Preservation of Progressive- and WPA-Era Murals in the Chicago Public Schools, 1904–1943* (San Francisco: Chronicle Books, 2002).

28. For background information and bibliography on Scott, see William E. Taylor and Harriet G. Warkel, *A Shared Heritage: Art by Four African Americans* (Indianapolis, Ind.: Indianapolis Museum of Art, 1996).

29. For example, Du Bois wrote, "Until the art of black folk compels recognition they will not be rated as humans." See W.E.B. Du Bois, "Criteria of Negro Art," *The Crisis* (October 1926), in *The Crisis Reader: Stories, Poetry, and Essays from the N.A.A.C.P.'s Crisis Magazine*, ed. Sondra Kathryn Wilson (New York: Random House, 1999), 325.

30. The literature on the Great Migration and Chicago's role in this movement of blacks to the city is enormous. The classic study is Drake and Cayton, *Black Metropolis*. See also James R. Grossman, *Land of Hope: Chicago, Black Southerners, and the Great Migration* (Chicago: University of Chicago Press, 1991).

31. Biographical details on the life of Farrow are drawn from the following sources: Francis C. Holbrook, "William McKnight Farrow: Artist and Craftsman," *The Southern Workman* (March 1925): 118–22; and *Who's Who in Colored America* (Yonkers-on-Hudson, N.Y.: C.E. Burckel, 1938–40), 181.

I wish to thank Sandra and William McKnight Farrow III for permitting me to quote from materials in their possession.

32. William McKnight Farrow, "Art and the Home," *Chicago Defender*, 21 February 1925, part 2, p. 3. Subsequent references to the Chicago Art League include Farrow, "The Chicago Art League," *The Crisis* 34, 10 (December 1927): 344, 358; Unsigned Article [Charles C. Dawson?], "Colored Artists of Chicago and Vicinity," in *The Negro in Chicago, 1779 to 1927*, vol. 1 (1927), 83; and Farrow, "The Chicago Art League," in *The Negro in Chicago*, vols. 1 and 2, 140, 153.

33. Alain Locke (ed.), *The New Negro* (1925; reprint, New York: Touchstone Books, 1999). Howard University, located in Washington, D. C., was charted by Congress in 1867.

34. Holbrook, "William McKnight Farrow," 119. The portrait of Dunbar illustrated here is a 1934 version of the 1923 original painted for Dunbar High School in Dayton. The original was reproduced in Locke, *The Negro in Art*, 27.

35. Charles C. Dawson Papers.

36. For the exhibition catalogue of the "Negro in Art Week," see *Exhibition of Primitive African Sculpture, Modern Paintings, Sculpture, Drawings, Applied Art, and Books* (Chicago: Chicago Woman's Club, 1927). The exhibition at the Art Institute was only one manifestation of a larger festival that included performances and lectures by a number of important figures at locations throughout the city. For a critical assessment of the exhibition, see Lisa Meyerowitz, "The *Negro in Art Week*: Defining the 'New Negro' Through Art Exhibition," *African American Review* 31,1 (1996): 75–89.

37. When Dawson learned that Harshe turned down the show due to lack of available space, he rushed to get the support of Harshe's boss, Arthur Aldis, who, according to Dawson, "immediately objected to the idea of a separate exhibition based on race, reminding me that I was aware that the Art Institute policy was, no segregation." Dawson prevailed by reminding Aldis that this would be an opportunity to show works of African art, which were in vogue in Paris and New York City. Although the show went forward, it was condescendingly installed in the galleries of the Children's Museum, a fact that must have stung Dawson, for he did not mention this.

38. For the Harmon Foundation exhibitions, see Gary A. Reynolds and Beryl J. Wright, *Against the Odds: African American Artists and the Harmon Foundation* (Newark, N.J.: Newark Museum, 1989). Founded in 1922, the Harmon Foundation was a philanthropic organization based in New York that promoted African American artists through exhibitions, catalogues, and awards.

39. For Dawson, who considered himself "the dean" of black students at the Art Institute, Motley's aloofness felt like betrayal (Charles C. Dawson Papers, 227, 351, 358–59). When Motley was asked later in life why he refused to show with the "Negro in Art Week" artists, his response was not unlike that of Scott's: "Because negroes were putting out such poor work." See Elaine D. Woodall, "Archibald J. Motley, Jr.: American Artist of the Afro-American People, 1891–1928" (M. A. thesis, Pennsylvania State University, 1977), 113. Farrow shared Dawson's concerns, but he may also have felt that Motley's work lacked propriety; see Woodall, 104.

40. After Woodall's important 1977 thesis, active scholarly interest in the work of Archibald Motley was ignited by an exhibition organized by the Chicago Historical Society; see Jontyle Theresa Robinson and Wendy Greenhouse, *The Art of Archibald J. Motley, Jr.* (Chicago: Chicago Historical Society, 1992). The literature on Motley grows year by year.

41. A Congregationalist minister and dynamic orator, Frank Gunsaulus so inspired Chicago meat-packing giant Phillip D. Armour with a sermon on social responsibility that the wealthy industrialist offered to establish a technical school for

the training of young men from working-class or disadvantaged backgrounds—if Gunsaulus would agree to run it. Armour provided scholarships for all students who were in need of financial aid, regardless of race or ethnic background. Founded in 1893, the Armour Institute was absorbed into the Illinois Institute of Technology in 1940; see McCarthy, *Noblesse Oblige*, 94.

42. The bibliography on the WPA's art programs is vast, but the most useful history of the Federal Art Project in Chicago is George J. Mavigliano and Richard A. Lawson, *The Federal Art Project in Illinois, 1935–1943* (Carbondale, Ill.: Southern Illinois University Press, 1990).

43. Teacher Kathleen Blackshear's support of black students was legendary, but other staff members and officers rendered assistance to black artists and furthered their careers at a time when art-gallery support was weak. Lester Bridaham, the museum's press officer, promoted the career of Eldzier Cortor. The museum actively supported the South Side Community Art Center with loans and administration. Also, in 1943 the Art Institute devoted a show to "Negro Artists of Chicago."

44. Transcript of Margaret Taylor Goss Burroughs Interview, 1988, Archives of American Art, Washington, D.C., 23.

45. Two articles provide indispensible, first hand accounts of the artists who gravitated to Neal and formed the Arts Crafts League: Bernard Goss, "Ten Negro Artists on Chicago's South Side," *Midwest: A Review*, 1, 2. (December 1936): 17–19; and Willard F. Motley, "Negro Art in Chicago," *Opportunity*, 18, 1 (January 1940): 19–31.

46. For a discussion of the Arts Crafts League's members, see Burroughs Interview, 22–23. The association is variously referred to by artists who joined as the "Arts Crafts League" and the "Arts and Crafts League." A comprehensive history of the center remains to be written, but information on its activities and founding can be located in a number of sources, including Judith Burson Lloyd and Anna Tyler, *The Flowering: African-American Artists and Friends in 1940s Chicago: A Look at the South Side Community Art Center* (Chicago: Illinois Art Gallery, 1993); Commission on Chicago Landmarks, *South Side Community Art Center, 3831 South Michigan Avenue* (Chicago: The Commission, 1993); Mavigliano and Lawson, *The Federal Art Project in Illinois*, 67–71; Margaret Goss Burroughs, "Chicago's Community Art Center: A Personal Recollection," in *Art in Action: American Art Centers and the New Deal*, ed. John Franklin White (Metuchen, N.J./London: Scarecrow Press, 1987), 131–44; Locke, "Chicago's New Southside Art Center," *Magazine of Art* 34, 7 (August–September 1941): 370–74; and the Art Institute of Chicago Scrapbooks.

47. Michael Denning, *The Cultural Front: The Laboring of American Culture* (London: Verso Books, 1997), 122–23.

48. For an examination of Cortor's Sea Islands pictures, see Lisa Gail Collins, "Visualizing Culture: Art and the Sea Islands," *International Revue of African American Art* 19,1 (2003): 53–59.

49. For an examination of the political background to the American Negro Exposition, see Robert K. Rydell, *World of Fairs: The Century of Progress Expositions* (Chicago: University of Chicago Press, 1993), 157–92.

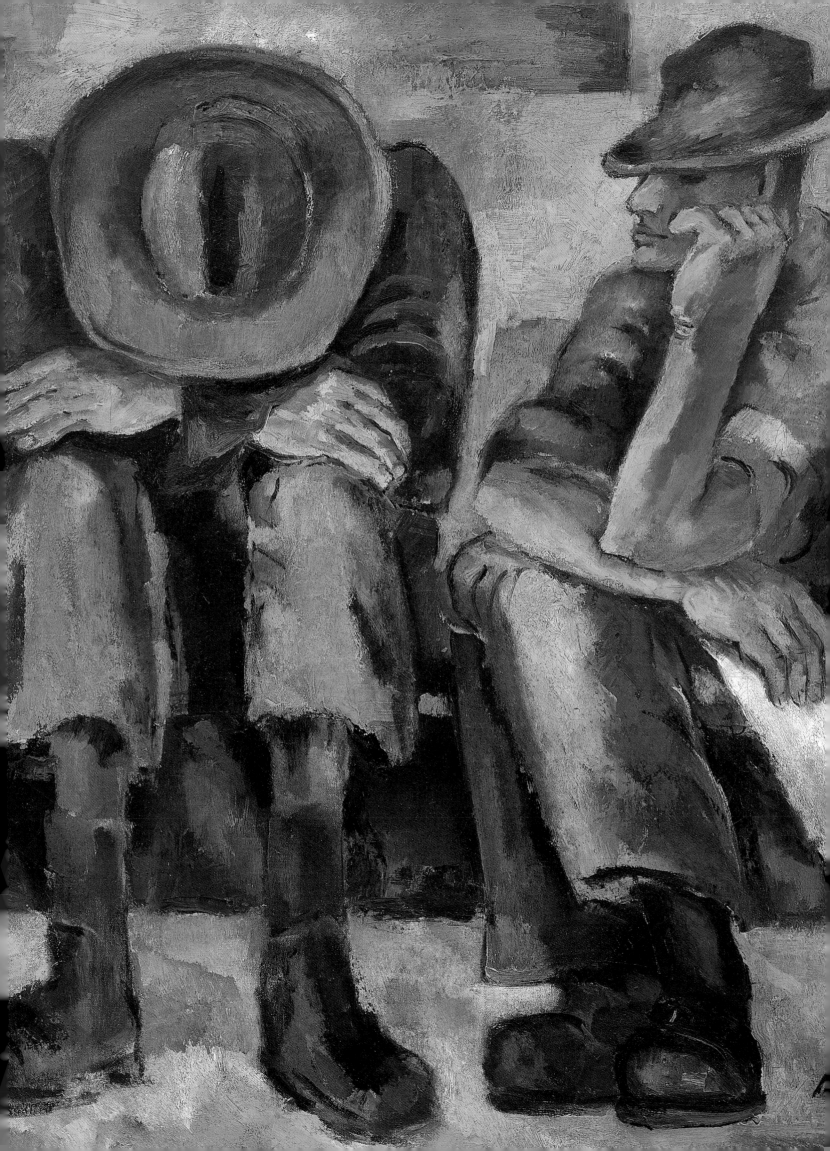

SUSAN S. WEININGER

COMPLETING THE SOUL OF CHICAGO:
From Urban Realism to Social Concern, 1915–1945

IN 1942 MITCHELL SIPORIN, a Chicago artist who came of age during the Great Depression, expressed his dedication to creating an art that would embody a uniquely midwestern vision of democracy and social consciousness. Citing Walt Whitman and José Clemente Orozco as his artistic models, Siporin commented "there is no synthetic regionalism here [in the Midwest], no collecting of obvious gadgetry, no jingoistic nationalism; but instead a human democratic art, deeply thoughtful and eloquent, an art out of the lives of the people. Through these voices we have been made aware of the scope and fullness of our environment, of the possibility of wedding modernism to a deeply moving social art."[1] This statement reflects the aims of many artists in Chicago in the period between 1915 and 1945, predominantly immigrant or first-generation Americans, who used the formal vocabulary of modernism to address social ills and to advocate redress through ideals of democracy and community. Siporin believed that such an art would aid "our 'little town' [Chicago] . . . in the process of completing her soul. This process can only continue in the free atmosphere of our world, our country, and our town."[2]

Chicago's status as a city of immigrants was one catalyst for the flowering of socially conscious art there in the first half of the twentieth century. According to historian Irving Cutler, while Chicago had a significant population of "native elites" who played an important role in the development of the city, they were never as influential as those in cities such as New York, Philadelphia, or Boston, where they had been established for over two centuries. In Chicago, immigrants, many of whom came directly from overseas, played a decisive role in the history of the city.[3] They tended to settle in ethnic enclaves and reproduce some of the conditions of their homelands by establishing religious institutions, social clubs, community centers, native-language newspapers, and other organizations. Early in the twentieth century, Chicago social activist Jane Addams described the polyglot neighborhood around Hull House, the settlement house she established in 1889, thus:

Between Halsted Street and the river live about ten thousand Italians. To the south on Twelfth Street are many Germans, and side streets are given over almost entirely to Polish and Russian Jews. Still farther south, these Jewish colonies merge into a huge Bohemian colony. To the northwest are many Canadian-French and to the north are Irish and first-generation Americans. The streets are inexpressibly dirty, the number of schools inadequate, sanitary legislation unenforced, the street lighting bad, the paving miserable and altogether lacking in alleys and smaller streets, and the stables foul beyond description.[4]

This environment, along with institutions such as Hull House, created the conditions that allowed a new generation of socially conscious artists to flourish. Many of them immigrants or first-generation Americans, they identified readily with others on the margins of society.

Such artists were sensitive to Chicago's history of economic, political, and racial injustice. The city was the center of the American trade-union movement in the nineteenth century; the Haymarket Riot of 1886 and the Pullman Strike of 1894 are only two of the most dramatic examples of labor unrest in the late nineteenth century. In 1919, as workers sought to consolidate the gains they had made in the war years, a prolonged series of strikes gripped Chicago, the second largest industrial area in the nation after New York. This was followed by a widespread but unsuccessful struggle for workers' rights that would be taken up with even greater zeal during the Great Depression.[5] For a young generation of Chicago artists, awareness of this history of labor agitation was reinforced by personal experience when, during the years of government support for the arts (1933–43), artists labored under conditions similar to other workers and formed leftist organizations such as the American Artists' Congress and the John Reed Club. Themes of social inequity and labor issues naturally found expression in their art.

In addition to these social and political conditions, Chicago artists, through the influence of the School of the Art Institute, inherited a staunchly academic tradition emphasizing representational art, the figure, and narrative. This history tempered progressive local painters' formal experimentation with composition,

CAT. 84 (DETAIL)

color, or shape, ranging from the unnatural use of color in fauvism to the sharply delineated shapes of precisionism, while encouraging their propensity for socially concerned art. Chicago's social-realist painting is linked with the popularization of urban subjects nationally during the 1910s and '20s and shows a strong connection to the Mexican mural movement, which used a modern, expressive, figurative style to champion the disadvantaged and promote revolutionary ideals. The socially concerned artists who are the subject of this essay sought to convey powerful messages of political or social import through a variety of modernist formal means, including expressive color, distorted shapes, and flattened space, while retaining enough connection to visual reality to be easily apprehended. While the mainstream American scene painting of the 1930s often glorified small-town and rural life in a normative realist style, the socially concerned artists of the 1920s and '30s used the techniques of European modernism and the spirit of the revolutionary Mexican artists to speak directly to and effect change for the dispossessed, the economically or socially disadvantaged, and those marginalized by the dominant culture.[6]

Between the world wars, many artists began to address the plight of the worker, the immigrant, and those on the margins of society in their work. In the 1920s, the conditions of the poor and exploited were thrown into relief against conditions of general prosperity, while in the next decade, the Great Depression made poverty a universal issue. Using an array of modern stylistic approaches, Chicago artists observed, critiqued, and offered solutions for the social problems of the time. Characterized by compassion, sympathy, and hope for a more democratic and egalitarian future, their modern interpretation of figurative work aimed, in Siporin's words, to "bind [them] closer to those to whom [they] speak."[7]

The Ashcan School and Its Influence

In 1908 a group of urban realists called The Eight gained national attention for an exhibition at the Macbeth Gallery in New York. Led by progressive artist Robert Henri, and including artists Arthur B. Davies, William Glackens, Everett Shinn, and John Sloan, The Eight sought to create an American art based on the modern urban experience. Dissatisfied with academic conventions and the European-derived landscape tradition, they directed their attention to the streets, parks, and other public places of New York. Demonstrating an avant-garde sensibility, their work was revolutionary in its focus on ordinary working people and their environment, as well as on the grittier aspects of urban life. Although members of the group employed a range of stylistic approaches, most sought to show the vitality of the urban scene in their

work in a celebratory, rather than critical, manner, using a rapid and seemingly spontaneous application of paint.

Members of The Eight were among the most popular exhibitors at the Art Institute of Chicago in their day. Despite its generally conservative nature, the Art Institute had a commitment to exposing the public to a wide variety of art, including examples of "strange and heretical doctrines," even if the expectation was that they be rejected.[8] By the time the Art Institute served as the first venue of the tour of The Eight's 1908 exhibition, all members of the group had previously exhibited there.[9] The museum's *Bulletin* described the artists as a "group of eccentric New York painters" who, although well trained, deny "all conventional and classical qualities."[10] It went on to note that the exhibition "excited much attention," and newspaper reviews reveal a range of responses to the "('Crazy') Eight," as critic Maude I. G. Oliver dubbed them.[11] Critics targeted their rapid, painterly technique in a manner reminiscent of the early attacks on the impressionists, but paid little attention to their urban subject matter. Such attention to technique is characteristic of the value placed on academic mastery and skill in Chicago at this time.

The group that came to be known (derisively) as the Ashcan school—Henri, Glackens, Shinn, Sloan, and Luks of The Eight and some younger associates—became an important source for the development of urban-realist and socially conscious painting in Chicago in the 1910s and '20s. The work of various Ashcan painters was regularly shown not only at the Art Institute but also at the Renaissance Society at the University of Chicago and at the Arts Club of Chicago, two organizations founded in the late teens dedicated to providing a local forum for progressive contemporary art.[12] After 1910 George Bellows exerted the strongest direct influence of any contemporary American artist on Chicago's progressive painters. Although not a member of the original Eight, he shared the Ashcan school's vigorous style and modern subject matter. By the time of his first solo exhibition in Chicago, at the Art Institute in 1914–15, the museum fully approved of his work, citing Bellows's "ability to sum up the significant features of such complex subjects as a circus, a fight, a skating party, in a manner that gives the observer the keenest possible impression of the totality of the scene. Strength, color and vigor of action are the striking notes of his exhibition."[13] *Love of Winter* (fig. 1), an ice-skating scene, was purchased by the Friends of American Art, an Art Institute support group, from the Bellows exhibition for the museum's permanent collection. It is not coincidental that several Chicago artists, including Aaron Bohrod, Gustav Dalstrom, Frances Foy, and Herman Menzel, created similar scenes.

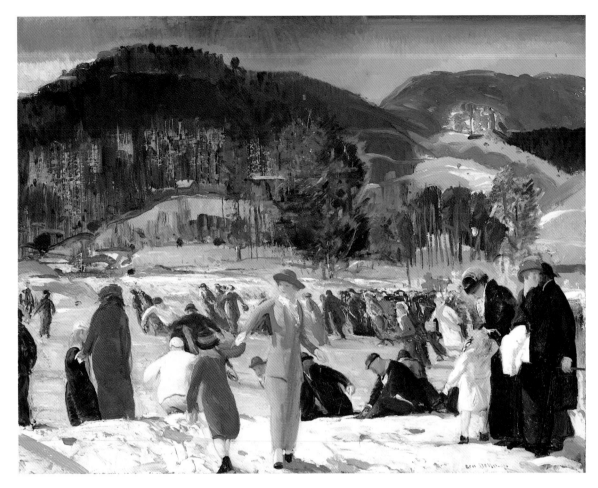

FIG. 1
George Bellows (1882–1925)
Love of Winter, 1914
Oil on canvas, 32 ½ x 40 ½ in.
The Art Institute of Chicago, Friends
of American Art Collection, 1914.1018

Bellows's popularity in Chicago continued to grow. He was featured in exhibitions at the Arts Club in 1916 and the Renaissance Society in 1917, and in 1919 he was invited to be a visiting teacher at the School of the Art Institute, followed by Randall Davey, another member of the Ashcan school.[14] Bellows's and Davey's emphasis on independence from prescribed rules was in contrast to the importance placed on technical mastery and figure drawing in the traditional pedagogy of the school, and their classes drew many progressive young students. Virtually all the practitioners of modern stylistic idioms who were associated with the school during Bellows's and Davey's short tenures there cite one or both artists as a significant influence on their work. These students' work evinces their eagerness to embrace new kinds of subject matter, notably scenes of ordinary urban life and popular entertainment, as in Frances Strain's *Cabaret* (fig. 2). Even more important sources of inspiration from the Ashcan school, however, were the commitment to freedom from academic rules and Bellows's dictum that artists paint what they know and express themselves honestly and sincerely.[15]

In response to such influences, many Chicago artists created works using thick applications of paint, bright colors, and broken brushstrokes. Many painted skaters or bathers along the miles of Lake Michigan beaches, people enjoying themselves in Lincoln or

FIG. 2
Frances Strain (1898–1962)
Cabaret, before 1927
Oil on canvas, location unknown;
reproduced in Sue Ann Prince (ed.),
*The Old Guard and the Avant-Guard:
Modernism in Chicago, 1910–1940*
(Chicago: University of Chicago Press,
1990), 90

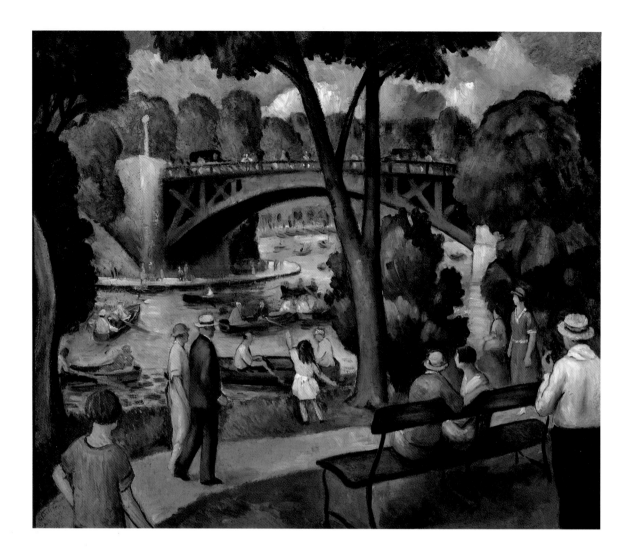

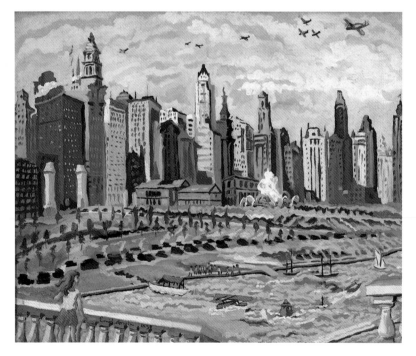

Jackson Parks, or ordinary Chicagoans in their own neighborhoods. Such works as Francis Chapin's *White Tower* (cat. 21), Gustav Dalstrom's *The Bridge, South Pond (Lincoln Park)* (fig. 3), and Emil Armin's *Towers* (fig. 4) present Chicago's social and ethnic variety and the visual color and chaos of urban life in a manner that is upbeat, even joyful, without euphemism or social critique. Some Chicago artists also depicted darker subjects. For example, Menzel executed a series of pool-hall scenes in the late 1920s in which this particularly popular pastime in Mexican neighborhoods is starkly portrayed, suggesting a barely controlled tension that portends a violent eruption (see cat. 51).[16] The message of individualism and emphasis on the commonplace in urban life taught by Bellows and Davey continued to serve as a model for socially conscious and artistically innovative Chicago artists into the 1930s.

The Development of Chicago's Urban Realism

The early 1920s saw the birth of painting of the so-called "American scene," which combined the urban realism of a previous generation with a growing desire to create an accessible American art that celebrated the values associated with a democratic way of life and

romanticized small-town and rural America. Such works were increasingly favored nationally and were later mandated by the government-supported art projects of the 1930s. In contrast to this were Chicago's socially conscious artists, who began addressing the immigrant experience, the worker, and the general oppression and poverty of the city in their art as early as the 1920s. Their works are the antithesis of triumphant American scene paintings, such as Rudolph Ingerle's *Salt of the Earth* (cat. 45), which glorify character types of northern European heritage as symbols of productive labor in wholesome and spacious surroundings.

In 1913 visitors to the International Exhibition of Modern Art (the Armory Show) at its Chicago venue, the Art Institute, were introduced to such avant-garde movements as post-impressionism, cubism, and futurism. Local artists with a modern inclination looked to this startling range of stylistic innovations as inspiration for a new artistic vocabulary that could express powerful themes of social realism and critique. William S. Schwartz saw the distortion of color, size, shape, and space in cubism, expressionism, and fauvism as a more powerful means of expression than the normative realism of earlier artists.[17] A Jewish immigrant from Russia, Schwartz was a versatile and innovative artist whose work ranged from pure abstraction to American scene images of small-town life and from nudes to portraits, all executed with fastidious attention to technique (see cat. 73, 74). Describing his vision of the immigrant's ideal of the United States and its possibilities, Schwartz wrote: "I expected to find America big and free and busy. I thought to find the streets, if not actually paved with gold, at least metaphorically surfaced with semiprecious materials, for America . . . meant opportunity."[18] Schwartz's art reflects an immigrant's experience of the contrast between an ideal and reality.

During the 1920s, Schwartz not only surveyed the urban environment, but he also addressed issues of social inequality in his art. One of Schwartz's most powerful works is *La Commedia* (fig. 5), which he painted in August 1929, immediately after the untimely death of his friend and fellow painter Anthony Angarola, and dedicated to Angarola's memory. Using the angular distortions and flattened space characteristic of cubism, this modern version of thirteenth-century poet Dante's *Divine Comedy*, with a central figure of a crucified Christ above two clerics and an overweight, distorted figure holding a huge coin, represents the corruption of church and state; other groups of figures are shown in a range of degrading activities, evoking the representations of the sins in a Boschian hell. The painting conveys the idea that greed, depravity, and immorality are thriving in the world and have contributed to the martyrdom of

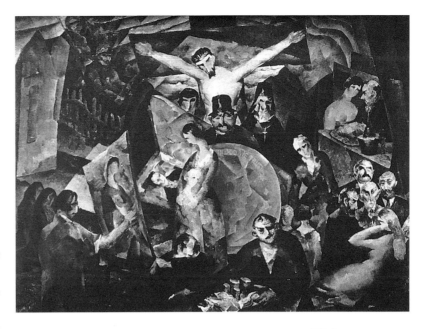

FIG. 5
William Schwartz (1896–1977)
La Commedia, 1929
Location unknown; reproduced in Manuel Chapman, *William S. Schwartz: A Study* (Chicago: L. M. Stein, 1930), 63

FIG. 6
Anthony Angarola (1893–1929)
Harmony in Red, 1918
Oil on canvas, 22 x 19 in.
Private collection

the Christlike artist (appearing also in the lower-left corner). Such straightforward allegory is rare in Schwartz's art; here it seems to emphasize his theme of social injustice.

Angarola similarly turned a modern eye to the urban realities of the 1920s. Born in Chicago in 1893, Angarola was a first-generation American whose parents were Italian immigrants unsympathetic to his artistic aspirations. Some of Angarola's early works suggest his concern for both social comment and formal experimentation, particularly as influenced by the symbolist movement that was so influential among Chicago artists who emerged as modernists in the late 1910s and '20s (see Weininger fantasy essay). Angarola explored the notion of an essential analogy between art and music, as demonstrated in the title of his 1918 painting *Harmony in Red* (fig. 6). This dark and melancholy landscape scene features a grim-faced

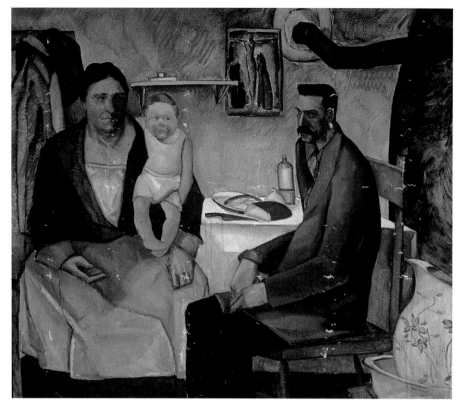

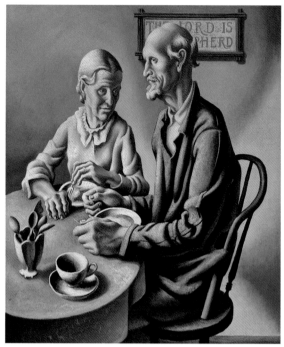

FIG. 7
Anthony Angarola
Proud, 1927
Oil on canvas, 44 x 50 in.
Private collection

FIG. 8
Thomas Hart Benton (1889–1975)
The Lord Is My Shepherd, 1926
Tempera on canvas, 33 ¼ x 27 ⅜ in.
Whitney Museum of American Art,
New York; Purchase 31.100

couple, their faces painted red, walking toward the viewer. While the unnatural color of the couple's visages shows an interest in the bright colors favored by fauvism and expressionism, the composition and paint application resonate with the work of Ashcan-school painters, in particular Sloan and Glackens.

Angarola's work, like that of many other artists who were immigrants or first-generation Americans, expressed his enormous sympathy for society's outsiders and dispossessed. Indeed, themes of compassion dominate American social-realist art during the Great Depression, but Angarola, who died before the 1929 stock-market crash, created works of social conscience in anticipation of the movement. In 1927 he painted *Proud* (fig. 7), which shows an impoverished family seated at a table laid with a meager meal in a bare interior. Given the relative prosperity of the 1920s, this is a particularly poignant image of the poverty that also existed in that decade. In contrast to the stoic, Yankee farm couple in Benton's 1926 *The Lord Is My Shepherd* (fig. 8), Angarola's portrayal presents a swarthy ethnic couple, dignified despite their poverty.

In 1926 Angarola's student (and romantic partner), Belle Baranceanu, was similarly drawn to subjects that expressed her sense of affinity with society's disenfranchised and outcast. As a Jewish woman of immigrant parents, Baranceanu understood the barriers to opportunity that women and other minorities faced in the United States, and she often spoke of the special bond she felt for African Americans and other dark-skinned people.[19] On a preparatory sketch for her 1926 painting, *Virginia*, depicting an African American domestic worker she had observed waiting for a train (fig. 9), she wrote: "Commonplace people are at every moment the chief and essential links in the chain of human affairs; if we leave them out, we lose all semblance of truth."[20] For Baranceanu, as for Schwartz and Angarola, family history and personal experience led her to identify her art with the cause of "commonplace people." Modernism, with its emphasis on direct, authentic experience, strengthened the link between Chicago artists and the "commonplace people" they powerfully memorialized.

Hull House

A number of institutions played a role in supporting the development of socially conscious artists in Chicago. One of the most important was Hull House, which was established to help assimilate immigrants into American life at the turn of the century. It was founded by social reformers Jane Addams and Ellen Gates Starr with the goal of moral uplift, a mission similar to that of such cultural institutions founded in the same decade as the Art Institute, the Chicago Symphony, and the Newberry Library. Hull House was founded to help elevate the immigrant population and to sensitize them to things of beauty that would allow them to transcend their environment.[21] To further this aim, it provided a wide range of classes, from English to music and art; offered support services, such as kindergarten and daycare facilities for children

of working mothers, as well as an employment bureau; and housed an art gallery, libraries, a theater, and a labor museum, which was also a meeting space for trade union groups.[22] While Hull House was the best-known settlement house, there were many smaller institutions serving specific ethnic populations in the city in similar ways.

As an institution where struggling immigrants could get training, support, and exhibition opportunities in the arts, Hull House played an important role in fostering an art that sympathetically portrayed the poor in Chicago. By the 1920s, there were a number of artists working regularly at Hull House who had begun to depict social realities. Among them were Emil Armin (see cat. 6), Bernece Berkman, Todros Geller, Carl Hoeckner (see cat. 44), Edward Millman (see cat. 52), Morris Topchevsky (see cat. 84), Gregory Orloff (see cat. 65), and William Jacobs. According to a contemporary account, Jacobs "[found] his inspiration in scenes such as those adjacent to Hull House itself."[23] Primarily known as a printmaker, he often depicted peddlers and the lively scene around Maxwell Street, close to Hull House on the near South Side, with its crowded and colorful open-air market; he also created paintings of these subjects (fig. 10). Like many socially conscious artists at the time, Jacobs considered his art "a contribution to society," in that it drew attention to an element of society that many were unaware of or simply ignored.[24]

The interest in representing underprivileged citizens predisposed several artists associated with institutions such as Hull House to look to the achievements of contemporary Mexican muralists. Characterized by a commitment to dignifying the formerly disenfranchised, to promoting universal education, and to the economic betterment of the populace, such work resonated powerfully with these artists. In the 1920s Chicagoans, along with artists across the United States, became aware of the mural paintings of Diego Rivera, José Clemente Orozco, David Alfaro Siqueiros, and others that had been created for public buildings, especially in Mexico City, under the sponsorship of the Mexican revolutionary government. Particularly appealing was the Mexican muralists' use of modern expressive devices to enhance the force and power of their message without sacrificing the readability of their images. As early as the 1920s, some Chicago artists even traveled to Mexico to observe and absorb the lessons of Rivera and the Mexican mural movement. Many artists associated with Hull House were profoundly influenced by the philosophy and work of the Mexican painters.

As has been noted, some of the artists whose work suggests a powerful commitment to social change were active before the Great Depression. Yet the wide-

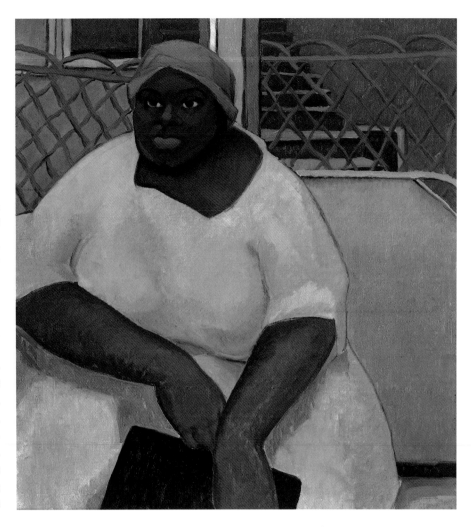

FIG. 9
Belle Baranceanu (1905–1988)
Virginia, 1926
Oil on canvas, 44 x 34 in.
Private collection

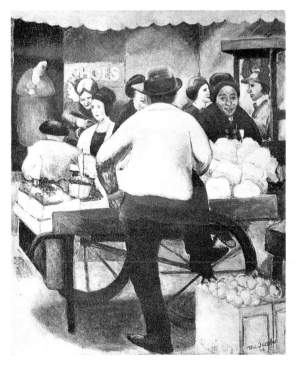

FIG. 10
William Jacobs (1897–1973)
Maxwell Street Market, before 1932
Oil on canvas
Location unknown; reproduced in J. Z. Jacobson, *Art of Today: Chicago 1933* (Chicago: L. M. Stein, 1932), 77

spread poverty and adversity it brought further strengthened Chicago artists' commitment to use their art to address social and economic issues. Many younger artists came of age in this difficult time, finding an opportunity to develop their artistic skills in

settlement houses and in the government-supported art projects of the 1930s. Hull House was an important influence on many artists, such as Morris Topchevsky. He had been a regular participant at Hull House throughout the 1920s, gathering there as early as 1921 with a group of eight other young men who called themselves the Independents—a reflection of his early identification with progressive ideas.[25] Born in Poland to a family who lost four children to anti-Semitic pogroms, Topchevsky was sensitive to human suffering from a young age and dedicated his life and art to the cause of the dispossessed. Critic C. J. Bulliet saw him as a "leading leftist among Chicago artists, [and] both by force of his talents and a driving personality . . . a propagandist. Only Topchevsky's emotional impulses and great technical skill are such that his preachments have a minimum of the fustian of the soapbox orator."[26]

As an instructor at Hull House and then at the Abraham Lincoln Center on Chicago's South Side, which served primarily African American students, Topchevsky became an influential teacher and mentor to Depression-era artists such as Leon Garland (see cat. 35), whom he met at the School of the Art Institute and introduced to Hull House. Garland loved the neighborhood and the people he met and observed around the settlement house. Inspired by Hull House ideals, Garland experienced his greatest satisfaction working on the New Deal art projects. A memorial publication of his work noted: "The ability to identify himself with his nation and his fellow workers was immeasurably valuable to him. He had the comfort of seeing that a sane approach was at last being adopted toward art and artists; that artists were going to be accepted as contributing citizens of the nation, were to be removed finally from the unwholesome atmosphere of luxury trade and patronage."[27]

In 1935 painter and writer Emily Edwards became the director of the Hull House art school.[28] Also a political activist, she was a member of the American Artists' Congress, a radical labor organization that took an antifascist stance, supported increased and permanent support for government arts programs, and sought to use art as a bridge to the working classes.[29] Edwards's personal history of commitment to social justice and activism and emulation of Rivera contributed to her leadership style at Hull House, where she encouraged artists who were committed to social reform as well as those who were interested in modern styles—and many who were interested in combining the two. Along with artist-activists such as Geller and Topchevsky, Edwards created an environment that encouraged younger artists to explore themes of injustice, racism, and discrimination, in an effort to create a more egalitarian society.

The New Deal and Its Influence

To ease the unemployment created by the Depression, President Franklin Roosevelt devised a wide range of government-supported work projects, a number of which were specifically designed to aid artists. Thousands of murals, easel paintings, sculptures, prints, and photographs were produced in the United States with government support in the period between 1933 and 1943. Most progressive artists in Chicago were employed by the short-lived Public Works of Art Project (PWAP) or by one of its successors, which included the regionally administered Works Progress Administration (WPA)/Federal Art Project (FAP), the federally administered Treasury Section of Painting and Sculpture ("the Section"), and the Treasury Relief Art Project (TRAP).[30] The Illinois Art Project (IAP) of the FAP was a locally administered relief-based project, while the Section funded projects for new federal buildings, many of them post offices, on the basis of competitions.

A commitment to "the American Scene in all its phases" was commonly cited as a mandate for acceptable subject matter for those working on the projects. However, this term had a multiplicity of meanings, depending on the particular project or administrator.[31] Many proponents and early administrators of the projects were committed to art that would be accessible and meaningful to a wide American audience. A key component of the government projects of particular importance for Chicago artists was the then-emerging ideas about the definition of an authentic American art. Most Chicago artists had already rejected art for art's sake and radical modes of modernism, opting instead for recognizable subject matter. In his often-cited 1933 letter to President Roosevelt, artist and writer George Biddle suggested employing artists to decorate public buildings in the straightforward manner of the revolutionary Mexican muralists, in order to convey the "social ideals you [Roosevelt] are struggling to achieve."[32] Such a stance would have sanctioned the exploration of themes of social issues that already concerned progressive and radical artists. In contrast, Increase Robinson, an artist and gallery-owner who was the controversial longtime regional and state director of the IAP beginning in 1935, encouraged artists "to look to [their] own environment for subjects worthy of [their] consideration, to make a lively record of our own time and place"[33]—although she also mandated "no nudes, no dives, no social propaganda."[34]

In the face of such constraints, some artists consciously moderated their efforts in the art they contributed to the IAP. However, many others working in the easel- and mural-painting divisions, and especially in the printmaking projects, continued to execute art

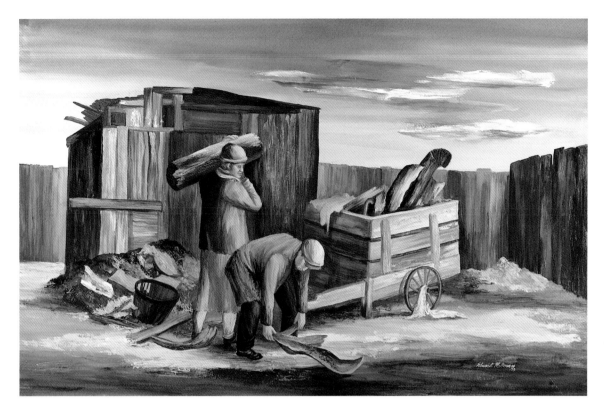

FIG. 11
Edward Millman (1907–1964)
Meager Living, 1939
Gouache, 19 x 28 in.
The St. Louis Art Museum,
Gift of the Federal Works Agency,
Work Projects Administration

that had a social agenda. For example, Bernece Berkman, Edward Millman, and Mitchell Siporin consistently used their work to convey the plight of the poor by using a figurative but hauntingly expressive modern style. Millman's *Meager Living* (fig. 11) focuses on two figures gathering what appears to be scraps left as trash in a makeshift wagon, a setting that conveys the barrenness of their existence. In Siporin's *Wreck* (fig. 12), a group of people dressed in tattered clothing are gathered on a smoking ruin. Rather than glorifying the worker as the hope for American economic recovery, as a conventional American scene image might, these paintings present the harsh living conditions endured by those left unemployed and impoverished by the Depression.

Millman and Siporin were selected to create murals for the post office in St. Louis, Missouri, the largest and most important commission awarded by the Treasury Section outside of Washington, D.C. Before executing the St. Louis murals, Millman and Siporin traveled to Mexico to study the work of Orozco, whom they considered "the greatest mural painter of our time."[35] The resulting St. Louis murals are tremendous in scope and reflect the events that shaped St. Louis's history, including the Civil War, emancipation, and Reconstruction. They do not minimize the violent history of racial politics in St. Louis, and they emphasize the collective struggle leading up to the 1930s. Millman and Siporin used bold colors, broad visible brushstrokes, and compressed forms to create highly energized scenes. While some viewers were unhappy with the completed murals—some commenting on the

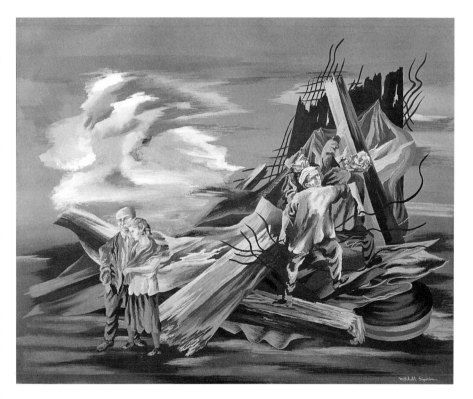

"Old Testament" (that is, Jewish) physiognomies of the figures—the artists retained the support of the superintendent of the Section, Edward Rowan, and St. Louis postmaster W. Rufus Jackson.[36]

Along with painter Edgar Britton, Millman and Siporin were also selected to decorate the post office in Decatur, Illinois. Art historian Andrew Hemingway has persuasively argued that the completed Decatur post office murals, which consist of Siporin's *Fusion of*

FIG. 12
Mitchell Siporin (1910–1976)
The Wreck, n.d.
Gouache on gray illustration board,
23 x 28 in.
The St. Louis Art Museum,
Gift of the Federal Works Agency,
Work Projects Administration

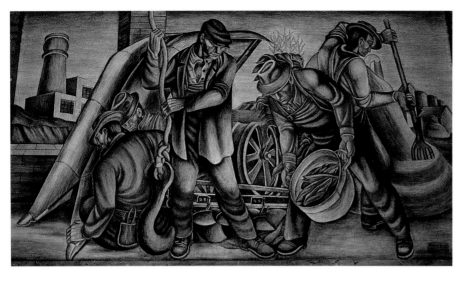

FIG. 13
Mitchell Siporin
*The Exchange of the Products of
Agriculture for the Products of Industry,*
from *The Fusion of Agriculture and
Industry in Illinois*, 1938
Fresco, 84 x 90 in.
Decatur, Illinois, United States
Post Office

Agriculture and Industry in Illinois (fig. 13), Britton's *Discovery, Use, and Conservation of Natural Resources* (fig. 14), and Millman's *Growth of Democracy in Illinois* (fig. 15), while not completely cohering as an artistic program, all communicate the ideal of a unified, dignified, and empowered laboring class. Modeling themselves on the Mexican muralists, these artists created forceful images meant to convey an ideal future in the midwestern industrial center of Decatur, a city suffering from labor problems. The lack of overt references to actual class conflicts or labor strife made them acceptable to the various constituencies that ultimately had to approve them.[37] On the basis of the St. Louis and Decatur murals, Millman, Siporin, and Britton achieved national reputations.

Such commissions serve as excellent case studies of the potential for socially committed art, even within the constraints imposed by the Section. These artists were dedicated to creating revolutionary art and to exhibiting it wherever there was an opportunity.[38]

In addition to their artistic goals, their radical politics were shared by many Chicago artists at this time. Siporin was a member of the Chicago Chapter of the John Reed Club, a national organization of artists and writers who were Communist Party members or sympathizers, and he had contributed illustrations to the radical journal *New Masses* as early as 1931. Millman and Siporin were also both members of the American Artists' Congress from its inception in 1935.[39] Such groups had a radical agenda and a membership that was heavily Jewish, reflecting the population of socially concerned artists in general.[40]

Jewish Artists and Socially Conscious Art

A disproportionate number of those whose work addressed social, political, and economic problems were immigrant or first-generation Jewish Americans. The combination of immigrant backgrounds with the Jewish experience of historic and contemporary sub-

jugation and anti-Semitism honed these individuals' sensitivity to injustice and oppression. For many Jewish Americans, the memory of Jewish slavery, reinforced each year at the Passover Seder, the central precept that repairing the world (*tikkun olam*) is the work of each Jewish person, and the commandment to give charity (*tzedakah*), all found expression in social consciousness and in socialist politics. Thus, many Jewish artists had a unique perspective on issues of social justice and a strong sense of their artistic responsibility to the disadvantaged.

Jewish artists in Chicago were frequently successful contenders in the city's progressive art scene. Many also worked at Hull House, which provided a space for classes and exhibitions, and at the Jewish People's Institute (JPI), a Jewish community center that offered similar opportunities in its spacious quarters on Taylor Street and later on the West Side.[41] In 1926 a Jewish artists' group named Around the Palette (succeeded by the American Jewish Artists Club) was founded.[42] Jewish artists were well represented in local progressive galleries, ranging from the Little Gallery, located in the Auditorium Theater tower and run by artist A. Raymond Katz in the 1920s, to Katharine Kuh's avantgarde gallery in the Diana Court Building on North Michigan Avenue in the 1930s. The Jewish presence in Chicago's progressive art community also included important art critics Manual Chapman and Sam Putnam. L. M. Stein published Jewish writer J. Z. Jacobson's *Art of Today: Chicago, 1933*, a compendium of Chicago modern artists that remains an essential primary document of the period. Philip Bregstone, writing in 1933, claimed that the Jews of Chicago appreciated more varied and broad cultural events than those in New York, who remained more insistently separate from mainstream society. He insisted that Chicago was a true melting pot, where Jews were exposed to English-speaking culture.[43]

Chicago's most important Jewish artists of the 1920s and '30s figured prominently in the local art scene while also maintaining a strong ethnic identity. Todros Geller (known as "the Dean of Chicago Jewish Artists"), Schwartz, and Emil Armin all had academic training abroad, all ultimately graduated from the School of the Art Institute, and all exhibited regularly at the Art Institute and with independent groups. Geller in particular was also firmly entrenched in the Jewish community, teaching for many years at the JPI, and producing stained-glass windows for synagogues as well as prints, book illustrations, and paintings with Jewish themes. His studio was a gathering place for artists ranging from Bohrod and Siporin to Baranceanu, with whom he worked closely in the early 1930s.[44] In addition to art that addressed contemporary political or social issues, he painted industrial landscapes, still lifes, and nudes. *Strange Worlds* (cat. 36) captures the artist's

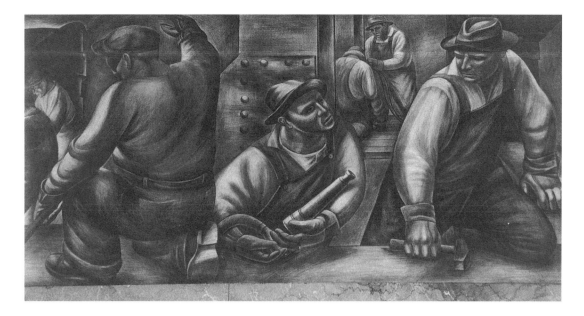

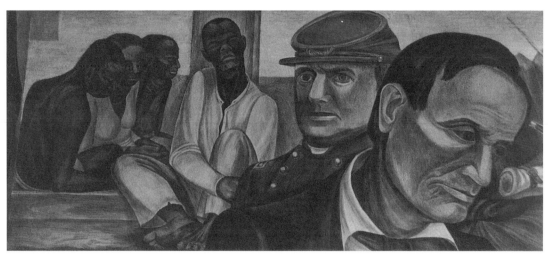

FIG. 14
Edgar Britton (1901–1982)
*Discovery, Use, and Conservation of
Natural Resources* (north lobby,
detail of south wall), 1938
Fresco, 48 x 240 in.
Decatur, Illinois, United States
Post Office

FIG. 15
Edward Millman
Growth of Democracy in Illinois
(south lobby, detail of south wall),
1938
Fresco, 48 x 240 in.
Decatur, Illinois, United States
Post Office

complex identity as both a participant in the vital local arts scene and a member of the Jewish immigrant community of Chicago.

An additional gauge of both the political and social commitment and cohesion of Jewish artists in the Chicago community can be observed in their contribution to the Birobidzhan project. Hoping to relocate the Jewish population, the Soviets declared the far eastern area of Birobidzhan the Jewish Autonomous Region in 1934. The John Reed Club in the United States responded by collecting donations of artwork that would form the core of a museum there. Twelve Chicago artists contributed a portfolio of prints, one copy of which was to go to the Birobidzhan museum; the others were sold to raise funds for the project.[45] These artists' contributions ranged from nostalgic invocations of *shtetl* life to representations of the effects of the Depression in Chicago—and most were executed in thoroughly modern stylistic modes. Accompanying the work were statements of solidarity with their Jewish brothers and sisters, which represented "the flowering of a new social concept wherein the artist becomes molded into the clay of the whole

people and becomes the clarion of their hopes and desires Thus we will better translate in our media, these aspirations for a new and better life . . . to a more understanding world, from our fountain of creation the first sparkling glimpses that are the new Jew in the making."[46] These artists had a deep commitment to social change, while retaining the ethnic identities that nurtured that commitment.

Social Realism During the Late Depression and World War II

The generation that came of age in the throes of the Depression often produced work with more explicit political and social agendas than that of their predecessors. As Topchevsky declared in 1933, "At the present time of class struggle, danger of war and mass starvation, the artist cannot isolate himself from the problems of the world and the most valuable contribution to society will come from the artists who are social revolutionists."[47] In the work of artists such as Berkman, a student of Geller and of Rudolph Weisenborn, the emotional content is heightened by modernist formal techniques. The oppressive work

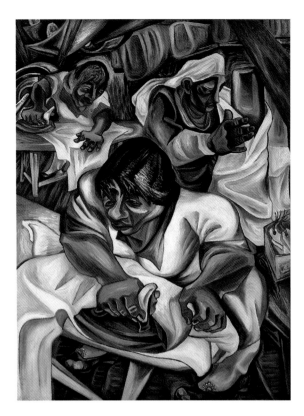

FIG. 16
Bernece Berkman (1911–1988)
Laundry Workers, 1938
Oil on canvas, 40 x 30 in.
Collection of the Flint Institute
of Arts, permanent loan from the
Isabel Foundation, L2003.37

done by the women in her *Laundry Workers* (fig. 16) is suggested by the extreme compression of the forms pressed up to the picture plane, the distortion of the figures, and the frenetically active linear patterns covering the painting's surface. Berkman's image presents a striking contrast to Gustav Dalstrom's more romanticized *Laundry* (cat. 25), in which the workers occupy a neat, orderly, and spacious setting rendered in cheerful pastel tones. Dalstrom's image, with its implication that the African American women staffing the laundry are content with their lot, typifies American scene painting's emphasis on the wholesome and the positive.

By the early 1940s, the domestic issues that had absorbed socially concerned artists were being superseded by the international events of World War II, and Chicago artists began to address these concerns in their work. Siporin's *Homeless* (cat. 78), which could represent victims of the Depression, can also be seen to allude to refugees from Europe. The huddled family, with their few belongings, stands in front of a ruined building. The dark tones, barren environment, and tensely energetic shapes succeed in "wedding modernism to a deeply moving social art,"[48] embodying Siporin's goals for the ideal Chicago art. In his attempts to connect artist and viewer directly and powerfully, using his art to convey ideas that could initiate the process of rectifying the ills of the world, Siporin is the archetypal artist of social conscience. Along with many of his contemporaries, his work advances the ideals of democracy and community in a way that is both midwestern and modern, rooted in the mix of immigrants, labor activism, and political commitment that is the essence of Chicago.

Author's note: I am grateful to David Sokol for suggesting the theme of this essay.

NOTES

1. Siporin, "Statement," in Dorothy C. Miller (ed.), *Americans 1942: 18 Artists from 9 States* (New York: Museum of Modern Art, 1942), 113. A slightly different version of this statement, "Mural Art and the Midwestern Myth," written in 1936, is found in Francis V. O'Connor (ed.), *Art for the Millions: Essays from the 1930s by Artists and Administrators of the WPA Federal Art Project* (Boston: New York Graphic Society, 1973), 64–67.

2. Siporin, "Statement," in Miller, *Americans 1942*, 114. This refers to the lines from Vachel Lindsay's poem *On the Building of Springfield*, which read: "Our little town cannot complete her soul/Till countless generations pass away."

3. Irving Cutler, *Chicago: Metropolis of the Mid-Continent*, 3rd ed. (Dubuque, Iowa: Kendall/Hunt Publishing Company, 1982), 43.

4. Addams quoted in ibid., 48–49.

5. Lizabeth Cohen, *Making a New Deal: Industrial Workers in Chicago, 1919–1939* (Cambridge, Mass.: Cambridge University Press, 1990), 12–52.

6. This corresponds to what Bram Dijkstra has labeled, in his recent book of the same name, "American Expressionism." Dijkstra argues for a reassessment of the art traditionally labeled social realist, and defines American Expressionism as "an approach to painting in which the artist's emotional engagement with social issues or personal experiences takes precedence over any formal stylistic considerations." See Bram Dijkstra, *American Expressionism: Art and Social Change, 1920–1950* (New York: Harry N. Abrams, 2003), 44.

7. Siporin, "Mural Art," in O'Connor, *Art for the Millions*, 67.

8. "Exhibition of Modern Art," *Bulletin of The Art Institute of Chicago* 6, 4 (April 1913): 51.

9. Daniel Catton Rich, "Half a Century of American Exhibitions," in *Annual Exhibition Record of the Art Institute of Chicago, 1888–1950*, ed. Peter Hastings Falk (Madison, Conn.: Sound View Press, 1990), 11 n. 9.

10. "'The Eight' Exhibition," *Bulletin of the Art Institute of Chicago* 2, 2 (October 1908): 18–19.

11. Ibid.; and Maude I. G. Oliver, [Chicago] *Record Herald*, 13 September 1908. Judith Zilczer, "The Eight on Tour, 1908–1909," *The American Art Journal* 14 (Summer 1984): 29 and 47 n.38, states incorrectly that there was no response in the Chicago press. For additional press response to the exhibition see [Chicago] *Post*, 12 September 1908; Maude I. G. Oliver, [Chicago] *Record Herald*, 20 September 1908; and [Chicago] *Post*, 29 September 1908.

12. In an early, if not the first, exhibition at the Renaissance Society at the University of Chicago in 1917–18, George Bellows was represented; see "Documentation," in *A History of The Renaissance Society: The First Seventy-five Years*, ed. Joseph Scanlan (Chicago: Renaissance Society at the University of Chicago, 1993), 133. In its first year, 1916, the Arts Club had an exhibition of Bellows, Sloan, and Henri, and other Ashcan-school artists and their followers were represented regularly in exhibitions in the 1920s; see "Chronology of Exhibitions," in *The Arts Club of Chicago: The Collection 1916–1996*, ed. Sophia Shaw (Chicago: Arts Club of Chicago, 1997), 122–25.

13. *Bulletin of the Art Institute of Chicago* 9, 1 (1 January 1915): 4; although Bellows's work had been seen at the Art Institute previously, this was his first solo exhibition.

14. On the Ashcan-school artists at the School of the Art Institute, see Charlotte Moser, "'In the Highest Efficiency': Art Training at the School of the Art Institute of Chicago," in *The Old Guard and the Avant-Garde: Modernism in Chicago*,

1910–1940, ed. Sue Ann Prince (Chicago: University of Chicago Press, 1990), 194, 202–4. Leon Kroll, a third artist associated with the Ashcan school, visited in 1924. Eighteen paintings by Davey were exhibited at the Art Institute in May 1915. He was described as a "modern" like Bellows, with work that "shows promise of no small future accomplishment"; see *Bulletin of the Art Institute of Chicago* 9, 5 (1 May 1915): 64.

15. Moser, "'In the Highest Efficiency,'" 203. By 1919 Bellows was focused on landscape, portraiture, and figure studies and less on the kind of urban realism explored here. Strain and other students may well have found his encouragement to express themselves freely particularly congenial in that it was introduced even in the familiar context of life-study classes; see ibid., 203, figure 11.3, for a photograph of Bellows with his Art Institute class, working on nude figure studies.

16. On Mexican pool halls in Chicago, see Mark Reisler, "The Mexican Immigrant in the Chicago Area During the 1920's," *Illinois State Historical Society Journal* 66:2 (Summer 1973): 152. Pool halls were the largest category of Mexican-owned businesses in Chicago in this period. Menzel's wife, Willa, in conversation with the author, recounted that her husband's interest in this subject motivated him to overcome his fear of going to the Mexican neighborhoods, which he perceived as dangerous.

17. As early as 1919, when he was still a student at the School of the Art Institute, Schwartz reportedly shocked his classmates with a blue and green nude, which he painted because "only those colors responded to his own inner necessity"; see Manuel Chapman, *William S. Schwartz: A Study* (Chicago: L. M. Stein, 1930), 39.

18. William Samuel Schwartz, "An Artist's Love Affair with America," *Chicago Tribune Magazine*, 5 April 1970, 64–65; as quoted in Douglas Dreishpoon, "Introduction," in *The Paintings, Drawings, and Lithographs of William S. Schwartz* (New York: Hirschl and Adler Galleries, 1984), 5.

19. Dijkstra, *American Expressionism*, 171–72.

20. As quoted in Bram Dijkstra, "Belle Baranceanu and Linear Expressionism," in *Belle Baranceanu: A Retrospective*, ed. Bram Dijkstra and Anne Weaver (La Jolla, Calif.: Mandeville Gallery, University of California, San Diego, 1985), 6.

21. Thanks to David Sokol for some of the information related to Hull House. For the establishment of cultural institutions in Chicago in the 1890s and their goals of uplift for the citizenry, see Helen Lefkowitz Horowitz, *Culture & the City: Cultural Philanthropy in Chicago from the 1880s to 1917* (Chicago: University of Chicago Press, 1976).

22. Mary Lynn McCree Bryan and Allen F. Davis, "Creative Years: 1900–1914," in *One Hundred Years at Hull House*, ed. Mary Lynn McCree Bryan and Allen F. Davis (Indianapolis: Indiana University Press, 1990), 63–66.

23. Frances Farmer, "Famous Art at Hull House," *Chicago Evening American*, 12 May 1930.

24. Jacobs, "Artist's Statement," in J. Z. Jacobson, *Art of Today: Chicago, 1933* (Chicago: L. M. Stein, 1932), 76.

25. *Hull House Yearbook* (Chicago: Frederick Hildman Printing Co., 1921), 14. This group is mentioned again in the 1925 *Hull House Yearbook*, 15, which also notes Topchevsky's departure for Mexico in December of the previous year.

26. C. J. Bulliet, "Artists of Chicago: Past and Present, No. 70: Morris Topchevsky," *Chicago Daily News*, 27 June 1936.

27. *Leon Garland: Ten Color Reproductions of His Paintings* (Chicago: Leon Garland Foundation, 1948), n.p.

28. Adena Miller Rich, "The Rich Years," in *One Hundred Years at Hull House*, ed. Mary Lynn McCree Bryan and Allen F. Davis (Indianapolis: Indiana University Press, 1990), 220.

29. See Andrew Hemingway, *Artists on the Left: American Artists and the Communist Movement, 1926–1956* (New Haven: Yale University Press, 2002), 123–24, for American Artists' Congress.

30. "The Section" was called the Treasury Department Section of Painting and Sculpture from 1934–38, the Treasury Department Section of Fine Arts from 1938–39, and the Section of Fine Arts from 1939–43, at which time it was transferred to the new Federal Works Agency. See Maureen McKenna, *After the Crash: New Deal Art in Illinois* (Springfield, Ill.: Illinois State Museum, 1983), 4, 6; and Hemingway, *Artists on the Left*, 77–79. For a detailed history of the various projects, see Richard D. McKinzie, *The New Deal for Artists* (Princeton, N. J.: Princeton University Press, 1973); for the post office murals, see Marlene Park and Gerald Markowitz, *Democratic Vistas: Post Offices and Public Art in the New Deal* (Philadelphia: Temple University Press, 1984).

31. Edward Bruce, " Implications of the Public Works of Art Project," *Magazine of Art* 27, 3 (March 1934): 114–15.

32. Letter from George Biddle to Franklin Delano Roosevelt, May 1933; as quoted in McKenna, *After the Crash*, 5. This appeal is often credited with persuading Roosevelt to allocate government money to support the arts.

33. "Increase Robinson Paints a Story of Corpus Christi," *Corpus Christi Caller-Times*, 14 November 1943; as quoted in George J. Mavigliano and Richard Lawson, *The Federal Art Project in Illinois* (Carbondale: Southern Illinois University Press, 1990), 24.

34. This statement is attributed to Robinson in Patricia Hills, *Social Concern and Urban Realism: American Painting of the 1930s* (Boston: Boston University Art Gallery, 1983), 12.

35. Reed Hynds, "2 Talented Artists to Do St. Louis P.O. Murals," *St. Louis Star-Times*, 20 September 1941; as quoted in Hemingway, *Artists on the Left*, 168.

36. Hemingway, *Artists on the Left*, 166–69.

37. Ibid., 161–66.

38. Ibid., 22.

39. Ibid., 159.

40. Andrew Weinstein, "The John Reed Club Gift to Birobidzhan," in *Complex Identities: Jewish Consciousness and Modern Art*, ed. Matthew Baigell and Milly Heyd (New Brunswick, N.J.: Rutgers University Press, 2001), 143.

41. Originally known as the Chicago Hebrew Institute, it was renamed the Jewish People's Institute in 1926; see Irving Cutler, *The Jews of Chicago* (Urbana: University of Illinois Press, 1996), 85–88, 228–30.

42. Around the Palette dissolved in 1939 and was succeeded by the American Jewish Artists Club in 1940, in order to express the solidarity of Jewish artists when news about the plight of European Jewry began to emerge. See Cutler, *Jews of Chicago*, 145–47; and Louise Dunn Yochim, *Harvest of Freedom* (Chicago: American References, 1989), 20–21.

43. Philip Bregstone, *Chicago and its Jews* (Chicago: privately published, 1933), 355.

44. Yochim, *Harvest of Freedom*, 53–54; Cutler, *Jews of Chicago*, 145–46. For Geller's relationship with Baranceanu, see Dijkstra, "Belle Baranceanu and Linear Expressionism," 21.

45. Weinstein, "The John Reed Club Gift to Birobidzhan," 149–56.

46. As quoted in Robert Weinberg, *Stalin's Forgotten Zion: Birobidzhan and the Making of a Soviet Jewish Homeland* (Berkeley: University of California Press, 1998), 57. Thanks to Arielle Weininger of the Spertus Museum of Judaica in Chicago for providing me with a list of the Chicago artists who contributed prints to the portfolio, of which the museum has a complete set. The artists are: Alex Topchevsky (Topp), Aaron Bohrod, Abraham S. Weiner, Mitchell Siporin, Morris Topchevsky, Louis Weiner, Ceil Rosenberg, David Ben Bekker, Edward Millman, A. Raymond Katz, William Jacobs, Todros Geller, Bernece Berkman, and Fritzi Brod.

47. Topchevsky, "Artist's Statement," in Jacobson, *Art of Today*, 129

48. Siporin, "Statement," in Miller, *Americans 1942*, 113.

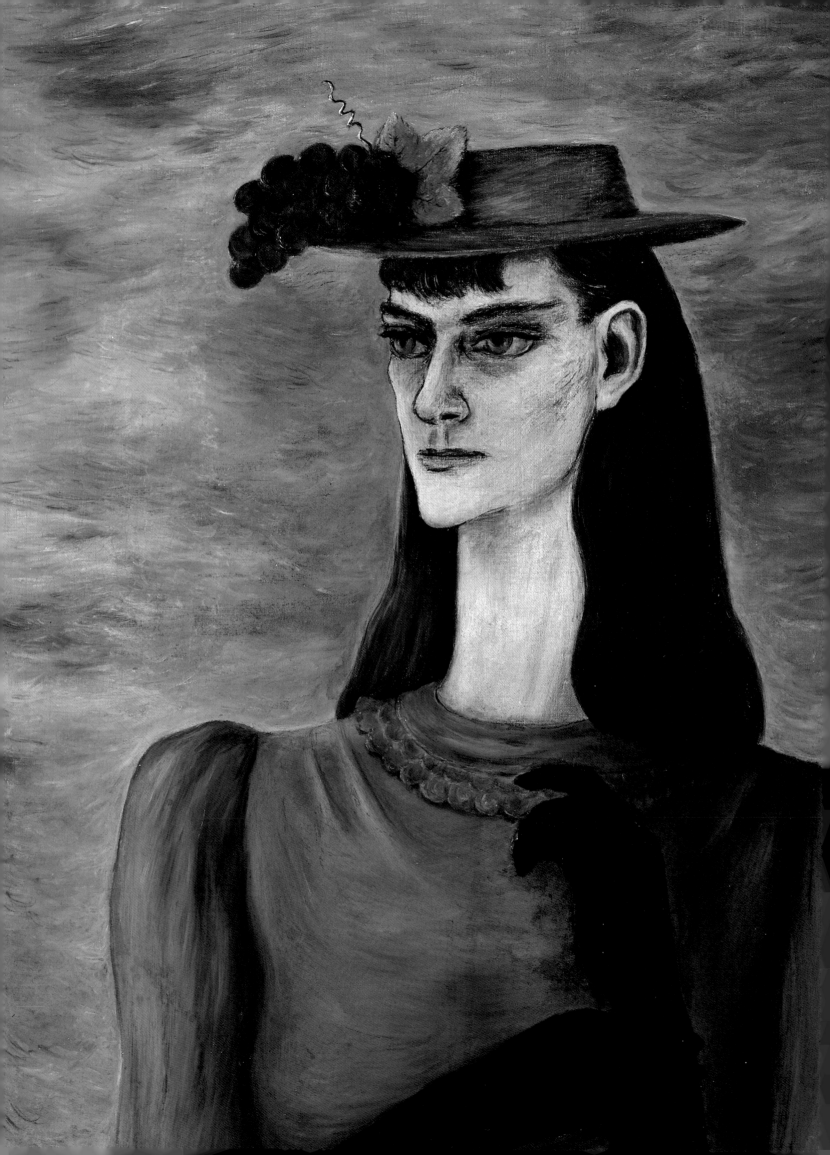

SUSAN S. WEININGER

FANTASY IN CHICAGO PAINTING:
"Real 'Crazy,' Real Personal, and Real Real"

IN 1950 CHICAGO ARTIST Gertrude Abercrombie defined good art by saying, "Art has to be real 'crazy,' real personal and real real, or it is nowhere. If it doesn't make you laugh, it's not so good either."[1] Abercrombie was one of a number of idiosyncratic artists who flourished in Chicago in the period between 1910 and 1945. Her definition goes a long way toward explaining the nature of the "fantastic" element, long prevalent in Chicago art, that produced work categorized variously by historians as surrealist, magic realist, visionary, or untutored.

In the catalog for a 1947 surrealism exhibition at the Art Institute of Chicago, curator Frederick Sweet argued that surrealism in the United States had its own character because of the strong romantic streak in American art, and so "the imaginative qualities of many of our artists have easily developed into the fantastic and dreamlike imagery which may be called surrealism."[2] Broadly defined in this manner, the term *surrealism* can be used to describe a wide range of American art. *Magic realism* is equally elastic, although the term is used frequently to refer to representational images that are rendered mysterious, disturbing, or out of the ordinary through unusual juxtapositions of common, naturalistically represented objects.[3] It is important to note that with few exceptions, however, such terms were not used by critics, writers, or the artists working at the time in Chicago; they have only been used retrospectively. The term *surrealism* can be used to broadly define a unique mode of painting practiced in Chicago between 1910 and 1945 that was marked by local concerns and interests. Chicago artists of the "fantastic" were not part of any one movement or formal group. Rather, they often moved easily from one stylistic mode to another, even from conservative to radical styles. Yet their common interest in creating an art based on the idiosyncrasies of individual personality and vision forged a vital trend in Chicago.

A number of factors contributed to the vitality of this strand of expression in Chicago. One was the consciousness of all Chicago artists of their status as relative outsiders in relation to the mainstream art world of the East Coast and Europe. Even within Chicago itself, the artist was a somewhat isolated figure within the city's energetically commercial and notoriously practical culture. This sense of marginalization was shared by the city's numerous creators of fantasy art. In addition, during this period, the absence of any one rigid, hegemonic artistic movement allowed artists to try a variety of styles. Even the generally conservative Art Institute of Chicago and its school tolerated and, in some cases, encouraged experimentation and eccentricity. Many important taste-makers in Chicago were also open to the newest artistic theories, including the modern idea of working in a subjective mode from "inner necessity." The influential critic C. J. Bulliet, in particular, was sympathetic to the odd, eccentric, peculiar, and bizarre. Chicago also offered opportunities for the exhibition of such art. Progressive artists created organizations and independent exhibition groups, free from the constraints of juries.

Fantasy art offered one outlet for many young Chicago artists seeking an alternative to a tradition of genteel, academic art. Historically, Chicago's art establishment valued technical mastery over expressive brushwork, realism over abstraction, and art with a message or edifying purpose over "art for art's sake." While this attitude dissuaded many Chicago artists from pursuing purely abstract styles, many artists were nonetheless eager to experiment with those aspects of modernism that emphasized individuality and personal expression. Some Chicago artists made fantasy their signature style, while others incorporated aspects of it into more traditional genres.

Fantasy art afforded these artists a way of departing from tradition without abandoning many of its values: grounded in figuration and narrative, such art gave expression to highly personal visions in accordance with the aims of modernism. With its ability to address the modern while honoring the past, Chicago's unique brand of fantasy art played an important role in pioneering a Chicago sensibility of the modern. Whether called fantastic or surrealist, the work described in this essay represents no single movement, but rather a wide range of images based in fantasy and dreams with a foundation in technique and figuration.

CAT. 1 (DETAIL)

67

Modernism and Fantasy

The roots of Chicago's fantasy styles can be found in the city's response to modernism in the early part of the twentieth century. By the 1910s progressive Chicago artists were beginning to "think modern." Artists were engaged in the "pursuit of the new" in ways that did not slavishly mirror what was happening in other art centers, but that followed its own logic—well seasoned with the ideas, if not the stylistic innovations, of the avant-garde. Chicago artists in this period were experimenting with aspects of pointillism, abstraction, and expressionism, sometimes in notably unorthodox ways. Even those who continued to work in traditional styles were beginning to absorb modern theoretical perspectives, such as working from "inner necessity."

Although a conservative stronghold, the Art Institute was important for these developments in offering Chicagoans opportunities to view avant-garde art. Often a host to traditional exhibitions and artists, the museum also had a policy of opening its galleries to progressive, even radical, exhibitions in the early part of the century. In 1908 the important exhibition of The Eight, a group of artists associated with Robert Henri's rebellion from the National Academy of Design, made its first stop on a national traveling tour at the Art Institute (see Weininger realism essay). In 1913 alone the Art Institute was a venue for the hugely influential International Exhibition of Modern Art, known as the Armory Show when shown in New York; an exhibition of contemporary German graphic art, including work by Wassily Kandinsky, Emil Nolde, and Max Pechstein; and an exhibition of contemporary Scandinavian art, which included work by Edvard Munch. An exhibition of the work of Albert Bloch, the only American to work with the Blue Rider group of German expressionists, took place at the Art Institute in 1915.

Some prominent members of Chicago art circles were receptive to modern ideas. As early as 1893, Arthur Jerome Eddy, the Chicago lawyer and art patron who had developed an interest in James McNeill Whistler, expressed the view: "It is one thing to paint the exterior of things, it is another thing to paint the soul of things, it is still another and greater thing to paint the soul, one's own soul into the soul of things. Art is representation plus the man, rather than subject matter or technique."[4] Later, Eddy discovered both the art and theory of the Russian-born artist-writer Wassily Kandinsky, who in his 1912 *Über das Geistige in der Kunst (Concerning the Spiritual in Art)* suggests that the formal relationships in a work of art convey a deeper, spiritual reality. Kandinsky's ideas were incorporated into Eddy's 1914 *Cubists and Post-Impressionism*, prior to the English publication of Kandinsky's book.[5] Eddy, an early and outspoken defender of modernism, delivered lectures on modern art to packed audiences at the Art Institute in 1913, while the International Exhibition of Modern Art was on view there. He also amassed a personal collection that included a large number of works by Kandinsky and other German expressionist artists.[6]

While Kandinsky's abstract painting style had little influence on the artists working in Chicago, his theories were often invoked.[7] Chicago artists and writers were particularly receptive to his idea that "the most important thing in the question of form is whether or not the form has grown out of inner necessity."[8] The belief, as entrenched in Chicago, that art had to be *about* something, that it functioned to edify, beautify, and even uplift the populace of this commercial and industrial city, was well understood by artists, both conservative and progressive. It may well account for the lack of sustained interest in pure abstraction among even the most radical of them.[9]

Much of the early progressive experimentation in the city had its roots in the late nineteenth-century European symbolist movement, which was often characterized by an interest in a fantasy. Symbolists focused on ideas emanating from the irrational realm of the imagination and created elusive and mysterious works that often relied on formal relationships of line, shape, and color—rather than fidelity to nature—to convey meaning. Chicago artists were consistently drawn to symbolism. For example, in Chicago the

FIG. 1
James Farrington Gookins (1840–1904)
Hummingbird Hunters, 1882
Oil on canvas, 40 ⅛ x 27 in.
Gift of Miss Delphine Bindley and William Bindley, Swope Art Museum, Terre Haute, Indiana, 1966.04

dreamy and mystical art of Arthur B. Davies was admired. Davies, associated with The Eight, not only studied at the School of the Art Institute, but also had regular exhibitions of his work at the museum, beginning in the 1890s, that were popular among both traditional and progressive artists in Chicago.[10]

Chicago had its own symbolist artists. As early as 1884, James Farrington Gookins painted highly detailed floral scenes populated by fairies and other imaginary folk (fig. 1).[11] In 1914 miniature painter Magda Heuermann exhibited her *Medusa* (unlocated), which depicts a disembodied, wide-eyed Medusa against a deep blue-green background, surrounded by swarming snakes in a curvilinear pattern. As late as 1930, conservative painter Louis Grell executed a monumental allegory, *Destiny* (fig. 2), an image of a spiraling multitude of bodies leading up to a male nude whose orange-red cloak unfurls against a complementary deep celestial blue background. A generation of painters that included Raymond Jonson (see cat. 46), Carl Hoeckner (see cat. 44), Gordon St. Clair (see cat. 72), and Ramon Shiva (see cat. 77) developed in the 1910s out of the experimental milieu of the Palette and Chisel Club, whose members sought a "greater freedom of imaginative design" and the "expression of feeling, of intimate emotions," rather than the description of objects.[12]

The club had been founded in 1895 with distinctly bohemian aspirations, but it had attained establishment status by 1914, when it was represented on the City of Chicago's newly formed Commission for the Encouragement of Local Artists. Nonetheless, the organization prided itself on being progressive in the Chicago mold.

Pioneering Art of the Fantastic

The idiosyncratic nature of Chicago fantasy art found another influential proponent in Polish artist Stanislaus Szukalski, who arrived in Chicago in 1913. In many ways, Szukalski's popularity reflected the peculiarities and seeming contradictions of Chicago's art world and its relationship to modernism in the early part of the century. He was trained in a traditional academic manner and his works of sculpture, painting, and drawing are figural yet distorted in highly imaginative ways. Densely written explanatory texts often accompany his art. An example is his 1917 *Flower of Dreams* (fig. 3), a carefully crafted image of a head held in a vise that is fixed to a wooden surface through which a huge flower emerges. This work is explicated by an accompanying text with a mystical poetic sensibility: "An idealist in his loneliness puts his head into the vise which holds him in place, while the roots of his flower ideal enter his brain and devour his blood The stem of this curious flower anxiously

gives out its bloom. This is the laboratory of the idealist. The bubble of blood in the blossom is a transbirth of the hapless love."[13]

Szukalski's work—technically masterful, always representational, and, lest the viewer not understand, overexplained—stands in contrast to his public persona and the philosophy of art that he shared repeatedly and willingly with all who would listen. He was a well-known public figure during his eleven years in Chicago. His bohemianism was evident both in his freely dispensed opinions and his physical appearance: longish hair, often covered with a tam worn at a rakish angle, and his ever-present walking stick. Szukalski's anti-institutionalism and emphasis on originality, personal freedom, and liberation from restric-

FIG. 3
Stanislaus Szukalski (1895–1987)
Flower of Dreams, 1917
Medium unknown (destroyed)
Reproduced in Stanislaus Szukalski,
The Work of Szukalski (Chicago:
Covici-McGee, 1923), n.p.

tive rules based on tradition had roots in his political experiences and his European education.[14] He played the part of the individualistic artist perfectly, attacking critics, the school, the museum, and other artists on a regular basis. He once tore up an honorable mention awarded to him by the Art Institute; in another instance he attempted to destroy an exhibit of his work when one piece, deemed objectionable by the museum administration, was removed.[15] A relentless self-promoter, Szukalski frequently reproduced his works in book form—a fortunate habit, since most of the work he produced during his Chicago years was destroyed in Poland during World War II.

Szukalski's philosophical stance, which remained unchanged throughout his lifetime, focused on the importance of the imagination as the source of art. He emphasized that academic technique is useless without ideas, stating that "the academic system is concerned only with the efficiency and perfection of technic [sic], but the talents thus raised have nothing to carry in the vehicle so acquired. If the talents, first of all, aim at having 'goods to sell' or to give, they will always find means of delivering them, later on. Even imperfect means will suffice. This we see demonstrated in the peasants' primitive arts, and in all the native arts of the last few thousand years."[16] In his combination of highly refined artistic technique and narrative subject matter with rebellious behavior and attacks on the sacred cows of art history and pedagogy, Szukalski was the embodiment of modernism in Chicago.

In many ways, Szukalski was Chicago's own proto-surrealist. Art historian Jack J. Spector's description of

European surrealists also applies to Szukalski, for Szukalski "achieved distinction . . . for the authenticity of [his] bizarre behavior and art work . . . [and] welcomed all deviations from the conventionally successful, including 'primitive,' child and psychotic art."[17] Szukalski created meticulously crafted objects similar to those of René Magritte and Salvador Dalí, and he drew from the deepest parts of his imagination and unconscious for guidance.[18]

It is not surprising that Chicago's progressive Arts Club chose to give Szukalski a solo exhibition in 1919, but his one-person shows at the Art Institute and his regular participation in the museum's annual exhibitions attest to his recognition in more traditional circles.[19] Indeed, conservative critics often praised his work. In a review of the Art Institute's 1916 American Annual exhibition, Maud I. G. Oliver explained the development of "modern art expression": "Not long since, the ideal was to express the spirit of things; before that, it was to represent the actual form; now, however, both form and spirit are giving place to a cult of symbolism—'story-telling,' as it were, transmuted to a higher plane, a philosophy rather than an art." She cited Szukalski as an example of the new trend, saying that even "the most adverse critics will grant [him] imagination, however sensational they may regard his mind creations to be. Apostle of the Ugly, if you will, this youth strikes a wild, primal note."[20] Another reviewer of the exhibition commented on Szukalski's uniqueness: "Even those who could not understand or appreciate his work paused to study and comment upon it, so strong was its individuality."[21] Although Szukalski returned to his native Poland in 1924, conservative critic Eleanor Jewett wrote a glowing review of his 1929 *Projects in Design*, casting him, interestingly, as an *anti*-modernist who upheld high standards of workmanship. Recognizing his lifestyle as more revolutionary than his art, Jewett said, "One connected him instinctively with the radical element in art. As far as that goes, he was a radical in living."[22] Szukalski's modernism, including his idiosyncratic behavior and attitude, was combined with his dedication to traditional academic technique, thus making him palatable to conservatives. Szukalski's qualities embodied the sort of fantastical modernism that came to be valued in Chicago: a mastery of academic technique, particularly drawing (see cat. 82); a strong narrative message, even if unpleasant; and an honest, authentic expression motivated by "inner necessity."

Fantasy in the Art of the 1920s and '30s

Against this backdrop, a larger group of highly individualistic artists emerged in the 1920s and '30s. Although they mingled in independent artists' groups, art fairs, or the art projects of the 1930s, many developed their

highly personal visions in isolation. Most exhibited locally on a regular basis but generally had few patrons, instead relying on teaching or commercial work to make a living.

In a seeming paradox, the School of the Art Institute fostered the movement toward personal, expressive art. Visiting instructors George Bellows (in 1919), Randall Davey (in 1919), and Leon Kroll (in 1924) bridged the gap between radicals and conservatives at the school.[23] Bellows had been considered a radical in the 1910s, as a rebellious student of Henri's and an avid organizer of the Armory Show. By the time he taught in Chicago, however, Bellows had abandoned the gritty urban realm to devote himself to lushly painted landscapes and ever more complex portraits of family and friends. Yet his interest in new theories of color and composition and his emphasis on personal expression made him a particularly apt mentor for the budding progressives he was teaching. While preaching freedom of expression, Bellows, Davey, and Kroll instructed their students not to neglect technical mastery. According to artist Emil Armin, Davey in particular "stressed the need for personal expression. He admonished the students to learn to draw and paint while at the Institute and then to go out and pour their individualities into the molds they had mastered the technique of making."[24] Also a motivator, Kroll inspired female students—who would form the core of the fantasy art movement—by quoting Mary Cassatt's dictum that "there is no sex in art."[25]

Another stimulus and support for the personal and individual in art came in 1920, when teacher Helen Gardner offered the first art history course at the school. In 1926 Kathleen Blackshear (see cat. 13) joined her on the faculty, and together they shaped the art history curriculum in a way that fostered the idiosyncratic strain in Chicago art. Rather than teach the canonical history privileging the Western tradition, and particularly the Italian Renaissance, Gardner and Blackshear had students explore non-Western art, art of the ancient Near East, Italian "primitive" art, and contemporary art.[26] The inclusiveness of their definition of art opened up an almost limitless series of possible models for the young artists of Chicago, placing great value on those that were sincere, authentic, and original forms of expression.

By the 1920s, many artists were actively creating highly personal art and finding exhibition opportunities in the numerous independent groups that emerged in this period. These groups began to appear in the late 1910s and offered more egalitarian alternatives to the juried annuals at the Art Institute. One of the earliest groups, the "Introspectives," promoted the idea that an artist "follows his own rules prompted by his inner consciousness."[27] The group included progressives Anthony Angarola (see cat. 5), Raymond Jonson (see cat. 46), and Rudolph Weisenborn (see cat. 87), along with Claude Buck (see cat. 18), who worked in a consciously anti-modern, academic mode, reflecting the fluidity of the Chicago art world. Their interest in personal art and inner realities anticipated the interests of most fantasy-based artists.

Perhaps the most unusual independent group was the short-lived Cor Ardens (Ardent Hearts), which was organized in 1921, the same year the Russian painter and philosopher Nicholas Roerich (fig. 4) visited

FIG. 4
Nicholas Roerich (1874–1947)
The Command, from the "Heroica" suite, 1917
Oil on canvas, 19 ¼ x 30 ¼ in.
Nicholas Roerich Museum, New York

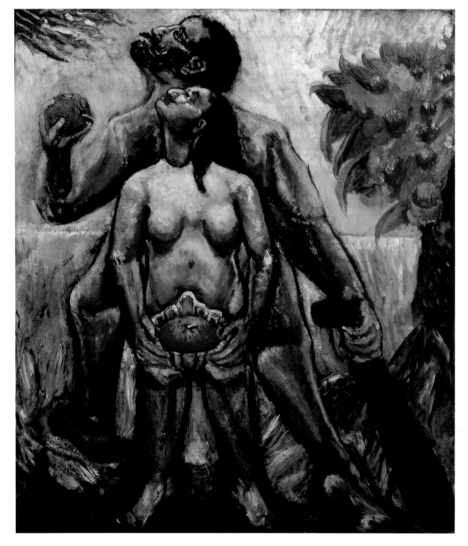

Chicago, where his work was being exhibited at the Art Institute.[28] Considered a charlatan by some, Roerich was committed to the spiritual aspects of all the arts, advocating an integration of music, theater, dance, literature, and the visual arts.[29] For a short time, Roerich's ideas, if not his art, inspired a number of Chicago artists and played a role in the formation of the Cor Ardens, which was spearheaded by Jonson, Weisenborn, and Hoeckner.[30] United by ideas rather than style, Cor Ardens included modern artists such as Jonson as well as the relatively conservative Introspectives Buck and Felix Russman, and the poet and writer Eunice Tietjens.[31] Their mission of creating a personal, spiritual art is evident from their declaration, "We must walk the rising road to grandeur, enthusiasms and achievement with all the powers of our spirit."[32]

Several important critics supported such groundbreaking endeavors by the 1930s. In his *Art of Today: Chicago, 1933*, a compendium of modern Chicago artists, J. Z. Jacobson stated that if an artist were "genuinely alive, sincere, and competent," he or she would produce a modern art. According to Jacobson, if an artist were working from "inner necessity," the art produced would be indisputably modern regardless of its outward manifestation—abstract, representational, expressionist, or traditional. His emphasis on competence underscored the high value that continued to be placed on traditional technique in Chicago's art world.[33]

Critic C. J. Bulliet employed similar ideas in his promotion of artists working in fantastical styles.[34] A tireless supporter of the arts in Chicago, Bulliet used individualism and originality—basic tenets of modernism—as the criteria for his artistic judgments, asserting that "the artist can't be an imitator—he can't be a petty Picasso, a midget Matisse, a dinky Derain."[35] In his 1927 *Apples and Madonnas*, Bulliet devoted

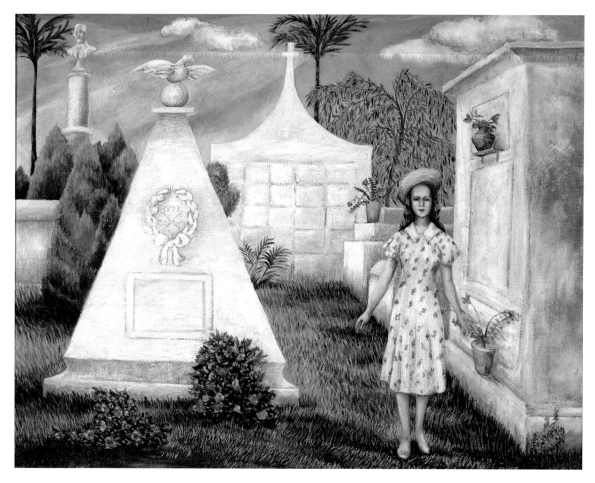

FIG. 7
Frances Strain (1898–1962)
Life and Death in New Orleans, 1937
Oil on canvas, 23 x 29 in.
Mr. and Mrs. Harlan J. Berk

most of his chapter on American modernism to developments in Chicago. He particularly praised Salcia Bahnc as an artist of "original and creative vision . . . one of the small group of 'Modernists' who feel genuinely the urge of the new spirit in art," and he chose to reproduce *The Shulamite* (fig. 5).[36] This image of a large, reclining nude is characterized by a heavily outlined, aggressively distorted body built of bulging and flattened forms, resembling the figures in George Josimovich's *Composition No. 2* (cat. 47). In addition to Bahnc, Bulliet commended the work of Davies and Chicagoan A. L. Pollack (fig. 6), an untutored artist who "approximates closely a one-hundred percent naiveté" and "the ring of the genuine 'Primitive.'"[37] Pollock's distorted and expressive images are energized by thick, rough paint application.

Women Artists and Fantasy

One of the interesting aspects of fantasy art in Chicago is the number of women artists who were drawn to this mode of expression. Marginalized by geography and gender, a number of women who worked in highly personal, individual styles emerged in the 1930s. The atmosphere in Chicago, in which originality and "inner necessity" were privileged, allowed this group to flourish. Women artists regularly received Bulliet's unwavering support and admiration. As he wrote in 1938, "Chicago's women painters are, on the whole,

superior to Chicago's men, and . . . are more inventive, more original than its men."[38] Bulliet's own large collection of Chicago art included work dedicated to him by many women, including Bahnc, Frances Foy, and Macena Barton.[39]

Women artists, both in Chicago and elsewhere in the United States, were numerous in the interwar years. There were abundant educational opportunities at the School of the Art Institute and at the Chicago Academy of Fine Arts, and the government-supported art projects of the Depression era employed a high percentage of women. Women in Chicago were part of every artists' organization, exhibited regularly at all major shows, and functioned in leadership positions in a variety of roles. Gallery owners Increase Robinson and Katharine Kuh promoted Chicago artists, as did Frances Strain, in her role as Director of the Renaissance Society of the University of Chicago; Robinson and Strain both also served as administrators on the government projects. There were also influential women newspaper critics such as Inez Cunningham Stark and Eleanor Jewett.[40]

Strain typically painted in a conservative manner, but she also experimented with fantastic styles in works such as *Four Saints in Three Acts, Introducing St. Ignatius* (cat. 80) and *Life and Death in New Orleans* (fig. 7). Likewise, Macena Barton adhered to an academic style and often exhibited in conservative ven-

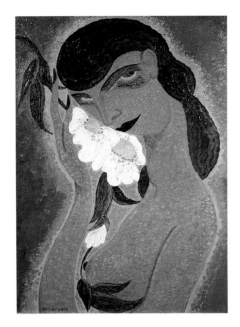
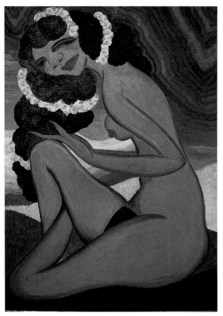

FIG. 8
Fritzi Brod (1900–1952)
Tatiana, 1932
Oil on board, 20 x 15 in.
Private collection, Sycamore, Illinois

FIG. 9
Fritzi Brod
Sakuntala, 1932
Oil on board, 24 x 17 in.
Private collection, Sycamore, Illinois

ues, such as the Chicago Galleries Association. For Bulliet, however, Barton's unique melding of academic conservatism and a quirky approach made her an exemplar of modernism; in 1935 he noted, "'Chicago's most significant individualist' is a synonymous phrase to characterize Miss Barton. For the much-disputed term 'modernism' means 'individualism' as opposed to 'regimentation.'"[41] Barton's 1932 *Portrait of C. J. Bulliet* (cat. 10) includes personal symbolism, as well as a suggestion of her interest in the occult seen in the halolike "aura" that surrounds his figure. She used this device frequently in her paintings in the late 1920s and early '30s.[42] Building on the success of her portraits, Barton created her striking over-life-size image of *Salome* (cat. 11), a wholly original and disturbing representation of the biblical figure, as a response to Bulliet. Though he was a champion of Chicago's women artists, he had earlier asserted that women "have accomplished nothing first-rate in the art of the nude—and congenitally, never can accomplish such."[43] After viewing Barton's rendition, Bulliet changed his mind and gave the work the highest praise.[44]

Another artist who experimented with fantastic elements was Fritzi Brod. Brod's training in Europe and experience as a textile designer shaped her work, as seen in her *Self Portrait* (cat. 17), which reflects her high level of technical skill as well as her familiarity with German and Austrian expressionist art. Brod pushed expressionism to its fantastical extremes, however, in two small nudes entitled *Tatiana* (fig. 8) and *Sakuntala* (fig. 9), both of which were in Bulliet's personal collection. *Tatiana* is a distorted and flattened acid-green, half-length nude cradling a large flower against her face. The image is outlined in a narrow band of gold and set against an orange-red background, creating a jarring and provocative effect.

Exhibited at the Grant Park Art Fair in 1932 and again at the Little Gallery in the same year, these two works, according to Bulliet, "fascinated the more sophisticated of our artists [when shown at the fair], but were hooted by the multitude." He commented appreciatively that Brod's compositions were more distorted than the widely acclaimed German expressionist George Grosz.[45]

Eccentricity was the hallmark of Julia Thecla in both her life and her art. A recluse working from her own fertile imagination, she embodied the isolation of many Chicago artists.[46] As Sweet noted, "American Surrealists are far less often exhibitionists but on the contrary are likely to be recluses like Julia Thecla . . . who create out of the intimate recesses of their imagination sensitive and compelling fantasies."[47] Thecla's sometimes impenetrable, dreamlike visions can be considered the most enigmatic of the works of the Chicago fantasists. Surrealist imagery resounds in her small *Hand With Key* (fig. 10). In this work, a huge disembodied hand holding a tiny key is situated in a landscape and beset by a hoard of tiny figures. Instead of using elements associated with canonical surrealism, however, Thecla appeared to have "embroidered upon her imagination on canvas."[48]

Gertrude Abercrombie, a friend of Thecla, learned of the surrealist movement after she had established her own personal style. Her work included numerous representations of the same austere interior—her own room—and mysterious landscapes, sometimes inhabited by a woman, always meant to be the artist herself. Early in her career, she developed a repertoire of personal motifs: a marble-topped table, a white compote, a bunch of grapes, and long black gloves. The gloves, for example, are a reference to Abercrombie's artistic roots; she began her career as a "glove artist," drawing them for the Sears catalog. Like other Chicago artists, Abercrombie thoroughly believed that art is about ideas; she once said, in her earthy, bebop-inflected manner, that "something has to happen, and if nothing does, all the technique in the world won't make it."[49] Still, while she professed to have little formal art training, she actually took every class she was able to at the University of Illinois, and skillful execution remained an important, if unacknowledged, component of her work.[50]

Reluctant Modern

Far better known than most of the artists discussed in this essay, Ivan Albright came to artistic maturity and began to execute his most characteristic work in the 1920s. His art becomes less anomalous and more clearly rooted in the fantastic when seen in the context of the work of other Chicagoans. Ivan and his twin

FIG. 10
Julia Thecla (1896–1973)
Hand with Key, 1940
Gouache on board, 9 ¾ x 11 ½ in.
Collection of the Museum of
Contemporary Art, Gift of the
Mary and Earle Ludgin Collection

brother, Malvin, sons of the popular painter Adam Emory Albright (see Greenhouse essay), studied at the School of the Art Institute, graduating in 1923. Despite the presence of Bellows and Davey and the newly emerging independents, Albright's own relationship to modernism is unclear. He did not exhibit with the no-jury groups, and he maintained a strong commitment to painstaking, academic practice in his work, continuing to do the kind of character studies and portraits that reveal his dependence on the example of such traditional Art Institute teachers as portrait painters Antonin Sterba and Leopold Seyffert.[51]

By the time Albright painted *Into the World There Came a Soul Called Ida* (cat. 3) in 1929–30, he had achieved a mature style. Creating works with the extraordinary technical proficiency of the old masters (whom he consciously emulated), Albright created images that embodied the passage of time, the decay of the flesh, and the transience of the material world. Albright later told curator and dealer Katharine Kuh that his work was not dependent on where it was produced, asserting, "If I lived on the moon it wouldn't matter."[52] Nonetheless, his painting is grounded in the Chicago context in which it was made. His wholly original vision was able to flourish among the other isolated independents in the city. His dark, mottled surfaces are reminiscent of Thecla's, for example, while

his obsessive personal vision parallels Abercrombie's. His work, like that of the other fantasists in the city, is strange and mysterious while retaining its readability.

The Legacy of Fantasy

By the early 1940s, the appeal of fantasy-based styles in Chicago was considerable, culminating in the Art Institute's 1947 American art annual dedicated to "Abstract and Surrealist American Art." The 1977 exhibition "Surrealism and American Art: 1931–47" at Rutgers University in New Brunswick, New Jersey, also attempted to come to terms with the wide variety of work called surrealist in the United States. Still, the extreme individuality and, in some cases, eccentricity of Chicago artists working in fantastical styles meant that they were often not included in these shows. In the 1947 exhibition at the Art Institute, few of the artists represented were Chicagoans: of the artists discussed in this essay, only Albright, Blackshear, and Thecla were included. And in the 1977 show, Thecla was the only Chicago artist whose work was represented.[53]

While Albright represents the most well known of the individualistic fantasy artists, many more traditional artists in Chicago seem to have felt the freedom to experiment with fantastical styles, knowing that their originality and personal vision would be appreciated.

Rowena Fry, a skilled technician whose work ranges from precise images of the Chicago cityscape to typical scenes of American life such as *Great Lakes Art Class* (cat. 33), took an imaginative look at a department-store window in *The Window Washer* (fig. 12). Gregory Orloff, whose recently rediscovered oeuvre includes portraits and urban-realist images from the 1930s, executed an untitled image of a group of Depression-era figures arranged on a rise in a city park (see cat. 65) that has all of the originality, inventiveness, and eccentricity characteristic of Chicago artists from this period.

Artists who embraced the values expressed in the work and writings of Szukalski—Thecla, Abercrombie, Albright, and other pioneering local surrealist artists—continued to work in Chicago in the postwar decades. Seymour Rosofsky, June Leaf, Don Baum, and the slightly later group of artists who came to be known as Imagists in the 1970s (notably Ed Paschke, Jim Nutt, Karl Wirsum, and Roger Brown) sustained the tradition of expressing personal visions in the form of finely crafted narrative. Relying on nontraditional sources such as folk art, comic books, toys, and other items of popular culture for inspiration, they parallel the earlier artists' use of "primitive" and non-Western art that had permeated the Chicago art world in the late 1920s. The relatively unknown individuals of the prewar genera-

tion were the acknowledged artistic ancestors of the later artists, providing a series of models for highly original work drawing on unconventional sources. More important, the later artists turned the geographical isolation of Chicago into a virtue that allowed them to create art with a unique character. Unlike the early fantasists, however, the Chicagoans who emerged in the post–World War II period achieved a level of national and international recognition of which their artistic predecessors could only dream.[54]

NOTES

1. Frank Sandiford, "About Gertrude," *Chicago Photographic* 3 (1950): n.p.
2. Frederick Sweet, "The First Forty Years," in *Abstract and Surrealist American Art: 58th Annual Exhibition of American Paintings and Sculpture* (Chicago: Art Institute of Chicago, 1947), 12.
3. For a complete discussion of surrealism in America and the origins and meanings of magic realism, see Jeffrey Wechsler, "Surrealism and American Art: 1931–1947," in *Surrealism and American Art: 1931–1947* (New Brunswick, N.J.: Rutgers University Art Gallery, 1977), 21–66.
4. Arthur Jerome Eddy, "The Apotheosis of the Commonplace," *Contributors Magazine* (1893): 33; as quoted in Stefan Germer, "Patterns in Chicago Collecting," in *The Old Guard and the Avant Garde: Modernism and Chicago, 1910–1940*, ed. Sue Ann Prince (Chicago: University of Chicago Press, 1990), 178.

5. Arthur Jerome Eddy, *Cubists and Post-Impressionism* (Chicago: A. C. McClurg, 1914).

6. In 1914 excerpts from Kandinsky's *The Art of Spiritual Harmony* (the British publication of what was later known in the United States as *Concerning the Spiritual in Art*) also appeared in Margaret Anderson's radical journal *The Little Review*, published in Chicago.

7. For a more complete discussion of the way in which Chicago artists were influenced by Kandinsky's ideas, see Susan S. Weininger, "Modernism and Chicago Art: 1910–1940," in Prince, *The Old Guard and the Avant-Garde*, 59–75; and Susan Weininger, "'Genuinely Alive, Sincere, and Competent': Kandinsky and Modernism in Chicago," *BlockPoints: The Annual Journal and Report of the Mary and Leigh Block Museum of Art* 3/4 (1996/1998): 58–75.

8. Wassily Kandinsky, "On the Question of Form," in *Der Blaue Reiter Almanach*, ed. Wassily Kandinsky and Franz Marc (Munich: Piper Verlag, 1912); as translated in Klaus Lankheit (ed. and trans.), *The Blue Rider Almanac* (New York: Viking Press, 1974), 153.

9. One can point to the short-lived experimentation with abstraction by members of the Palette and Chisel group about 1915, when they created non-representational paintings that were explained as political allegories, an approach totally antithetical to the intentions of someone like Kandinsky. See, for example, the discussion of Victor Higgins's abstract experiments in this milieu in Dean Porter, *Victor Higgins: An American Master* (Salt Lake City, Utah: Peregrine Smith Gibbs Smith Publishers, 1991), 78–81.

10. Daniel Catton Rich, "Half a Century of American Exhibitions," in *Annual Exhibition Record of the Art Institute of Chicago, 1888–1950*, ed. Peter Hastings Falk (Madison, Conn.: Sound View Press, 1990), 11 n. 9. For positive responses to Davies's work shown in the exhibition of The Eight, see [Chicago] *Post*, 12 September 1908; Maude I. G. Oliver, [Chicago] *Record Herald*, 20 September 1908; and [Chicago] *Post*, 29 September 1908.

11. On Gookins, see William H. Gerdts, *Art Across America: The South, Near Midwest* (New York: Abbeville Press, 1990), 288–90.

12. The quotes are from "Club Walls Aglow," *The Cow Bell*, 1 June 1915, n.p.; and Gene Morgan, "Seeing Chicago Clubdom: Here Are Prospering Artists Who Boost Prices, Cut Hair and Win International Prizes," *Chicago Sunday Herald*, 25 April 1915; both as quoted in Marianne Richter, "The History of the Palette and Chisel Academy of Fine Arts" (unpublished graduate school paper, University of Illinois at Chicago), 13.

13. Stanislaus Szukalski, *The Work of Szukalski* (Chicago: Covici-McGee, 1923), n.p. Up until Szukalski's death in 1987, he continued to publish his art and accompanying explanatory texts; see, for example, Glenn Bray and Lena Zwalve (eds.), *Inner Portraits by Szukalski* (Sylmar, Calif.: G. Bray, 1982).

14. For Szukalski's identification with Poland and strong feeling of Polish nationalism, see Blanche Gambon, "Stanislaw Szukalski: Painter, Sculptor, Architect, Philosopher," *The New American* (September 1935): n.p.

15. "Artist Tears Pictures From Institute Wall," *Chicago Tribune*, 22 May 1917.

16. Stanislaus Szukalski, *Projects in Design* (Chicago: University of Chicago Press, 1929), 45.

17. Jack J. Spector, "Surrealism in Europe," in Wechsler, *Surrealism and American Art*, 11.

18. Although there is no evidence that he had firsthand knowledge of André Breton's Surrealist manifestos, Szukalski felt that the arts "aid materially in the making of a new civilization" (Szukalski, *Projects in Design*, 33), an idea that corresponds to the revolutionary ideals of the 1929 "Second Manifesto of Surrealism," which suggests that "every means must be worth trying in order to lay waste to the ideas of *family, country, religion*" (André Breton, "Second Manifesto of Surrealism," in *André Breton: Manifestoes of Surrealism*, trans. Richard Seaver and Helen R. Lane [Ann Arbor: University of Michigan Press, 1972], 128). See also Spector, "Surrealism in Europe," 10, for the political aspects of surrealism. This is only one of many written documents in which surrealists asserted that revolutionary change in the world could emanate from works of art.

19. Szukalski had one-person shows at the Art Institute in 1916 and 1917 and frequently exhibited at its annual exhibitions in the 1910s.

20. Maud I. G. Oliver, "Chicago in Art," *International Studio* (December 1916, suppl.): xlv. I am grateful to Wendy Greenhouse for bringing this source to my attention.

21. Evelyn Marie Stuart, "The Twenty-Ninth Annual Exhibition at the Art Institute," *The Fine Arts Journal* 34 (December 1916): 630.

22. Eleanor Jewett, "Szukalski Wins Honor Here and Abroad," *Chicago Tribune*, 22 September 1929.

23. Charlotte Moser, "'In the Highest Efficiency': Art Training at the School of the Art Institute of Chicago," in Prince, *The Old Guard and the Avant-Garde*, 202.

24. J. Z. Jacobson, *Thirty-Five Saints and Emil Armin* (Chicago: L.M. Stein, 1929), 85.

25. Jean Campbell Macheca, "A Critical Relationship: Macena Barton and C. J. Bulliet in the 1930s" (M.A. thesis, School of the Art Institute of Chicago, 2001), 7.

26. Moser, "'In the Highest Efficiency,'" 206. Gardner and Blackshear echoed the ideas of Kandinsky, who regarded the value of non-Western, "primitive," and tribal arts as "authentic" expressions and thus of greater value than the corrupt, materialist tradition of post-Renaissance Europe.

27. As quoted in an undated, unsigned clipping in the Emil Armin Papers, Archives of American Art, Washington, D.C., roll 3770, frame 138. In the foreword to the catalogue of its 1921 exhibit, held at the Arts Club, the group proclaimed that its artists were "not limited to a certain formula. [They] sincerely [strive] for self-realization, hence the word Introspective. The seeking of one's inner self and, thru [sic] that, the realization of the material world within the imagination."

28. Christian Brinton, *The Nicholas Roerich Exhibition* (Chicago: The Art Institute of Chicago Publications, 1921).

29. John Bowlt says Roerich "was regarded as a charlatan and an intriguer and was not welcomed into the Symbolist fold [in Russia]"; see Bowlt, "Esoteric Culture and Russian Society," in *The Spiritual in Art: Abstract Painting, 1890–1985*, Maurice Tuchman et al. (Los Angeles and New York: Los Angeles Museum of Art and Abbeville Press, 1986), 170.

30. According to Maurice Tuchman, Roerich founded the group, but I have seen no other evidence for this assertion; see Tuchman, "Hidden Meanings in Abstract Art," in ibid., 43.

31. Typescript list of the membership made available to me by Carl Hoeckner Jr., the son of the artist.

32. As quoted in Paul Kruty, "Declarations of Independents," in Prince, *The Old Guard and the Avant-Garde*, 79.

33. J. Z. Jacobson, *Art of Today: Chicago, 1933* (Chicago: L. M. Stein, 1932), xvii–xviii.

34. For Bulliet, see Macheca, "A Critical Relationship"; Sue Ann Kendall [Prince], "Clarence J. Bulliet: Chicago's Lonely Champion of Modernism," *Archives of American Art Journal* 26, 2–3 (1986): 21–32; Sue Ann Prince, "'Of the Which and the Why of Daub and Smear': Chicago Critics Take On Modernism," in Prince, *The Old Guard and the Avant-Garde*, 95–117; and Susan Weininger, *The 'New Woman' in*

Chicago, 1910–45: Paintings from Illinois Collections (Rockford, Ill.: Rockford College Art Gallery, 1993), n.p.

35. C. J. Bulliet, "Artless Comment," *Chicago Daily News*, 27 May 1933. His series of biographical articles, "Artists of Chicago: Past and Present," published in the *Chicago Daily News* between 1935 and 1939, profiled both progressives and conservatives.

36. C. J. Bulliet, *Apples and Madonnas: Emotional Expression in Modern Art* (Chicago: Pascal Covici, 1927), 200.

37. Ibid., 218

38. C. J. Bulliet, "Salon of Chicago's Women," *Chicago Daily News*, 5 November 1938; see also, for example, C. J. Bulliet, "Around the Galleries: Women's Salon Exciting," *Chicago Daily News*, 13 January 1940, where he states: "That the women painters of Chicago are, as a group, better than the men, is an opinion I have expressed frequently."

39. Macheca, "A Critical Relationship," 39, points out that Bulliet was given work by male artists as well.

40. For a fuller discussion, see Weininger, *The 'New Woman' in Chicago.*

41. C. J. Bulliet, "Around the Galleries: Our Leading Modernist," *Chicago Daily News*, 9 February 1935.

42. Barton's interest in such things may have been inspired by her father, a businessman and lawyer who also published a monthly called *The Philomatheon* that was "devoted to scientific and occult affairs"; see Macheca, "A Critical Relationship," 3. Barton's late work is often focused on subjects that look as if they were inspired by science fiction.

43. C. J. Bulliet, *The Courtezan Olympia* (New York: Covici-Friede, 1930), 161–63; as quoted in Sue Ann Prince, "A Saucy Salome for Chicago: Macena Barton takes on Oscar Wilde, Pablo Picasso and C. J. Bulliet," *BlockPoints: The Annual Journal and Report of the Mary and Leigh Block Museum of Art* 3/4 (1996/1998): 108.

44. Prince, "A Saucy Salome for Chicago," 111–12.

45. C. J. Bulliet, "Fritzi Brod's Expressionism," *Chicago Daily News*, 26 November 1932; in Fritzi Brod Papers, Archives of American Art, Washington, D.C., roll 4190, frame 665.

46. For more on Thecla, see Maureen McKenna, *Julia Thecla* (Springfield, Ill.: Illinois State Museum, 1984).

47. Sweet, "The First Forty Years," 12.

48. Wechsler, *Surrealism and American Art,* 33–34. *Hand with Key* is the single work by a Chicago artist included in the 1977 exhibition "Surrealism and American Art."

49. Abercrombie as quoted in Sandiford, "About Gertrude," n.p.

50. For Abercrombie, see Susan Weininger and Kent Smith, *Gertrude Abercrombie* (Springfield, Ill.: Illinois State Museum, 1991); and Susan Weininger, "Gertrude Abercrombie," in *Women Building Chicago, 1790–1990: A Biographical Dictionary,* ed. Rima Lunin Schultz and Adele Hast (Bloomington: Indiana University Press, 2001), 12–14.

51. Susan Weininger, "Ivan Albright in Context," in Courtney Donnell, Susan Weininger, and Robert Cozzolino, *Ivan Albright* (Chicago: Art Institute of Chicago, distributed by Hudson Hills Press, 1997), 56–57.

52. Katharine Kuh, "Ivan Albright," in *The Artist's Voice: Talks with Seventeen Artists* (New York, 1960), 28.

53. See *Abstract and Surrealist American Art*; and Wechsler, *Surrealism and American Art.*

54. A core group of these artists exhibited together for the first time at the Hyde Park Art Center in 1966 as the "Hairy Who." In 1972 an exhibition of "Chicago Imagist Art" originating at the Museum of Contemporary Art in Chicago traveled to the New York Cultural Center; in 1973 "Made in Chicago," including many of the same artists, was the United States' entry in the São Paulo Bienal XII (the exhibition was also seen in Buenos Aires, Washington, D. C., and Chicago); see Whitney Halstead et al., *Made in Chicago* (Washington, D. C.: National Collection of Fine Arts and the Smithsonian Institution Press, 1974). Imagist artist Ed Paschke was the subject of a retrospective exhibition organized by the Art Institute of Chicago that was also seen in Paris; see Neal Benezra, *Ed Paschke* (Chicago and New York: Art Institute of Chicago and Hudson Hills Press, 1990). For a history and references to other exhibitions, see Lynne Warren et al., *Art in Chicago: 1945–1995* (Chicago and New York: Museum of Contemporary Art and Thames and Hudson, 1996), 178–95.

CATALOGUE

Amy Galpin, Wendy Greenhouse, Caroline Schloss, Daniel Schulman, Susan S. Weininger

1.

Gertrude Abercrombie
1909–1977

Self Portrait of My Sister, 1941
Oil on canvas, 27 x 22 in. (68.6 x 55.9 cm)
Powell and Barbara Bridges Collection
(Wilmette, Illinois)

Gertrude Abercrombie credits her selection in 1934 for employment in the Public Works of Art Project, the first of the government-supported art projects of the 1930s, with giving her the external validation and income she needed to consider herself a professional artist.[1] The paintings she produced for the government projects over the course of the 1930s supported her and allowed her to develop her distinctive, personal art, which was characterized by humorous, idiosyncratic, surrealist, and magic-realist elements. She would continue this work over subsequent decades in Chicago, living in the Hyde Park neighborhood near the University of Chicago.

By 1941, when Abercrombie painted *Self Portrait of My Sister*, she had established a repertoire of personally significant objects that appeared regularly in her work—among them the long black gloves, flat-topped, brimmed hat, and bunch of grapes seen in this *Self Portrait*. The gloves, which have a lively energy independent of the rigid figure to which they are supposed to be attached, refer to Abercrombie's first job as what she called a "glove artist" for the Sears catalog.[2] With its mysterious title (Abercrombie was an only child), self-referential subject, and characteristic limitation of means, *Self Portrait of My Sister* is an excellent and representative example of Abercrombie's work during a period of enormous productivity and creativity in her life.[3] The exaggerated elements—an elongated neck and sharp features—contribute to a haunting quality and witchlike appearance often found in her self-portraits, a purposeful reference to one of the guises she assumed in art and life to exercise a modicum of control over a world she perceived as chaotic.[4] Like Julia Thecla (see cat. 83), Ivan Albright (see cat. 3), and other contemporary Chicago artists, Abercrombie created works of mesmerizing interest and power based on her eccentric inner vision. SW

2

Jean Crawford Adams
1890–1972

View from the Auditorium, c. 1935
Oil on canvas, 24 ¼ x 18 ½ in. (61.6 x 47 cm)
Chicago Historical Society, 1990.435

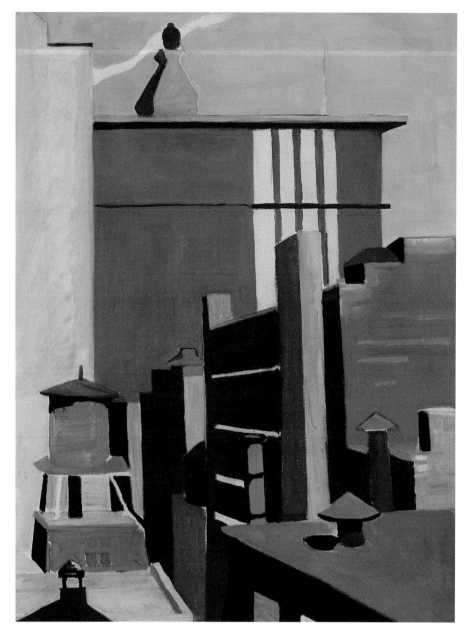

Jean Crawford Adams was a prolific painter of still lifes and colorful landscapes, often reflecting the influence of fauvism, a style she certainly became familiar with during her European travels in the 1920s. She was also inspired by Chicago, the city where she lived, finding a source for her art in its dynamism and vitality, slaughterhouses, gangland denizens, and political upheavals. She wrote, "Out of this thundering chaos intermingled with amazing efficiency and order emanate currents of power which may be spiritualized and transmuted into art."[1]

As early as 1922, Adams exhibited a painting titled *Chicago River, Buildings* in the first Chicago No-Jury Society of Artists show.[2] She executed a number of precisionist city scenes similar in style to *View from the Auditorium* in the late 1920s and early 1930s, suggesting that the painting dates from this period. Like Ramon Shiva (see cat. 77) and Romolo Roberti (see cat. 71), her cityscapes glorify the contemporary city as a place of possibility. In *View from the Auditorium*, Adams reduces the roofs, water tanks, and tall buildings seen from the window of the celebrated Auditorium Building (designed by Dankmar Adler and Louis Sullivan) to simple geometric forms, arranged as a series of almost abstract geometric shapes and colors. Of all her city scenes, this is the one that approaches a pure precisionist aesthetic. Critic Eleanor Jewett, who was not enamored of the modernists, thought Adams's work "denie[d] the spiritual" and was devoid of "nuance, shading, the romantic, the sentimental, the picturesque." In what can be construed as unintentional praise, Jewett continues, "Metallic and solid, adequately patterned, resonant as the strike of chisel on steel, her pictures stand out in rhythmic procession, a constant round of color."[3] In this painting, Adams has represented the city as an unpopulated, mechanized embodiment of the promise of the modern urban landscape in the wake of World War I. CS/SW

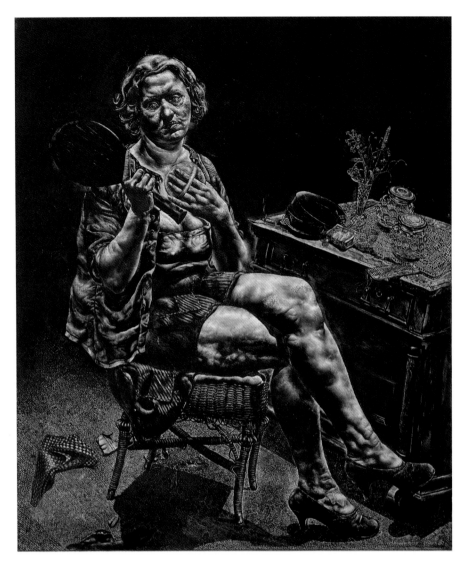

3.

Ivan Le Lorraine Albright
1897–1983

*Into the World There Came a Soul Called
Ida*, 1929–30
Oil on canvas, 56 ¼ x 47 in. (142.9 x 119.4 cm)
The Art Institute of Chicago, Gift of Ivan Albright, 1977.34

Although Ivan Albright spent sixty-eight of his eighty-six years in Chicago, he consistently sought validation on the national and international stage. He was determined to distinguish himself from the local and contemporary art world and to locate himself in the larger history of art. Often successfully, he pursued prizes in national exhibitions such as the Pennsylvania Academy of the Fine Arts annuals in Philadelphia, the Carnegie internationals in Pittsburgh, the Corcoran biennials in Washington, D.C., and the Whitney annuals in New York, all of which brought him to the attention of a national audience. He achieved a moment of celebrity when he was commissioned to paint the shocking *Portrait of Dorian Gray* for the eponymous 1944 film.[1]

Into the World There Came a Soul Called Ida, a characteristic work, displays Albright's technical proficiency, which was based on his conscious emulation of the achievements of the old masters and his traditional education at the School of the Art Institute of Chicago. Thematically, it is a modern *vanitas*, in which the transience of the flesh and the short-lived pleasures of the material world are symbolized by the drooping flowers, money, and burning cigarette on the table, as well as by the patched and tattered clothing and aging flesh of the model, Ida Rogers—who was in fact a pretty twenty-year-old when she served as Albright's model. Ida gazes into a hand mirror, directly connecting this image with the medieval representations of the sin of vanity, in which the reflected image is often a demon or skeleton that serves as a reminder of the fleeting nature of youth and beauty. Albright's interest in the effects of the passage of time is realized by a systematic distortion of the materiality of his figures, in which he painstakingly, obsessively added detail upon detail to force the viewer to confront the process of corporeal deterioration. The painting's emphasis on technique, its implied narrative, and its deeply personal nature are all consonant with the unique, individual visions of many Chicago artists of the period. SW

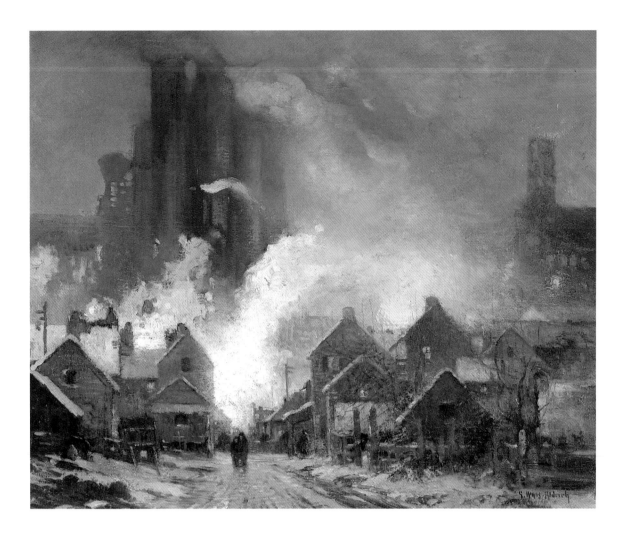

4.

George Ames Aldrich
1872–1941

The Melting Pot, Chicago, c. 1926
Oil on canvas, 30 x 36 in. (76.2 x 91.4 cm)
Collection of Clifford Law Offices (Chicago)

Like his teachers, impressionist painters John Henry Twachtman and Fritz Thaulow, George Ames Aldrich became best known for his pastoral landscapes.[1] However, he also executed a few urban scenes. *The Melting Pot, Chicago* depicts the steel mills of South Chicago, the sight of which would have been quite familiar to the artist from his frequent train rides between Chicago and South Bend, Indiana, where he worked beginning in 1922. The North Chicago Rolling Mills (later the South Works of the United States Steel Corporation) was one of many plants located at the improved Calumet Harbor beginning in the 1870s; low-cost workers' housing quickly sprang up around this industrial complex.[2]

The snow-clad, humble cottages of the mill workers in the foreground of *The Melting Pot* recall Aldrich's more typical French village scenes. Here, however, they are dwarfed by the steel plant rising behind them, the lurid glow of its furnaces dramatized by the nighttime setting.

This horrifying yet riveting sight is a metaphor for industrial power as both an aggrandizement of human force and a monstrous consumer of the humble workers, represented here by the huddled pair on the road in the foreground, who serve its needs. The painting's title refers most obviously to the smelting process that creates the brilliant light illuminating the scene, but it also evokes an image of the American industrial workplace, with its insatiable appetite for labor, as a crucible of immigrant peoples from many lands.[3]

The decorative impressionism of *The Melting Pot* sets any critical social comment at a polite remove, however. The steel plant, with its artificial glow, appears as a fantastic city of the imagination. Commingling plumes of smoke, glowing from within by the glare of golden light, soften and obscure the harsh ugliness of the utilitarian structures. Aldrich's public may well have found the image not an indictment of the brutality of industrialism but rather an uplifting token of Chicago's prosperity; indeed, his closely related painting *Steel*, displayed in the 1929 Hoosier Salon, was awarded the first Downs Prize for the "best industrial scene painted anywhere along the route of the Illinois Central Railroad." *The Melting Pot* was exhibited in 1926 in the Hoosier Salon, an annual exhibition of work by Indiana artists, at the Marshall Field & Company Gallery. WG

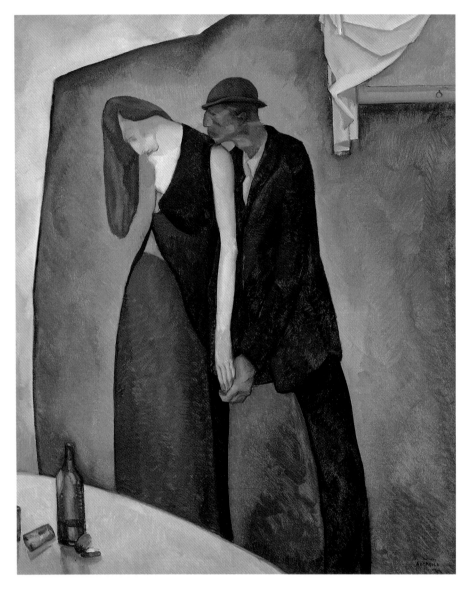

5.

Anthony Angarola
1893–1929

Snow Birds, 1928
Oil on canvas, 44 x 36 in. (111.8 x 91.4 cm)
Davis Museum and Cultural Center, Wellesley College,
museum purchase, Wellesley College Friends of Art
(Wellesley, Massachusetts)

After graduating from the School of the Art Institute of Chicago, Anthony Angarola taught at a number of midwestern art schools, including the Layton School of Art in Milwaukee (1921), the Minneapolis School of Art (1922–25), the School of the Art Institute of Chicago (1926), and the Kansas City Art Institute (beginning 1926), where he was appointed head of the Department of Drawing and Painting in 1927. Like the regionalists Thomas Hart Benton, John Steuart Curry, and Grant Wood, Angarola celebrated Middle America. Unlike them, he was interested in the pockets of ethnicity that flourished in Chicago, Minneapolis, and Lawrence, Kansas. Works from the 1920s such as *Swede Hollow, Little Italy, St. Paul, German Picnic, Ghetto Dwelling,* and *Bohemian Flats* show his interest in the enclaves created by immigrant communities in the early part of the century, and they highlight the strengths that these groups lent to the fabric of the country. Although exalting the American heartland, Angarola did so exclusively within the parameters of a modernist stylistic vocabulary, creating compositions of formal harmony using flattened forms and large areas of brilliant color.

Angarola, like other immigrants or first-generation Americans, had great sympathy for those who found themselves outside the mainstream, and he created a number of images in which his compassion for his subjects is evident. *Snow Birds*, done in the period of Prohibition in the United States, is an image of a drug- and alcohol-addicted couple in a stark interior in which a bottle of liquor and a small container of cocaine are the only adornments. The two flattened, elongated figures are portrayed with minimal line and color. *Snow Birds* is among Angarola's most sophisticated and powerful modernist images, combining cubist-inspired forms with a subject that expresses his deep compassion for the dispossessed.

Early in 1928, Angarola was asked to submit a group of paintings to the prestigious Carnegie International Exhibition in Pittsburgh. The new invitational policy instituted by the director of the Carnegie Institute, Homer St. Gaudens, was meant to ensure a representation of excellent modern work in the exhibit.[1] Angarola exhibited four paintings, including *Proud* (see Weininger realism essay, fig. 7) and *Snow Birds*. *Snow Birds* was completed and exhibited before the artist left to travel in France and Italy in 1928–29 on a Guggenheim Fellowship.[2] SW

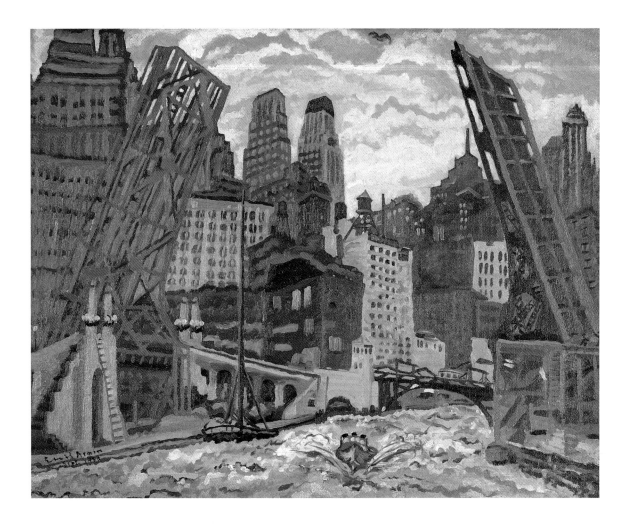

6.

Emil Armin
1883–1971

The Open Bridge, 1930
Oil on Masonite, 22 x 27 in. (55.9 x 68.6 cm)
Collection of the Illinois State Museum, Gift of Susanna and
Matthew Morgenthau in Memory of their Mother, Irma
Thorman Morgenthau, 1981.33 (Springfield)

After studying with George Bellows and Randall Davey
at the Art Institute of Chicago in 1919–20, Emil Armin
had an epiphany regarding his art. Awakened to the
importance of individual expression, he stated, "In the
summer of 1920 I was aroused, as it were, by a feeling that
the work I had done till then was lacking in expression
peculiar to myself."[1] The deliberate naïveté that charac-
terizes his mature work resulted from his exposure to the
exhortations of Bellows and Davey to work from per-
sonal experience rather than conform to academic pre-
scriptions. Combined with the heritage of his craftsman
father and the influence of Herman Sachs, an immigrant
who taught industrial arts (including printmaking, batik,
ceramics, toymaking, and other practical arts) at Hull
House, Armin developed his mature style—an exuber-
ant, energetic, colorful, and personally expressive idiom.

Although Armin, an immigrant from Romania, had
already worked in a variety of media—executing sculp-
tures, prints, and paintings with themes ranging from
landscape to portraits to the Jewish subjects that were so
meaningful to him—by the mid-1920s he turned his
attention to Chicago, the city that was his adopted home.
He wrote, "I found the characteristics of the environment
I live in expressed in my work, I found the steel ribs of the
tall towers in the construction of my compositions, the
earth being pushed up out of the lake for an outer drive in
the texture of the paint and the whistlings, screeches, elec-
tric flashes, whirrings and fast motion mixed with sunlight
contained in the light of the painting. Environment speaks;
and I have come to know myself as a natural expressionist
for I hear, see, and vibrate, without any special effort, with
the things I have tried to describe above, and then when I
paint, these qualities come out on the canvas."[2]

Armin's words resonate with *The Open Bridge*, in which
the energy of the city is suggested by the painting's vivid
color and broken brushstrokes. The raised bridge, opened
to let a tall-masted ship through, was a common occur-
rence in Chicago, pointing to both the commercial and
the recreational activity on the river. Although the
cityscape is unpopulated, it bursts with an explosive
energy and optimism. Armin represents the positive
aspects of the modern, bustling city with a sense of child-
like wonder. CS/SW

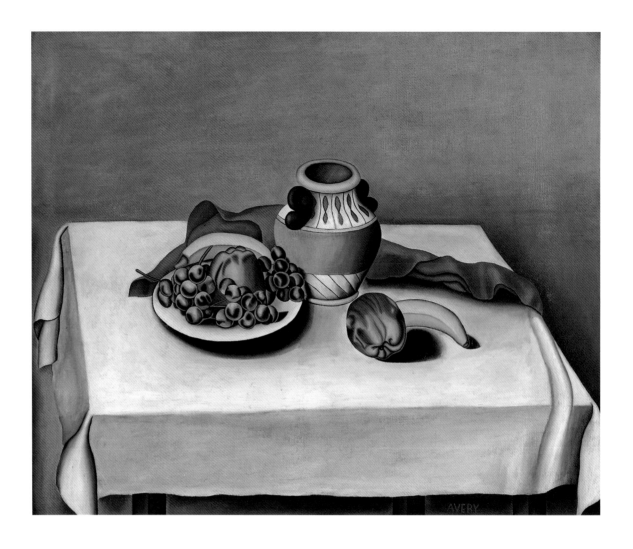

7.

Henry Avery
1906–unknown

Still Life with Grapes, c. 1940
Oil on canvas, 30 x 36 in. (76.2 x 91.4 cm)
South Side Community Art Center Collection (Chicago)

Henry Avery was born in Margatan, North Carolina. It is not known exactly when he came to Chicago, but government employment records indicate that Avery worked in both the easel- and mural-painting divisions of the Illinois Art Project of the Work Projects Administration (WPA) in the late 1930s. He was an original member of the WPA supported South Side Community Art Center in Chicago's Bronzeville, and his work was featured in the most important book on African American art of his day, Alain Locke's *The Negro in Art* (1940). While few details of his life are known, the works Avery produced in Chicago around 1940, mostly portraits and still lifes, reveal him to be an artist of extraordinary talent and originality.

The austere *Still Life with Grapes* was shown at the inaugural exhibition of the South Side Community Art Center in 1941. Avery's meticulous attention to detail and tight handling of paint verge on the obsessive. The glassy surface of the painting is untroubled by any visible trace of brushstroke. The tipped-up tabletop and simplified, almost metallic precision of the modeling of the still-life elements produce a kind of airless vacuum. Avery's dogged pursuit of precision seems at first to link him to a naïve tradition that places a higher value on linear clarity than painterly finesse and atmospheric effect. However, Avery's vision is so unique as to suggest that his style was carefully calculated to produce a kind of hypnotic intensity. His portraits of ordinary folk are painted with the same visionary power. DS

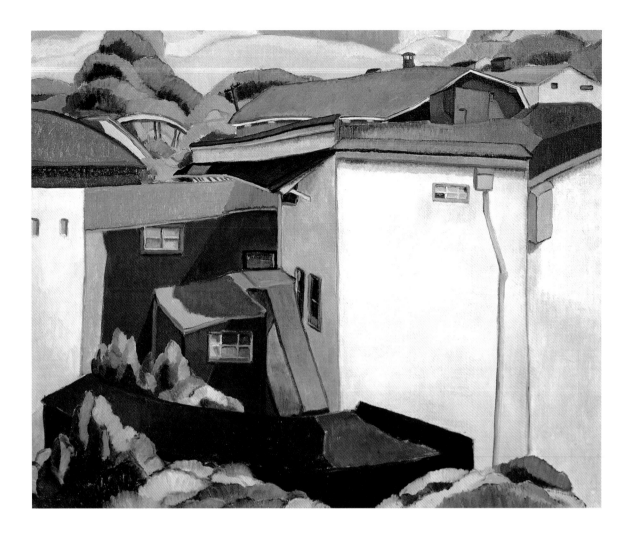

8.

Belle (Goldschlager) Baranceanu
1902–1988[1]

Riverview Section, Chicago, 1926
Oil on canvas, 28 x 34 in. (71.1 x 86.4 cm)
Collection of the San Diego Historical Society, Gift of
Belle Baranceanu

Belle Baranceanu's immigrant parents separated when she was a young child, and she was brought up on her maternal grandparents' farm in North Dakota, ultimately finishing high school in Minneapolis and graduating from the Minneapolis School of Art in 1924. She became a student of Anthony Angarola (see cat. 5) when she began post-graduate work in Minneapolis in 1924, and she returned to Chicago the following year to continue studying with him at the Art Institute of Chicago. She described Angarola as the artist who had the most influence on her, saying: "Through [him] I learned to understand Giotto, El Greco, and Cézanne, who have been, if not conscious, no doubt, unconscious influences in my work."[2] The relationship eventually became personal as well, and, against the wishes of Baranceanu's orthodox Jewish father who objected to the Italian-Catholic Angarola, the couple had plans to marry when Angarola died suddenly in 1929. About 1932 Belle changed her

name from Goldschlager, her father's surname, to Baranceanu, that of her mother, both in response to her father's earlier stance and in an effort to associate herself more with her Eastern European heritage.[3]

When *Riverview Section, Chicago* was exhibited at the Art Institute of Chicago's 1926 Annual Exhibition of American Paintings and Sculpture, Angarola wrote to Baranceanu that he "was so happy that [he] nearly lost [his] breath. . . . Imagine it took [William S.] Schwartz eight years to make that show, and you—on your first effort get in."[4] A reviewer said that *Riverview Section, Chicago*, hung on the same wall as Angarola's *Squatter's Lodging*, could "at first glance be taken for an Angarola."[5] However, while Baranceanu's work owed much to her teacher, she had in fact already developed a mature personal style. Like Angarola and Schwartz, she abstracted, flattened, and distorted the elements of the landscape or figures she painted. In *Riverview Section* she created an almost abstract design based on the architecture of a Chicago neighborhood, flattening the simplified shapes of the buildings into a balanced interplay of form and color. Bram Dijkstra describes Baranceanu's unique accomplishment in this work as "creating a representational painting whose essential attraction is the manner in which it articulates the fundamental links between abstract form and the human environment."[6] SW

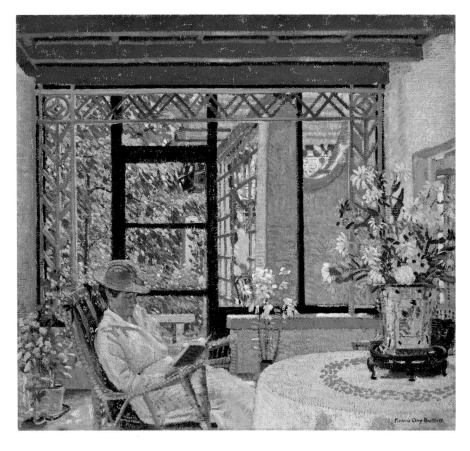

9.

Frederic Clay Bartlett
1873–1953

Blue Rafters, c. 1916
Oil on canvas, 28 x 30 ¼ in. (71.1 x 76.8 cm)
The Art Institute of Chicago, Friends of American Art
Collection, 1919.107

"Chicago, the most forward-looking and advancing of all cities, should have an adequate expression of modern art," declared Frederic Clay Bartlett in 1926, as he presented his outstanding collection of post-impressionist art to the Art Institute of Chicago.[1] His gift included Georges Seurat's *A Sunday on La Grand Jatte—1884* (1884–86), as well as the first works by Pablo Picasso, Vincent van Gogh, and Paul Cézanne to enter the Art Institute's collection.

Bartlett, the well-to-do son of a prominent Chicago business and civic leader and a trustee of the Art Institute, received conventional artistic training in Europe. In the 1900s and 1910s, he executed rather stylized, academic murals, many in a classical or neo-medieval mode, that show the influence of his mentor, the great French mural painter Pierre Puvis de Chavannes. By the late 1910s, however, Bartlett's easel paintings, mostly landscapes, began to reflect his growing interest in post-impressionist art in their strong sense of formal structure, patterned paint application, and expressive, if understated, color.

Women posed in gardens or seated by windows and doors opening onto vibrant outdoor scenes had long been a favorite theme among impressionist painters, as seen in Karl Buehr's *News from Home* (cat. 19), for example. The title of Bartlett's painting, however, underscores its emphasis on setting rather than figure. *Blue Rafters* shows the porch of the studio-residence at House in the Woods, the Lake Geneva, Wisconsin, country estate owned by the artist and his father.[2] Frederic had collaborated on its design with architect Howard Van Doren Shaw in 1905; he created *trompe-l'oeil* wall decorations for the house and probably determined the color scheme of the porch, with its deep blue rafters and white walls.[3] The figure in the painting's foreground is thought to be Bartlett's first wife, Dora Tripp, whom he married in 1898.[4] Serenely reading in her rattan chair, oblivious to the viewer, she fits unobtrusively into the cool, white interior of the porch. Contrasting in the background is the strong light and color of the garden and pergola, kept at a remove by the framing elements of rafters, walls, ornamental fretwork, and door and window mullions. *Blue Rafters* prophesies Bartlett's coming attraction to post-impressionism in its formalist interplay of decorative, textured brushwork, and the rigid structure of the architectural setting. WG

10.

Macena Barton
1901–1986

Portrait of C. J. Bulliet, 1932
Oil on canvas, 47 x 41 ½ in. (119.4 x 105.4 cm)
Mr. and Mrs. Harlan J. Berk (Chicago)

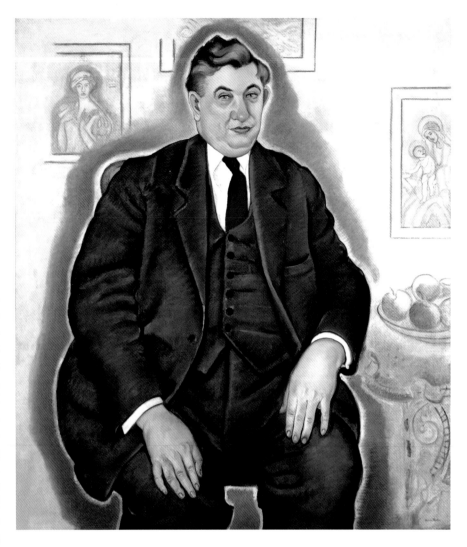

Macena Barton's work owes a great deal to Leon Kroll, one of her teachers at the School of the Art Institute in 1924. By the time of his teaching stint in Chicago, Kroll, who was associated with the Ashcan school of urban realists from New York, was painting primarily figure studies, portraits, and lush landscapes. He encouraged personal expression, the use of high-keyed colors, and painting the nude. Barton took all of this advice to heart, not only producing richly colored, firmly contoured fig-urative images, including many nudes, but also becoming a sought-after portraitist.[1] Like many Chicago artists, Barton also moved easily from conservative to progressive styles and exhibition venues. C. J. Bulliet, the subject of this painting and one of the most important critics sup-porting modernists in Chicago, tried to explain this aspect of Barton's oeuvre: "The 'moderns' sense her as an indi-vidualist, an egoist, going her unique way, untrammeled by the 'schools.' The 'conservatives' recognize her techni-cal equipment and note her contempt for the 'isms.'"[2]

Soon after Barton asked Bulliet to write an introduction for the catalogue of an exhibition of her work at Knoedler's Gallery in 1931, the two met and found that, in addition to their mutual interest in art and literature, they shared an interest in a variety of less mainstream subjects, such as the occult, abnormal psychology, crimi-nology, and deviant sexual behaviors.[3] Although Bulliet was married, they soon became lovers and carried on a public relationship for over a decade, during which time Bulliet promoted Barton shamelessly.

This portrait of Bulliet, exhibited at the Annual Exhibition of American Paintings and Sculpture at the Art Institute in 1932, was a public celebration of the relationship. In a deep blue suit and red tie, he is surrounded by a reddish "aura"—a device that Barton employed regularly between 1932 and 1935—that may have alluded to a mys-tical belief in psychic "force fields," although Bulliet insisted these were decorative devices.[4] Barton alludes to Bulliet's book *Apples and Madonnas: Emotional Expression in Modern Art* (1927), placing an image of the Madonna and Child behind him on the right over a bowl of apples on a table by his side. Behind Bulliet on the left side of the canvas is Barton's *Macena with a Turban*, which not only sets her parallel to the Virgin Mary, but also makes a pointed reference to the romantic relation-ship between artist and subject.[5] SW

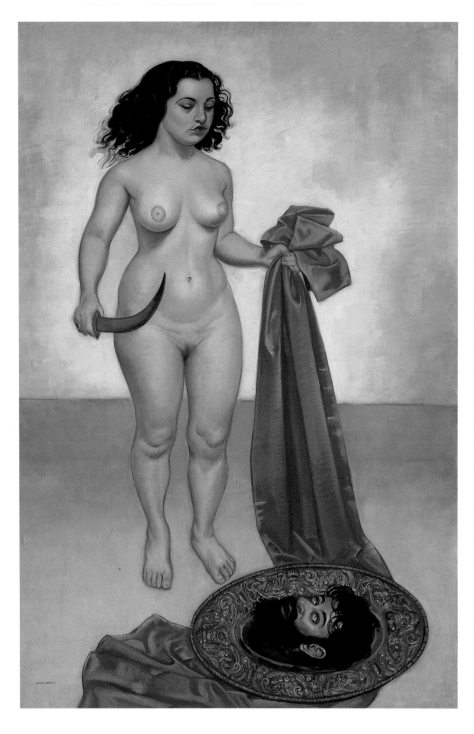

11.

Macena Barton
1901–1986

Salome, 1936
Oil on canvas, 76 x 50 in. (193 x 127 cm)
Collection of Jim Romano and Rick Strilky (Chicago)

Macena Barton, initially encouraged by her teacher Leon Kroll, painted nudes from the beginning of her career, creating a bare-breasted *Salome* as early as 1928.[1] She became interested in the subject in 1925, when she read an illustrated article on the history of Salome imagery by the Chicago art critic C. J. Bulliet, who would later become her champion and lover, but with whom she was not yet personally acquainted.[2] When Bulliet claimed that women "have accomplished nothing first-rate in the art of the nude—and congenitally, never can accomplish such" in his 1930 book, *The Courtezan* [sic] *Olympia*, Barton took it as a personal challenge.[3] As a feminist and individualist, she was certain that women artists could do whatever men could. Her *Salome* of 1936 was one of a series of nudes that were made in response to Bulliet. Remarkably, Barton's paintings caused Bulliet to change his mind, and he publicly renounced his earlier position, asserting that her nudes had "no rival anywhere in America."[4]

Barton's 1936 *Salome*, exhibited in the Chicago Society of Artists show of that year, is an over-life-size image of a squat, dark, wholly nude figure proudly holding a bloody knife over the head of John the Baptist, which lies at her feet, its greenish cast giving it a ghoulish appearance. The brilliant contrasting color—the acid yellow-green background, the red-pink swath of cloth linking Salome and John the Baptist's head—are characteristic of Barton's work and show the influence of Kroll. Sue Ann Prince has argued that Barton created an unrepentant, self-confident, and unique image of Salome because of her freedom "from the male-dominated rhetoric of both modernism and mainstream Regionalism," a result of her location away from the centers in which these movements were defined.[5] Like Gertrude Abercrombie (see cat. 1), Julia Thecla (see cat. 83), and other women artists in Chicago, Barton was able to work independently, creating personal, idiosyncratic paintings in a milieu in which these qualities were highly valued. SW

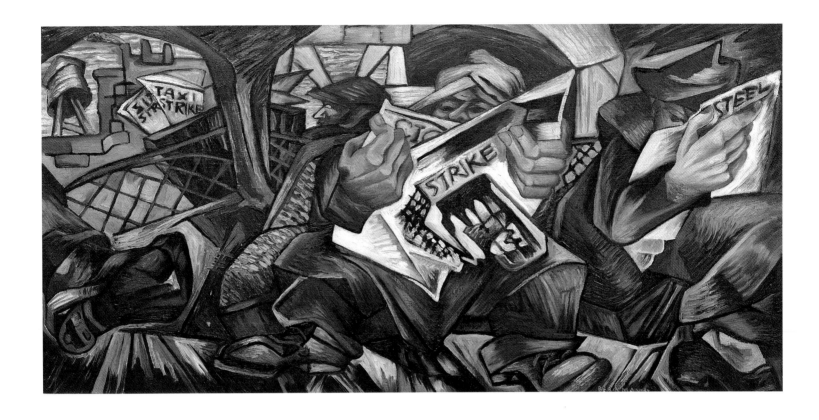

12.

Bernece Berkman
1911–1988

Current News, 1937
Oil on board, 20 x 40 in. (50.8 x 101.6 cm)
Jim and Randi Williams (Nashville, Tennessee)

Bernece Berkman was the child of a Jewish immigrant father, as were many socially active artists in the Depression era. Her Jewish heritage and commitment to activism acted as intertwining strands in her artistic career. She studied with both the Jewish activist Todros Geller (see cat. 36) and the artistic activist Rudolph Weisenborn (see cat. 87), and she was involved in a number of Jewish artists groups as well as in the radical American Artists' Congress.[1] Berkman also participated in the group of Chicago artists who made prints to raise funds for the Jewish community of Birobizhan under

the auspices of the John Reed Club, a left-wing group of artists and writers whose mission was to make art that would effect social reform and alleviate oppression and suffering.

Current News was inspired by the Republic Steel strike of 1937 in South Chicago, in which a confrontation between strikers and police led to the deaths of four people and injuries to more than eighty. Berkman does not present the strike and its violence directly, but rather she frames it through the image of ordinary citizens reading about the events in the newspaper. Her style, which is reminiscent of both Geller and Weisenborn in its use of cubist and expressionist elements, enables her to suggest the oppression and rage of the ethnic working people in a forceful and convincing way. Angular shapes, compressed space, vibrant color, and distorted forms communicate the injustice and danger the strikers faced as well as the anguish and pain of the clash. SW

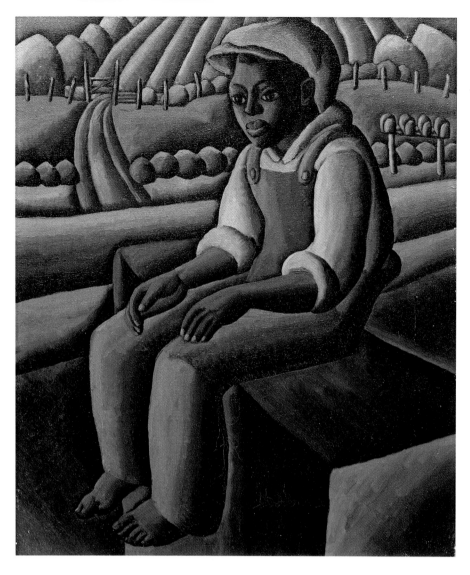

13.

Kathleen Blackshear
1897–1988

A Boy Named Alligator, 1930
Oil on canvas, 22 x 18 ⅛ in. (55.9 x 46 cm)
The Art Institute of Chicago, Gift of Mr. and Mrs.
William J. Terrell, Sr., 1991.160

Kathleen Blackshear was not only an artist but also an extraordinary educator who helped shape a generation of artists during her career as a teacher at the School of the Art Institute of Chicago from 1926 to 1961.[1] She was born in Navasota, Texas, to a family whose roots there dated back to the 1850s; she spent summers and Christmas holidays in Navasota and eventually retired to her hometown in 1961. Her early association with the African American workers on her maternal family's farm, despite the social conventions that forbade such interactions, formed the basis of many aspects of her work as both an artist and a teacher. Like her mentor, Helen Gardner, her approach to art history was multicultural and anthropological, and she encouraged students to look at the art of non-Western and pre-Renaissance traditions for inspiration. She taught students to find elements of abstract formal interest in the work of a wide variety of cultures, thus promoting a modernist point of view.

Her own feelings of marginalization as a woman may have made her sympathetic to people who were treated unjustly. Her personal relationships with African Americans led her to mentor African American students, whom she "accepted and treated . . . not as blacks, but as human beings," according to one of her students, the artist Margaret Burroughs.[2] During the period from 1926 to 1940, most of Blackshear's art was dedicated to depictions of African Americans, many of them based on people from Navasota. *A Boy Named Alligator* is a typical work of the period, combining the image of a young African American field worker at rest with a stylized landscape suggestive of the regionalism of Grant Wood. Blackshear's figure consists of a series of simplified, rounded forms that are echoed in the fertile fields and paths in the background. The figure and landscape are merged in a rhythmic repetition of shapes that conveys a peaceful union between person and place. Like Wood, Blackshear exalts the fertility and possibility of the American landscape, but, unlike him, she embeds a member of a marginalized group in this vista, including him in the productive future. SW

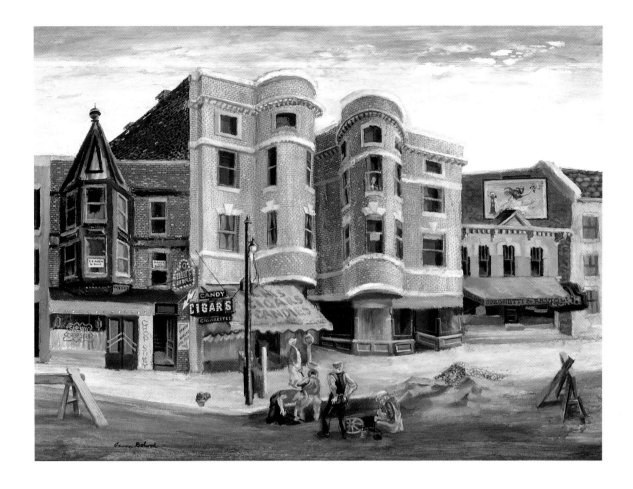

14.

Aaron Bohrod
1907–1992

Clark Street, Chicago, 1934
Oil on board, 23 15/16 x 31 3/4 in. (60.8 x 80.6 cm)
Barry and Merle K. Gross (Chicago)

Aaron Bohrod was born on the West Side of Chicago to Jewish immigrant parents, and he studied for two years at the School of the Art Institute of Chicago (beginning 1927), followed by two years at the Art Students' League in New York (beginning 1929). His teachers included Kenneth Hayes Miller, Boardman Robinson, and, most importantly, John Sloan, whom Bohrod said "awoke in me the necessity of a definite point of view—a personal reaction to subject matter."[1] Bohrod credited Sloan's respect and understanding for the old masters, combined with his attention to ordinary urban life, with motivating him to attempt to "do in my own way with my own city what Sloan had done with New York."[2]

Clark Street, Chicago is one of a series of paintings Bohrod did of the neighborhood near his home on the North Side of Chicago during the 1930s. While some of Bohrod's paintings have a celebratory American scene quality, this depiction of a street populated with only two pedestrians and a small group of workers conveys the desolation of the Depression. Rather than a bustling, crowded neighborhood, Bohrod's street has empty storefronts interspersed between the corner candy store and a restaurant, neither of which seems very busy. Bohrod lightens the mood, however, with a whimsical figure looking out of the second-floor window and a billboard advertising gasoline that features a fantastic-looking bird.

Although in many respects *Clark Street* is a characteristic street scene of the 1930s, emphasizing the small-town quality of the neighborhood rather than the towering skyscrapers of downtown Chicago, it also foreshadows the *trompe l'oeil* painting that Bohrod increasingly turned to by the late 1940s. There are hints of the care that Bohrod would lavish on each of the carefully observed objects in his later still lifes here in the series of brick buildings with jutting bays and turrets, their varying rooflines treated in a decorative manner, and in the lavish detail given to each architectural feature, store sign, and advertisement. The enormous attention given to anecdotal detail also predicts the accumulation of objects he would depend on in his later work. SW

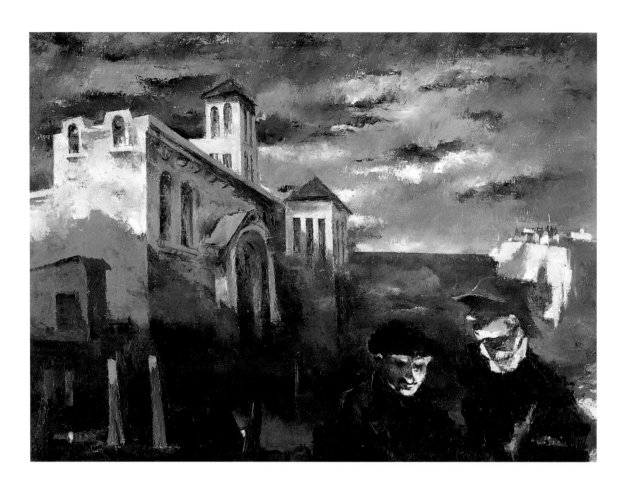

15.

Raymond Breinin
1910–2000

At the Pier, 1941
Oil on canvas, 30 x 40 in. (76.2 x 101.6 cm)
Private collection

Raymond Breinin was born in Vitebsk, Russia, and he studied there with the same teacher as Marc Chagall, another Jewish fantasist. Breinin's memories of his birthplace, ranging from "white cupola-topped Russian churches" to the "market place, always colorful with peasant wares . . . visiting gypsies . . . [and] . . . the war—a revolution—and changing regimes," shaped his vision as an artist.[1] Like other immigrants, when he came to Chicago, he worked at a variety of jobs while attending evening and Saturday classes at the Chicago Academy of Fine Arts and the School of the Art Institute of Chicago. With many others of his generation, he began his professional life as an artist on the Illinois Art Project of the Works Progress Administration. His paintings range from interiors to rural landscapes to depictions of urban neighborhoods, all of them created from a dreamlike, fantastic perspective. In the context of Chicago painting of the 1930s, Breinin's work was part of the strand of fantastic art that flourished in the work of artists such as Gertrude Abercrombie (see cat. 1), Ivan Albright (see cat. 3), and Julia Thecla (see cat. 83).

In *At the Pier*, Breinin painted memories of his youth in Russia, as seen in the monumental architectural structure on the left side of the painting and the colorful distant city in the background. He combined these elements to create an image of current reality made brooding and mysterious through softened forms, atmospheric light, and ambiguous space. Bram Dijsktra has concluded: "These elements create an eerie sense of isolation and longing, of exclusion and hope . . . reflective of the sense of displacement at the center of the immigrant experience."[2] Breinin's immigrant experience was reinforced by being a member of the artistic community of Chicago, where his dreamy, poetic approach was accepted and praised. SW

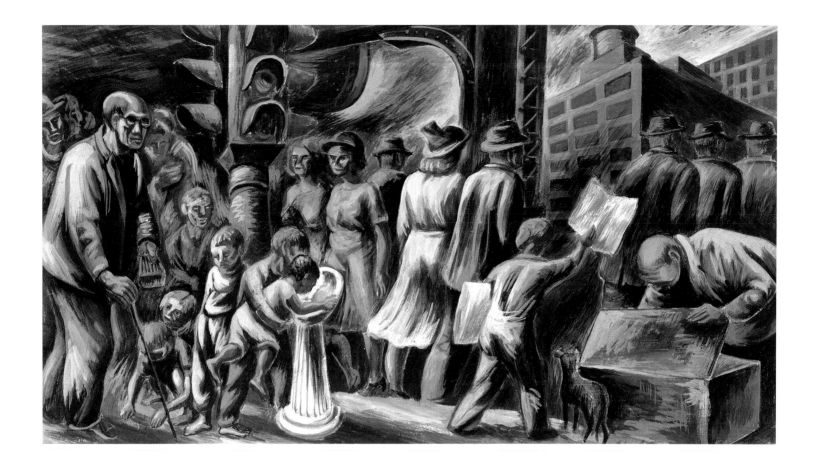

16.

Edgar Britton
1901–1982

untitled (mural study), 1938
Gouache on gessoed board, 8 ¾ x 15 ¾ in. (22.2 x 40 cm)
Mr. and Mrs. Harlan J. Berk (Chicago)

Edgar Britton established his reputation during the Depression years, producing easel paintings and murals for various government-supported art projects and serving as Technical Director from 1940–41 of the mural division of the Illinois Art Project (a part of the Works Progress Administration).[1] During his career, he executed a number of murals in the Chicago area, including works at Lane Technical High School, Bloom Township High School, Highland Park High School, and the University of Illinois Medical Center. He was also the recipient of commissions from the federally administered Treasury Section to create murals for the East Moline, Illinois, and Decatur, Illinois, post offices. When Britton contracted tuberculosis in 1941, his doctor advised him to seek a drier climate; he ultimately settled in Colorado, where he spent the rest of his life, devoting himself mainly to the creation of sculpture.[2] Although he spent a relatively short part of his life in the city, Britton left an indelible mark on Chicago.

Britton's works reflect the influence of the Mexican muralists José Clemente Orozco, David Siqueiros, and Diego Rivera, whose combination of revolutionary politics and figurative styles appealed to many Chicago painters of this period. Drawing on the simplified, weighty forms, and crowded compositions favored by these muralists, in this work Britton creates a quotidian urban scene filled with the activity and dynamism of modern city life, including the beams of the elevated train, a newspaper boy with a dog, and an elderly man hobbling with a cane. The figures march in machinelike lockstep, and those whose faces are visible are without affect, a reference to the dehumanizing quality of urban life during the Depression; this corresponds to the strong social consciousness Britton demonstrated in other projects, such as the Decatur post office murals (see Weininger realism essay, fig. 14). The subject and horizontal format suggests that this was a study for a mural, perhaps intended for a Chicago setting in which it would offer a tough, straightforward look at the variety of life in the urban fray.[3] AG/SW

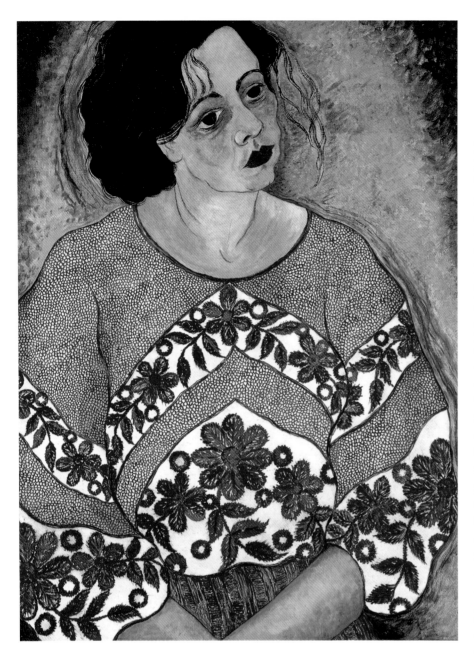

17.

Fritzi Brod
1900–1952

Self-Portrait, 1934
Oil on board, 27 ½ x 20 in. (69.9 x 50.8 cm)
Mr. and Mrs. Harlan J. Berk (Chicago)

Born in Prague, Fritzi Brod was educated at art schools in Prague and at the competitive Kunstgewerbeschule in Vienna. She was an accomplished textile designer by the time she arrived in Chicago in 1924, and she had a successful career in this field before she began to paint seriously. In addition to her European artistic training, she was also undoubtedly familiar with the work of European modernists, whose work she would have encountered in the frequent visits to museums and galleries she made with her art-loving mother as a youth.[1]

Brod's compositions are often built around one or several large female forms, often half or bust length. Her *Self-Portrait* conforms to that pattern. Closely related to the Austrian expressionist style, and particularly reminiscent of the work of Egon Schiele, Brod's painting is characterized by a clear, yet restless and jittery contour line that imparts an energy to the flattened forms. The white skin, red lips, and black hair of the figure and the contrast of the orange-red, intricately patterned blouse with the green-yellow of the background are classic expressionist stylistic techniques, employed with great skill. In combination with the obsessive attention paid to the embroidered design on her blouse, a link with her background in textile design, these devices contribute to a forceful and jarring emotional effect similar to that of the German and Austrian expressionists.

Brod's expressionism drew some negative critical response in the local press. In explanation of her modernist style, her husband invoked the link to her Czechoslovakian roots: "A country where the art, though quite primitive among the peasants, is individual and where the colors are unique in gayety. This background is one which leads to a most genuine appreciation of modern art." He went on to a defense of the exaggerations in her work, stating, "The public objects to distortions in modern art and desires realism, but in realism there can be no expression of individuality. There are really no set rules in art, and primitive artists used distortions."[2] The justification of Brod's modernism on the basis of individual expression and its relationship to untutored, or "primitive," work underscores the high value of individuality and personal expression current in Chicago during this period. SW

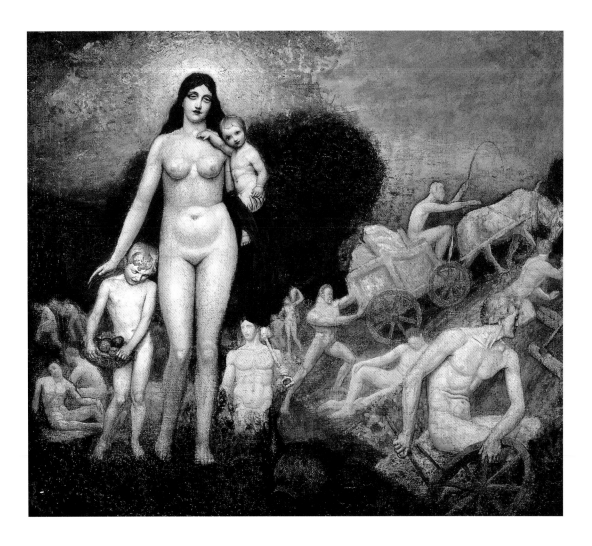

18.

Claude Buck
1890–1974

Labor, undated[1]
Oil on canvas, 16 x 18 in. (40.6 x 45.7 cm)
Mr. and Mrs. Harlan J. Berk (Chicago)

Claude Buck arrived in Chicago in 1919 as a leading member of an avant-garde symbolist artists' group known as the Introspectives, whose members pursued the expression of subjective emotion and experience.[2] In Chicago, the group attracted considerable attention and some new members—notably Rudolph Weisenborn (see cat. 87), Emil Armin (see cat. 6), and Raymond Jonson (see cat. 46)—who would shortly emerge as leaders among the city's artistic radicals. Buck, however, was a qualified modernist whose work was conspicuously indebted to the past. He admired Leonardo da Vinci and was also influenced by the visionary art of the eccentric American painters Ralph Blakelock and Albert Pinkham Ryder.[3] From the beginning of his career, Buck painted fantastic, sometimes disturbing images on allegorical and literary themes drawn from such Romantic sources as the poetry of Edgar Allan Poe and the operas of Richard Wagner, as

well as from classical mythology and the New Testament. After the early 1920s, to support his family Buck also executed highly finished, hyperrealistic portraits and figural works in addition to still lifes; these works won approval from critics and juries in establishment circles and made him a darling of the anti-modern "Sanity in Art" movement, which was headquartered in Chicago.[4]

Buck's undated painting known as *Labor* uses a variety of idealized, classical nude figures to represent an abstract concept in the academic tradition of grand-scale allegorical imagery. Yet the image is characteristic of the artist's overtly symbolist paintings in its intimate scale and its heavily worked surface that glows through the use of transparent glazes in the manner of old master paintings. The figures in the composition seem arbitrarily placed in a dreamlike landscape, with little logical sense of relative scale or interaction between groups. Some are engaged in physical work; at the right, for example, a muscled man strains to push an oxcart uphill; others, however, sit or recline in indolent attitudes. All are secondary to the only female figure, the standing nude that dominates the image. With her two children, she is apparently a personification of motherhood as well as fecundity, as suggested by the vessel of fruit borne by the older child at her side. WG

19.

Karl Albert Buehr
1866–1952

News from Home, 1912
Oil on canvas laid down, 39 ½ x 32 in. (100.3 x 81.3 cm)
Edenhurst Gallery, Los Angeles and Palm Desert (California)

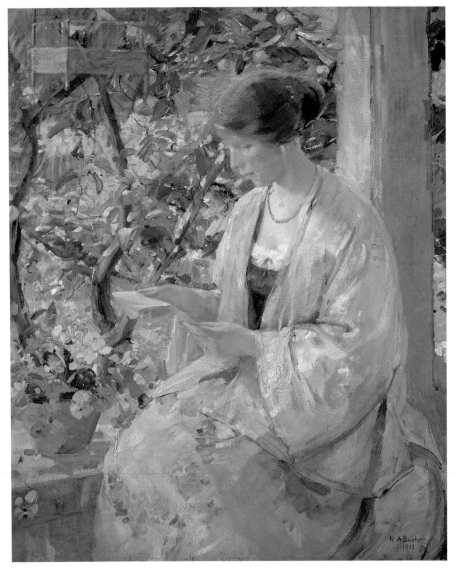

Karl Albert Buehr was among the young Chicago painters experimenting with impressionist technique in the 1890s, when he was a continuing student and instructor at the School of the Art Institute of Chicago. However, it was during a stay in France, just before World War I, that he realized his ultimate "conversion" to the mode.[1] At that point, beginning with such works as *News from Home*, Buehr began to specialize in gorgeously colored images of young women on porches overlooking brilliant summertime gardens. The subject is typical of the decorative figural themes favored by American painters Frederick Frieseke, Richard E. Miller, fellow Chicagoan Pauline Palmer (see cat. 67), and others who were Buehr's associates during his residence in Giverny between 1909 and 1911.[2]

In his later treatments of this theme, Buehr's female figures often fix the viewer with a direct, unsmiling stare. In *News from Home*, however, the casually dressed sitter is absorbed in her letter, momentarily unaware both of the viewer's gaze and of the lush scenery just beyond the boundaries of the porch. The structure's solid geometry, echoed in the hanging birdcage at upper left, contrasts with the random patchwork of the pear tree, with its cool blue-greens, and the flamelike notes of the nasturtium flowers at lower left. *News from Home* was probably painted in the village of Sainte-Genéviève, near Giverny, where Buehr's family lived from about 1912 to 1913.[3] The wedding band on the sitter's left hand invites speculation that she is the artist's wife, Mary Hess Buehr, a miniature painter. Buehr evidently thought highly of *News from Home*, for he exhibited it both in the Paris Salon of 1913 and at the Art Institute's Annual Exhibition of American Paintings and Sculpture later that year. WG

20.

Elbridge Ayer Burbank
1858–1949

Portrait of a Woman, Munich, 1892
Oil on canvas, 37 ⅝ x 31 ⅞ in. (95.6 x 81 cm)
Courtesy of Rockford Art Museum (Rockford, Illinois)

After several years of study in Munich and Paris, Elbridge Ayer Burbank made his debut on the Chicago art scene in 1892 with an exhibition of paintings in his newly opened studio. Among the most important of these, noted the *Chicago Tribune*'s reviewer, was his striking portrait of a woman in white, which he showed again a few months later in a commercial gallery: "The rending [sic] of the different qualities of white in a symphony of this kind is a most difficult feat of painting, and in this Mr. Burbank has been most successful."[1]

Within a few years Burbank would turn his attention to sentimental genre paintings of rural African Americans and then to ethnographic portraits of Native Americans, the subject that monopolized his talents for the rest of his career.[2] But Burbank's exhibition of portraits such as this soon after his arrival in Chicago suggests that he initially hoped to attract portrait commissions. *Portrait of a Woman, Munich* is a thorough demonstration of Burbank's considerable technical prowess, particularly in the handling of varied surface materials, the rendering of subtle tonalities of white against white, and the powerful realization of the sitter's individuality.

The woman portrayed here is probably the artist's wife, Alice Blanche Wheeler, known as Blanche; the portrait's pale palette may refer obliquely to her name. She sits directly facing the viewer, fashionably and formally dressed, as if awaiting some social event. At the same time, her averted, abstracted gaze and somewhat melancholic expression insert a note of disquietude that hints at the artist's own mental instability and anticipates the couple's estrangement by the end of the decade.[3] *Portrait of a Woman, Munich* is replete with tension between formal conventions of society portraiture and psychological realities. WG

21.

Francis Chapin
1899–1965

White Tower, c. 1931
Oil on canvas, 31 x 38 in. (78.7 x 96.5 cm)
Private collection

Francis Chapin's sunny—even joyous—images of the people he knew and the places he visited on his many travels to Mexico, Europe, and Martha's Vineyard are countless, the result of ceaseless work. But it is in the many paintings, drawings, and lithographs of Chicago's Old Town neighborhood, where he lived and worked, that some of Chapin's most extraordinary achievements are seen. His virtuoso technique and the optimistic spirit of his work made him one of the city's most popular artists, dubbed "The Dean of Chicago Painters," in the 1930s, '40s, and '50s.

As unlikely as it seems, one of his closest artist-friends was Ivan Albright (see cat. 3), his polar opposite in both physical and artistic terms. Albright was small, Chapin very tall; Albright was obsessive and secretive about his work, often laboring for years on a single painting, while Chapin set his easel up on the street corner and executed his work quickly; Albright's work is quirky and personal, while Chapin's is open and transparent. Albright's respect for his friend is conveyed in comments he made after Chapin's death: "Francis Chapin was above all an enthusiast for living and for people. . . . He was especially deft in his use of color and in his ability to reach the essence of his subject with a few seemingly casual lines. He was a wizard at the sketch pad, and this is perhaps why his finished paintings have such a quality of freshness and spontaneity."[1]

White Tower, which was awarded the Cahn Prize at the Art Institute of Chicago's 44th Annual Exhibition of American Paintings and Sculpture in 1931, depicts the low-rise buildings, water tower, White Castle restaurant, and elevated tracks in the neighborhood around North Avenue and Sedgwick, close to Chapin's home. The tall man with a canvas under his arm among the crowd crossing the street is Chapin himself.[2] *White Tower* is characterized by the bravura brushstroke and dazzling colors that Albright admired. In its emphasis on the virtues and pleasures of the small-town quality of the Old Town area, with its bustling human activity, rather than on the sleek modernity of the skyscrapers of the city center, the work conforms to the American scene painting that was so popular at this time. SW

22.

Richard A. Chase
1892–1985

The Palmolive Building, after 1929
Oil on Masonite, 24 x 24 in. (61 x 61 cm)
Chicago Historical Society, Gift of the Artist,
Richard Chase, 1980.195.7

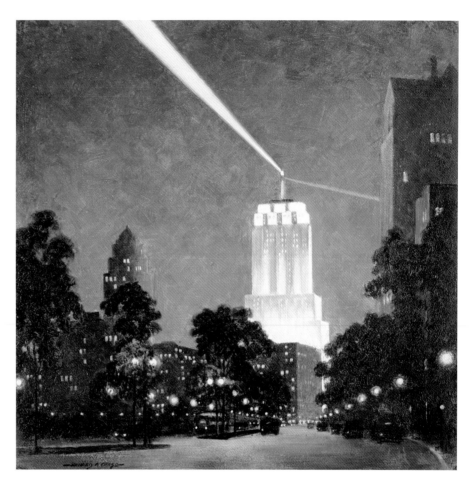

For over sixty years, Richard Chase, once dubbed "the chronicler in color of Chicago's epic march to world mastery," devoted his art to creating a "Portrait of Chicago" through images of its built—and building—urban environment.[1] Working in a straightforward, realistic, but invariably upbeat manner, Chase depicted skyscrapers, bridges, and industrial structures as newly hatched or under construction, implying a youthful city of boundless energy and breezy self-confidence that was emerging into the brilliant sunlight of its own future. Appropriately, Chase was selected as an illustrator of and mural painter at the 1933 Century of Progress Exposition, Chicago's futuristic gesture of optimism in defiance of the Great Depression.

The new Palmolive Building (later the Playboy Building) was a natural subject for Chase's "Portrait of Chicago." After it opened with much fanfare in June 1929, the streamlined structure garnered much praise and won an award for the most beautiful new building in the rapidly developing upper Michigan Avenue district.[2] Designed by the venerable Chicago firm of Holabird & Root, the Palmolive epitomized an architectural age that glorified sheer height. It was then by far the tallest building on upper Michigan Avenue, its modernist verticality emphasized by recessed channels running up its face and by a crowning 150-foot-tall aerial, which supported a powerful airplane beacon that swept the skies at night. In the early 1930s, the Palmolive commanded the North Michigan Avenue skyline both day and night. It marked the boundary of a busy commercial quarter: to its north stretched a district of elegant new high-rise apartment buildings, from which this view is taken.

In this perfectly square composition, balancing elegance and modernity, Chase positions the Palmolive as the brilliant finale of tree-lined Lake Shore Drive. Lines of streetlights, reminiscent of strands of pearls, provide a graceful counterpoint to the defiantly angled beacon set against a velvety blue sky. The Palmolive embodied Chicago's image as a city of the future, but Chase's blue-saturated, evening rendering is an essentially romantic view that distances the viewer from the city's daytime cacophony. WG

23.

Alson Skinner Clark
1876–1949

The Coffee House, before 1906
Oil on canvas, 38 x 30 in. (96.5 x 76.2 cm)
The Art Institute of Chicago, Gift of Mr. and Mrs.
Alson S. Clark, 1915.256

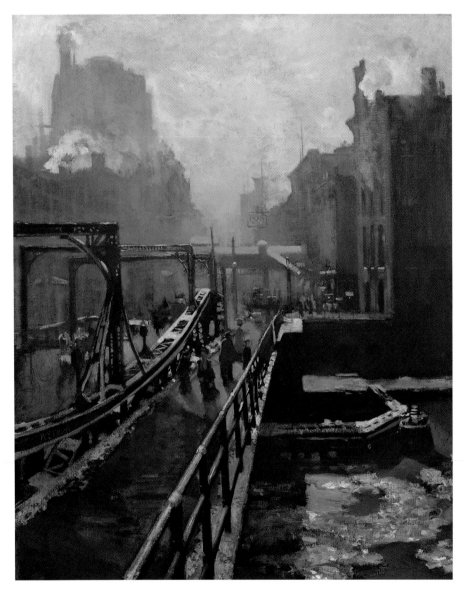

Only after painting urban views in Paris, London, and Watertown, New York, did Chicago native Alson Skinner Clark see his hometown's possibilities as an artistic subject. Clark may well have been influenced by growing local interest in the portrayal of Chicago. In 1904 and 1905, for example, members of the Palette and Chisel Club and the Art Students' League organized efforts to capture "picturesque Chicago." Such activity reflected not only pride in the city's unique character and internationally famous architecture, but also growing national attention to urban themes in painting, printmaking, and photography. The city embodied and symbolized modernity; its portrayal likewise served as a banner of artistic modernism.

The Coffee House looks south from the State Street bridge toward the warehouses and processing plants that once crowded the banks of the Chicago River. The utilitarian armature of the bridge, the pervasive smoke diffused through weak sunlight, and the remnants of dirty snow underfoot further emphasize the grim physical environment of wintertime Chicago. Yet the profile of the twenty-one story Masonic Temple Building at the upper right and the presence of well-dressed female pedestrians on the bridge hint at the proximity of an elegant shopping and commercial quarter only two blocks to the south.[1] The painting's vertical format, which emphasizes the increasingly perpendicular character of Chicago's crowded downtown, and the powerful diagonal thrust of the bridge from the lower left into the center of the composition both suggest the influence of the Japanese *ukiyo-e* prints that deeply influenced Western artists beginning in the late nineteenth century.

Shown in the Art Institute's 1906 annual American art exhibition, *The Coffee House* won attention and praise from local reviewers. As a "twentieth-century" transcription of a familiar scene, Clark's image proved that the Chicago River "holds as many points of picturesqueness as any Holland canal."[2] Equally striking was the painting's deliberate lack of finish, emphasis on evocative atmospheric effects, and decorative qualities. Probably thanks to the critical success of *The Coffee House*, which was awarded the Martin B. Cahn Prize, Clark was given a solo exhibition at the Art Institute the following year. WG

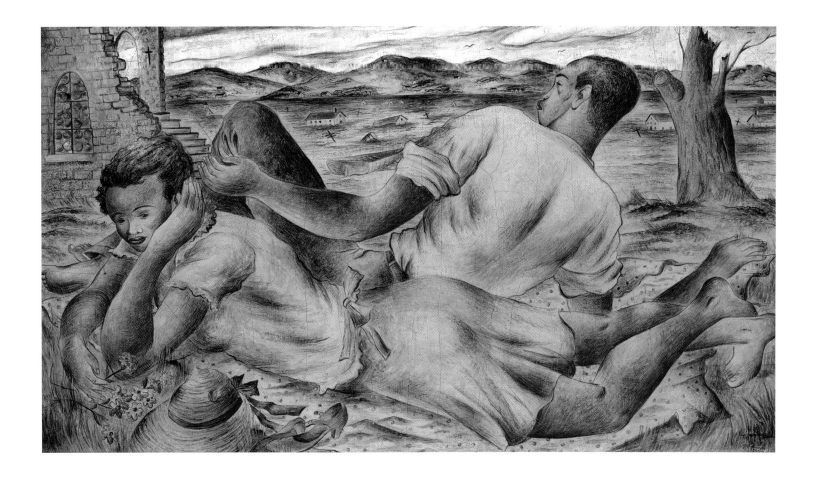

24.

Eldzier Cortor
born 1916

Southern Landscape, c. 1938–40
Tempera and gesso on board, 20 x 34 in. (50.8 x 86.4 cm)
Robert Henry Adams Fine Art (Chicago) and Greenwich
Gallery of American Art (Greenwich, Connecticut)

Eldzier Cortor and his family arrived in Chicago from
Richmond, Virginia, in 1917. Settling first on the West
Side, a mixed ethnic immigrant community, in the early
1930s the Cortors moved to the predominantly black
South Side neighborhood known as Bronzeville. Although
Cortor originally aspired to be a cartoonist, he became
interested in fine art when he and Englewood High School
classmates Charles White (see cat. 88), Charles Sebree
(see cat. 76), and Margaret Burroughs began attending
Saturday classes at the Art Institute of Chicago. After
graduating from high school, Cortor took night classes at
the School of the Art Institute in 1936, and he enrolled as
a full-time student in 1937. Cortor was introduced to
African art, as well as to principles of modernism, by the
influential teacher Kathleen Blackshear (see cat. 13), who
took her classes to view and sketch the non-Western
collections of the Field Museum of Natural History.

Cortor's early work centered on daily life in Chicago's
Bronzeville surroundings. He was particularly drawn to
portraying women—in both active and contemplative
moments. *Southern Landscape*, which can be dated to
the late 1930s on the basis of Cortor's style and the tech-
nique of tempera on gessoed panel, is a departure in that
it depicts an imagined—and strangely ambiguous—rural
scene. A young couple reclines dreamily, remarkably
unperturbed by the scene of destruction in the distance
in which a swollen river is carrying away houses, build-
ings, and telegraph poles. The startling disjunction
between the scene in the background, which would have
reminded viewers of the devastating Ohio River flood of
1937, and the beautifully drawn pair of distracted, pic-
nicking lovers elevates the scene to the level of allegory.
But its meaning is elusive. The figures are as unaware of
the flood as they are psychically separated from one
another. Perhaps their estrangement is meant to parallel
the inhospitable environment of the rural South.[1]

Southern Landscape prefigures Cortor's subsequent
interest in the South and in other cultural manifestations
of the African diaspora, subjects that found an outlet
later in the 1940s as a result of his travels to the Sea
Islands region of Georgia and to Haiti. DS

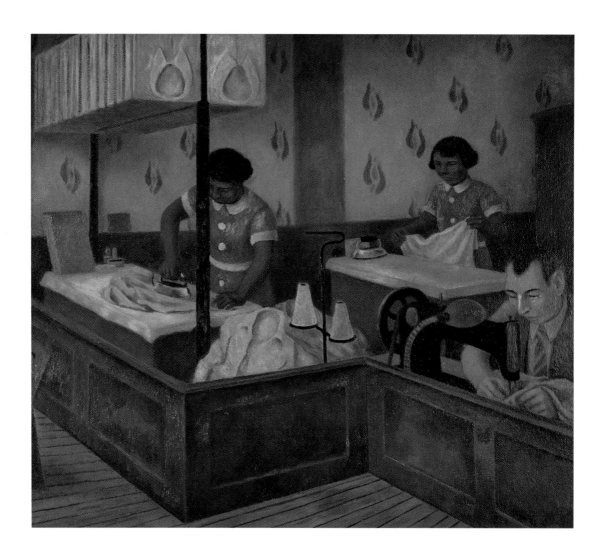

25.

Gustav Dalstrom
1893–1971

Laundry, 1942
Oil on artist board, 27 x 30 in. (68.6 x 77.5 cm)
Collection of the Illinois State Museum, 1990.48
(Springfield)

Gustav Dalstrom studied with George Bellows and Randall Davey at the School of the Art Institute of Chicago in 1919. During the 1920s and '30s, Dalstrom executed numerous paintings of Chicago, particularly the Lincoln Park area in which he lived for most of his adult life with his wife, artist Frances Foy (see cat. 32), whom he married in 1923. His buoyant and upbeat images of people strolling on park paths, enjoying the zoo in the park, or ice skating on the frozen pond in winter share the interests of New York urban realists such as Bellows, Davey, and John Sloan. Dalstrom said, "Being a resident of Chicago I cannot help but partake of some of its characteristics. The term American and Chicagoan pertain to the style of work rather than to the quality of art."[1]

Laundry, a typical American scene painting—slices of ordinary life that became popular in the 1920s and were

mandated by the government-supported art projects in the 1930s—depicts African American laundry workers during the Depression. The painting is executed in Dalstrom's typical style, in which robust, simplified figures reminiscent of both the shoppers of Kenneth Hayes Miller and the flappers of Guy Pène DuBois are shown in clear, spacious settings.

Dalstrom noted, "While I think the phenomenon of art is outside the division of society into its economic, racial, and religious aspects, I feel it is possible for an artist who is sympathetic to stimulate the spirit of these by means of his art."[2] In contrast to the more activist art of the period, however, Dalstrom's images reinforce the status quo, romanticizing the work done by these laundry workers. Dressed in what could be Sunday dresses, and set in a spacious, beautifully wallpapered room, the workers appear to be working at a calm, relatively leisurely pace. The reality of their lives, as an oppressed minority earning a fraction of what their Caucasian counterparts received, was a far cry from the peaceful, pastel painted scene. The popularity of such idealizations of American life, in which there is no racial and class strife, is underscored by the selection of *Laundry* for the 1943 Annual Exhibition of American Paintings and Sculpture at the Art Institute of Chicago. CS/SW

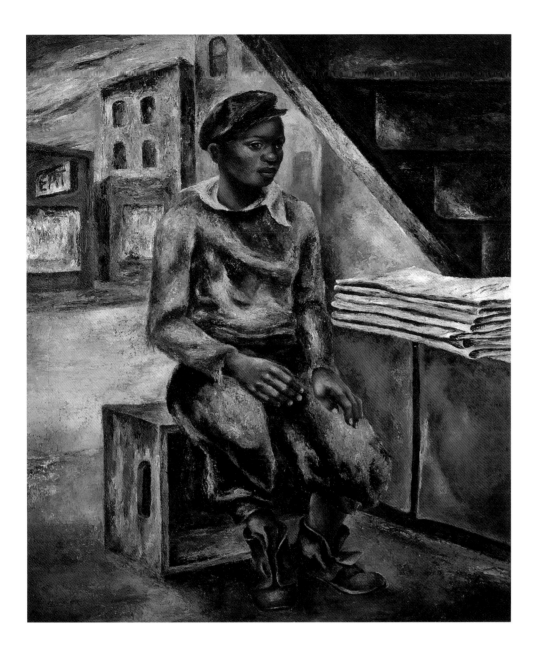

26.

Charles V. Davis
1912–1967

Newsboy (The Negro Boy), 1939
Oil on canvas, 36 x 30 in. (91.4 x 76.2 cm)
Howard University Gallery of Art (Washington, D.C.)

Charles V. Davis was employed in the easel-painting division of the Illinois Art Project of the Work Projects Administration (WPA) and was a founding member of the South Side Community Art Center. He briefly took classes at the Art Institute and at Hull House. In a 1940 article in the Urban League's *Opportunity* magazine, painter Archibald J. Motley Jr.'s nephew, Willard Motley, profiled several young black artists from the Bronzeville neighborhood of the 1930s, all of whom were committed to rendering the local scene and its citizens with dignity and truth. In this article, Motley quotes Davis on what motivated him to take as his subject the Bronzeville

neighborhood: "I live here because I have a deep sympathy for the people who live here. These people and the whole neighborhood have something to say. I want to paint real people and real places."[1]

Ideally beautiful but at the same time minutely observed, the figure in Davis's *Newsboy* dominates the picture. Seated on an upended crate and sheltered from the street, he gazes ahead distractedly and unselfconsciously, as if lost in thought. Using a technique similar to that employed by Eldzier Cortor in his 1941 *Girl Washing Her Hair* (see Schulman essay, fig. 11), Davis builds up a series of rich color glazes over a white ground, which gives the painting an extraordinary luminosity. *Newsboy* was painted under the auspices of the WPA. The government deposited it—along with many other works from a traveling exhibition called *Art of the American Negro*, shown first at the Library of Congress in Washington, D.C., from December 1940 to January 1941—with Howard University in Washington, D.C. DS

27.

Manierre Dawson
1887–1969

Prognostic (center panel), 1910
Oil on canvas, 33 ¾ x 35 ¾ in. (85.7 x 90.8 cm)
Milwaukee Art Museum, Purchase, M1967.78 (Wisconsin)

Although passionate about art from an early age, Manierre Dawson trained as a civil engineer as a compromise with his parents, who wanted him to pursue a professional path rather than study art, and he earned a B.S. from the Armour Institute of Technology (now the Illinois Institute of Technology) in 1909.[1] By the time he traveled to Europe in 1910, where he saw examples of avant-garde art and visited Gertrude Stein's apartment with its large collection of modern art, he had already executed *Prognostic*, a wholly abstract triptych, the central panel of which is in this exhibition. Recognizing the young Dawson's talent, Stein purchased a painting that he brought to show her for 200 francs. It was Dawson's first sale.[2] Until recently, scholars were confounded by the idea of a provincial Chicagoan conceiving of non-representational painting independent of outside influences. Some were convinced that Dawson altered the dates of his work.

Randy Ploog has shown that Dawson arrived at his abstract style after his graduation, while working as an architectural draftsman at the firm of Holabird and Roche in Chicago. Combining the principles of Arthur Wesley Dow, whose text *Composition*, published in 1899, popularized a formalist approach to making art; his own study of Japanese prints; the theories of James McNeill Whistler, as expounded by Chicago lawyer and art patron Arthur Jerome Eddy; Denman Ross's *Theory of Pure Design*; and elements from his civil-engineering training, Dawson created something wholly original.[3] Rather than depending on modern theorists of fine art such as Wassily Kandinsky to provide a justification for abstraction, Dawson was thinking independently along the same lines. Often relying on the musical analogies that were widespread at the time to help understand abstraction, Dawson wrote in his journal that art was "an attempt to fix forms by painting or sculpture that have given me an emotion, hoping to find some who reacted as I did to these shapes and colors [when they are] presented on canvas or in some plastic material."[4]

The best explanation of *Prognostic*'s genesis is Dawson's own, written in 1969: "*Prognostic* is one of seven paintings painted shortly after I graduated from college where I had so many engineering and mathematics courses that the influence of this shows in the background of coordinates and super-position of differentials. . . . The black line and circles thrown over (*Prognostic*) are subconsciously possibly suggested by pencils, pens and erasers generally strewn over a student's drawing board."[5] SW

28.

Julio de Diego
1900–1979

Vamda, 1937
Oil on canvas, 40 x 30 ¼ in. (101.6 x 76.8 cm)
Mr. and Mrs. Harlan J. Berk (Chicago)

Julio de Diego was born in Madrid and worked in Paris before coming to Chicago in 1924. His first artistic experience was as an apprentice to a scenery painter with the Madrid Opera Company, and, although he had no formal training, he was involved in a wide variety of creative activities in theater, film, and ballet, and in the commercial arts as a magazine illustrator, graphic artist, and jewelry designer.[1] His firsthand familiarity with European modernism grounded his subsequent work, which drew on a variety of sources to achieve his "purely personal expression."[2] While de Diego's later work is often overtly political and appears to be teeming with fragments of imaginative imagery, his painting from the mid- to late 1930s is most indebted to the large, still figures of Picasso's classical period, as seen through de Diego's inventive and original eye.

Similar to works by de Diego such as *The Perplexity of What to Do* (1940) and his *Self-Portrait* (1938), *Vamda* is an image of a lone figure, lost in thought, in a limited space. *Vamda* suggests the artist's aforementioned familiarity with Picasso's work and with the realism then current in the United States, but it also has about it the air of mystery that was embraced in Chicago. The pensive isolation of the figure, the austerity of the setting, and the open letter on the floor add to its haunting quality. In 1962 a critic said of de Diego: "As an artist, he fits into no easy pigeonhole. . . . He is a traditionalist at heart—and one of the best—yet he is not afraid to pursue an eccentric notion wherever it may lead."[3] He shares this eccentricity with a number of other Chicago artists, such as Gertrude Abercrombie, whose *Self Portrait of My Sister* (cat. 1) possesses some of the same austere mystery as *Vamda*. AG/SW

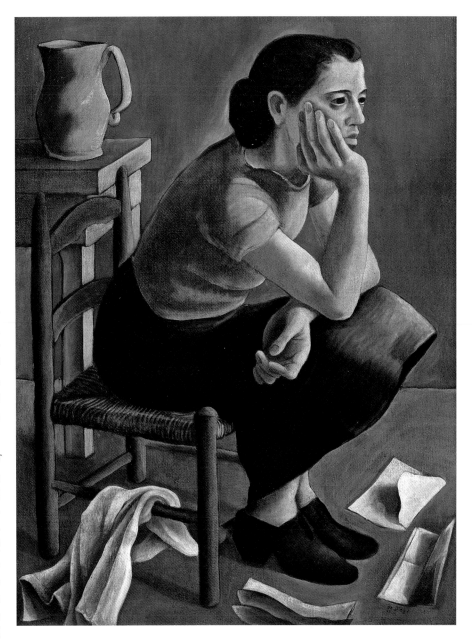

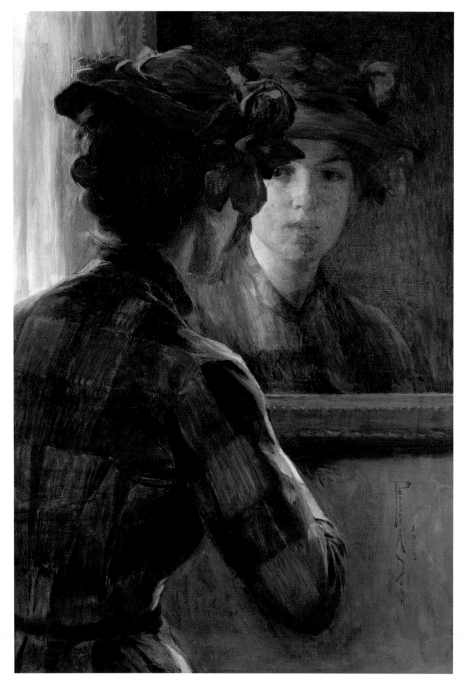

29.

Pauline Dohn (Rudolph)
1865–1934

A Village Belle, 1899
Oil on canvas, 29 x 20 in. (73.7 x 50.8 cm)
Illinois Historical Art Project (Techny, Illinois)

Chicago native Pauline Amalie Dohn studied at the Art Institute of Chicago and then in Philadelphia with Thomas Eakins and his student, Thomas Anschutz, before completing her artistic training in Europe.[1] She returned to Chicago in 1891 because, she said, "I like to study and paint my own land and my own people."[2] Before her marriage in 1901 virtually ended her painting career, she achieved considerable standing in the Chicago art world, which boasted a prominent community of women artists.[3] Many had been attracted to the city by the Art Institute, where female students sometimes outnumbered male in its early years, and by commercial work.[4] In the 1890s, Chicago's women artists included many progressives sympathetic to new movements in art. Indeed, *A Village Belle*, with its attention to subtle modulations of filtered light and its feathery brushwork, reflects the influence of impressionism.

The conceit of a woman contemplating her image in a mirror, unaware of the viewer's gaze, attracted numerous painters in the late nineteenth and early twentieth centuries. Aside from the purely decorative appeal of the beautiful female figure in a static pose, the theme invites reflection on such modern concerns as the social and psychological construction of identity, the nature of seeing and being seen, and creativity as a parallel act of self-describing.

These ideas lurk just below the surface of Dohn's *Village Belle*. The work's title and the figure's costume, characterized as "old-timey" by one reviewer, hint at nostalgic anecdote.[5] The artifice of her outfit contrasts, however, with the psychological immediacy of the image, in which the viewer is a seeming intruder into a private moment of self-examination. The theme of woman as contemplated object—seen here both by the viewer and by herself—takes on added significance, for *A Village Belle* appears to be in fact Dohn's self-portrait.[6] WG

30.

Walter Ellison
1900–1977

Train Station, 1935
Oil on cardboard, 8 x 14 in. (20.3 x 35.6 cm)
The Art Institute of Chicago, Charles M. Kurtz Charitable
Trust and Barbara Neff Smith and Solomon Byron Smith
funds; through prior gifts of Florence Jane Adams, Mr. and
Mrs. Carter H. Harrison and estate of Celia Schmidt, 1990.134

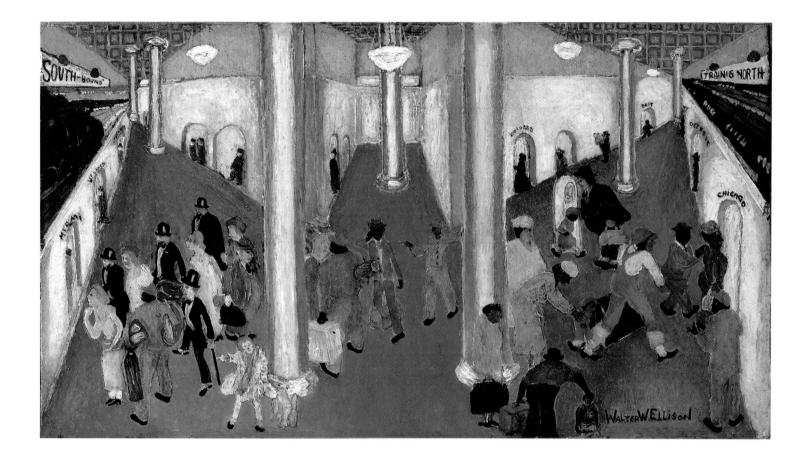

Little is known about the life of Walter Ellison. Legend has it that as a young man he hopped a boxcar and came to Chicago from his native Georgia. While he supported himself largely as a decorative painter and housepainter, Ellison studied briefly at the School of the Art Institute of Chicago and was employed by the easel-painting division of the Illinois Art Project of the Work Projects Administration. His works appeared in exhibitions at the South Side Community Art Center and in important exhibitions of works by black artists around 1940, but he apparently stopped exhibiting actively after World War II.

Ellison was a keen social observer whose works typically illustrate the harmful effects of segregation on the lives of African Americans. His paintings and prints are often wryly satirical and betray strongly left-wing political sympathies. It is not surprising to find sources that claim he was trained by social progressives Morris Topchevsky (see cat. 84) and Adrian Troy.[1] *Train Station,* painted in

1935, is a masterly portrayal of both Jim Crow and the Great Migration in brilliant microcosm. Intentionally painting in a naïve or folk-art style, Ellison divided the station platform into three zones—a device reminiscent of both an early Renaissance predella panel and a modern cartoon strip. On the left, formally dressed whites approach portals labeled with the names of the resort towns of Miami and West Palm Beach. On the right, respectably dressed, but lower-class, blacks head to doors marked "Chicago," "Detroit," and "NY," destinations of choice for thousands of African Americans who left the oppression and poverty of the rural South in search of jobs and opportunity beginning in World War I. In the center, a redcap comes to the aid of an obviously confused traveler. In 1941 Jacob Lawrence would paint an epic cycle that dealt with the same subject in a series of sixty small panels entitled *The Migration of the Negro.* DS

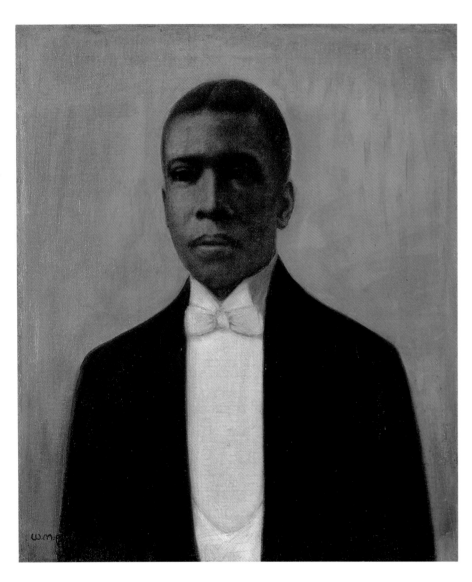

31.

William McKnight Farrow
1885–1967

Paul Laurence Dunbar, 1934
Oil on canvas, 35 ¼ x 32 ⅛ in. (89.5 x 81.6 cm)
National Portrait Gallery, Smithsonian Institution,
NPG.93.86 (Washington, D.C.)

William McKnight Farrow was born in Dayton, Ohio. He attended high school in Indianapolis, Indiana, in 1903–4, where he came into contact with artist William Edouard Scott (see cat. 75), who encouraged him to enroll at the School of the Art Institute of Chicago. Farrow moved to Chicago in 1908 and was associated with the Art Institute for almost twenty years, first as a student (from 1909 to 1918) and then as head of the museum's printing department, assistant to the curator of exhibitions, and manager of its modest collection of Egyptian art. With his colleagues Scott and Charles Dawson, Farrow was actively involved in creating exhibition opportunities for black artists and encouraging an appreciation for art in the larger black community. In 1923 he founded the Chicago Art League, which held annual exhibitions at the Wabash Avenue YMCA in Bronzeville, and he wrote occasional art criticism for the black weekly newspaper the *Chicago Defender*. Known most widely for his graphic work, Farrow made a living as a commercial artist and taught evening classes at Carl Schurz High School from 1926 to 1948. Farrow was fired from the job he loved when school officials—who assumed Farrow was white—were told of a profile of the artist that appeared in the *Pittsburgh Courier*, an African American newspaper.[1]

Farrow's formal portrait of the poet Paul Laurence Dunbar is a later version of a work originally painted in 1923 for Dunbar High School in Dayton, Ohio, the hometown of both the poet and the artist. Farrow vividly remembered attending readings presented by Dunbar as a young man in Dayton. The portrait presents Dunbar, the first black poet to attain national prominence, dressed formally as if for a recital. Farrow obviously wanted to stress Dunbar's respectability, but the sitter's distant expression suggests his tragic fate as well. The lyricism of Dunbar's poetry in black vernacular dialect was recognized, but the genre risked perpetuating plantation caricatures of blacks; because he died young, Dunbar's work in other modes was largely ignored. DS

32.

Frances Foy
1890–1963

The Cheese Vendor, 1928
Oil on Masonite, 27 ¾ x 24 in. (70.5 x 61 cm)
Powell and Barbara Bridges Collection (Wilmette, Illinois)

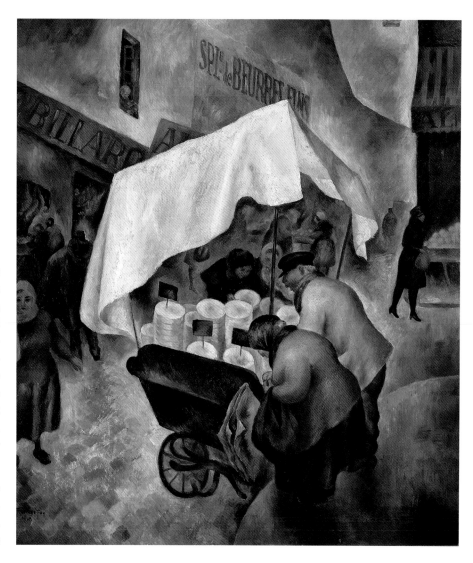

Frances Foy attended night classes at the School of the Art Institute of Chicago, where she studied with Wellington Reynolds and, when they were visiting instructors in 1919–20, with George Bellows and Randall Davey. Her successful career as a fashion illustrator enabled her to absorb concepts of design and composition with ease.[1] Foy considered subject matter to be all-important in painting, saying, "I use whatever I have of knowledge and skill and feeling to portray the subject the way I see it. As long as any artistic quality—color, rhythm, abstract form—furthers this portrayal, I consider it good."[2]

In 1928 Foy and Gustav Dalstrom (see cat. 25), whom she married in 1923, joined their colleagues and friends Frances Strain (see cat. 80), Fred Biesel, and Hazel and Vin Hannell on a working trip to Europe. Foy spent the trip "painting almost continually and studying independently in the galleries there,"[3] noting that, upon her return, "[she] had made a noticeable advance in [her] work."[4]

In a departure from Foy's more straightforward and realistic portraits and flower paintings, *The Cheese Vendor* shows evidence of experimentation with modernist styles, notably cubism. Elements of street life swirl in abstracted patterns around the central image of the cart, with its bright yellow awning protecting the display of cheese beneath. Foy incorporates all of the background elements, including the lettering in the shop signs, into an abstract design, while still retaining her characteristic delicacy of color and texture. Upon Foy's return, art critic Marguerite Williams noted of the painting, "Frances Foy takes an increasing delight in whatever the theme, in a free and easy technique and daring color, keying up a

market scene to a bright yellow awning. . . . The art . . . seems to grow from a fresh enthusiasm for the pageant of nature and life rather than from any effort to follow some successful painter."[5]

The painting was exhibited at the Art Institute of Chicago in 1929 in a joint exhibition with Dalstrom and the following year in a New York exhibition of The Ten, an independent exhibition group from Chicago (not to be confused with the New York group of the same name). The painting was singled out for notice by several critics, including J. Z. Jacobson, who called *The Cheese Vendor* "the most delightful" of Foy's paintings, in which the subject "is not too literary and . . . does not usurp the primacy that in all genuine art, belongs to form and color."[6] CS/SW

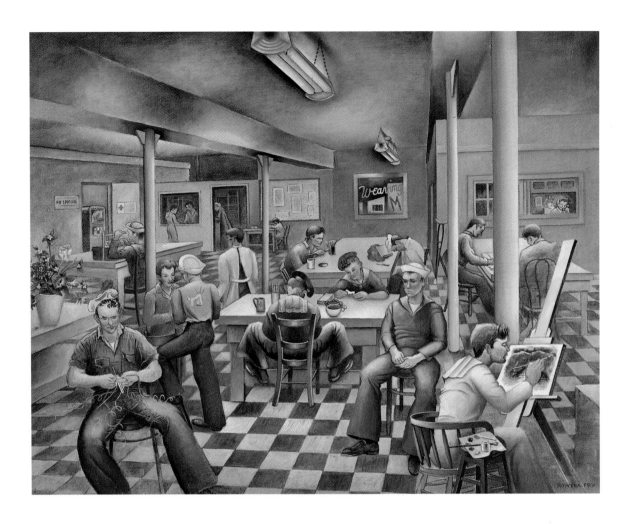

33.

Rowena C. Fry
1895–1989

Great Lakes Art Class, 1941–45
Oil on canvas, 24 x 30 in. (61 x 76.2 cm)
Mr. and Mrs. Harlan J. Berk (Chicago)

Rowena Fry came to Chicago in the late 1920s and studied at both the School of the Art Institute and the Hubert Ropp School of Art. She was a resident of the Tree Studios for many years, sharing a one-room studio with artist Natalie Henry and, according to Annie Morse, living with her in "what friends and neighbors recall, with no little wonder, as complete harmony."[1] Fry identified herself as an "American Naïve," and her numerous views of the Near North Side of Chicago, complete with charming and identifiable details of ordinary life, make this an apt appellation.[2] Her work conforms to the widespread American scene painting of the late 1920s and '30s, with its focus on the small-town aspects of Chicago neighborhoods (as contrasted with the skyscrapers or industrial areas of the modern city) and the minutia of daily life. Like other artists in the United States during the Depression and war years, she wanted her art to "give the viewer some kind of uplift."[3]

From 1942 to 1946 Fry worked at the Great Lakes Naval Hospital, teaching art classes to recuperating sailors. The scene in *Great Lakes Art Class* is clearly based on her experience. In it, Fry situated the sailors in a large room that is warm and friendly, despite its institutional lighting and lack of decoration. She softened the forms, foreshortened the space, and unified the scene with a lively checkerboard tile floor. The sailors are cheerfully engaged in various activities, belying their real circumstances. Despite the fact that all of these men are recovering from war injuries, there is a feeling of "uplift" and optimism about the scene, a sense that these men are happily involved in pastimes that reflect the productive work they will do upon leaving the hospital. The feeling of well-being contrasts with the powerful social critique of some of Fry's contemporaries.

In 1945 Fry exhibited a painting called *Convalescent Workshop* at the 56th Annual Exhibition of the Chicago Society of Artists. Described in a newspaper review as an "extremely interesting and beautifully painted" image of "a group of sailors painting, weaving or just sitting staring into space," it could well refer to the painting we now call *Great Lakes Art Class.*[4] SW

34.

Frederick F. Fursman
1874–1943

Maizie Under the Boughs, 1915
Oil on canvas, 40 x 30 in. (101.6 x 76.2 cm)
Powell and Barbara Bridges Collection (Wilmette, Illinois)

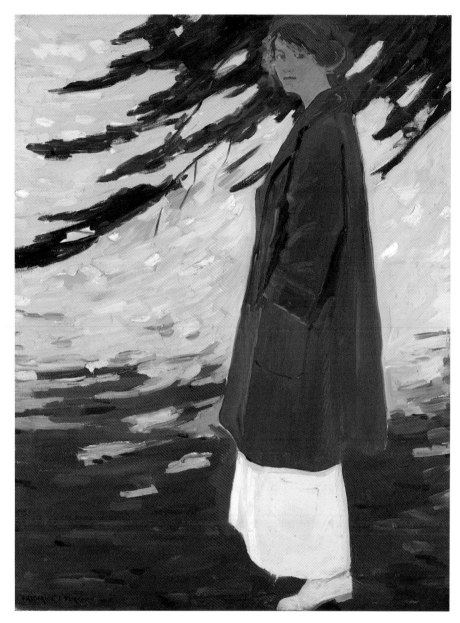

Academically trained in Chicago and Paris, Frederick Frary Fursman began his career as an impressionist painter, picturing the landscape of Brittany and out-of-doors figural subjects on the spot with rapid strokes and a loaded brush. In 1910 Fursman and fellow artist Walter Marshall Clute founded a summer school of painting at Saugatuck, Michigan.[1] Saugatuck's brilliant color, crisp air, and broad vistas of dunes and lake triggered a shift in Fursman's painting, and he began to emphasize pattern and repetition and the decorative potential of his typical impressionist subjects: women at leisure in sun-dappled surroundings. On a return trip to Brittany in 1913–14, Fursman moved further toward the abandonment of objective representation, reducing his subjects to broad, flattened areas of decorative, even sensational color that suggest the influence of the contemporary artistic movements of post-impressionism and fauvism.

Maizie Under the Boughs is one of a group of images of a single female figure outdoors that Fursman executed in the summer of 1915. Possibly intended in part to serve as teaching tools for his students, these experimental works exploit figure and setting as the vehicles for abstract compositions that are created not by the distortion or stylization of forms, but by a reductive, patterned interplay of pure, unmodulated color. Broadly rendered, Maizie is posed against a brilliantly tinted background of tree boughs and ground. These surroundings are marked by strong areas of light and shadow described by flat, contrasting areas of cool and warm colors. The contrast of the figure's light skirt against the deep-pink ground, for example, is echoed in the contrast of her face and hair—rendered in the same pinks as the ground—against the rich blue-green of the tree boughs. These seemingly fantastic colors capture the blinding effects of brilliant, full sun backlighting a figure in the deep shade of Michigan pines. WG

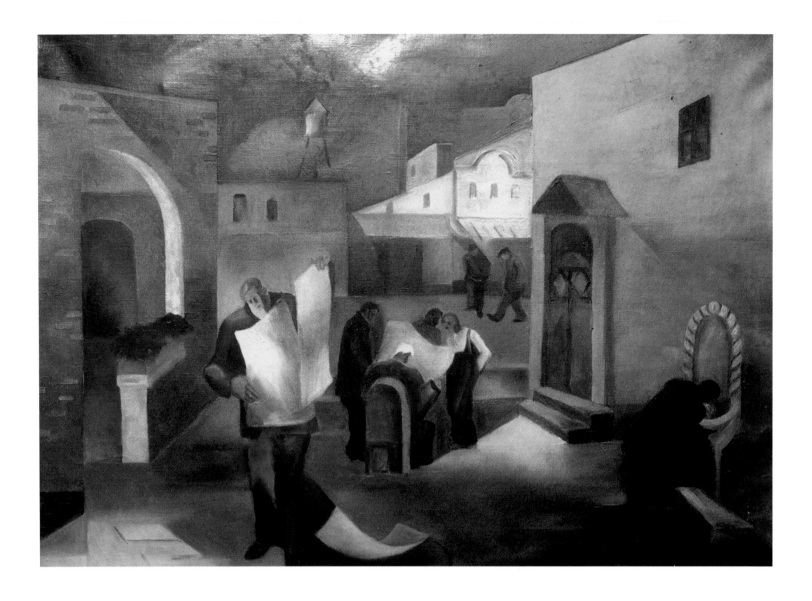

35.

Leon Garland
1896–1941

Unemployed Men in the Hull-House Courtyard, c. 1930–31
Oil on canvas, 30 x 40 ¹⁄₁₆ in. (76.2 x 101.8 cm)
Jane Addams Hull-House Museum, University of Illinois at Chicago

Throughout his career, Leon Garland remained unconcerned with selling his works, preferring an audience of his fellow artists over patrons and philanthropists. He demonstrated a devotion to his craft and chose to create works that corresponded to his tastes rather than to those of the critics, once saying of a work, "I guess that one isn't as good as I thought; everybody likes it."[1] His commitment was to ordinary working people, particularly those in his adopted community around the Jane Addams Hull House on the Near South Side of Chicago. Artist and educator Morris Topchevsky (see cat. 84) introduced

Garland to Hull House, and, as a Jewish immigrant from Russia and a passionate artist, Garland thrived in this environment. He worked, taught, exhibited, and lived at Hull House with his wife, Sadie, whom he met there.

Garland's painting *Unemployed Men in the Hull-House Courtyard* depicts the ambiance of the communal outdoor space in subtle hues of blue, pink, and gray. The delicacy and refinement of his painting technique is combined with suggestions of cubism in the planar treatment of the buildings and the geometric faceting of many of the forms. In this painting, Garland documented with great sympathy the aimless tedium and dejection suffered by victims of the Great Depression, as well as the way in which Hull House functioned as a haven for them. Despite their circumstances, the men are dignified, many of them dressed in suits, ready for work. Garland's sense of himself as a worker, rather than a member of an elite class of artists, allowed him to feel a solidarity and sympathy with the plight of the unemployed. Like other socially concerned artists of the period, he saw art as a means to making the world a better place. AG/SW

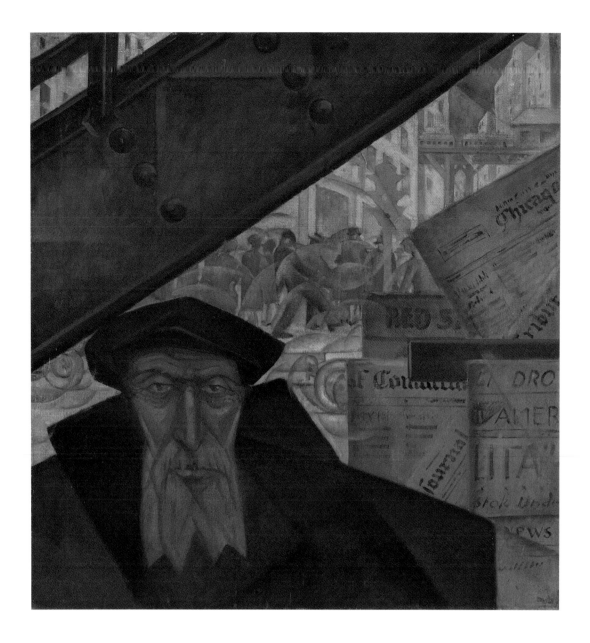

36.

Todros Geller
1889–1949

Strange Worlds, 1928
Oil on canvas, 28 ¼ x 26 ⅛ in. (71.8 x 66.4 cm)
The Art Institute of Chicago, Gift of Leon Garland
Foundation, 1949.27

Todros Geller was called "the Dean of Chicago Jewish Artists," inspiring a younger generation to depict Jewish themes and awakening them to "the need for solidarity in working out problems of mutual interest, and for participating as a group in the life of the community."[1] He taught at Hull House, the Jewish People's Institute, and the College of Jewish Studies, and worked in a variety of media ranging from prints to painting to stained-glass windows. He created a great many images with biblical themes, Chagall-like fantasies of *shtetl* (a small eastern European Jewish village) life, and scenes of modern Palestine, which he visited in 1929, as well as visual responses to the horrors faced by European Jewry during World War II. Geller also turned his attention to the modern urban environment, executing cubist- and precisionist-inspired cityscapes that were starkly modern.

In *Strange Worlds*, which was shown in 1930 at the 34th annual Chicago and Vicinity exhibition at the Art Institute of Chicago, he combined these interests. An old man, whose features and somber garb are redolent of the eastern European *shtetl*, looks out at the viewer from his newsstand under the iron staircase to the "El" platform; in the brighter background is a modern, almost futuristic cityscape through which the figures of office workers dash in a blur of activity. Geller used a range of modernist effects, such as the flattening of angular forms and the blurring of background figures, to suggest the speed, anonymity, and mingled harshness and opportunity of modern urban life. This activity is juxtaposed against the static, dominating form of the old man in the foreground, a representative of one strange world through whose shrewd vision we perceive the strangeness of the other. AG/SW

37.

J. Jeffrey Grant
1883–1960

Michigan Avenue, c. 1934
Oil on canvas, 40 x 35 in. (101.6 x 88.9 cm)
Collection of Clifford Law Offices (Chicago)

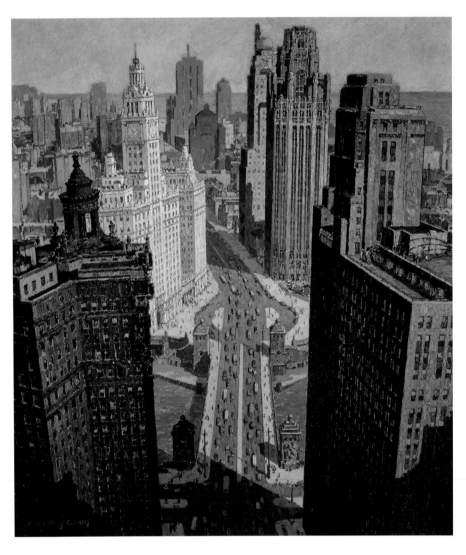

The bridging of the Chicago River at Michigan Avenue, completed in 1920, realized an important goal of architect and planner Daniel H. Burnham's 1909 "Plan of Chicago," an ambitious proposal to impose order, cohesion, and grandeur on the layout of the central business district. Within a decade of the bridge's opening, the largely residential neighborhood of upper Michigan Avenue had been transformed into a showcase of contemporary architecture with the erection of the distinctive high-rise structures seen in stately array in James Jeffrey Grant's bird's-eye view. Additionally, with the development of Grant Park in the 1920s, Michigan Avenue from Roosevelt Road to Oak Street became the city's trophy, a grand boulevard whose impressive vistas appealed to many artists.

Grant's dramatic aerial view, probably taken from the tower top of the forty-story Carbide and Carbon Building (1930), takes in the full range of skyscrapers from the London Guarantee Building (1923) and the 333 North Michigan Avenue building (1928) just south of the bridge to the Palmolive Building (1930) at the avenue's northern end; beyond stretches the aquamarine expanse of a peaceful Lake Michigan. The vertical composition's tipped-up perspective and high horizon emphasize the buildings' soaring height and the canyonlike nature of Michigan Avenue, a gray ribbon of asphalt dense with brightly colored vehicles. The relatively somber facades of the foreground buildings dramatize the brilliance of the white terra-cotta-clad Wrigley Building (1921, 1924) caught in the morning sun.

In the 1930s, Grant, who had settled in Chicago around 1920 after studies in his native Aberdeen, Scotland, and in Munich, was best known for his picturesque images of New England fishing villages and Illinois small towns. *Michigan Avenue* is one of several Chicago street scenes by the artist that share a restrained palette, matte surface, solid modeling, and decorative brushwork. Within the rigid control of the strongly defined building forms of *Michigan Avenue*, broken strokes of subtly modulated color, applied in patterned patches, make the painting's surface almost vibrate with energy. One of several Chicago street scenes the artist included in his one-man exhibition at the Art Institute of Chicago in 1935,[1] *Michigan Avenue* is a celebratory image of Chicago as a modern metropolis at once dynamic and orderly. WG

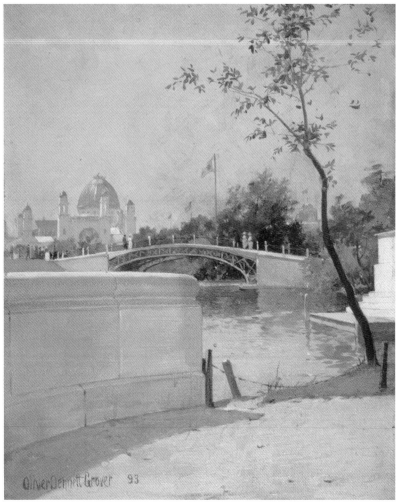

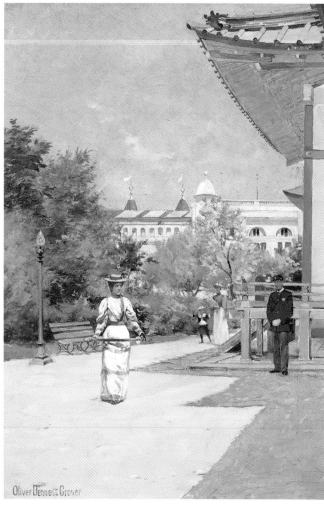

38

39

Oliver Dennett Grover
1861–1927

38.

Midsummer, 1893
Oil on panel, 10 x 8 in. (25.4 x 20.3 cm)
Illinois Historical Art Project (Techny, Illinois)

39.

On the Island, World's Columbian Exposition, 1893
Oil on panel, 10 x 7 in. (25.4 x 17.8 cm)
Mr. and Mrs. Kenneth Probst (Chicago)

40.

A Windy Day, 1893
Oil on panel, 10 ⅛ x 8 ⅜ in. (25.7 x 21.3 cm)
Private collection

The World's Columbian Exposition of 1893 symbolized not only Chicago's phoenixlike recovery from the devastation of the Great Fire of 1871 but also her cultural arrival as a great metropolis. The fair's predominantly classical exhibition halls and mural and sculptural decorations presented an official triumph of traditional cultural values. Yet with such innovative technology as nighttime electrical illumination, the Ferris wheel, and moveable sidewalks, the fair also celebrated modernity. Inside its Palace of Fine Arts, a vast art exhibition bore witness to the arrival of the new style known as impressionism, in paintings by European and American artists that pictured contemporary life in fresh, naturalistic light and color and rapid, broken brushwork.

As a decorative painter for the fair and contributor to its art exhibition, Oliver Dennett Grover hewed to tradition. When he painted the fair itself, however, Grover demonstrated his attraction to the new mode. These intimately scaled works, with their softly textured brushwork, contemporary immediacy, and attention to sunlight and atmospheric effects, suggest the influence of such American impressionist painters as William Merritt Chase and Childe Hassam, who also painted views of the exposition. Grover's three paintings were praised as "marvelously dainty bits" by one reviewer when exhibited at the Art Institute of Chicago in 1894.[1]

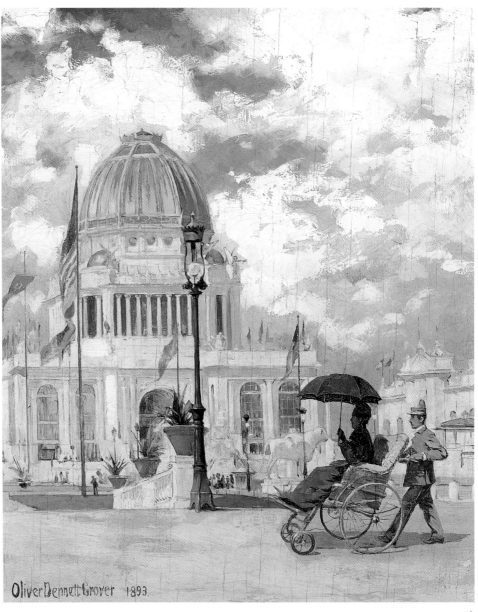

Artists and illustrators alike typically pictured the exposition so as to emphasize its formal grandeur and vast scale. Like Hassam and Chase, however, Grover created intimate glimpses of the ideal "White City" that evoke an individual fairgoer's respite from crowds and endless displays. Notwithstanding these images' informal, snapshot quality, the artist selected and edited his views to present the White City as the elegant *urbs in hortus*—city in a garden—that Chicago itself aspired to be.

Midsummer, a view south from a spot near the gondola landing in front of the Merchant Tailors Building, emphasizes the dense verdure of the Wooded Island, an oasis of studied "naturalism" set in a lagoon at the heart of the White City.[2] The flag of Japan marks the location of one of the few structures on the island, the traditional Japanese temple, known as the Ho-o-den, that was one of the most exotic and architecturally influential buildings of the fair. In *On the Island*, the viewer stands in the shadow cast by the graceful flared eaves of the middle of the three structures that comprised the Ho-o-den. Grover simply ignored the northernmost building, which would have blocked the view east from this spot, so as to frame the scene with the trees on the left; in the distance are the classical-styled exposition halls to which the Ho-o-den presented such a revelatory contrast.[3]

A Windy Day offers a more typical aspect of the White City: the Administration Building, with its high, gilded dome. Grover downplays its architectural formality, however, to suggest quotidian experience. The fluttering, colorful flags and banners that validate the work's title enliven the scene, while attention is dominated by the ordinary incident of a woman, shielded by a parasol against the bright sun, being pushed in a wheeled chair by a blue-uniformed attendant. Like the elegant, unescorted female visitors, one accompanied by a child, that appear in *On the Island*, this figure attests to the White City as a calm, uncrowded milieu of public safety, comfort, and decorum, an exemplum of perfected urbanism in conscious contrast to Chicago's clamorous reality. WG

41.

William Harper
1873–1910

August in France, c. 1908–9
Oil on canvas, 36 ⅛ x 36 ⅛ in. (91.8 x 91.8 cm)
Tuskegee University Archives and Collection (Tuskegee,
Alabama)

William Harper was the first African American artist to achieve significant critical success at the Art Institute of Chicago's annual juried exhibitions. Harper enrolled at the Art Institute in 1895, earning tuition and expenses by working as a janitor and night watchman. After graduation in 1901, he studied in France from 1903 to 1905, in the classroom at the Académie Julien in Paris, and in the countryside with experienced Chicago landscape painters William Wendt and Charles Francis Browne. The Chicago newspapers gave extensive coverage to Harper when the artist took the Municipal Art League's blue ribbon for a group of nine paintings he exhibited at the Art Institute in 1905; his rise to prominence was called "meteoric." Harper returned to France in 1907–8 and was one of the few artists to study with African American expatriate artist Henry Ossawa Tanner. He appeared to be well on his way to establishing a career before dying of tuberculosis at the age of thirty-six. After Harper's untimely death, long considered a tragic loss to the cause of African American artists, a memorial exhibition of sixty works was held at the Art Institute.

Autumn in France, probably painted during Harper's second trip to France, was shown at the annual American exhibition at the Art Institute in 1909 and again at the memorial exhibition the next year. Harper's use of heavy impasto is reminiscent of Tanner's work, but his active brushstroke and brilliant evocation of light and atmosphere clearly point to an interest in the artists of the Barbizon school such as Henri Rousseau, Jean-Francois Millet, and Constant Troyon. According to artist Charles Dawson, at his suggestion, the painting was given to Tuskegee University as a gift from the Art Institute of Chicago.[1] DS

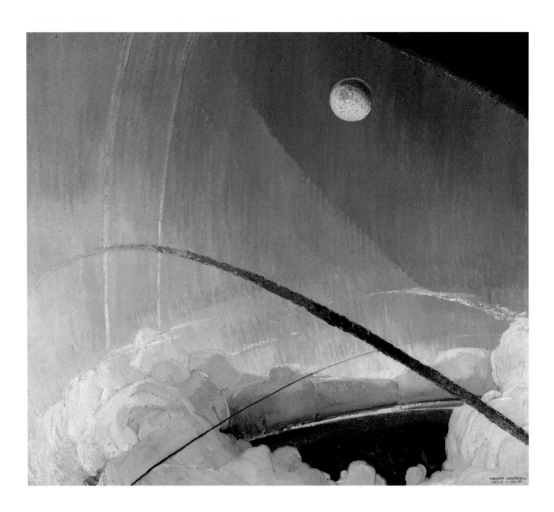

42.

Victor Higgins
1884–1949

Circumferences, 1914–19
Oil on canvas, 51 ¼ x 57 in. (130.2 x 144.8 cm)
The Snite Museum of Art, University of Notre Dame, Gift of
Mr. And Mrs. John T. Higgins, 63.53.4 (South Bend, Indiana)

Victor Higgins was a member of the diverse group of painters who worked in Taos, New Mexico, in the first half of the twentieth century, inspired by the region's unique light, color, landscape, and local culture. Higgins's career was deeply rooted in Chicago, however, and his early years of painting in the Southwest coincided with the period of his greatest prominence in Chicago's art scene.[1] In 1914, the year he first traveled to Taos with the encouragement of Chicago mayor and art patron Carter H. Harrison Jr., Higgins was appointed to the seven-member municipal Commission for the Encouragement of Local Art as the representative of the influential Palette and Chisel Club. Through Carter and the commission, Higgins established relationships with numerous important local art patrons, and his work was exhibited frequently and with acclaim, garnering nine prizes within five years. In the unsettled climate in the wake of the Armory Show, Higgins's was a progressive yet moderate voice speaking from within Chicago's art establishment.

Yet, beginning in 1914, Higgins also digressed from his popular interpretations of New Mexico native life and scenery with an anomalous series of semi-abstract allegorical paintings. *Circumferences* is the only surviving work in the series, said to comment on President Woodrow Wilson's reluctant decision to enter the war against Germany.[2] The painting presents an imaginary aerial view of earth, with the moon suspended overhead. Parting clouds reveal the landforms of Mediterranean Europe, with a fiery band on the northern horizon indicating the destruction of war. The fantastic arcing lines and sky forms that dominate the composition are said to symbolize aspects of Wilson's cautious diplomacy.[3]

Higgins's experimentation in semi-representational, symbolist art was not an isolated incident. In the aftermath of the Armory Show's Chicago presentation, several members of the Palette and Chisel Club, a self-styled bohemian organization, were eager to "futurize art in Chicago," according to the club's president.[4] Disclaiming any association with cubism or futurism, Higgins led a group of artists who explored direct expressions of personal emotion in painting and composed "symphonic color harmonies" of pure color, line, and form inspired by music.[5] Such alternate modernism showed, according to a sympathetic critic, that art "could diverge from nature without being abnormal."[6] WG

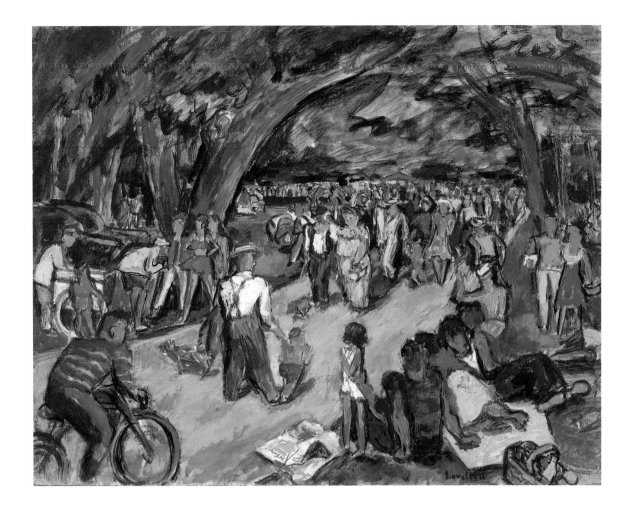

43.

Samuel Himmelfarb
1904–1976

Jackson Park, 1938
Oil on board, 23 ¾ x 29 ⅝ in. (60.3 x 75.2 cm)
Molly Day and John D. Himmelfarb (Chicago)

Originally from Wisconsin, Samuel Himmelfarb trained there and at the National Academy of Design and the Art Students' League, both in New York City. After designing several exhibits for the Century of Progress World's Fair in 1933, he developed this skill into a successful industrial exhibit and display design company, Three Dimensions, while continuing to paint, exhibit his work, and win prizes in Chicago and elsewhere. Once settled in Chicago in the 1930s, he became part of the arts community, along with his wife, Eleanor, also a well-known artist. A member of the Arts Club and Artists Equity, he exhibited his work at numerous Art Institute shows.[1]

Jackson Park is a brightly colored image of a crowded Chicago park that is similar to scenes painted by Aaron

Bohrod (see cat. 14), Gustav Dalstrom (see cat. 25), Frances Foy (see cat. 32), and Herman Menzel (see cat. 51) during the same period. In the tradition of the Ashcan-school artists so important to Chicagoans, Himmelfarb celebrated the pleasures of the urban experience, emphasizing the small-town qualities of the city rather than the industrial or built environment. His rapid brushwork and the spontaneous appearance of his paint application suggest the vitality and dynamism of the modern city. The painting is best described in Himmelfarb's own words: "My paintings are exceedingly friendly. Like me, they speak easily for themselves. Look at them from a distance and then move in. You'll be amazed at how you become involved if you go along. . . . I record the unprogrammed, the unglorified, the casual human scene. Essentially I'm a narrator developing intriguing 'thing' patterns formed by overlapping ornamentation of people shapes, thing shapes, and color shapes. Together they form an active, vibrating, coherent narrative. The depiction of [a] simple happening on a city street—in a beanery—on a bus ride—becomes a tune in praise of the unspectacular."[2] AG/SW

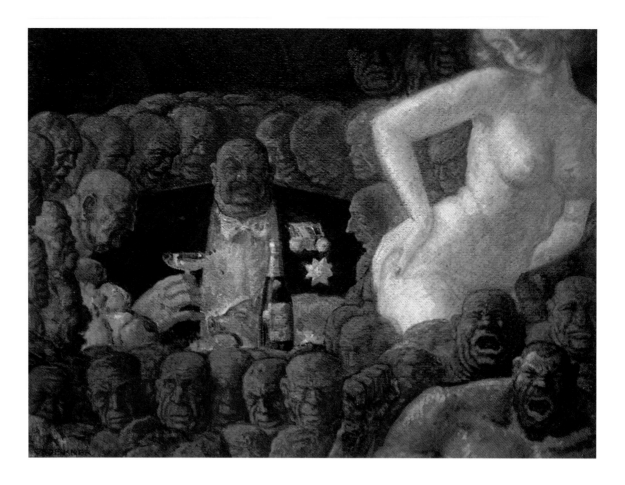

44.

Carl Hoeckner
1883–1972

The Yes Machine, undated
Oil on board, 33 ½ x 43 ¾ in. (85.1 x 111.1 cm)
Mr. and Mrs. Harlan J. Berk (Chicago)

In 1937 critic C. J. Bulliet characterized Carl Hoeckner as the "most formidable of Chicago artists dealing with 'the social scene' [and] yet the least 'propaganda minded.'"[1] Hoeckner was a German-born artist who immigrated to Chicago in 1910, and he began his career doing commercial art and executing large, decorative works. Radicalized by World War I, he painted his monumental protest painting, *The Homecoming of 1918*, which depicts a throng of gaunt, wounded, and haunted people marching toward the viewer. This work was, in the words of Bulliet, "perhaps the most powerful indictment of war ever painted in America."[2] Retaining the abstract linear forms of his earlier work, Hoeckner presented such an intense level of pain and anguish in the mass of disfigured humanity that the work is difficult to view. From this time on, he dedicated himself to making art that addressed political and social issues. As director of the graphics division of the Illinois Art Project of the Works Progress Administration in the 1930s, he not only executed prints that expressed his point of view but was also able to encourage other artists to do the same.[3]

Hoeckner often cut down his paintings, and *The Yes Machine* was once part of a larger composition. Based on an early photograph of the painting, it originally was about twice as high and a bit wider on the right side than it is now. The lower portion included a reclining nude female figure and the enormous, muscular body of the figure whose head remains in the lower-right corner.[4] The loss of this part of the painting does nothing to diminish the power of Hoeckner's message, however. He juxtaposed caricatured and bloated figures of gluttonous, greedy, licentious male capitalists, military figures, and politicians with a nude female figure in a titillating pose, critiquing the economic inequities of the period and also making a connection between material consumption and the exploitation of women.[5]

Hoeckner's image shares the tightly compacted form and repetitive images of Diego Rivera's depiction of the Mexican elites who were overthrown in the revolution, images he may have become familiar with through artists such as Morris Topchevsky (see cat. 84), who had studied this work in Mexico. Hoeckner's personal transformation, based on the trauma of World War I, shaped his artistic interest in "truth—in bitter truth and the struggle of life in general."[6] AG/SW

45.

Rudolph Ingerle
1879–1950

Salt of the Earth, c. 1932
Oil on canvas, 52 ¼ x 48 ¼ in. (132.7 x 122.6 cm)
Courtesy of Rockford Art Museum (Rockford, Illinois)

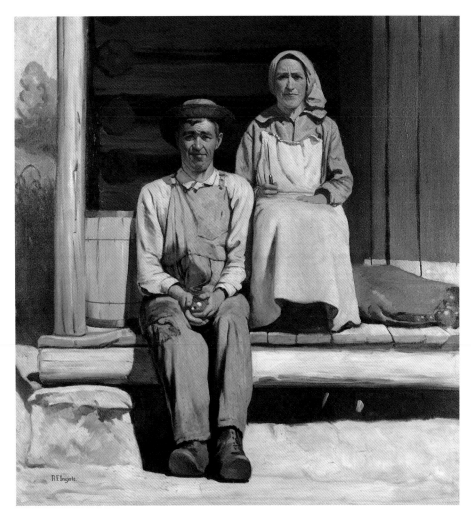

As a child in his native Vienna, Austria, Rudolph Ingerle was entranced by the "quaint" inhabitants of the nearby mountains of Moravia.[1] Insisting that American artists should paint their own country, Ingerle devoted his artistic career to a search for equally authentic subject matter to represent his adopted land. He painted landscapes in Brown County, Indiana, and in the Ozark Mountains of Missouri. In the mid-1920s, he discovered the Smoky Mountains of Tennessee and North Carolina. Ingerle portrayed that still "pure" American region in studio-constructed, decorative landscapes and in a number of character studies of the local folk, whom he praised as "the grandest people in the world—the finest Americans in the country."[2]

Ingerle's idealized portrayal of the Smoky Mountains as the authentic America—rural, peopled by hardy Anglo-Saxon stock, and untainted by social unrest, political ferment, or the challenges of urbanism or modernity—embodied his staunch artistic as well as political conservatism. A leader of Chicago's artistic traditionalists, the artist was much praised by conservative critics and admired by museum-goers who were baffled by modernism. *Salt of the Earth*, for example, was a runner-up for the popularity prize awarded at the Chicago artists' exhibition at the Art Institute in 1932. The painting was exhibited and reproduced widely throughout the 1930s.

With its pairing of stiffly posed male and female types of country folk, *Salt of the Earth* unavoidably recalls Grant Wood's contemporary *American Gothic*,[3] but it evinces none of the latter's gently satiric take on its "authentically American" subjects. Ingerle rendered this farming couple with an accessibly straightforward naturalism—and a touch of humorous anecdote. The unequal spatial relationship between the figures and their contrasting expressions of apprehension and determination seem justified by the objects each holds: a red apple in the man's hands and an unsheathed knife in his wife's resolute grip. WG

46.

Raymond Jonson
1891–1982

The Decree, 1918
Oil on canvas, 35 x 41 in. (88.9 x 104.1 cm)
Jonson Gallery Collection, University of New Mexico Art
Museum, Bequest of Raymond Jonson, 82.221.0072
(Albuquerque)

Raymond Jonson is best known as a founder of the
Transcendental Painters Group in Santa Fe, New Mexico,
where he settled in 1924 and executed works of pure
abstraction. Before this period of his career, he spent
fourteen formative years in Chicago, and his artistic
experiences in that city were the basis for his later devel-
opment. He was deeply affected by his Chicago mentor,
B. J. O. Nordfeldt (see cat. 63); by the International
Exhibition of Modern Art (Armory Show) when it trav-
eled to Chicago in 1913; and by the five years he spent as
a set and lighting designer for the city's avant-garde Little
Theatre. Jonson traveled to California, Colorado, and
the Southwest numerous times while he lived in Chicago,
eventually concluding that he needed to leave the
crowds, dirt, and chaos of the city for the peace, serenity,

and closeness to nature that he could find in Santa Fe.[1]
Like Wassily Kandinsky, whom he admired, Jonson
thought "one works for emancipation from material. To
be able to live and actually work in the spiritual is of
course a great ideal and one to hope and work for."[2]

In *The Decree*, Jonson applied the attitudes toward sub-
ject matter and form of late nineteenth-century symbol-
ism and the otherworldly color and flattened forms he
learned from designing stage sets and lighting to a western
mountain landscape. In a diary entry written in 1918, the
same year he painted *The Decree*, Jonson wrote, "My
idea is a powerful arrangement of contrasting lines, color
and form to give the sensation of architectural form result-
ing in an emotion of spiritual power and dignity."[3] In *The
Decree*, Jonson abstracted the mountains into geometric
shapes that suggest the forms of skyscrapers, while retain-
ing the decorative, pointillist style that he employed in
other works from this period. The dramatic flash of light-
ning turns the mountains and the undersides of the clouds
a flaming pink, alluding to the supernatural intervention
implied in the title. Jonson's work, originally entitled *The
Storm*, has portentous religious and philosophical subject
matter, suggesting some sort of divine message emanating
from the lightning flash, that he attempts to convey solely
through the relationship of line, color, and shape. SW

47.

George Josimovich
1894–1986

Composition No. 2, 1922
Oil on canvas, 24 x 32 in. (61 x 81.3 cm)
Mr. and Mrs. Harlan J. Berk (Chicago)

Like so many progressive artists who studied at the School of the Art Institute around 1919, George Josimovich was strongly influenced by George Bellows, who was a visiting instructor there for three months that year. A 1929 article credits Bellows with influencing Josimovich to depart "from the academic attitude toward painting which did not satisfy him, and become gradually a strong exponent of the modern movement. . . . His attitude is that every canvas presents a new problem of creation, and the approach to that problem is determined by the emotion evoked by the particular subject at hand. . . . He expresses his emotion through the intense flow of color and form."[1] Bellows's teachings focused on three main principles: truth in expression, color theory, and geometric composition, all leading to unique artistic creations. Bellows told stu-

dents to paint what they knew; he introduced them to the color theories of Denman Ross and Hardesty Maratta, who linked color harmony and musical harmony; and he acquainted them with a variety of compositional theories including Jay Hambidge's dynamic symmetry. In addition, Josimovich worked with Herman Sachs, who taught industrial arts at Hull House, learning a range of practical techniques and decorative, expressive styles.[2]

Composition No. 2, an early example of modernism in Chicago, is the culmination of these influences. The three overlapping nudes are a combination of geometric and organic shapes arranged to create an abstract pattern on the surface of the picture plane. The figures are distinguished from the greenery of the abstracted landscape, which echoes the curvilinear contours of the figures. Josimovich also employed triangular forms, which his roommate, friend, and fellow Sachs employee Emil Armin believed to be a symbol of life.[3] Although Josimovich only worked in this manner for a short time, he remained dedicated to investigating modernist styles, executing forceful, expressionist work characterized by thick, visible brushwork as well as wholly abstract paintings later in his career. CS/SW

48.

A. Raymond Katz
1895–1974

The Argument, 1938
Oil on canvas, 58 x 65 in. (147.3 x 165.1 cm)
Barry and Merle K. Gross (Chicago)

Although A. Raymond Katz was probably best known for the art he created with Jewish themes (often for synagogues or other Jewish settings), he also achieved renown for his murals for the Century of Progress World's Fair in Chicago and various government-supported art projects of the 1930s; for his abstracted compositions in white on black; and for his important Little Gallery, where progressive art was exhibited until the gallery closed in 1933.[1] Based on his early work decorating theater interiors and creating posters for theater owners Balaban and Katz (no relation), he was also prepared to execute the kind of popular narrative that was widespread in the United States in the 1930s.

While showing little interest in social critique, Katz had a deep interest in painting the American scene, as shown in his series of Chicago alley depictions. *The Argument* is a charming example of the sort of scene that was promoted by both the government art projects and by a xenophobic arts community, which saw the glorification of typical American pursuits such as baseball games as appropriate subject matter. Katz depicted a confrontation between members of two opposing baseball teams that is echoed by the spectators in the foreground, probably at Wrigley Field in Chicago. Despite the potentially serious nature of the conflict, Katz emphasized the lighter aspects of the scene through his use of slightly caricatured figures arranged in a large triangle on the picture plane. Katz's work in poster design undoubtedly contributed to his ability to create an inventive, humorous view of a wholesome entertainment that was available to large numbers of people in the midst of the Depression. *The Argument*, extolling the national pastime with its appeal to people of all classes and backgrounds, is a paean to democracy. With its high-keyed color and theatrical brawl, it represented a harmless struggle during a time of both internal and external threat to the country. CS/SW

49.

Paul Kelpe
1902–1985

Construction Relief, 1927
Wood, metal, paint, and board, 17 x 13 x 4 ⅝ in.
(43.2 x 33 x 11.7 cm)
Kresge Art Museum Collection, Michigan State University,
MSU purchase, 73.25 (East Lansing)

Paul Kelpe was trained in his native Hanover, Germany, before immigrating to the United States in 1925. Before he left Germany, he was introduced to the abstraction of such artists as Wassily Kandinsky, El Lissitsky, László Moholy-Nagy, and Naum Gabo. Even more significant for his *Construction Relief*, however, was his exposure to Friedrich Vordemberge-Gildewart, Kurt Schwitters, and other practitioners of constructivism who were working in Hanover.

As an artist whose work, in his own words, "consist[ed] of absolute or abstract painting," Kelpe was an anomaly in Chicago.[1] He was the only artist in J. Z. Jacobson's compendium of modern art in Chicago, published in 1932, to be represented by an abstract work of art.[2] In 1931 Kelpe had a solo exhibition at the Little Gallery in Chicago, where a number of his constructions were exhibited, and, along with the concurrent exhibition of Raymond Jonson's (see cat. 46) work at the Studio Gallery at the Diana Court Building, this was, Kelpe wrote, "the first time that any one-man shows of abstract art took place in Chicago."[3] Despite this, the demand for representational style and narrative subject matter by the Illinois Art Project of the Works Progress Administration (WPA) in the 1930s caused Kelpe to move to New York in 1936, where the administrators of the art projects were much more flexible.[4]

Construction Relief is an elegant combination of abstract painting and found objects that achieves a balanced, ordered, and harmonious world of its own. Joan Marter has argued that Kelpe's constructions of the late 1920s were the earliest examples of such work in the United States, and that they were based on the abstract painting of Vordemberge-Gildewart and on Schwitters's use of found objects to create the combination two- and three-dimensional artwork that characterized the constructivists. Schwitters's work provided Kelpe with a model for his own experimentation with these ideas.[5] Kelpe thought that Schwitters's paint application was too messy, however, and so he used pristine geometry and barely visible brushstrokes in his own composition. He also treated the found objects that he incorporated into his work as abstract elements—unlike Schwitters, who maintained that the original significance of the objects had importance.[6] In *Construction Relief*, Kelpe achieved his aim to transform a "plain rhythmic composition, of spaces and lines, circles, cubes, architectonic forms, and sometimes parts of machinery" into art.[7] SW

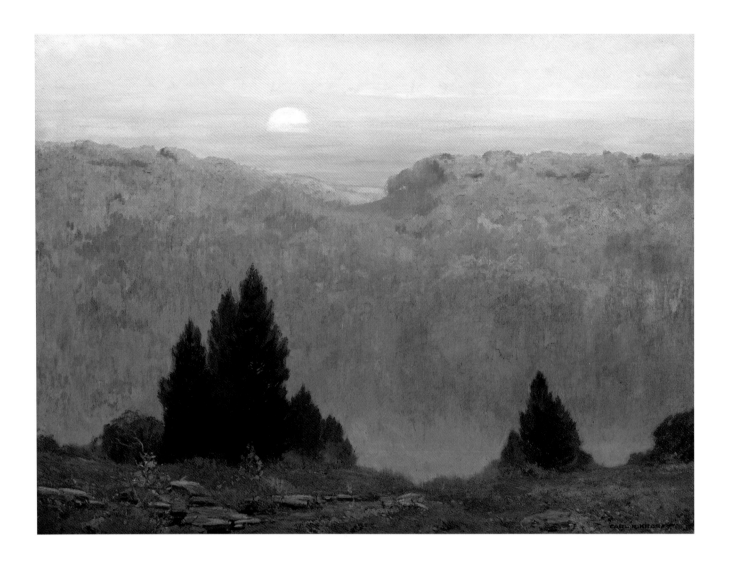

50.

Carl R. Krafft
1884–1938

The Charms of the Ozarks, c. 1916
Oil on canvas, 45 x 50 in. (114.3 x 127 cm)
Collection of the Union League Club of Chicago, UL 1976.33

Carl Rudolph Krafft was supporting his family as a commercial artist when, in 1912, he and fellow painter Rudolph Ingerle first traveled to the Ozark Mountains of Missouri in search of subjects for paintings. Enchanted by the region's dramatic landscape and the delicate color of its hazy atmosphere, they returned the following year, founding the Ozark Society of Painters along with several artists visiting from St. Louis. The appeal of such seemingly uncorrupted landscapes as the subjects of decorative, even escapist portrayals quickly grew in the following years as Europe, the traditional source of landscape subjects, was plunged into war, and as American artists grappled with the challenges of modernism. Krafft painted in the Ozarks, his "cathedral of nature,"[1] for more than two decades.

The Charms of the Ozarks marked a turning point in Krafft's career. Displayed in the Art Institute's 1916 annual exhibition for Chicago-area artists, it was awarded a prize of $500 and was purchased for the permanent collection of the Municipal Art League, a federation of local arts organizations dedicated to civic beautification. This recognition encouraged Krafft to devote more time to painting and brought him local private patronage.

The Charms of the Ozarks probably shows the Arcadia Valley, with its rolling blue and purple ridges, which Krafft enthusiastically described in a 1916 interview.[2] The carefully delineated foreground, with its conifers and scattered boulders, contrasts with the almost magical presence of the distant ridge, softened by intervening haze to a pale mauve. The composition's high horizon emphasizes the apparent depth of the view. Beyond, the rising moon swims in a cloud bank that mimics yet another line of hills, a distant land of the imagination. With its romantic palette, reductive composition, and mood of dreamy reverie, *The Charms of the Ozarks* exalts the native landscape in a virtually pre-Adamic state of purity, an oblique reaction against contemporary realities. This work epitomizes the "imaginative" quality a Chicago critic singled out as characteristic of the "Ozark School."[3] WG

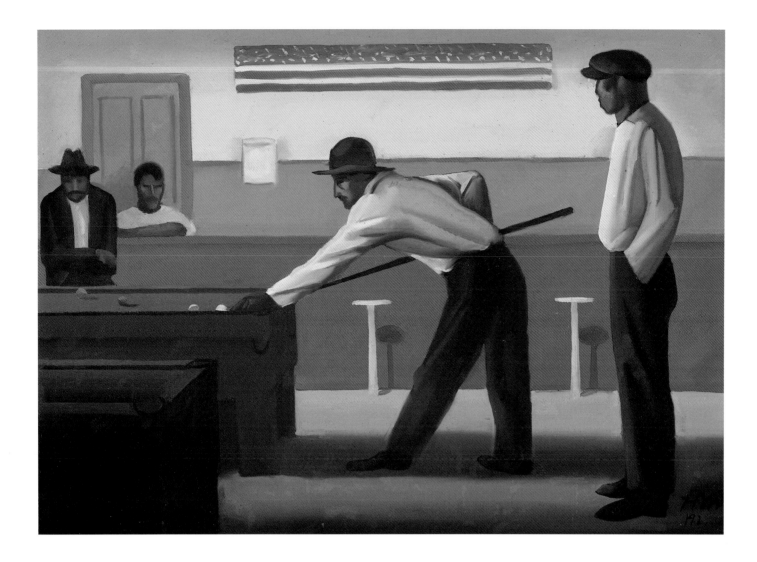

51.

Herman Menzel
1904–1988

Mexican Pool Room, S. Chicago # 2 (with Bunting), 1927
Oil on canvas, 18 ⅜ x 25 ¹¹⁄₁₆ in. (46.7 x 65.2 cm)
Jeanne D. Lutz (Winnetka, Illinois)

Herman Menzel spent much of his life working in isolation, painting both urban and rural scenes that, while enlivened by patterned brushwork and lush color, are also permeated by a silence and calm that may be related to the gradual loss of hearing that left him totally deaf by the time he was thirty.[1] Like his Chicago contemporaries Gustav Dalstrom (see cat. 25), Frances Foy (see cat. 32), and Frances Strain (see cat. 80), he turned his attention to representing scenes of ordinary life in Chicago. In the 1920s and '30s, Menzel executed paintings of people enjoying the urban outdoors—skaters, swimmers, sunbathers, and fishermen—in the celebratory manner of both the earlier Ashcan-school artists and the contemporary American scene painters. At the same time, however, Menzel was also mining the less cheerful world of speakeasies and the Mexican pool halls for subject matter. As the child of German immigrant parents, Menzel grew up speaking German at home and was the object of discrimination during and after World War I. His own experience of marginalization may have contributed to his interest in such subjects.

Mexican Pool Room, S. Chicago #2 (with Bunting) is one of four surviving paintings that Menzel created of this subject.[2] Although a number of the more pessimistic images Menzel did are characterized by a dark palette, the denizens of this pool room are placed against a background consisting of an orange bar, behind which is a green and yellow wall. The contrasting colors, creating a jarring effect, are arranged in broad horizontal bands that resolve into an abstract pattern, evidence of Menzel's modernist style. Although the central figure is about to hit the ball with his cue, the image is suffused with a tense silence, with each of the figures isolated from the others. High on the back wall is an American flag bunting, stretched in a horizontal band echoing the bar and the painted wall. This may convey Menzel's belief that the United States embraced all immigrants and ethnic groups, and that it would ultimately offer even those who were marginalized the opportunity to become part of a free community. SW

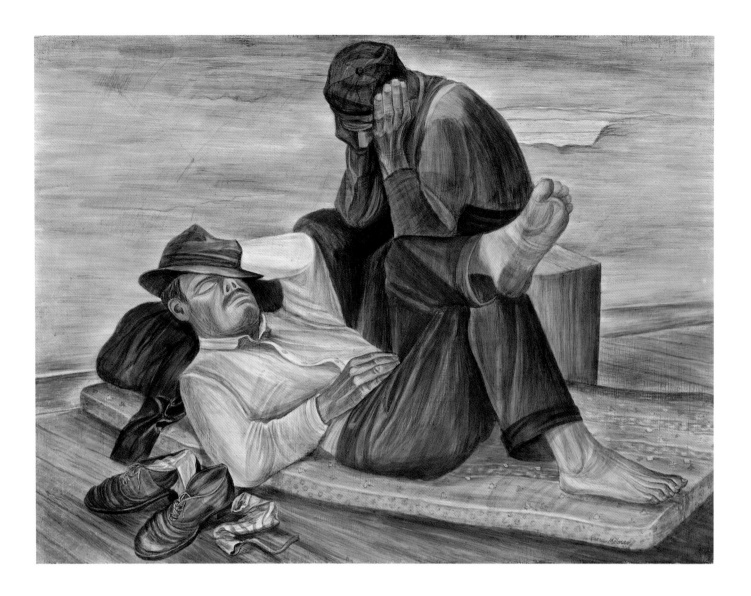

52.

Edward Millman
1907–1964

Flop House, 1937
Tempera on fiber board, 23 x 29 ⅞ in. (58.4 x 75.9 cm)
Smithsonian American Art Museum, Transfer from The
Museum of Modern Art

Edward Millman gained a national reputation as a mural painter based on his work on various government-supported art projects during the Depression. Although he had already executed murals for the Century of Progress Exposition in Chicago in 1933, he went to Mexico to study mural technique with Diego Rivera the following year, attracted by the revolutionary political ideals and style of the Mexican master. When he returned, Millman received numerous commissions from both the Illinois Art Project and the more competitive Treasury Section of Painting and Sculpture awards for post offices in Moline, Illinois (1935), and Decatur, Illinois (1936).[1] In 1939 he and Mitchell Siporin (see cat. 78) were commissioned to create murals for the post office in St. Louis, Missouri—a project worth $29,000, the largest award made by the

United States government.[2] He also served as State Director of Mural Projects for the Federal Art Project in Illinois from 1935–36, and he created murals for the state project in Chicago-area schools, such as those at Lucy Flowers Technical High School, and the Chicago Bureau of Water, in City Hall.

Like many socially conscious artists, Millman was affiliated with Hull House, where he taught fresco painting from 1939–42 and worked regularly in the graphics studio. His commitment to progressive causes was intimately connected to his work as an artist. His painting *Flop House* has been described as "two men, adrift in a sea of unadorned space, anchored only by a wooden box and a mattress, [who] evoke a vision of desperate poverty. Their well-rounded forms have the firmness of rocks, creating a visual metaphor for the leaden hopelessness of their lives."[3] Millman's commitment to clear and readable images does not preclude his reliance on modern techniques: the emphasis on the large, rough hands and feet of the figures conveys their status as workers, while the compressed space suggests the oppression of their daily lives. Like Rivera, Millman's sympathy and respect for these men who are victims of circumstance is evident. AG/SW

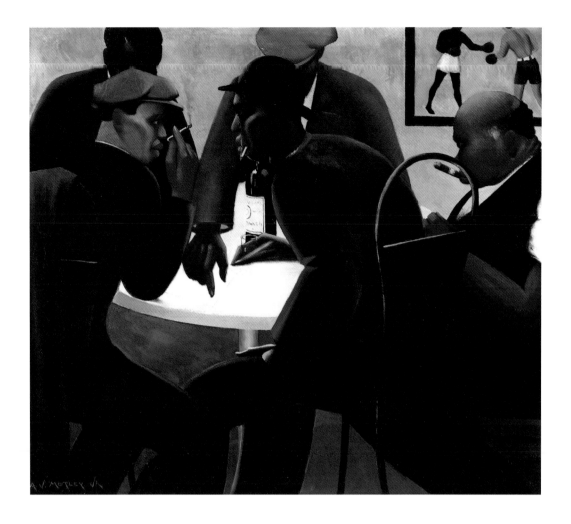

53.

Archibald J. Motley Jr.
1891–1981

The Plotters, 1933
Oil on canvas, 36 x 40 in (91.4 x 101.6 cm.)
The Walter O. Evans Collection of African American Art
(Savannah, Georgia)

Archibald J. Motley Jr. was born in New Orleans, of Creole and African American ancestry. He was an infant when he and his parents moved to Chicago, the city that became his life-long inspiration. After graduating from Englewood High School, Motley attended the School of the Art Institute of Chicago, from 1914 to 1918, where his first year was funded by Frank Gunsaulus, president of the Armour Institute, an egalitarian engineering and architecture college. A popular and respected student, Motley's instructors included John W. Norton (see cat. 64), Karl A. Buehr (see cat. 19), and George Wolcott; in 1919 he returned to take classes with George Bellows.

Motley forcefully advocated that black artists devote themselves to African American subjects in a modern setting. Early in his career, he concentrated on portraits of family members as well as a series of studies of women of mixed racial heritage. As many art historians have noted, Motley was not only fascinated by depicting vari-

ations in the skin tone of his subjects, but his work also reflected social conventions of the age that accorded higher social status to lighter-skinned blacks.[1] After his return in 1930 from a year living in Paris on a Guggenheim Foundation grant—where he expressed homesickness for Chicago—Motley widened his scope to encompass the larger spectacle of the south-side neighborhood of Bronzeville: its dance halls, bars, social clubs, and thriving, around-the-clock street life.

Motley was enthralled with the sporting types and gamblers he observed in bars and pool halls. *The Plotters* brings us to the boundary of a privileged conversation taking place within an obscure, but probably illicit space—such as the back room of a speakeasy or a private social club. The expressions of the two men facing one another across the empty, white space of the table are no more readable that those of their partially obscured companions. The slightly caricatured, stock figures are given heft and credibility through the boldness of their contours and the manner in which their dark forms are set off against the grays of the background. In its novel composition and palette, *The Plotters* is reminiscent of the work of an earlier innovative renderer of urban genre whom Motley admired: the French impressionist Edgar Degas, who was also captivated by the potential strangeness and thrill of modern life at its bohemian fringes.[2] DS

54

55

James B. Needham
1850–1931

54.

Chicago River, Chicago and Northwestern Railroad Station, 1902
Oil on canvas on board, 8 x 6 in. (20.3 x 15.2 cm)
Chicago Historical Society, Gift of Mrs. Joseph Du Canto, 1986.768.8

55.

Chicago Waterfront, 1901
Oil on canvas on board, 5 ⅞ x 6 ½ in. (14.9 x 16.5 cm)
Chicago Historical Society, Gift of Mrs. Joseph Du Canto, 1986.768.15

56.

Sailboat at Dusk, c. 1895–1915
Oil on canvas on board, 6 x 5 ¼ in. (15.2 x 13.3 cm)
Chicago Historical Society, Gift of Mrs. Joseph Du Canto, 1986.768.5

57.

S.S. Seneca, 1903
Oil on canvas on board, 7 ⅞ x 6 ¼ in. (20 x 15.9 cm)
Chicago Historical Society, Gift of Mrs. Joseph Du Canto, 1986.768.19

58.

Steamer at Dock, c. 1895–1915
Oil on canvas on board, 6 ⅝ x 8 ⅛ in. (16.8 x 20.6 cm)
Chicago Historical Society, Gift of Mrs. Joseph Du Canto, 1986.768.4

59.

Tugboat, c. 1895–1915
Oil on canvas on board, 6 x 5 in. (15.2 x 12.7 cm)
Chicago Historical Society, Gift of Mrs. Joseph Du Canto, 1986.768.14

60.

Tugboats, c. 1895–1915
Oil on canvas on board, 8 ⅛ x 12 ⅛ in. (20.6 x 30.8 cm)
Chicago Historical Society, Gift of Mrs. Joseph Du Canto, 1986.768.1

61.

Waterfront at Dusk, 1907
Oil on canvas on board, 5 ½ x 6 ½ in. (14 x 16.5 cm)
Chicago Historical Society, Gift of Mrs. Joseph Du Canto, 1986.768.9

Before a 1997 exhibition revived interest in his career, the work of the African American painter James Bolivar Needham appears to have been almost entirely forgotten.[1] Apart from the mention of his name in an 1895 article, the only known prior reference to the artist was a feature story in the *Chicago Daily News*, published shortly after Needham's death at the age of eighty-one in March 1931.

56

57

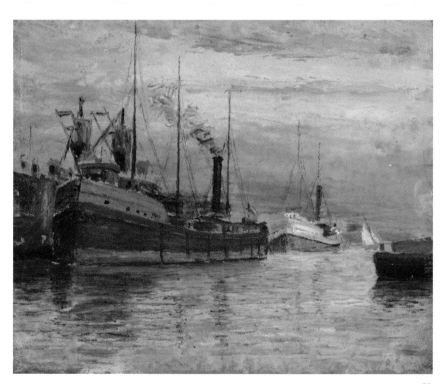

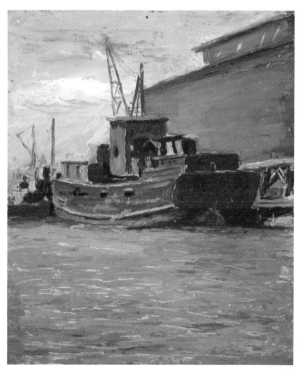

58

59

The author of the illustrated profile reverently portrayed Needham as a shy and humble man who painted purely for his own pleasure. This may well be true, since the artist appears to have been unknown even to the most avid chroniclers of early black artistic achievement in Chicago.

Born in Chatham, Ontario, a terminus of the Underground Railroad, Needham worked on lumber-carrying schooners that sailed the Great Lakes. After his arrival in Chicago in 1867, Needham earned a living as a decorative painter and housepainter and spent his free time painting scenes of the Chicago River, the bustling commercial and maritime heart of the city in the nineteenth century. Although many of his paintings have been destroyed or lost, what remains suggests that Needham was a keen and remarkably sensitive recorder of activity on the river. And, while there is evidence that he received some aca-

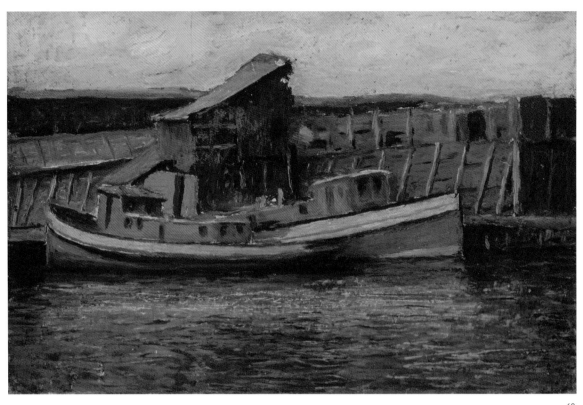

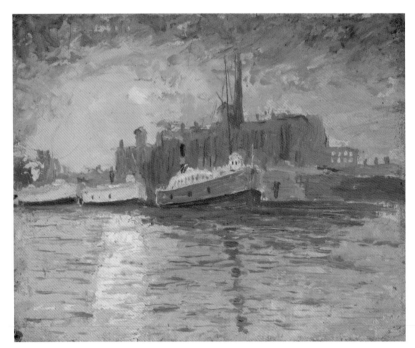

to prevent warping. The craft and ingenuity of these supports bring to mind Needham's early nautical experience: they seem made from the same materials that comprise the subject of his paintings. Only someone who felt completely at home on the river could have painted it with such tenderness. Thanks to the artist's ability to access the river, the viewer penetrates into the scene with him. Needham's pictures are almost all unconventionally and unselfconsciously composed. While many are "portraits" of ships (see cat. 57), others make the viewer who is unfamiliar with activity on the river wonder exactly what the paintings depict. Some represent no activity, such as *Chicago Waterfront* (cat. 55), which shows a lumber barge, probably at Wolf Point where lumber was stacked awaiting loading onto schooners or at a location on the south branch, with its many slips to ease congestion. Even when there is a distinct architectural feature such as the Northwestern Railroad Station, it is shown shunted off to one side, cropped, and minimized. Instead, it was the bow of a tug, a blur of laborers, and an expanse of dock that received Needham's focus (see cat. 54).

demic training, he was not a "view" painter by any means. The river as a subject in Needham's time was not conducive to the view-painter's art. As a vital component of Chicago's phenomenal growth between 1848 and 1900, it was congested, filthy, noisy, and probably quite malodorous.[2] Yet, for all its ugliness, Needham transformed the river into something beautiful through his simple but concentrated powers of observation and transcription.

Most of Needham's works are small in scale and painted on finely woven linen, mounted on panels that are cradled

Painted rapidly but carefully in front of the motif, the small paintings have the freshness and immediacy of French impressionist painting, which Needham could have seen at the Art Institute. If there is a discernable theme or subject that unites his work generally, it is the challenge of rendering the struggle of the sun to shine through the smoke, haze, and muck. One rarely sees pure blue in the sky: it is either a greenish slate gray or shot through from a low sun with vibrant hues of pink, rose, peach, and violet. DS

62.

(James) Harold Noecker
1912–2002

The Genius?, c. 1942–43
Oil on canvas, 30 x 36 in. (76.2 x 91.4 cm)
Collection of Barton Faist (Chicago)

Harold Noecker, whose work has only recently been rediscovered, was trained as an architect, and in the 1930s and early 1940s he lived and worked in Chicago, where his "mysterious poetic subject matter" found a welcome home.[1] Noecker worked in a realistic manner, combining familiar objects in ways that are ultimately haunting and enigmatic. His paintings include subjects typical of the period—small-town streetscapes, houses, and churches—with quirky twists. Often rendered with extreme foreshortening, his paintings feature houses that are isolated and sometimes given the appearance of stage sets in which the facades have nothing behind them. Noecker also sometimes included a rushing figure or a hissing snake, ratcheting up the mystery of the scene.

While reminiscent of the work of surrealists such as René Magritte and Giorgio de Chirico, *The Genius?*, exhibited at the 47th Annual Exhibition of Artists of Chicago and Vicinity in 1943, is also related to the work of Chicagoan Gertrude Abercrombie (see cat. 1). Perhaps because of the resonance between their works, Noecker and Abercrombie were given a joint show in the room of Chicago art—a space dedicated to rotating exhibitions of local artists—at the Art Institute of Chicago in 1944. Critic Frank Holland described them as "well-known Chicago painters [who] both use imaginative fantastic subject matter to create haunting eerie pictures that have a curious dreamlike other-worldness about them."[2]

In *The Genius?*, a seated figure sits in an austere interior, and a curtain is drawn back to reveal the scene, giving it a theatrical aspect. The upper part of the figure's face, which is turned to the viewer, is deeply shadowed so that the eyes are not visible; blindly, he works on a drawing of a simple stick figure. The only objects in the room are an arrangement of greens and flowers on the table next to him, a simple bed, and a picture on the wall, which looks like one of Noecker's own deserted streetscapes. An opening in the back wall offers some release, revealing a deep, but uninhabited, landscape. Like Abercrombie, who often depicted interior spaces and used the "picture-in-a-picture" technique seen in *The Genius?*, Noecker created a room that resonates with the interior life of the artist. SW

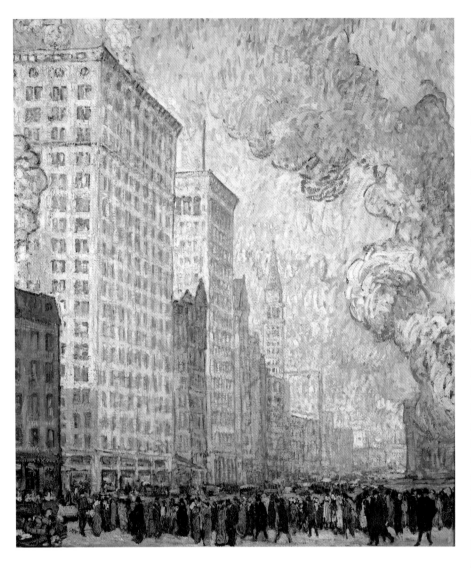

63.

B. J. O. Nordfeldt
1878–1955

Chicago,[1] 1912
Oil on canvas, 41 ½ x 35 ¾ in. (105.4 x 90.8 cm)
Weatherspoon Art Museum, The University of North Carolina at Greensboro, Gift of Mr. and Mrs. W. S. Weatherspoon in memory of Elizabeth McIver Weatherspoon, 1969, 1969.1638

Bror Julius Olsson Nordfeldt spent several extended periods of time in Chicago beginning in 1899, when he attended the School of the Art Institute, and he later lived in the outbuildings of the World's Columbian Exposition of 1893, which became the heart of the vital 57th Street Artists' Colony. Although he spent a relatively short time in the city, his influence was enormous, as a set designer for the radical Little Theatre and the teacher of Raymond Jonson (see cat. 46), and as a modernist working in Chicago before the International Exhibition of Modern Art (Armory Show) of 1913 came to the Art Institute.

In 1912, following shows of modernists Jerome Blum and Arthur Dove in 1911 and 1912, respectively, at W. Scott Thurber's gallery in the Fine Arts Building, Nordfeldt had two successful solo exhibitions in Chicago. The first one, at Albert Roullier's gallery, included a series of paintings of Chicago, while the second, at Thurber's gallery late in the year, featured radical portraits that represented a real departure from his earlier work.[2] Although *Chicago*, almost certainly one of the group of eight Chicago scenes exhibited at Roullier's, does not look radically modern today, this and other paintings in the show were perceived quite differently in 1912.[3] Some critics were indignant, while others, such as Harriet Monroe, called the paintings "the most ambitious and successful pictorial interpretation of Chicago which has been achieved as yet."[4]

While works such as Nordfeldt's *The Electric Sign*, also exhibited in the 1912 show, are radically modern images of the industrial city, *Chicago* retains some of the idealized and romanticized qualities that characterized representations by more traditional painters. Unlike them, however, Nordfeldt emphasized the rushing crowds and the skyscrapers dwarfing the people crossing the street at the corner of Michigan Avenue and Adams Street. The silvery gray tonality, billowing smoke, and broken brushstrokes all contribute to create a sense of the vigor of the dynamic modern metropolis on a cold winter morning. CS/SW

64.

John Warner Norton
1876–1934

Study for *Ceres*, 1930
Oil on board, 40 ⅛ x 11 ½ in. (101.9 x 29.2 cm)
Private Collection of John Norton Garrett (Houston, Texas)

John Warner Norton successfully bridged the gap between conservative ideals and modern impulses in Chicago's early twentieth-century art world.[1] A product of the traditional pedagogy at the Art Institute of Chicago, beginning in 1910 he became one of the school's most progressive teachers. Norton helped transform mural painting, the artistic field most resistant to change, into a contemporary art form through his work for such innovative projects as Frank Lloyd Wright's Midway Gardens and the Century of Progress Exposition.

Norton's success as a mural painter lay in his stylistic adaptability and his sensitivity both to specific architectural setting and local cultural context. In the late 1920s, he collaborated on decorative programs for major commercial and civic buildings designed by the Chicago architectural firms Holabird & Root and Graham, Anderson, Probst, & White, pioneer designers in the modern style known as Art Deco. For such projects as the 1929 Chicago Daily News Building, Norton created murals similarly characterized by Art Deco features such as flat, stylized forms, rhythmic, linear patterning, and geometric abstraction.

Commissioned to execute a large, vertical mural to decorate the south wall of the main trading floor of Holabird & Root's new Chicago Board of Trade Building (1930), Norton chose a single, monumental figure: Ceres, the Roman goddess of grain.[2] He experimented with treatments influenced by archaic Greek art and African-inspired cubism.[3] As this final study indicates, however, he settled on an eroticized semi-nude whose powerful physique is reminiscent of traditional personifications of fertility and plenty. Dramatically lit from below as if by the golden glow of the various grains at her feet, Ceres strides toward the viewer, clutching a sheaf of wheat in her right hand while dropping coins from her left. Classical in her elegant simplicity and balanced but asymmetrical pose, she also reflects the streamlined, stylized aesthetic of contemporary design. Norton further updated this symbolic image of grain in a backdrop of silhouetted skyscrapers representing Chicago, the city created from the rewards of human mastery over nature's bounty. WG

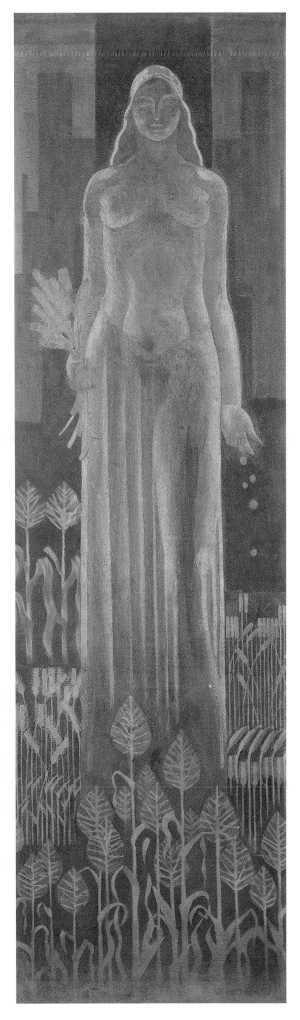

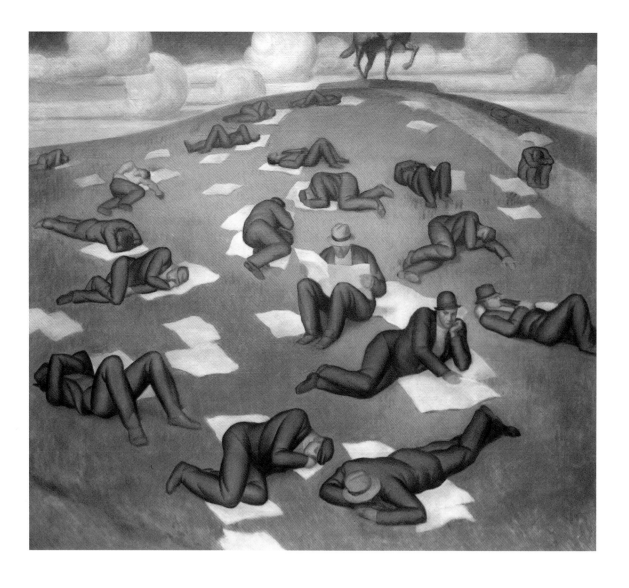

65.

Gregory Orloff
1890–1981

Men on Hill Reading Newspapers, undated
Oil on canvas, 36 x 40 in. (91.4 x 101.6 cm)
Mr. and Mrs. Harlan J. Berk (Chicago)

Gregory Orloff's recently rediscovered oeuvre reveals a body of work that is characteristic of Chicago modernism in its combination of technical proficiency, interest in narrative, and elements of both social concern and fantasy. In addition to portraiture, Orloff executed typical American scene paintings of rural life, many done for the Federal Art Project during the Depression. Like Frances Foy (see cat. 32), Gustav Dalstrom (see cat. 25), Herman Menzel (see cat. 51), and others, he painted the parks and beaches of Chicago in a celebratory way. In addition to these pleasant images, Orloff created scenes in which African American and Caucasian children mingle on the stoops of typical Chicago residences, as well as a series of scenes of nightclubs, restaurants, and public entertainments that may have been inspired by the Century of Progress World's Fair of 1933.

Men on Hill Reading Newspapers is an image of a group of out-of-work men dressed in brown suits and caps or fedoras, arranged in various poses on a park's hill that is topped with an equestrian statue (only partially visible at the top of the canvas). Orloff's sturdy, heavily outlined figures are typical of realist work of the period, and, while all of the elements in the composition are readily identifiable, they are combined in a way that creates a disturbing unease. The repetition of brown-suited figures suggests the extent of unemployment during this period, giving the feeling of an unending and anonymous group of dispossessed people who are either homeless or suffering a defeat that makes them incapable of action. Aside from the two central figures, all of the men are resting or sleeping. The patterning of the figures and the elegant, stylized clouds visible above the hill resolve into an abstract pattern. It is clear from this painting that Orloff is "more interested in the manifestations of life as it is lived by the great mass of mankind than by the select few."[1] Orloff's combination of abstraction, social critique, and an eccentric, slightly surreal attitude reflects the work of other Chicago artists from this period. An artist of versatility and great skill, Orloff's achievements await further study. SW

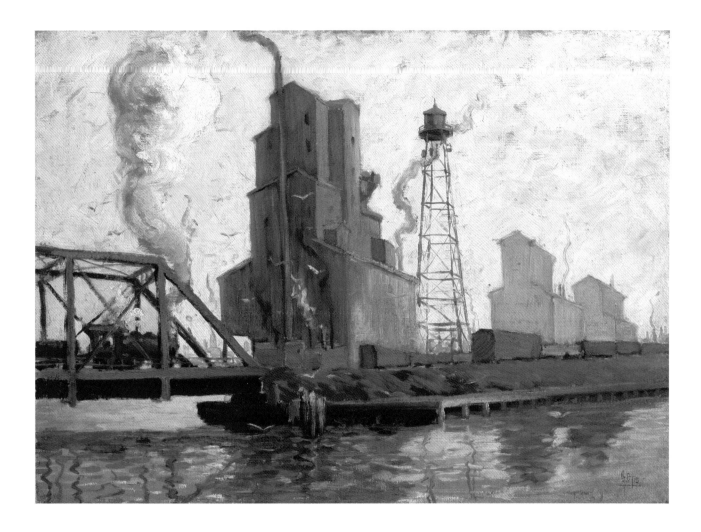

66.

George Demont Otis
1879–1962

Grain Elevators, Goose Island, undated
Oil on canvas, 18 x 24 ³⁄₁₆ in. (45.7 x 61.4 cm)
Chicago Historical Society, 1970.153

In the 1910s the artistic portrayal of Chicago expanded beyond scenes of the city's parks, downtown waterways, and streets to include industrial sites. Such subjects symbolized not only Chicago's historic character as a broad-shouldered hub of transportation, processing, and manufacturing but modernity itself. Urban and industrial landscapes challenged artists to develop new stylistic vocabularies with which to represent the stark reality of a man-made but sometimes dehumanizing world. Some responded by abstracting, distorting, or exaggerating forms to express the essence of modern life; others developed a contemporary realism, using a variety of techniques to enliven conventional pictorial values for reportorial or romantic effects.

The painterly informality of George Demont Otis's undated *Grain Elevators, Goose Island* suggests the influence of Robert Henri, one of his teachers, and his friend John Sloan; both were leaders of the circle of New York artists, known as the Ashcan school, who around the turn of the century pioneered a modernist realism rooted in urban imagery.[1] Otis also studied with impressionist painter William Merritt Chase; in this work, Otis's fantastic, even playful palette prefigures the colorful, light-filled impressionist landscape paintings he executed in California, where he moved in 1919 after spending much of his early career in Chicago.[2]

By the early twentieth century, Goose Island, a man-made island in the north branch of the Chicago River, was dominated by manufacturing and processing facilities and the rail yards of the Soo Line.[3] This view shows the northern tip of the island, where an iron truss bridge carries freight tracks across the river just south of North Avenue. An arriving locomotive sends up a billowing plume of steam. It is echoed by wispy columns of smoke issuing from the elevator buildings ranged like sentinels into the hazy distance, their drab facades tinted with pastel tones in the late-afternoon light. The broken surface of the river and the gulls flapping in the sky on the upper left provide additional elements of animation to counter the stolid presence of the massive grain elevators. Otis's sympathetic treatment of this artificial, utilitarian landscape offers neither critique nor celebration but rather an almost fanciful interpretation of a familiar yet alien world. WG

67.

Pauline Palmer
1865–1938

The Morning Sun, c. 1920
Oil on canvas, 50 x 40 in. (127 x 101.6 cm)
Courtesy of Rockford Art Museum (Rockford, Illinois)

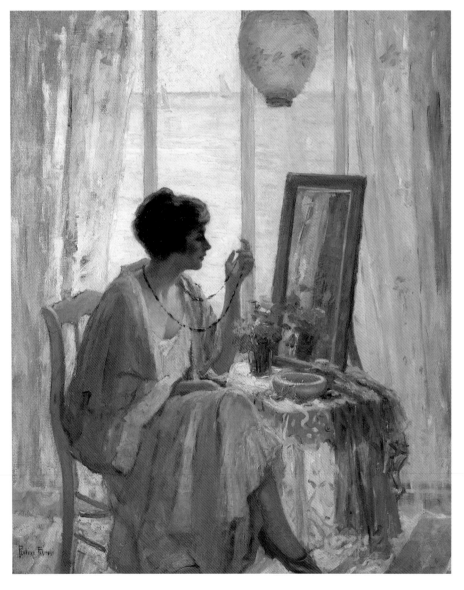

The theme of the pretty woman in a sun-filled interior appealed strongly to American impressionist painters, who exploited the combined effects of sunlight, pleasing color, a variety of textures, and evocative objects and interiors. The similarity between Pauline Lennards Palmer's *The Morning Sun* and the works of Karl Buehr (see cat. 19), another member of the group of American painters who worked together in Giverny in the early 1910s, was not lost on one reviewer.[1] In the 1920s Palmer painted several interpretations of this subject, inspired by the bright light and leisure setting of Provincetown, Massachusetts, on Cape Cod, where she spent increasing periods of time beginning in 1920. *The Morning Sun* probably was painted there, as suggested by the high horizon of a calm, sail-studded sea, partly screened by diaphanous curtains, that forms the image's backdrop. This thinly and sketchily rendered setting, punctuated by the hanging paper lantern—a touch of *japonisme* echoed in the sitter's kimono-style dressing gown—recall the works of James McNeill Whistler. But the fashionable coif and ease of gesture of the young woman silhouetted against the morning sun, as well as the cropping of the figure at the picture's lower edge, unmistakably imprint Palmer's image with an air of modernity.

Palmer was an early adherent of impressionism, with which she remained associated throughout her long career. She was a versatile artist whose portraits, figural works, landscapes, and still lifes in oil, watercolor, pastel, and tempera met with critical as well as commercial success. Palmer also pioneered women's leadership of artists' organizations; at the time she painted *The Morning Sun*, for example, she was serving as the first female president of the Chicago Society of Artists. Palmer's stature as an upholder of traditional artistic values was undoubtedly fixed in 1913 when her first one-person exhibition at the Art Institute of Chicago opened at the same time as the notorious Armory Show.[2] Locally, the ferment that followed that introduction of artistic modernism climaxed around the time that Palmer painted *The Morning Sun*. This work, admired as "extremely lovely" by one critic,[3] affirmed Palmer's adherence to a "sane" progressivism for many Chicagoans. As Palmer argued in 1920, "The artist must keep in touch with all the new movements, but retain sanity and not be swept away by any new school of art or adopt its theories before making a careful study of its ideas and products."[4] WG

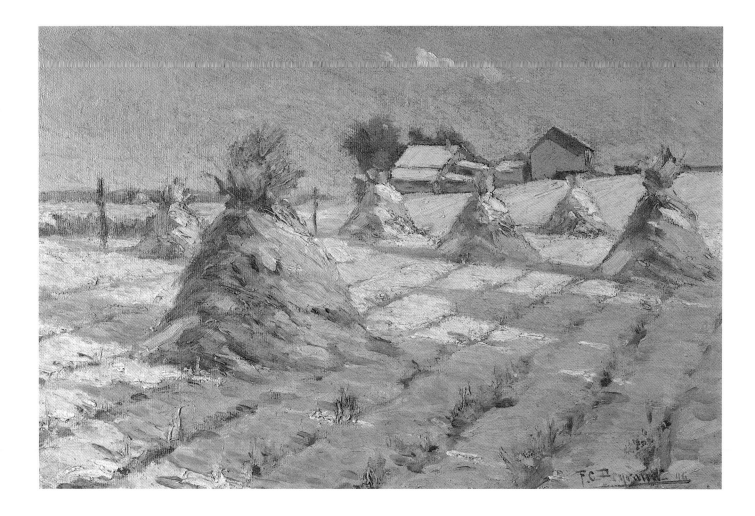

68.

Frank C. Peyraud
1858–1948

Winter Light on the Farm,[1] 1896
Oil on canvas, 12 x 18 in. (30.5 x 45.7 cm)
The Marshall Collection (Peoria, Illinois)

In the years following Chicago's World's Columbian Exposition of 1893, impressionism emerged as a distinctly modern mode in American art. Impressionism was more than an artistic style characterized by brilliant light effects and rapid, broken brushwork. As an expression of direct, everyday experience, it validated a growing search for a distinctly national art. For observers such as writer Hamlin Garland, the Midwest, with Chicago as its capital, seemed the obvious site for the development of a modern American art, and impressionism seemed the idiom of an authentic indigenous cultural expression.

Swiss-born and trained as an architect, Frank Charles Peyraud was a successful painter of murals and cycloramas (in-the-round murals) in Chicago in the late 1880s and '90s. As a landscape painter, however, he was the most successful of the progressive Chicago painters who experimented with impressionist approaches in the years following the exposition. Critics appalled by radical

impressionism's seeming amorality and repudiation of technique lauded Peyraud's "valid impressionism."[2] Technically unadventurous, his paintings were a revelation for their poetic interpretation of the prosaic landscape of rural Illinois.[3] His unpeopled scenes of farm fields and prairie meadows, often depicted at sunset, were painterly in brushwork and delicately tinted, evoking a timeless sense of reverie and the implication of universal truths embedded in the humble, local setting.

Sketchlike in its intimate scale and facile brushwork, Peyraud's 1896 farmland scene evokes the crystalline atmosphere and fleeting light of a waning winter afternoon. His subject recalls French impressionist master Claude Monet's serial paintings of haystacks in fields under varying conditions of light and weather. In contrast to orthodox impressionism's seemingly unedited recording of optical effects, however, Peyraud's "valid impressionism" evinces a creator's control over composition and mood. Receding furrows, which draw the eye toward the distant farm buildings nestled on the high horizon, are balanced by the subtle thrust of the scattered haystacks and by the long, purple shadows they cast. The late-afternoon setting not only offers dramatic contrasts of subtle color but also reinforces the elegiac mood of a winter scene redolent of abandonment and dormant expectation. WG

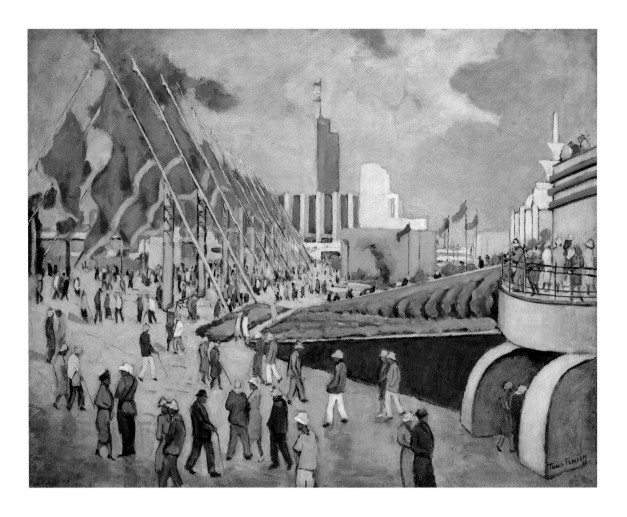

69.

Tunis Ponsen
1891–1968

untitled (Century of Progress, World's Fair),
c. 1933–34
Oil on canvas, 24 x 30 in. (61 x 76.2 cm)
Collection of the Union League Club of Chicago, UL2000.3

Tunis Ponsen came to the United States from Holland in 1913, settling along with many other Dutch immigrants in the western Michigan town of Muskegon.[1] He continued to build upon the study of art he had initiated in Holland, taking classes at the Hackley Art Gallery (now the Muskegon Museum of Art) while working as a house-painter. By the time he moved to Chicago to attend the School of the Art Institute in 1924, he had had a good deal of training and experience. In Chicago he studied with the traditional artist George Oberteuffer as well as the New York realist Leon Kroll, who was a visiting professor the year Ponsen arrived. While much of Ponsen's work consists of pleasant, uncomplicated landscapes or figure studies, executed with the technical proficiency so valued at the School of the Art Institute, he seems to have effortlessly crossed over into the area of a bold, modernist style when it suited him.

The Century of Progress World's Fair in Chicago celebrated the advent of modern technology and the sleek, geometric, machine-derived aesthetic associated with it. Ponsen was invited to show his work in the Century of Progress International Exhibition of 1933–34 held at the Art Institute, and, like numerous artists, he was motivated to execute a series of paintings of the fair, all of which can be securely dated to 1933–34.[2] In this untitled work, Ponsen adopts some of the simplified forms and large, flat color areas associated with precisionism to create a brilliantly colored representation of the fair's main thoroughfare, the Avenue of the Flags, with the Hall of Science in the distance. In addition to paintings of the fair itself, Ponsen did a series of urban scenes at this time, perhaps inspired by the style promoted by the fair. Among his most modernist paintings, they represent the industrial city, with its skyscrapers, bridges, and elevated structures reduced to their essential geometric elements. Unlike some of his contemporaries who glorified the built environment of the modern city to the exclusion of its inhabitants, however, Ponsen almost always humanized his paintings by including people. Here, the brightly colored figures hurrying around the fairgrounds pick up the color of the flags and the buildings around them and enliven and energize the image. SW

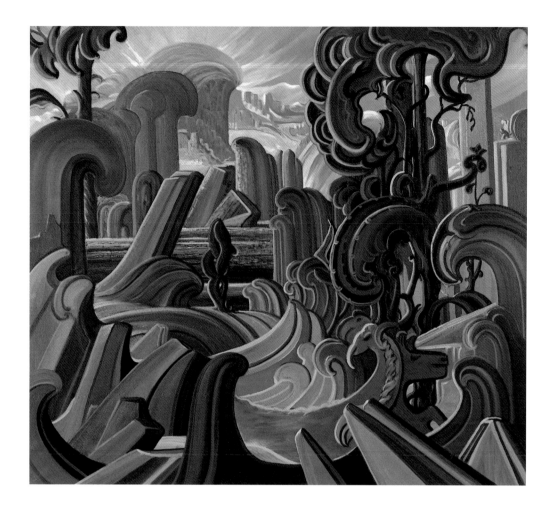

70.

Harvey Gregory Prusheck
1887–1940

Lunar Landscape, 1920
Oil on canvas, 36 ½ x 40 in. (92.7 x101.6 cm)
Jonson Gallery Collection, University of New Mexico Art
Museum, Bequest of Raymond Jonson, 82.221.1197
(Albuquerque)

Little is known about Harvey Gregory Prusheck, a peripatetic artist who lived in Chicago in the 1920s and early '30s, exhibiting regularly in the No-Jury Society of Artists exhibitions and at the Annual Exhibition of Artists of Chicago and Vicinity. Unlike many of his Chicago contemporaries, he experimented with abstraction, executing a number of wholly non-representational paintings in the early 1920s, including a controversial futurist-inspired work (*The Storm*) at the first No-Jury exhibition in 1922. *Sunrise*, exhibited in the second No-Jury show in 1923, and *Cactus*, exhibited in a solo exhibition at the Milwaukee Art Institute in 1929, are closer to the organic abstraction of *Lunar Landscape*.[1] By the early 1930s, his work became more representational, characterized by simplified, blocky houses in stylized landscapes.

Like some of his other abstractions, *Lunar Landscape* seems to have been inspired by visits to the desert landscape of the southwestern United States, to which Prusheck, a "lover and believer in Nature," was very attracted.[2] Ordered like a natural scene, with a sense of organic growth emerging from the ground, sky above, and other landscape elements in the distance, *Lunar Landscape* is a wildly imaginative distortion of reality. Shapes that look like something viewed through a microscope, growing underwater, or coming from some completely unknown realm, dominate the image. *Lunar Landscape* is painted in the blue that dominated much of Prusheck's work, which the artist related to his proximity to the sea while growing up. One critic noted that "he sees this world in terms of blue—bright blue, somber blue—but always blue."[3] Artist-theorist Wassily Kandinsky associated blue with the spiritual, suggesting that the use of blue in painting "calls man toward the infinite, awakening in him a desire for the pure and, finally, for the supernatural. It is the color of the heavens, the same color we picture to ourselves when we hear the sound of the word 'heaven.'"[4] Whether or not he was familiar with Kandinsky's theory, Prusheck's contention that "the motivating spirit in my work is the hope and wish that I may help others see and feel the beauty which I see and feel.... If the spirit of art could be disseminated widely it would be a great help in building a more noble future for the world," suggests a similarity in outlook.[5] SW

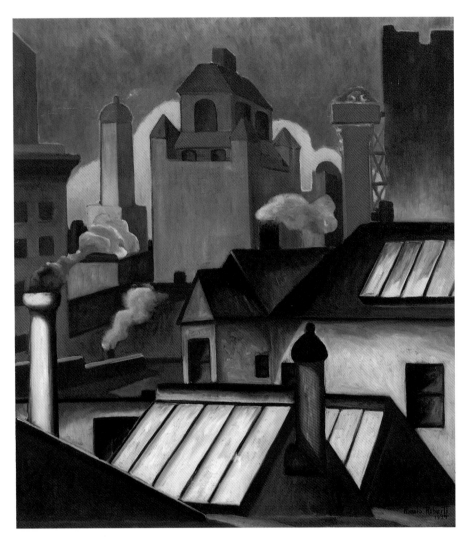

71.

Romolo Roberti
1896–1988

Roofs (Tree Studios), 1934
Oil on canvas, 34 x 30 in. (86.4 x 76.2 cm)
Western Illinois University Art Gallery (Macomb, Illinois)

A year before painting *Roofs (Tree Studios)*, Romolo Roberti stated, "My duty is to paint and to continue to express whatever I find to be of profound interest in life."[1] This may account for the range of styles and subjects that he, like many of his Chicago contemporaries, painted. In addition to precisionist cityscapes such as *Roofs*, Roberti did still lifes, portraits, and paintings of imagined mythic and pagan subjects that share the eccentricity and interest in fantasy of many local artists.

The subject of *Roofs* is a view of the rooftops of the Tree Studios, a building, conceived in 1894 by the philanthropist Judge Lambert Tree and his wife, Anna Magie Tree, consisting of artists' studios and commercial spaces that helped keep the studio rents low. Hoping to attract and keep artists in Chicago in the wake of the success of the 1893 World's Columbian Exposition, the Trees financed the construction of the building on land behind their mansion on Wabash Avenue between Ohio and Ontario Streets. The studios were arranged around an open courtyard and had skylights and large windows to capture the limited sunlight available in Chicago. They were home to generations of artists in Chicago, including Macena Barton (see cat. 10, 11), Karl Buehr (see cat. 19), Ruth van Sickle Ford, Rowena Fry (see cat. 33), John Warner Norton (see cat. 64), Pauline Palmer (see cat. 67), and John Storrs. Roberti lived in the Tree Studios in the 1920s and '30s.[2]

Roberti's view of Chicago over the skylit roofs of the Tree Studios is a cubist-inspired view of the modern city, emphasizing the clear, geometric forms of the skyscrapers rising above the repeated slanting glass roofs of the studios. The positive view of the industrialized city as a place of promise and optimism is also apparent in Ramon Shiva's *Chicago MCMXXIV* (cat. 77) and Jean Crawford Adams's *View from the Auditorium* (cat. 2). Unlike the social critique seen in the work of other artists of this period, however, Roberti's painting uses the architectural framework of the idealistic artists' community in which he lived as a metaphor for a belief in a future free of travail, grime, and distress. AG/SW

72.

Gordon St. Clair
1885–1962

Entrance to Xanadu, c. 1915
Oil on canvas, 54 x 38 ½ in. (137.2 x 97.8 cm)
Mr. and Mrs. Harlan J. Berk (Chicago)

Little is known about Gordon St. Clair, but his work is linked to Chicago contemporaries, particularly Rudolph Weisenborn (see cat. 87), Ramon Shiva (see cat. 77), and Raymond Jonson (see cat. 46). Based on the few works that can be examined, St. Clair worked in a decorative symbolist manner, combining literary, narrative subject matter with an inventive style. As an active member of the Palette and Chisel Club and the Chicago Society of Artists and as a resident of the Tree Studio Building, he was an established member of the art community in Chicago.[1]

The Palette and Chisel Club, founded in 1895 by a progressive group of artists, was a fairly conservative group by the 1910s. In the period between 1913 and 1919, however, Palette and Chisel members began to experiment with various modernist styles, including pure abstraction and pointillism. A series of exhibitions and events showcased these works. St. Clair's pointillist technique and reliance on a palette of deep purple-blues and pinks, employed in *Entrance to Xanadu*, is similar to that employed by Jonson, Weisenborn, and Shiva during the 1910s and early 1920s.[2]

In 1919 St. Clair was awarded an honorable mention at the Art Institute's Annual Exhibition of Works by Artists of Chicago and Vicinity for a painting called *Song at Dusk*. A reviewer said of this work that it "is executed somewhat after the pointellist [sic] method, a fact which is only to be noted, however, on careful inspection. The fascination of the work is to be found in its fancifulness and the little sharp accents of light and color."[3] This could apply to the monumental *Entrance to Xanadu* as well, considered by St. Clair himself as one of his most important paintings.[4] It is a symbolist fantasy with literary roots, based on Samuel Taylor Coleridge's *Ballad of Kubla Khan*, in which St. Clair uses modern technique in an inventive way. The "stately pleasure-dome/. . . Where

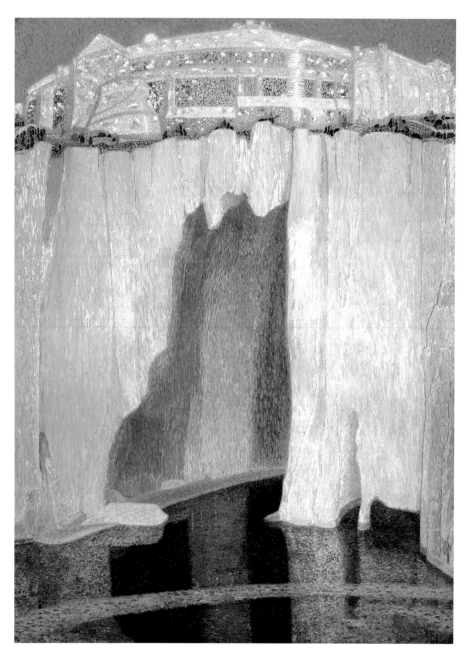

Alph, the sacred river, ran/Through caverns measureless to man" is painted in small strokes and dots of fanciful color, creating a hallucinatory scene that resonates with the poem. The pleasure-dome is visible atop the huge cliffs through which the river meanders. His work can be seen as a progenitor of the fantasy art that flourished in Chicago in the 1920s and '30s. SW

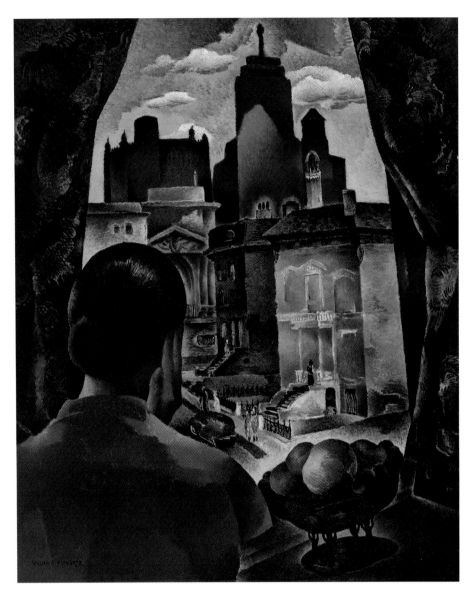

73.

William Schwartz
1896–1977

From Window #29, 1937
Oil on Masonite, 30 x 24 in. (76.2 x 61 cm)
The Keys Collection, Waterford, Michigan 010,
Courtesy of Richard Norton Gallery (Chicago)

In addition to abstractions linked with music, William Schwartz painted almost every conceivable subject: portraits, landscapes, still lifes, allegories, nude and clothed figure studies, scenes of Jewish life in the *shtetl* of the "old country" and in the ethnic neighborhoods of his adopted Chicago, and scenes of small-town and modern urban America. He employed a modernist vocabulary of fauve-derived, high-keyed color and cubist-derived angular shapes. In the words of his biographer, Manuel Chapman, Schwartz used these techniques in an effort to "liberate forms from nature which in turn would liberate the souls of the beholders. True art he felt was spirit informing matter; always it transmuted the particular material into a higher form. He was fired with the vision of bringing redemption, light and glory to the low, humble, and oppressed."[1]

Schwartz was a longtime resident of the Near North Side of Chicago; in the 1930s he lived in a studio home at 102 East Hubbard, above Riccardo's restaurant, a popular gathering place. This studio and its immediate surroundings appear in many of his paintings of the period, including *From Window #29*. In this painting, Mona Turner, whom Schwartz married in 1939, is seen from behind, the cityscape spreading out before her through the opened curtains. By combining the figure with the still life arranged on the windowsill, and by showing a cityscape with both low-rise neighborhood structures and skyscrapers in the background, Schwartz showed his extraordinary skills in all of these genres. His technical mastery and modernist bent is also evident in the distorted, crowded forms of the buildings and in the slightly tilted fruit bowl, all of which communicate the sense of industrial modernity and vibrant activity characteristic of the contemporary city.

Although Schwartz often addressed the humble and oppressed in his work, this painting is much more characteristic of the celebratory American scene painting of the 1930s, suggesting his impressions of the American city when he arrived as a young immigrant. In 1970 he recalled his early days: "No one had told me I could expect to come upon such fresh and moving subjects for brush and canvas. No one had hinted at the variety of the American landscape, at the range and richness of American coloration, at the number and interest of themes on every hand. I have spent most of my life painting my response to the American scene."[2] AG/SW

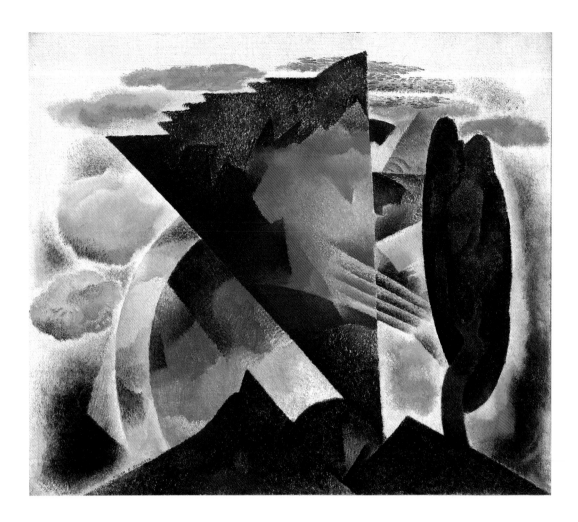

74.

William Schwartz
1896–1977

Symphonic Forms No. 6, c. 1932
Oil on canvas, 29 ½ x 26 in. (74.9 x 66 cm)
Collection of Clifford Law Offices (Chicago)

William Schwartz was one of the most prolific and versatile artists among Chicago progressives in the first half of the twentieth century. His rebellious nature was evident early on, as reflected in the story told by his biographer, Manuel Chapman, about the blue-and-green nude Schwartz created in a class at the School of the Art Institute in 1916—because "only those colors responded to his inner necessity."[1] As a professionally trained tenor who was able to support himself with his singing, Schwartz was particularly sensitive to the relationship between music and visual art.[2] By the late nineteenth century, analogies between music and painting were widespread and were often used to justify pure abstraction in painting. Although abstraction was not popular among Chicago artists, Schwartz experimented with nonfigurative art while simultaneously producing more traditional representational images. As early as 1924 he began the series of sixty-six abstract paintings he called "symphonic forms," which are dependent on formal relationships of line, shape, and color, and he continued to execute them until his death.[3] He exhibited a group of them, which included *Symphonic Forms No. 6*, for the first time in 1935, where they were described by curator Daniel Catton Rich as revealing "a freedom of emotion, resourcefully harmonized and controlled into effects that may be named symphonic."[4]

Symphonic Forms No. 6 is one of a large number of abstractions Schwartz executed in the early 1930s. While some of the "symphonic forms" are pure abstractions, this one is clearly based upon a landscape: mountains, clouds in the sky, and a large tree on the right side of the canvas are all identifiable, albeit drastically generalized. Lawrence Lipton's 1932 analysis of Schwartz's work is applicable to *Symphonic Forms No. 6*: "He does not abandon subject; he extracts from all possible subjects—figures, trees, clouds, mountains, planets—their essential forms and uses them to picture the visual content of the mind during the composition of music. It is the pictograpy of musical sensation."[5] Schwartz sought the harmony of pure form, but always in the service of a higher purpose. Like the painter-theorist of abstraction, Wassily Kandinsky, Schwartz believed that his abstract paintings would communicate directly with the viewer, saying, "Viewing these paintings is like listening to music, but it is the spectator who 'makes' the music."[6] AG/SW

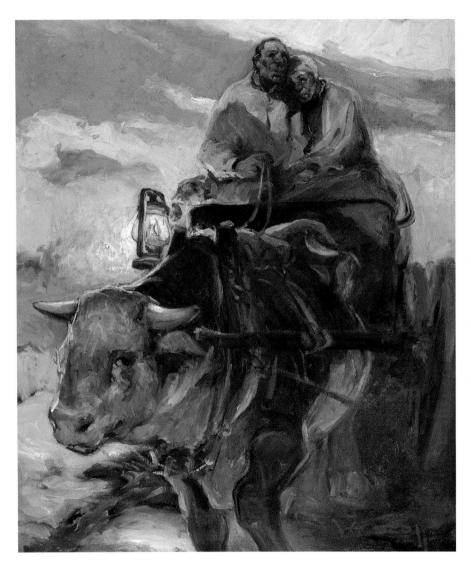

75.

William Edouard Scott
1884–1964

Traveling (Lead Kindly Light), 1918
Oil on canvas, 22 ⅛ x 18 in. (56.2 x 45.7 cm)
Huntington Museum of Art, Gift of Mrs. Virginia Van Zandt
(West Virginia)

A prolific mural painter, portraitist, and award-winning exhibitor in both France and the United States, William Edouard Scott was considered the "dean" of African American painters in Chicago. After showing great promise in art at Manual High School in his hometown of Indianapolis, Indiana, Scott entered the School of the Art Institute of Chicago in 1904. He graduated in 1907 but continued to take courses until 1909. Before leaving for his first study trip to Paris, Scott gained attention locally by painting a mural that was purchased for the Public School Art Society by the noted Chicago philanthropist Kate Buckingham. Still installed at Lane Technical High School today, it was the first of what would be scores of murals Scott painted for public buildings and churches in Chicago, Indianapolis, and Washington, D.C.

Between 1909 and 1914, Scott made three trips to France. Like William Harper (see cat. 41) before him, Scott studied with Henry Ossawa Tanner, as well as at the academies Julien and Colarossi in Paris. Upon his return, Scott was sought after by prominent black leaders Booker T. Washington and W. E. B. DuBois to represent African American subjects. DuBois commissioned Scott to create several covers for the National Association for the Advancement of Colored People (NAACP) publication, *The Crisis. Traveling (Lead Kindly Light)*, created for the Easter 1918 issue, is painted in Scott's typical buttery impasto and rich palette. Depicting an elderly, exhausted, but determined couple driving an oxcart through the night, *Traveling* literally and metaphorically engages the theme of the difficult journey of African Americans toward a better life. Throughout his long career, Scott maintained his focus on black life and themes. He was a regular exhibitor in exhibitions of African American artists supported by the Harmon Foundation, a philanthopic organization dedicated to the recognition of black achievement in the arts. In 1931 Scott was awarded a Julius Rosenwald grant to paint the life and landscape of Haiti. DS

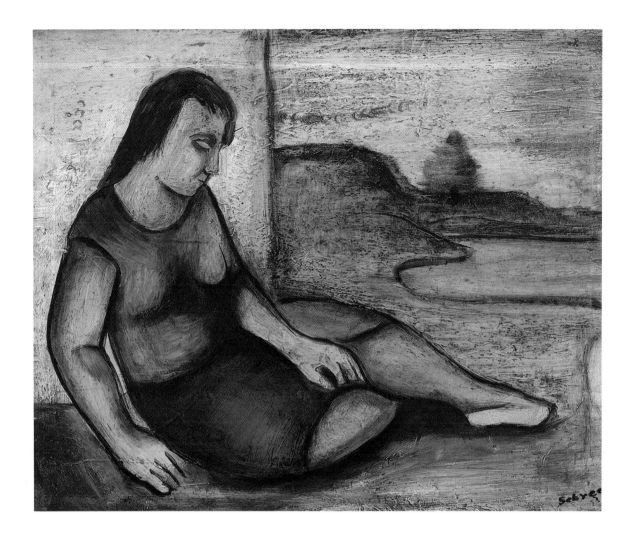

76.

Charles Sebree
1914–1985

untitled (Seated Woman), 1938
Oil on canvas, 21 ⅞ x 25 ⅝ in. (55.6 x 65.1 cm)
Laurie and Alan Reinstein (Highland Park, Illinois)

Born in a small town in eastern Kentucky, Charles Sebree arrived in Chicago with his mother at the age of ten. A prodigy, he was encouraged in art by a teacher at Burke Elementary School. Sebree attended Saturday lectures at the Art Institute of Chicago with Englewood High School classmates Charles White (see cat. 88), Eldzier Cortor (see cat. 24), and Margaret Burroughs. Sebree and his friends were students of George Neal, the artist whose informal Bronzeville studio classes formed the basis of the Arts Crafts Guild. The young artists were also frequent visitors to the integrated loft-salon of Katherine Dunham, the University of Chicago anthropology student and modern-dance pioneer. Through Dunham and her circle, Sebree became interested in theatrical production, design, and writing.

Sebree, whose work was less directly inspired by daily life in the Black Belt than that of his colleagues, became the darling of the white bohemian artistic community in Chicago. He showed at the Renaissance Society at the University of Chicago, whose charismatic director, Incz Stark, later taught poetry at the South Side Community Art Center, and at the Katharine Kuh Gallery, which highlighted the latest trends in European modernism.

This untitled painting of a seated woman, which was once owned by Kuh, exemplifies Sebree's trademark imagery of dreamy, idealized youth, both male and female. Reclining before a Leonardesque landscape, the robust and heavily outlined figure is patterned after modern masters such as Pablo Picasso, Max Beckmann, and Georges Rouault. The technique of building up the image by applying tint over and into a heavily impastoed layer of paint imparts an aged, frescolike appearance. Sebree's romanticized neo-primitivism and acceptance by the predominately white gallery world were looked upon with suspicion—and, in the case of his success, with envy—by his colleagues who painted the local Bronzeville scene but were unable to penetrate the white-dominated mainstream art market. DS

77.

Ramon Shiva
1893–1963

Chicago MCMXXIV, 1924
Oil on canvas, 53 x 50 in. (134.6 x 127 cm)
Mr. and Mrs. Harlan J. Berk (Chicago)

Ramon Shiva arrived in Chicago, after an itinerant youth spent in Spain, Greece, Turkey, and Panama, in time to see the International Exhibition of Modern Art (Armory Show) at the Art Institute in 1913. He later declared that seeing the exhibition persuaded him to give up the idea of pursuing commercial art in favor of devoting his talents to painting. He also decided to make his living apart from art, so that he would not be forced to sell his work to support himself.[1] With these goals in mind, Shiva found a menial job in a lithography shop as a "paper boy"—pushing carts of paper to the pressmen. Since he had some technical training and experience as a chemist, combined with an interest in art, when ink became scarce during World War I he was asked to develop colors that

could be used for printing Liberty Bond posters.[2] Shiva's success in developing the brilliant and long-lasting inks necessary for this project spurred experimentation that led to the development of Shiva Artist Oil Colors. Initially formulated in his bathtub, these high-quality paints became so in demand among local artists that he soon needed to move the operation to a real factory, which was located on Goethe Street in Chicago for many years. Shiva devoted an increasing amount of his time to the paint business, and less to his painting, but he fulfilled his objective to not work as a commercial artist or sell his work to survive.

Chicago MCMXXIV, which was displayed at the 1924 Chicago No-Jury Society of Artists exhibition, is a reflection of the range of rich colors developed by Shiva. The simplified, geometric treatment of the industrial landscape is softened and romanticized by the warm, lush hues and imaginative brushwork. Like New York artist Charles Sheeler or Chicagoans Jean Crawford Adams (see cat. 2) and Romolo Roberti (see cat. 71), Shiva celebrated the promise of the new industrial city and the belief that technology would aid in making a better world. AG/SW

78.

Mitchell Siporin
1910–1976

Homeless, 1939
Oil on canvas, 30 x 40 in. (76.2 x 101.6 cm)
Private collection

As the son of an immigrant union organizer, Mitchell Siporin was introduced to ideas of social responsibility early in life. He began his career working on the Federal Art Project, executing many murals for both the Illinois Art Project and the competitive Treasury Section of Painting and Sculpture, for which he was awarded the commission for the St. Louis post office murals in 1939. He and Edward Millman (see cat. 52) spent three years working on this project, the largest mural commission outside of Washington, D.C., inspired by the modernist style and commitment to social ideals of Mexican artists Diego Rivera and José Clemente Orozco. Siporin's interest in social issues was evident from the beginning of his career, when he did illustrations for the radical journal the *New Masses* and a series of sensitive and powerful drawings documenting the events of the Haymarket Riot

of 1886. He was also an artist who saw the Midwest as a newly fertile source of meaningful art, "only now bringing forth the artists who will reveal the physiognomy and the meaning of their place."[1]

Siporin's easel paintings are no less dedicated to the plight of the dispossessed, impoverished, and marginalized than his more public works. In *Homeless*, a group of ragged figures with their meager belongings huddle in the corner of a ruined, roofless structure. The patch of land on which they stand seems to float in space, reflecting the unmoored physical and psychic state of the figures. Combining the expressive use of color and space with surrealism, Siporin suggested the dislocation of these people. While his murals clearly address the plight of Americans in the Depression, such easel paintings from the late 1930s and the 1940s can be seen to speak more generally to world events. In *Homeless*, which is similar to a painting entitled *Refugees*, also executed in 1939, Siporin's figures might as easily refer to those fleeing oppression in Europe as to the destitute in the United States. Siporin's work represents one of the art world's most consistent and forceful visual responses to social inequity. SW

79.

Willard Grayson Smythe
1906–1995

Abstraction, 1943
Oil on canvas, 39 ⅜ x 28 ½ in. (100 x 72.4 cm)
Shane Qualls (Cincinnati, Ohio)

Although Willard Grayson Smythe was executing abstract paintings in the early 1930s, he found a community in a group called the New Bauhaus, which emerged in the later part of the decade. Abstract artists did not flourish in Chicago, where the taste tended much more to figuration, narrative, and works of art that were clear and readable. While the early non-representational works of Chicagoan Manierre Dawson (see cat. 27) may have been the earliest abstract paintings executed in America, his departure from the city in 1914 left no followers. Despite occasional experiments with pure abstraction, the art community of Chicago did not foster or support such work until the late 1930s, when László Moholy-Nagy established the New Bauhaus and the School of Design (later the Institute of Design) in the city. These institutions were concerned primarily with design and design education, but Moholy-Nagy maintained a personal interest in fine arts, producing abstract paintings and nurturing a group of like-minded painters and photographers.[1]

After completing his studies at the School of the Art Institute of Chicago, Smythe joined the faculty there, teaching from 1929 to 1973, while at the same time maintaining an active practice as an art director for various publications. He achieved success as both a graphic designer and a fine artist, participating in many exhibitions at the Art Institute and elsewhere, including the important Abstract and Surrealist American Artists exhibition in 1947. He rejected Moholy-Nagy's invitation to join the New Bauhaus faculty, apparently preferring the independence he enjoyed as an instructor at the Art Institute.[2]

Smythe developed a compositional theory that he called "Scattered Balance Design" in which he "combined both geometric and organic elements with various flat and textured forms."[3] In *Abstraction*, he employs rectilinear geometric forms, blocks of color, and pure line to create a balanced and dramatic composition set against a background of flat, brilliant pink and red. Smythe's work represents a strand of Chicago painting that is too often overlooked. SW

80.

Frances Strain
1898–1962

Four Saints in Three Acts, Introducing
St. Ignatius, 1934
Oil on canvas, 36 x 30 in. (91.4 x 76.2 cm)
Courtesy of Michael Rosenfeld Gallery, New York

By the 1930s, Frances Strain was well established as an artist in Chicago, with links to a number of modernist groups.[1] She lived in Hyde Park with her artist-husband Fred Biesel and began her association with the Renaissance Society at the University of Chicago, where she became exhibition director in 1941. In this position, which she held until her death, Strain worked tirelessly to bring art of all periods to the public. She was particularly dedicated to introducing contemporary American and European artists to a wider audience, and she always included locals in the exhibitions she organized. She studied with George Bellows and Randall Davey at the School of the Art Institute of Chicago, and through them she met Ashcan-school artist John Sloan, with whom she had a lifelong relationship. These artists emphasized personal expression, which Strain valued throughout her career. She said: "It is necessary for me to have a definite image from which to work . . . [but] . . . I try to concern myself more with what the subject means to me than with its appearance."[2]

Coinciding with the 1934 visit of Gertrude Stein and Alice B. Toklas to Chicago, at which time Stein lectured at the University of Chicago, the opera *Four Saints in Three Acts*, with a libretto by Stein and music by Virgil Thomson, was staged at Chicago's Auditorium Theater.[3] The work was a surrealist drama in four acts that employed an all African American cast for the first time in a work unrelated to African American life. The ostensible story is of religious life in sixteenth-century Spain, but it is really a metaphor for the artistic lives of Stein and Thomson.[4] The prologue to the opera, on which this painting is probably based, consists of a choral introduction to the saints. In Strain's painting, St. Ignatius Loyola occupies center stage and is being introduced to the audi-

ence by the Compere and Commere who flank him, while a group of figures in the background are in active poses, dancing and praying. The background looks as if it is the painted backdrop for the scene, with its stylized palms and rows of white-garbed angels. Although Strain generally painted in progressive styles, ranging from the Ashcan-derived realism of her urban scenes to images that have the thickly applied and brilliantly colored paint characteristic of expressionism, she occasionally executed works, such as this one, that have a surreal quality. CS/SW

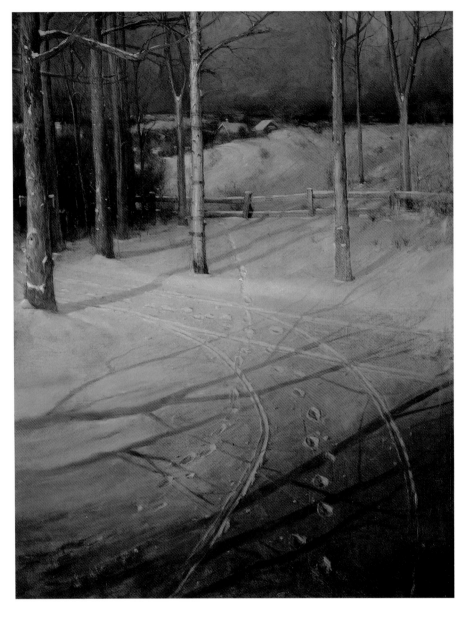

81.

Svend Svendsen
1864–1934

Winter Sunset in Norway, 1897
Oil on canvas, 43 x 32 ¾ in. (109.2 x 83.2 cm)
Collection of the Union League Club of Chicago, UL1906.1

Svend Svendsen was a Norwegian-born painter who arrived in Chicago in the early 1880s to work as a lithographic artist. In 1895, just as impressionism was making a stir in the city, one of his snow scenes won a prize at the Young Fortnightly competitive exhibition at the Art Institute of Chicago, launching the artist's fame.[1] For the next few years, Svenden's landscapes, particularly his moonlight and twilight snow scenes, were "perilously popular," according to one observer.[2] Lauded as "half impressionistic and half realistic, but wholly true," they represented what local critics described as a thoroughly modern approach to landscape painting, not only for their bold, even exaggerated color and freedom of handling, but also for the directness and freshness of their interpretation of nature.[3]

Winter Sunset in Norway was a product of one of Svendsen's several visits to his native Norway, where the wintertime landscape yielded subjects for many of his paintings. This particular work demonstrates Svendsen's ability to evoke understated drama from an ostensibly simple scene of peaceful rusticity. Here, tree trunks and a snowy expanse of rural ground frame a cluster of cottage roofs in the background. The seemingly static composition is subtly charged with narrative, however. Footprints, marking a way barred by the fence, lead into the background, defying the path of converging tracks of horse-drawn sleighs curving off to the left. From behind the viewer, a low, midwinter sun tinges the snowy foreground with eccentric color, while unseen trees cast long, purple shadows at the lower left. These signs of otherwise unseen figures, sun, and trees lend *Winter Sunset in Norway* an unexpectedly disquieting air. WG

82.

Stanislaus Szukalski
1895–1987

Rudolph Weisenborn, 1919
Charcoal on paper, 23 ¼ x 18 ½ in. (59.1 x 47 cm)
Mr. and Mrs. Harlan J. Berk (Chicago)

Stanislaus Szukalski was an idiosyncratic artist whose behavior endowed him with an almost mythic status. In the decade or so that he spent in Chicago, he exerted an enormous influence on the artistic community there by performing the role of radical artist—disdaining institutions and the canonical art of the past—while producing sculpture and drawings that combined a high level of technical refinement with peculiar subject matter. In 1924 he returned to his native Poland, taking his entire oeuvre with him. Most of his work was destroyed there during World War II.

Szukalski's portrait of his artist-friend Rudolph Weisenborn (see cat. 87), which remained in Chicago, escaped the fate of his other work. Szukalski's penetrating depiction of his friend is executed with the skillful technique that he employed in all of his work, despite his open rejection of art schools. The subject is more traditional than most of his politically charged images, although there are hints of the planar faceting and distortions that appear in his sculpture and in some drawings at this point in his career. Weisenborn's head is placed to the right side of the composition, leaving a large empty space on the left, a compositional device that Weisenborn adopted in the numerous portrait drawings that he produced in the 1920s. According to contemporary reports, Szukalski "forced Weisenborn to sit for him in a cold room from 2 a.m. till morning and Weisenborn loved the completed picture."[1] Weisenborn is represented in the guise of a monk, presumably to suggest his role as the visionary artist who will aid, in Szukalski's words, in the "making of a new civilization."[2] SW

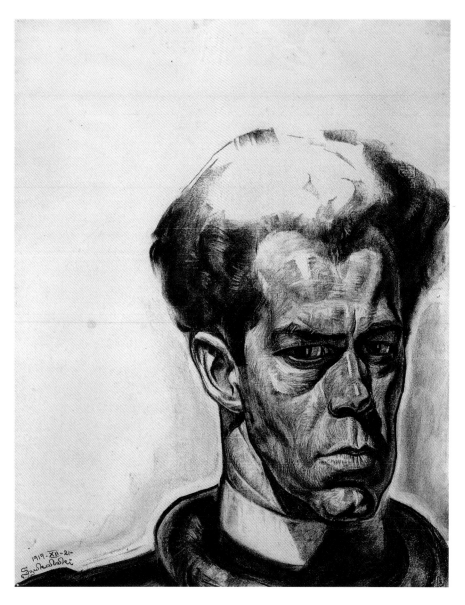

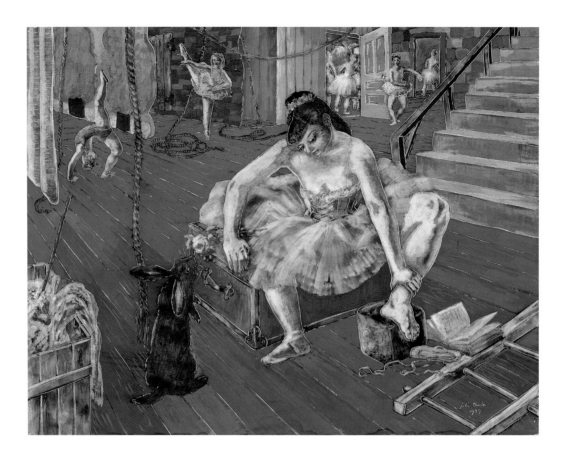

83.

Julia Thecla
1896–1973

Bunny Backstage, 1939
Opaque watercolor on cardboard with gesso ground, 20 x 25 in.
(50.8 x 63.5 cm)
Collection of the Illinois State Museum, 1943.16/912.11
(Springfield)

Julia Thecla's work, variously categorized as fantastic or surrealist, is part of the strong tendency toward imaginative and dreamlike images that blossomed in Chicago in the 1920s and '30s. Thecla was a well-known character in the city, identified by her odd way of dressing and childlike persona, and she lived alone in a tiny apartment with an assortment of animals, including a chicken and a rabbit.[1] She used an original technique in which she rubbed through the top layer of a thickly applied, opaque watercolor surface to create a smudged, mottled surface that was often crossed by delicate, scratched lines. Using these techniques in combination with imagery that included an odd assortment of objects, disembodied hands, and hybrid creatures, Thecla created work that is uniquely evocative. Like her contemporaries Ivan Albright (see cat. 3) and Gertrude Abercrombie (see cat. 1), with whom she shared an attitude toward art-making, Thecla made concrete visions of her inner reality.

Bunny Backstage is one of a series of paintings of ballet dancers that Thecla began in the late 1930s and contin-

ued to do throughout the 1940s and '50s, perhaps under the influence of her friendship with dancer/choreographer Berenice Holmes and her student, Mary Guggenheim, who served as the model for many of Thecla's paintings (including *Bunny Backstage*). Thecla even designed sets and costumes for several of Holmes's ballets.[2] While mysterious and idiosyncratic, *Bunny Backstage* is not as eccentric as some of the artist's work, perhaps because it was painted for the Illinois Art Project of the Works Progress Administration, which often motivated artists to produce more mainstream images. Even within those constraints, however, *Bunny Backstage* reveals Thecla's innovative style and fertile imagination.

Thecla situated her anomalous, somewhat clumsy, ballerina in a backstage area in which other dancers are visible, practicing and preparing for a performance. The central figure has removed one shoe to massage her sore foot, which rests on a large die on which there is a club, diamond, and heart. The mottled surface of the flesh and clothing, the brilliantly colored blue wood floor that unifies the image, and the large bunny seated at attention near the ballerina's feet are the strangest aspects of the composition. All of these elements reappear in various ways in other work by Thecla, attesting to their personal importance to her. The introspective ballerina, seemingly unaware of the misplaced rabbit or the rest of her surroundings, is characteristic of Thecla's fantasy imagery and is representative of this tendency in Chicago painting of this period. AG/SW

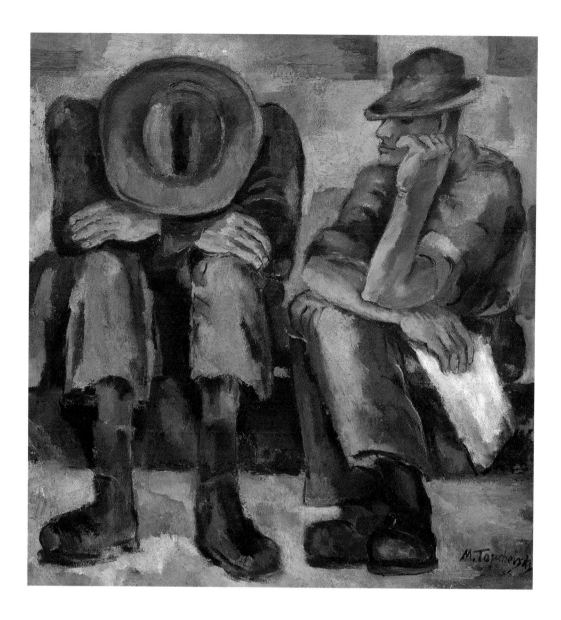

84.

Morris Topchevsky
1899–1947

Unemployed, undated
Oil on canvas, 27 ½ x 29 ½ in. (69.9 x 74.9 cm)
Private collection

Morris Topchevsky had a profound commitment to issues of social justice, a passion ultimately stemming from his experience of oppression in Poland, where he spent his first eleven years. Unable to understand why his family's Judaism would elicit such loathing from his neighbors, who were otherwise nice individuals, he was sensitized early to hatred based on stereotypes.[1] Topchevsky developed into a radical, joining the Artists' Union and serving as secretary of the Chicago branch of the politically leftist American Artists Congress, among other activities. He studied, worked, and taught at Hull House and at the Abraham Lincoln Center on the South Side of Chicago, where he served a largely African American constituency. He influenced many art students

at the center, including Charles White (see cat. 88), transmitting to them his passion and belief in art as a way to change the world.

Late in 1924, Topchevsky made the first of many trips to Mexico, where he "worked under the stimulating influence of Diego Rivera," although not directly with the artist.[2] Inspired by Mexican culture and by the revolutionary public art he saw there, Topchevsky returned to Chicago in 1926 where he produced compelling works that embodied the concerns of the powerless. Like the Mexican artists he admired, Topchevsky used a modernist stylistic vocabulary to convey the plight of the subjugated, marginalized, and helpless in the most forceful and sympathetic terms possible. In *Unemployed*, the profound desolation of the two "everyman" figures seated on the curb is conveyed through angular forms, compressed space, and minimal detail. In this painting, Topchevsky began to realize his ambitious aspiration to create work that "will be a means of helping the revolutionary movement of this country and the liberation of the working masses of the entire world."[3] AG/SW

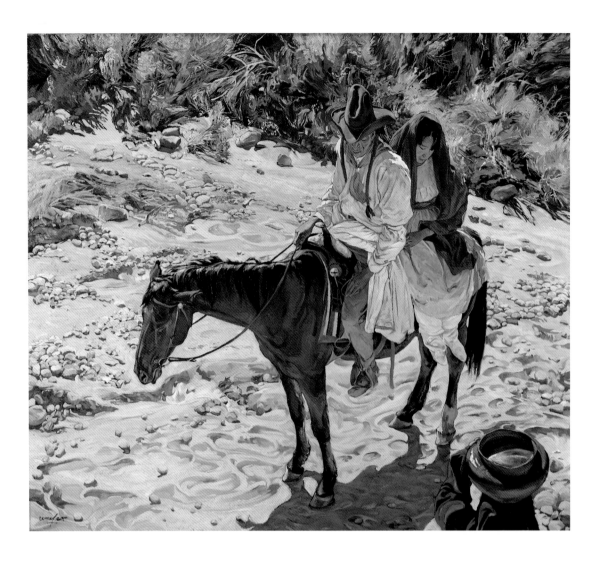

85.

Walter Ufer
1876–1936

Near the Waterhole, 1921
Oil on canvas, 36 ½ x 40 ½ in. (92.7 x 102.2 cm)
Collection of the Union League Club of Chicago, UL1976.51

In the early twentieth century the American Southwest emerged as an important site for the development of a realist modern art that was consciously independent of European avant-garde precedents in spirit, subject matter, and style. A place of indigenous exoticism, stark visual contrasts, and brilliant natural light, the Southwest was also an increasingly popular tourist destination for Midwesterners. Walter Ufer was one of several Chicago-based artists who began working in New Mexico in the mid-1910s. They were directly supported by a group of wealthy midwestern patrons and by a Chicago municipal organization, the Commission for the Encouragement of Local Art, founded in 1914 to both patronize local artists and beautify the interiors of public buildings.[1]

Many artists perpetuated the image of indigenous peoples as a dying race by showing Native Americans engaged in traditional customs and rites. Ufer, however, presented the Indian realistically as a contemporary denizen of his world, at the urging of his Chicago patrons. He applied the strong draftsmanship, bravura brushwork, and broad treatment of detail of his Munich training to native figural subjects rendered with startling realism heightened by powerful contrasts of sunlight and shadow.

By the time he painted *Near the Waterhole*, Ufer had begun to experiment with ambitious compositions that combine figures and landscape elements.[2] This almost square, horizonless painting is among his most innovative. The viewer looks down from an elevated position onto the shadowed figures of Jim Mirabel, the artist's friend and favorite model, and a woman on horseback; a third figure, truncated at the lower-right corner of the composition, bears on her head a clay vessel filled with water from the nearby but unseen waterhole.[3] Ufer's vigorous delineation of the figures, their clothing, and the body of their mount is continued in the restless, print-marked surface of the pebble-strewn sandy ground and its upper border of gray-green desert scrub. The exaggerated realism of Ufer's technique together with the picture's unconventional viewpoint impart an unmistakable air of contemporary reportage to an ostensibly traditional subject, tempered with the tension of intrusion into an alien culture. WG

86

Frank R. Wadsworth
1874–1905

A River Lavadero, Madrid, undated (c. 1905)
Oil on canvas, 30 ¼ x 36 ¼ in. (76.8 x 92.1 cm)
Collection of the Union League Club of Chicago, Gift of the
estate of Sarah F. Wadsworth, 1940A.4.2

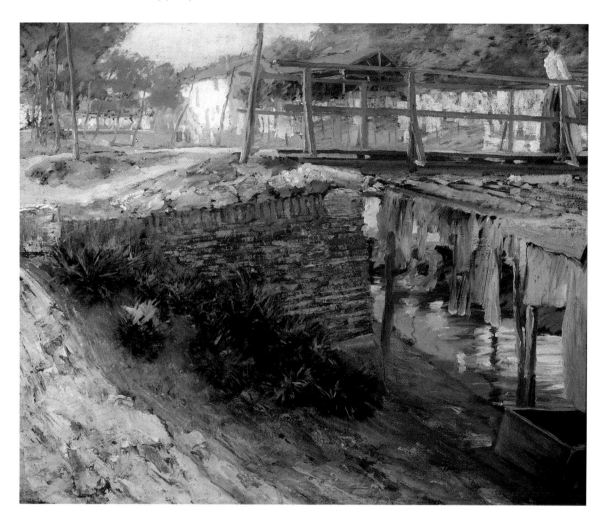

Between 1895 and his premature death in 1905, Francis Russell Wadsworth was highly regarded by both critics and fellow artists for his landscapes and figural works. Wadsworth's "delicate touch upon picturesque facts" and the "gay color and eager, buoyant spirit" of his paintings of gardens and river vistas epitomized the modified impressionism that found favor in Chicago beginning in the late 1890s.[1] Wadsworth studied and worked with the esteemed American impressionist painter and teacher William Merritt Chase in New York and in Europe.

On his final trip with Chase to Spain, where he died, Wadsworth painted Madrid's quaint waterways in several works. He was particularly drawn to the site of a riverside public *lavadero,* or laundry, and executed at least three views of its rickety footbridges, its stream banks blanketed with hanging laundry, and the washerwomen who used it.[2] The quotidian nature of the laundry makes it a typically impressionist subject. In this example, the oblique perspective and active brushwork, reminiscent

of Chase, further impart an air of spontaneity and immediacy. Indeed, *A River Lavadero, Madrid* does not picture the laundry so much as it exploits the scene to create an independent composition. The image focuses on the brick foundation of a wooden footbridge, clumps of spiky greenery, and muddy ground that slants precipitously toward the river below. The objects that identify the painting's ostensible subject, meanwhile, are flattened and crowded almost to the point of distortion: the laundry's buildings and the lines draped with drying white fabric are pressed against the high horizon in the distance, and the forms of two laundresses—one kneeling over her washing by the stream's edge, the other carrying a basket as she crosses the bridge at the upper right—are almost lost in the scene. Preoccupied with composing rather than representing, Wadsworth anticipated the decorative impressionism that would occupy many American painters in the coming two decades. WG

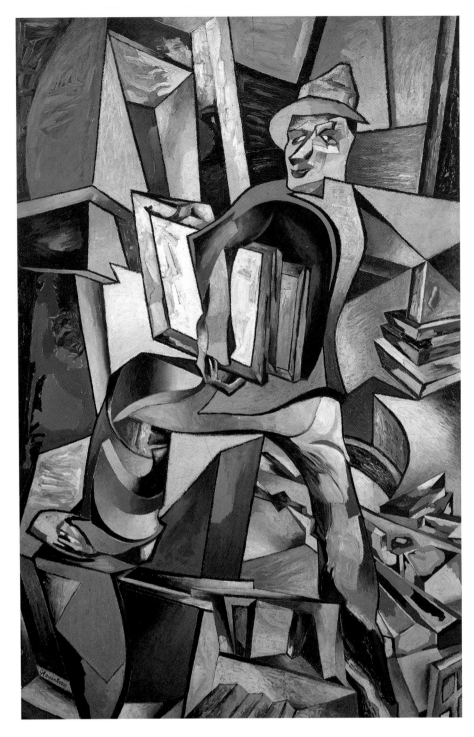

87.

Rudolph Weisenborn
1881–1974

The Artist in the City (The Chicagoan),
1926–27
Oil on canvas, 72 x 47 ½ in. (182.9 x 120.7 cm)
West and Velma Weisenborn (River Forest, Illinois)

After studying art for four years in Denver, Colorado, in 1913 Rudolph Weisenborn arrived in Chicago, where he spent the rest of his long life. He was a committed modernist, working in a variety of styles that ranged from pointillism and vorticism to a cubist-derived abstraction, even during his employment by the relatively conservative Federal Art Project in the 1930s. In addition, Weisenborn was one of the leaders of almost every radical artists' group—the Salon des Refuses, the Chicago No-Jury Society of Artists, the Cor Ardens, and Neo-Arlimusc, for example—to emerge in the heady 1920s and '30s in the city. Always feisty and engaged, Weisenborn was, according to contemporary accounts, the first artist to exhibit an abstract painting at the Art Institute of Chicago when, in 1928, his enormous *Chicago* was exhibited at the annual American art exhibition there, after being rejected several times before. He described the work as "an interpretation of the spirit of Chicago. . . . It doesn't represent anything pictorially. To me the painting is interesting as a construction almost any way I hang it."[1]

In the 1920s Weisenborn was also dedicated to the project of founding a Gallery of Living Artists, for which a series of No-Jury Balls were held to raise funds. The early catalogs of the No-Jury Society are explicit about this, stating "the ultimate hope of the No-Jury artist and their friends is the erection of a temple of Living Art in Chicago, a gallery . . . which shall be a place where the art of the living may be viewed and encouraged."[2]

In *The Artist in the City (The Chicagoan)*, Weisenborn depicted the central figure, an abstracted image of an artist with canvases under his arm, ascending a flight of stairs. In a preparatory drawing, a sign reading "Gallery of Living Artists" is clearly visible above the doorway toward which the artist moves. The painting reflects Weisenborn's personal rendition of modernist styles—a combination of abstract, angular, and curvilinear forms; brilliant, thickly applied color; and painstaking technique. This painting is a realization of his contention that "a painting is an unlimited creation like the music of Stravinsky or boogey-woogey. Music is not imitative and neither is painting. The artist's response to what he feels cannot be limited to naturalistic representation . . . the motivation is abstract, the result is abstract."[3] SW

88.

Charles White
1918–1981

Spiritual, 1941
Oil on canvas, 36 ¼ x 30 ⅛ in. (92.1 x 76.5 cm)
South Side Community Art Center Collection (Chicago)

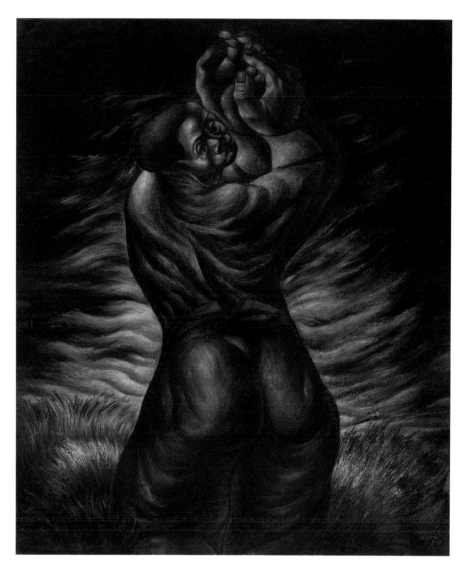

Born on the South Side of Chicago to a young, unmarried domestic worker who had only recently migrated from Mississippi, Charles White took to art at a young age and developed prodigious talent by the time he was a teenager. With fellow high-school students Charles Sebree (see cat. 76), Eldzier Cortor (see cat. 24), and Margaret Burroughs, White attended Saturday lectures at the Art Institute and took instruction from Art Institute student George Neal back in Neal's Bronzeville studio. White's early discovery of the art and philosophy of the "New Negro" movement and his exposure to the stimulating South Side literary, artistic, and theatrical coterie of Katharine Dunham, Richard Wright, and Horace Cayton, among others, transformed the young man into a crusader for social justice and racial equality.

White attended the School of the Art Institute of Chicago on scholarship in 1937, completing the two-year course of study in only one year. Once eligible to work on the Illinois Art Project of the Work Projects Administration, he began taking instruction from the most prominent mural painters in the Midwest, Mitchell Siporin (see cat. 78) and Edward Millman (see cat. 52). An extraordinarily gifted draftsman, White soon surpassed his teachers in the mural field. Before leaving Chicago in 1941 to work in New Orleans, Hampton, Virgina, and New York, he executed three murals dealing in innovative ways with issues in black history.[1] In paintings such as *Spiritual*, the themes of White's murals, as well as their rhetorical power and sweep, are distilled into extremely potent images that are emblematic of contemporary black experience and aspirations. *Spiritual* shows a solitary figure of heroic, Michelangelesque proportions. Rooted in the earth, the figure rises toward the sky and twists in a pose of mannerist torsion. An image of

strength and endurance, but also of unfulfilled potential, *Spiritual* was painted during White's first extended trip to the South. He had traveled there to accompany his wife, artist Elizabeth Catlett, who had accepted a teaching post at Dillard University in New Orleans. For many black artists of White's generation who had grown up in northern cities, the South was considered key to understanding the authentic, folk roots of black life in the United States. DS

NOTES

GERTRUDE ABERCROMBIE
Self Portrait of My Sister

1. For Abercrombie, see Susan Weininger, "Gertrude Abercrombie," in *Gertrude Abercrombie* (Springfield: Illinois State Museum, 1991), 9–37. All of the information in this entry relies on the research for that essay, which is fully documented in the catalogue. The catalogue also includes an exhibition history and chronology of Abercrombie's life. The most important sources of information on Abercrombie include her papers, located in the Archives of American Art, Washington, D.C., as well as the important information supplied in my interviews with her friends and family, particularly Margot Andreas, Don Baum, Gordon Cameron, Elinor Carlberg, Dinah Livingston, and Wendell Wilcox.
2. See ibid., 18–20, 24, for a discussion of these personal emblems and *Self Portrait of My Sister*.
3. Abercrombie's records refer to this painting as *Portrait of Artist as Ideal—Self Portrait of My Sister*; Abercrombie Papers, Archives of American Art, Washington, D.C., roll 1433, frame 452.
4. See Weininger, "Gertrude Abercrombie," 19, for Abercrombie's purposeful identification of herself as a witch.

JEAN CRAWFORD ADAMS
View from the Auditorium

1. Jean Crawford Adams, "Statement," in J. Z. Jacobson, *Art of Today: Chicago, 1933* (Chicago: L. M. Stein, 1932), 32.
2. This painting is listed as number 4 in the catalogue. Other Chicagoans were also painting images such as these in the early 1920s. See, for example, Raymond Jonson's *The Night—Chicago* (1921) and Ramon Shiva's *Chicago MCMXXIV* (1924).
3. Eleanor Jewett, "Old and New at the Art Institute," *Chicago Tribune*, 3 August 1930.

IVAN LE LORRAINE ALBRIGHT
Into the World There Came a Soul Called Ida

1. For complete information on Albright, including his exhibition history, see Courtney Donnell, Susan Weininger, and Robert Cozzolino, *Ivan Albright* (Chicago: Art Institute of Chicago, distributed by Hudson Hills Press, 1997).

GEORGE AMES ALDRICH
The Melting Pot, Chicago

1. For Aldrich, see Judy Oberhausen, *The Work of George Ames Aldrich, L. Clarence Ball & Alexis Jean Fournier in South Bend Collections* (South Bend, Ind.: The Art Center, 1982), n. p.; and William H. Gerdts, "The Golden Age of Indiana Landscape Painting," in *Indiana Influence: The Golden Age of Indiana Landscape Painting; Indiana's Modern Legacy. An Inaugural Exhibition of the Fort Wayne Museum of Art 8 April–24 June 1984* (Fort Wayne, Ind.: Fort Wayne Museum of Art, 1984), 53.
2. Harold M. Mayer and Richard C. Wade, *Chicago: Growth of a Metropolis* (Chicago: University of Chicago Press, 1969), 186.
3. The notion of America as "the melting pot" was popularized in a 1908 drama of that title by Israel Zangwill.

ANTHONY ANGAROLA
Snow Birds

1. Maynard Walker, "Art Notes," *Kansas City Journal*, 15 January 1928; in Angarola Papers, Archives of American Art, Washington, D.C.
2. Based on the modernist style of the painting, critics have assumed that *Snow Birds* was done in France; however, research reveals that it was painted prior to the artist's departure for Europe. In addition to the Carnegie exhibition, it appears in a typescript list of paintings dated April 1928 in the Angarola Papers.

EMIL ARMIN
The Open Bridge

1. Emil Armin, "Statement," in J. Z. Jacobson, *Art of Today: Chicago, 1933* (Chicago: L.M. Stein, 1932), 40.
2. Ibid.

BELLE (GOLDSCHLAGER) BARANCEANU
Riverview Section, Chicago

1. Although most sources give Baranceanu's birth date as 1905, late in her life she told Bruce Kamerling of the San Diego Historical Society that she was born in 1902. Kamerling was able to locate a birth certificate for her younger sister dated February 20, 1904, supporting Belle's assertion. Her birth date could not be later than 1903. Kamerling gave her birth date as 1902 in the "Chronology" in the exhibition catalogue, *Belle Baranceanu: A Retrospective*, ed. Bram Dijkstra and Anne Weaver (La Jolla, Calif.: Mandeville Gallery, University of San Diego, 1985), 59. The year of her birth is also given as 1902 in Bruce Kamerling, "Belle Baranceanu," *Journal of San Diego History* 40,3 (Summer 1994): 113. See also the obituary, "Belle Baranceanu, Widely Known Artist," *San Diego Union*, 21 January 1988. I am grateful to Bram Dijkstra for sharing this information with me.
2. Belle Baranceanu, "Statement," in J. Z. Jacobson, *Art of Today: Chicago, 1933* (Chicago: L. M. Stein, 1932), 43. *Riverview Section, Chicago*, identified as *Landscape*, is reproduced with Baranceanu's statement on 42.
3. For Baranceanu's life and her name change, see Bram Dijkstra, "Belle Baranceanu and Linear Expressionism," especially 14–18, and the "Chronology," 59–61, both in *Belle Baranceanu*.
4. Letter to Belle Baranceanu from Anthony Angarola, 22 October 1926, Baranceanu Papers, San Diego Historical Society. I am grateful to Bram Dijkstra for sharing this reference with me.
5. Karen Fisk, "The Annual American Exhibition at the Art Institute of Chicago," *American Magazine of Art* 17, 12 (December 1926): 624.
6. Dijkstra, "Belle Baranceanu and Linear Expressionism," 16.

FREDERIC CLAY BARTLETT
Blue Rafters

1. Trustee Minutes, Jan. 26, 1926, Art Institute of Chicago Archives, as quoted in Courtney Graham Donnell, "Frederic Clay and Helen Birch Bartlett: The Collectors," *The Art Institute of Chicago Museum Studies* 12 (1986): 93. In idem, 85–101, Donnell provides an overview of Bartlett's life and collecting.
2. The property included A. C. Bartlett's large house and the artist's studio-residence, separated by a formal garden. See Henry H. Saylor, "The Best Twelve Country Houses in America. XI. The House in the Woods, the Home of A. C. Bartlett Esq., Lake Geneva, Wis., Howard Shaw, Architect," *Country Life* 29 (March 1916): 38–41; as cited in Donnell, "Frederic Clay and Helen Birch Bartlett," 98, n.8.
3. Donnell, "Frederic Clay and Helen Birch Bartlett," 87.
4. Ibid., 86. Dora died in 1917. In 1919 Bartlett married Helen Birch, with whom he began seriously collecting modern art. Their collection was named the Helen Birch Bartlett Memorial Collection and given to the Art Institute following Helen's death in 1925. *Blue Rafters* was long thought to have been painted in 1919 and to picture Helen. However, the painting was exhibited

in 1917 and again in 1918. I am grateful to Daniel Schulman for providing this information from the Art Institute's curatorial file for this work.

MACENA BARTON
Portrait of C. J. Bulliet

1. Jean Campbell Macheca, "A Critical Relationship: Macena Barton and C. J. Bulliet in the 1930s" (M.A. thesis, School of the Art Institute of Chicago, 2001), 5–7.
2. C. J. Bulliet, "Artists of Chicago, Past and Present: No. 12, Macena Barton," *Chicago Daily News*, 13 May 1935.
3. Macheca, "A Critical Relationship," 30–33.
4. Ibid., 34–36.
5. *Macena with a Turban* is reproduced in J. Z. Jacobson, *Art of Today: Chicago, 1933* (Chicago: L.M. Stein, 1932), 44. Its present location is unknown.

MACENA BARTON
Salome

1. This location of this painting is unknown, but it is reproduced in Sue Ann Prince, "A Saucy Salome for Chicago: Macena Barton takes on Oscar Wilde, Pablo Picasso and C. J. Bulliet," *BlockPoints: The Annual Journal and Report of the Mary and Leigh Block Museum of Art* 3/4 (1996/1998): 109
2. Ibid., 104.
3. C. J. Bulliet, *The Courtezan Olympia* (New York: Covici Friede, 1930), 161–63; as quoted in Prince, "A Saucy Salome," 108.
4. Bulliet, *Chicago Daily News*, 11 May 1935; as quoted in Prince, "A Saucy Salome," 108, 111.
5. Prince, "A Saucy Salome," 113.

BERNECE BERKMAN
Current News

1. Biographical information is from a typescript biography in the Bernece Berkman Pamphlet file, Ryerson and Burnham Libraries, Art Institute of Chicago, P-02921.

KATHLEEN BLACKSHEAR
A Boy Named Alligator

1. For biographical information see Carole Tormollan, "A Tribute to Kathleen Blackshear," in *A Tribute to Kathleen Blackshear* (Chicago: School of the Art Institute of Chicago, 1990), 12–26; and Carole Tormollan, "Kathleen Blackshear," in *Women Building Chicago, 1790–1990*, ed. Rima Lunin Schultz and Adele Hast (Bloomington: Indiana University Press, 2001), 84–86.
2. Margaret T. Burroughs, in *A Tribute to Kathleen Blackshear*, 9.

AARON BOHROD
Clark Street, Chicago

1. Handwritten autobiography dated 30 March 1935, Ryerson and Burnham Libraries, Art Institute of Chicago, pamphlet file P-15323.
2. Aaron Bohrod, *A Decade of Still Life* (Madison, Milwaukee, London: University of Wisconsin Press, 1966), 5

RAYMOND BREININ
At the Pier

1. Raymond Breinin, in Dorothy C. Miller (ed.), *Americans 1942: 18 Artists from 9 States* (New York: Museum of Modern Art, 1942), 24.
2. Bram Dijkstra, *American Expressionism* (New York: Harry N. Abrams, 2003), 242.

EDGAR BRITTON
untitled (mural study)

1. Jane Hilberry, *The Erotic Art of Edgar Britton* (Denver: Documents of Colorado Art, 2001), 43; and George J. Mavigliano and Richard A. Lawson, *The Federal Art Project in Illinois: 1935–43* (Carbondale: Southern Illinois University Press, 1990), 8. See also "Chicago Artists Biographies, June 1938: Edgar Britton," typescript in Ryerson and Burnham Libraries, Art Institute of Chicago, pamphlet file P-01093, for the reference to his participation on the easel-painting project. According to Mavigliano and Lawson, 115, he was also employed on the sculpture project.
2. Cile M. Bach and Marlene Chambers (eds.), *Sculpture by Edgar Britton/Paintings by Gene Matthews: Two Concurrent One Man Shows* (Denver: Denver Art Museum, 1973), 6.
3. At this time, there is no evidence that this study was ever made into a mural. David Lusenhop of Adams Fine Art Gallery, Chicago, has found no extant or executed mural that corresponds to this study.

FRITZI BROD
Self-Portrait

1. C. J. Bulliet, "Artists of Chicago: Past and Present, No. 74: Fritzi Brod," *Chicago Daily News*, 1 August 1936.
2. Oswald Brod, "Oswald Brod, Brentano Art Department, Discuss Modern Art at Maddox House," (lecture, Rockford College, Rockford, Illinois, October 31, 1935); Fritzi Brod Papers, Archives of American Art, Washington, D.C., roll 4190, frame 694.

CLAUDE BUCK
Labor

1. Based on subject matter as well as style, *Labor* is thought to date to about the mid-1920s.
2. Paul Kruty, "Declarations of Independents: Chicago's Alternative Art Groups of the 1920s," in *The Old Guard and the Avant-Garde: Modernism in Chicago, 1910–1940*, ed. Sue Ann Prince (Chicago: University of Chicago Press, 1990), 78–79. In 1920 the success of Buck's solo exhibition at Thurber's Art Galleries in Chicago convinced other members of the New York Introspectives, Benjamin Kopman and Felix Russman, to follow Buck to the Chicago area; all three settled in rural Palos Park, approximately twenty-five miles southwest of the city.
3. Buck discusses his influences in his foreword in the brochure for the exhibition "The Allegorical Paintings of Charles Claude Buck," Thurber's Art Galleries, Chicago, April 5 through May 1, 1920; Buck is quoted on Da Vinci in I. K., "Mr. Claude Buck," *Christian Science Monitor*, 12 March 1932.
4. Buck's best-known portrait, *Girl Reading* of 1932, is featured on the cover of the movement's bible, *Sanity in Art* (Chicago: A. Kroch, 1937), written by founder Josephine Hancock Logan.

KARL ALBERT BUEHR
News from Home

1. Richard P. Norton, *Karl Albert Buehr (1866–1952)* (Chicago: Richard Norton Gallery, 2002), 4.
2. On the Giverny group, to which Buehr belonged, see *Lasting Impressions: American Painters in France 1865–1915* (Evanston, Ill.: Terra Foundation for the Arts, 1992), 85–90; and Bruce Weber, *The Giverny Luminists: Frieseke, Miller and Their Circle* (New York: Berry Hill Gallery, 1996).

3. *110 Years of American Art: 1830–1940* (New York: Spanierman Gallery, 2001), 105.

ELBRIDGE AYER BURBANK
Portrait of a Woman, Munich

1. "The Fine Arts," *Chicago Tribune*, 7 August 1892 and 8 January 1893; the quote is from the latter.
2. M. Melissa Wolfe, *American Indian Portraits: Elbridge Ayer Burbank in the West (1897–1910)* (Youngstown, Ohio: Butler Institute of American Art, 2000).
3. Ibid., 16–17. Burbank suffered a series of mental breakdowns in the late 1880s and early 1890s while working in St. Paul, Minnesota, and in Munich, about the time he painted *Portrait of a Woman, Munich*. He later spent several years in a mental hospital in San Francisco.

FRANCIS CHAPIN
White Tower

1. Ivan Albright, "Biographical Comments," November 1973, typescript, the Francis Chapin Collection, Lake Forest, Illinois.
2. I am grateful to Professor Robert A. Harris, Francis Chapin's son-in-law, who recognized this painting as *White Tower*, provided me with the exhibition information, and identified the figure of Chapin.

RICHARD A. CHASE
The Palmolive Building

1. "The Spirit of a Century of Progress," *Chicago Journal of Commerce*, 10 August 1934.
2. Robert Bruegmann, *Holabird & Roche and Holabird & Root: An Illustrated Catalogue of Works, 1880–1940* (New York: Garland Publishing, 1991), no. 1160.

ALSON SKINNER CLARK
The Coffee House

1. Erected in 1892–93 from a design by the Chicago firm of Burnham and Root, the Masonic Temple Building was one of the city's most celebrated skyscrapers. It was demolished in 1939.
2. L. M. McCauley, "Painting Exhibit Stirs Enthusiasm," *Chicago Evening Post*, 20 October 1906; newspaper clipping from *Chicago Record-Herald*, 21 October 1906, in the Art Institute of Chicago Scrapbooks, vol. 22, Ryerson and Burnham Libraries, Art Institute of Chicago; see also Maud I. G. Oliver, "American Artists' Exhibit at the Art Institute," *Inter Ocean*, 28 October 1906.

ELDZIER CORTOR
Southern Landscape

1. The compositional structure and subject of *Southern Landscape*, with its pair of lovers extended across the oblong canvas, is reminiscent of Italian renaissance *cassone* panels of mythological lovers by artists such as Sandro Botticelli or Piero di Cosimo. A more immediate formal and thematic stimulus may have been provided by Pablo Picasso's popular 1919 tempera and watercolor of peasant laborers asleep in a field (*Sleeping Peasants*, Museum of Modern Art, New York). Cortor could have seen it illustrated in the catalogue to the exhibition, *Pablo Picasso* (Hartford, Conn.: Wadsworth Atheneum, 1934), pl. 33.

GUSTAV DALSTROM
Laundry

1. Gustav Dalstrom, "Statement," in J. Z. Jacobson, *Art of Today: Chicago, 1933* (Chicago: L.M. Stein, 1932), 58.
2. Ibid.

CHARLES V. DAVIS
Newsboy (The Negro Boy)

1. Willard F. Motley, "Negro Art in Chicago," *Opportunity* 18, 1 (January 1940): 31.

MANIERRE DAWSON
Prognostic (center panel)

1. Randy J. Ploog, "The First American Abstractionist: Manierre Dawson and his Sources," in *Manierre Dawson: American Pioneer of Abstract Art* (New York: Hollis Taggart Galleries, 1999), 62–64.
2. Ibid., 69.
3. Ibid., 60–68; see also Randy Ploog, "The Chicago Sources of Manierre Dawson's First Abstract Paintings," *BlockPoints: The Annual Journal and Report of the Mary and Leigh Block Museum of Art* 3/4 (1996/1998): 32–57.
4. Manierre Dawson Journal, 26 December 1908; as quoted in Randy J. Ploog, "The First American Abstractionist," 66.
5. Manierre Dawson to Tracy Atkinson (Director, Milwaukee Art Center), letter, 6 April 1969, Milwaukee Art Museum Collection; as quoted in Randy J. Ploog, "The First American Abstractionist," 65.

JULIO DE DIEGO
Vamda

1. For biographical information, see *Julio de Diego, The War Series or Los Desastres del Alma* (New York: Museum of Contemporary Hispanic Art, 1988), n.p.; *Julio de Diego: A Journey* (Sarasota, Fla.: Corbino Galleries, 1992), n.p.; and Lester Burbank Bridaham, "Julio de Diego," *Art in America* 39, 2 (April 1951): 67–79.
2. Julio de Diego, "Statement," in *J. Z. Jacobson, Art of Today: Chicago, 1933* (Chicago: L. M. Stein, 1932), 61.
3. *Time*, 15 June 1962; as quoted in *Julio de Diego: A Journey*, n.p.

PAULINE DOHN (RUDOLPH)
A Village Belle

1. For biographical information on Dohn, I am indebted to Joel Dryer.
2. Dohn as quoted in an article from *Chicago Chronicle*, 4 February 1901; in the Art Institute of Chicago Scrapbooks, vol. 13, 139.
3. See for example "Chicago Women in Art," *Chicago Times-Herald*, 12 February 1899.
4. See for example "Our Clever Poster Girls," unidentified newspaper clipping dated circa 16 May 1899, the Art Institute of Chicago Scrapbooks, vol. 2, 6–7.
5. "Tissot Exhibition Extended," *Chicago Times Herald*, 26 February 1899.
6. The features of the woman's reflected face in *A Village Belle* correspond with Dohn's in an engraved portrait or self-portrait of the artist published in "Art and Artists," *The Graphic*, 30 April 1892, and with a portrait photograph in the collection of the artist's descendants. I am grateful to Joel Dryer for making a copy of the latter available to me.

WALTER ELLISON
Train Station

1. Theresa Dickason Cederholm, *Afro-American Artists. A Bio-bibliographical Directory* (Boston: Trustees of the Boston Public Library, 1973), 88.

WILLIAM MCKNIGHT FARROW
Paul Laurence Dunbar

1. Tina Dunkley, *Afro-American Paintings and Prints from the Collection of Judge Irvin C. Mollison: A Gift to the Atlanta University Art Collections. William Edouard Scott, William McKnight Farrow, Archibald Motley, Jr.* (Atlanta: Waddell Gallery, 1985), n.p.

FRANCES FOY
The Cheese Vendor

1. C. J. Bulliet, "Artists of Chicago Past and Present. No. 27: Frances Foy," *Chicago Daily News*, 24 August 1935.
2. Frances Foy, "Statement," in J. Z. Jacobson, *Art of Today: Chicago, 1933* (Chicago: L. M. Stein, 1932), 64.
3. "Plans for Study—Frances Foy," Application for Guggenheim Fellowship, Frances Foy and Gustav Dalstrom Papers, Archives of American Art, Washington, D.C., roll 4077.
4. Ibid. According to Foy's nephew, Thomas McCanna, in a letter to Powell Bridges (24 February 1994) *The Chase Vendor* was painted from Ernest Hemingway's Paris apartment during this trip. This is possible, since Foy's family lived in Oak Park, Illinois, where the elder Hemingway was the Foy family physician.
5. Marguerite B. Williams, "The Dalstroms Return," *Chicago Daily News*, 15 August 1928.
6. J. Z. Jacobson, *The Chicagoan*, 17 August 1929; in the Biesel Family Papers, Archives of American Art, Washington, D.C., roll 4208, frames 663–64.

ROWENA C. FRY
Great Lakes Art Class

1. Annie Morse, "Capturing Sunlight: The Art of Tree Studios," in *Capturing Sunlight: The Art of Tree Studios* (Chicago: City of Chicago Department of Cultural Affairs, 1999), 31.
2. Fry as quoted in Louise Dunn Yochim, *Role and Impact: The Chicago Society of Artists* (Chicago: Chicago Society of Artists, 1979), 132.
3. Ibid.
4. Eleanor Jewett, *Chicago Tribune*; as quoted in Yochim, *Role and Impact*, 79.

FREDERICK F. FURSMAN
Maizie Under the Boughs
1. In 1921 the Saugatuck Summer School of Painting was renamed the Oxbow School. It served as a summer school for the Art Institute of Chicago.

LEON GARLAND
Unemployed Men in the Hull-House Courtyard
1. *Leon Garland: Ten Color Reproductions of His Paintings* (Chicago: Leon Garland Foundation, 1948), n.p.

TODROS GELLER
Strange Worlds
1. *Todros Geller: Memorial Program and Exhibition* (Chicago: Board of Jewish Education and the American Jewish Arts Club, 1949), n.p.

J. JEFFREY GRANT
Michigan Avenue
1. *Michigan Avenue* is reproduced in a notice of the exhibition, "Art Masterpieces Go on View," *Chicago American*, 25 July 1935.

OLIVER DENNETT GROVER
Midsummer; On the Island, World's Columbian Exposition; A Windy Day
1. "Peeps at the Show," *Chicago Tribune*, 28 October 1894. The paintings Grover exhibited at the Art Institute in 1894 were listed in the catalogue as *On the Island, World's Columbian Exposition* (no. 140), *Midsummer* (no. 141), and *Manufactures Bldg., World's Columbian Exposition* (no. 139). Although *A Windy Day* (the title inscribed on an old label on the back of the painting) clearly portrays the Administration Building and not the Manufactures Building, it is possible that this work was the third in this trio. All three paintings descended in the artist's family.
2. Grover had painted a series of decorative panels for the interior of the Merchant Tailors Building.
3. Compare Grover's painting with the photograph of the Ho-o-den in Stanley Applebaum, *The Chicago World's Fair of 1893: A Photographic Record* (New York: Dover Publications, 1980), fig. 92.

WILLIAM HARPER
August in France
1. The provenance of the painting is still unclear. It was reproduced in the *Chicago Record-Herald* of August 7, 1910, with the caption, "August in France"; see the Art Institute of Chicago Scrapbooks. When he was curator at Tuskegee in the 1940s, Dawson recalled, "the school had a very good painting by Wm. A. Harper, which the Art Institute of Chicago presented to the school, some years before, at my suggestion by my old friend Mr. Newton Carpenter, the then Director"; see Charles C. Dawson Papers, DuSable Museum of African American History, Chicago, 431. Newton Carpenter, Secretary of the Art Institute, found employment for both Harper and Dawson, making it possible for them to pay tuition. Although there is no record of the painting in the collection of the Art Institute,

perhaps it was owned by the school or a staff member. Art historian James Porter, on the other hand, recalled seeing a painting with the title *An Autumn Day in France* hanging in Chicago's Wabash Avenue YMCA; see James Porter, *Modern Negro Art* (1943; reprint, Washington, D.C.: Howard University Press, 1992), 80.

VICTOR HIGGINS
Circumferences
1. Dean A. Porter, *Victor Higgins: An American Master* (Layton, Utah: Gibbs Smith, Publisher, 1991), 47.
2. *Circumferences* was the final work in the series; hence the date 1914–19 undoubtedly refers to the series rather than to the individual painting.
3. Porter, *Victor Higgins*, 80–81.
4. Gene Morgan, "Seeing Chicago Clubdom: Here Are Prospering Artists Who Boost Prices, Cut Hair and Win International Prizes," *Chicago Sunday Herald*, 25 April 1915; as quoted in Marianne Richter, "The History of the Palette and Chisel Academy of Fine Arts" (unpublished graduate course paper), 12, cited with the author's generous permission.
5. "New Art May Be Hung Any Way Your Fancy Says," unidentified clipping, c. May 1915; in Palette and Chisel Logbooks, vol. 2, opp. p. 113, on deposit at the Newberry Library, Chicago.
6. Clipping from *Chicago Sunday Herald*, 23 May 1915; in Palette and Chisel Logbooks, vol. 2, opp. p. 110.

SAMUEL HIMMELFARB
Jackson Park
1. "Biographical Notes," *Samuel Himmelfarb: People Paintings and Drawings* (Milwaukee: Charles Allis Art Library), n.d.; and typescript biography, Chicago Public Library, Chicago Artists' Archives. Himmelfarb's son, John, is also a well-known artist, and he exhibits frequently in Chicago and elsewhere.
2. "The Artist's Statement," *Samuel Himmelfarb: People Paintings and Drawings*.

CARL HOECKNER
The Yes Machine
1. C. J. Bulliet, "Artists of Chicago, Past and Present, No. 86: Carl Hoeckner," *Chicago Daily News*, 10 July 1937.
2. Ibid.
3. George J. Mavigliano and Richard A. Lawson, *The Federal Art Project in Illinois* (Carbondale and Edwardsville, Ill.: Southern Illinois University Press, 1990), 8.
4. The photograph was one of a group of reproductions of Hoeckner's work that were sent to accompany a solo exhibition of his work arranged by George Drury at the Sheil School of Social Studies in Chicago in 1944, and it was shared with me by Professor Drury, to whom I am grateful. The photograph is inscribed "Masters of Men," in what Drury assumes was Hoeckner's own hand, on the reverse. However, *Masters of Men* is not listed in the exhibition brochure. According to Hoeckner's son, Carl, Jr., *The Yes Machine* was formerly called *Mystic*

Reality, a painting that is listed in the brochure. Among the photographs of paintings in Drury's possession were some that were not in the exhibit. Either Hoeckner wrote the wrong name on the photograph or it was not in the exhibit and was originally called *Masters of Men*. Unless some other evidence emerges, this cannot be conclusively resolved.
5. The figure pictured in this painting and a related work, *Gold at the Century of Progress*, is thought to be Sally Rand, the famous fan dancer at the Century of Progress World's Fair. The connection between commerce and sex at the progress fairs of the 1930s is discussed by Robert Rydell, *World of Fairs* (Chicago: University of Chicago Press, 1993), 115–56.
6. Hoeckner as quoted in Bulliet, "Artists of Chicago."

RUDOLPH INGERLE
Salt of the Earth
1. C. J. Bulliet, "Artists of Chicago Past and Present. No. 23: Rudolph Ingerle," *Chicago Daily News*, 27 July 1935.
2. Ingerle describes the Smokies as a "pure" region in R. F. Ingerle, "A Painter's Paradise and Its Lure," *Palette & Chisel* 8 (May 1931): 1–2. Ingerle is quoted describing the inhabitants of the Smokies in Edna Sellroe, "Rudolph Ingerle—Famous Painter of Landscapes and Character Studies of Mountaineers," *Artistry* 3 (December 1937): 2–3. A copy of this article, from an extremely scarce periodical, is located in curatorial file UL1976.27 at the Union League Club of Chicago.
3. The similarity between Wood's and Ingerle's paintings was noted by critic Eleanor Jewett in "Two Interesting New Art Shows Opened Here," *Chicago Tribune*, 5 May 1935.

RAYMOND JONSON
The Decree
1. Herbert R. Hartel, Jr. "The Art and Life of Raymond Jonson (1891–1982): Concerning the Spiritual in American Abstract Art" (unpub. Ph.D. diss., City University of New York, 2002), 86–100.
2. Raymond Jonson Diary, 4 August 1921; as quoted in Marianne Lorenz, "Kandinsky and Regional America," in *Theme and Improvisation: Kandinsky and the American Avant-Garde, 1912–1950*, ed. Gail Levin and Marianne Lorenz (Boston: Little, Brown and Company, 1992), 93.
3. Raymond Jonson Diary, 1 August 1918; as quoted in MaLin Wilson, *Raymond Jonson: Cityscapes* (Albuquerque, N.M.: Jonson Gallery of the University Art Museum, 1989), n.p.

GEORGE JOSIMOVICH
Composition No. 2
1. "George Josimovich," *The Chicago Woman's Aid Weekly Bulletin* 12, 25 (14 March 1929).
2. J. Z. Jacobson, *Thirty-Five Saints and Emil Armin* (Chicago: L.M. Stein, 1929), 92–98.
3. Ibid., 27.

A. RAYMOND KATZ
The Argument

1. For biographical information, see Ralph Hudson, "A Brief Biography," typescript, Ryerson and Burnham Libraries, Art Institute of Chicago, pamphlet file, P-04715; and C. J. Bulliet, "Introduction," in A. Raymond Katz, *Prelude to a New Art for an Old Religion* (Chicago: L.M. Stein, 1944), n.p.

PAUL KELPE
Construction Relief

1. Paul Kelpe, "Statement," in J. Z. Jacobson, *Art of Today: Chicago, 1933* (Chicago: L. M. Stein, 1932), 83.
2. Ibid., 82. The painting *Composition* is reproduced.
3. Kelpe as quoted in Maarten van de Guchte, "Paul Kelpe: A Life in Quotes," in *Paul Kelpe: Abstractions and Constructions: 1925–1940* (Urbana-Champaign: Krannert Art Museum, University of Illinois at Urbana-Champaign, 1990), 6.
4. Joan Marter, "Paul Kelpe and Constructivism in America," in *Kresge Art Museum Bulletin* 3 (1988): 30. For Kelpe's own description of the rejection of his nonrepresentational work by the Chicago WPA administrators, see Maarten van de Guchte, "Paul Kelpe: A Life in Quotes," 6.
5. Marter, "Paul Kelpe and Constructivism in America," 27.
6. Ibid., 28.
7. Kelpe, "Statement," Jacobson, *Art of Today*, 83.

CARL R. KRAFFT
The Charms of the Ozarks

1. C. J. Bulliet, "Artists of Chicago Past and Present. No. 38: Carl Rudolph Krafft," *Chicago Daily News*, 9 November 1935.
2. Lena McCauley, "A Painter Poet of the Ozarks," *Fine Arts Journal* 34 (October 1916): 469–72.
3. "Art and Artists," *Chicago Evening Post*, 10 February 1916.

HERMAN MENZEL
Mexican Pool Room, S. Chicago # 2 (with Bunting)

1. For Menzel, see Wendy Greenhouse and Susan S. Weininger, *A Rediscovered Regionalist: Herman Menzel* (Chicago: Chicago Historical Society, 1994).
2. Compared to other artists, Menzel exhibited very little, but records show that a painting entitled *Pool Room* (#126) was exhibited at the Art Institute of Chicago's Annual Exhibition of American Paintings and Sculpture in 1929 and a *Pool Room* (#326) was exhibited at the Pennsylvania Academy of the Fine Arts Annual in 1929. There is no way to determine which of the pool-room paintings are referred to, but both of these were prestigious juried exhibitions.

EDWARD MILLMAN
Flop House

1. Biographical information from typescript in Ryerson and Burnham Libraries, Art Institute of Chicago, pamphlet file, P-16557.

2. "Millman and Siporin Win $29,000 Federal Competition for St. Louis," *Art Digest* 14, 1 (1 October 1939): 12.
3. Patricia Hills, *Social Concern and Urban Realism: American Painting of the 1930s* (Boston: Boston University Art Gallery, 1983), 71.

ARCHIBALD J. MOTLEY JR.
The Plotters

1. For three different interpretations of Motley's engagement with the issue of skin coloration and class, see Amy M. Mooney, "Representing Race: Disjunctures in the Work of Archibald J. Motley Jr.," *The Art Institute of Chicago Museum Studies* 24,2 (1999): 163–79; Dennis Raverty, "The Self As Other: A Search for Identity in the Painting of Archibald J. Motley Jr.," *International Revue of African American Art* 18,2 (2002): 25–35; and, Michael D. Harris, "Color Lines: Mapping Color Consciousness in the Art of Archibald J. Motley Jr.," in *Colored Pictures: Race and Visual Representation* (Chapel Hill: University of North Carolina Press, 2003), 149–87.
2. The off-center and strangely cropped figures bring to mind Degas's scenes of the Paris Opéra, and the picture-within-a-picture device at upper right is reminiscent of Degas's office interiors.

JAMES B. NEEDHAM
Chicago River, Chicago and Northwestern Railroad Station; Chicago Waterfront; Sailboat at Dusk; S.S. Seneca; Steamer at Dock; Tugboat; Tugboats; Waterfront at Dusk

1. *James Bolivar Needham* (Chicago: Robert Henry Adams Fine Art, 1997).
2. At the time of Needham's arrival in Chicago in 1867, the Chicago River was one of the busiest waterways in the world; it had more traffic than the ports of San Francisco, New Orleans, and New York combined. See Emily J. Harris, "The Triangle: The Waterways That Built Chicago," in Edward Ranney, *Prairie Passage: The Illinois and Michigan Canal Corridor* (Urbana: University of Illinois Press, in association with Canal Corridor Association, c. 1998), 47.

(JAMES) HAROLD NOECKER
The Genius?

1. Frank Holland, "Chicagoans Create Own Artistic Style," *Chicago Sun Times*, 21 May 1944.
2. Ibid.

B. J. O. NORDFELDT
Chicago

1. Possibly originally entitled *November Morning, Michigan Avenue.*
2. For a discussion of Nordfeldt's connection with Chicago, focusing on the modernist portraits of 1912, see Paul Kruty, "Mirrors of a 'Post-Impressionist' Era: B. J. O. Nordfeldt's Chicago Portraits," *Arts* 61, 5 (January 1987): 2–33, particularly 29–30.
3. These paintings were: *November Morning, Michigan Avenue; Van Buren Street Viaduct; Chicago Smoke; Ice Bound; Blue Water; Floating Ice;* and *The Electric Sign.* Based on the titles, the Weatherspoon *Chicago* can probably be identified as *November Morning, Michigan Avenue.* See Van Deren Coke, *Nordfelt the Painter* (Albuquerque, N.M.: University of New Mexico Press, 1972), 36, for the titles of the works in the Roullier show.
4. Harriet Monroe, *Chicago Tribune*, 12 May 1912; as quoted in Kruty, "Mirrors of a 'Post-Impressionist' Era," 30.

JOHN WARNER NORTON
Study for Ceres

1. Norton's career and his mural painting in particular are documented in Jim L. Zimmer, Cheryl Hahn, and Richard N. Murray, *John Warner Norton* (Springfield, Ill.: Illinois State Museum, 1993).
2. Grain had long been a staple of Chicago's exchange market and futures trade. A statue of a streamlined Ceres, designed by John Storrs, looks northward from the pinnacle of the Chicago Board of Trade Building, just as Norton's *Ceres* did on the structure's interior. Norton's mural was removed in 1974, when the building was renovated and expanded, and it was later installed in the new atrium; see Zimmer, Hahn, and Murray, *John Warner Norton*, 25.
3. Ibid., 46.

GREGORY ORLOFF
Men on Hill Reading Newspapers

1. Gregory Orloff, "Statement," in J. Z. Jacobson, *Art of Today: Chicago, 1933* (Chicago: L. M. Stein, 1932), 98.

GEORGE DEMONT OTIS
Grain Elevators, Goose Island

1. George Roberts, "George Demont Otis: Western Impressionist," *American Artist* 43 (November 1979): 74.
2. Little is known of Otis's training and early career in Chicago. He exhibited only once in an Art Institute annual exhibition (in the 1926 American art show). Although biographical sources list him as a founding member of the Palette and Chisel Club, Otis is not noted as such in the club's own materials. On Otis, see, in addition to Roberts, "George Demont Otis," noted above, Bill Earle, "He Paints with Reverent Realism," *Independent Journal* [Marin County, Calif.], 13 February 1960, reprinted in Golden Gate Collection, *George Demont Otis 1879–1962: American Impressionist Painter of America* (n.d. [1977]), n. p., and a brief typescript autobiography dated 1948, both in pamphlet file on Otis, Ryerson and Burnham Libraries, Art Institute of Chicago. Entries on Otis in standard artists' biographical dictionaries echo these materials and were evidently based on information supplied by the artist or his heirs.
3. Harold M. Mayer and Richard C. Wade, *Chicago: Growth of a Metropolis* (Chicago: University of Chicago Press, 1969), 350.

PAULINE PALMER
The Morning Sun

1. M. B. W. [Marguerite B. Williams], "Noted for Merit in Color," *Chicago Daily News*, 3 February 1922.
2. Andrew Martinez, "A Mixed Reception for Modernism: the 1913 Armory Show at The Art Institute of Chicago," *The Art Institute of Chicago Museum Studies* 19, 1 (1993): 47, 52.
3. Josephine Balluff, "Chicago Artists in Annual Exhibition at Art Institute," clipping from unidentified newspaper, dated 30 January 1922, in the Art Institute of Chicago Scrapbooks, vol. 43, Ryerson and Burnham Libraries, Art Institute of Chicago.
4. Palmer as quoted in Minnie Bacon Stevenson, "Woman Heads Artists' Society of Chicago," *Fort Dearborn Magazine* 1, 7 (April 1920): 9.

FRANK C. PEYRAUD
Winter Light on the Farm

1. *Winter Light on the Farm* is a recently assigned title. Peyraud's original title is unknown, but this work may be identical with the painting *A Winter Afternoon*, listed in the catalogue for the fifth annual Cosmopolitan Art Club exhibition in 1896 (number 145, for sale for $100).
2. "Art," *Chicago Times-Herald*, 26 February 1899.
3. See for example "Juries of Selection," *Arts for America* 5,6 (July 1896): 235.

TUNIS PONSEN
untitled (Century of Progress, World's Fair)

1. For Ponsen, see Patrick Cofffey, William H. Gerdts, Susan Weininger, and Kenneth B. Katz, *The Lost Paintings of Tunis Ponsen* (Muskegon, Mich.: Muskegon Museum of Art, 1994).
2. Ponsen exhibited the painting *Rock Quarry*. It is listed in the catalogue *A Century of Progress Exhibition of Paintings and Sculpture* (Chicago: Art Institute of Chicago, 1933), 74, #618. For Ponsen's and other Chicago artists' images of the fair, see Weininger, "Tunis Ponsen," in *Lost Paintings of Tunis Ponsen*, 26–27.

HARVEY GREGORY PRUSHECK
Lunar Landscape

1. *The Storm* and *Sunrise* are reproduced in the catalogues of the exhibitions, an option available to any exhibitor who paid an additional fee. *Cactus* is reproduced in "Prusheck Work Wins Favor at Art Institute," *Milwaukee Leader*, 3 May 1929.
2. Letter from Mariann Prusheck to Mr. and Mrs. [Raymond] Jonson, 7 July 1940, from the files at the Jonson Gallery of the University Art Museums, the University of New Mexico. I am grateful to Carol Cheh of the Jonson Gallery for providing me with a copy of this letter.
3. Marguerite B. Williams, "Prusheck Uses Blues to Give Color to Work," *Chicago News Journal*, 14 February 1930.
4. Wassily Kandinsky, *On the Spiritual in Art*, 2nd ed. (Munich: R. Piper & Co., 1912); as quoted in *Kandinsky: Complete Writings on Art*, ed. Kenneth C. Lindsay and Peter Vergo (New York: Da Capo Press, 1982), 181.

5. Harvey Prusheck, "Statement," in J. Z. Jacobson, *Art of Today: Chicago, 1933* (Chicago: L.M. Stein, 1932), 104.

ROMOLO ROBERTI
Roofs (Tree Studios)

1. Romolo Roberti, "Statement," in J. Z. Jacobson, *Art of Today: Chicago, 1933* (Chicago: L.M. Stein, 1932), 108.
2. For the Tree Studios, see *Capturing Sunlight: The Art of Tree Studios* (Chicago: City of Chicago Department of Cultural Affairs, 1999). The Tree Studios was sold to developers, who have altered the building. They put the remaining studio space outside the financial range of most of those who lived there, forcing them to move out in 2001.

GORDON ST. CLAIR
Entrance to Xanadu

1. Gordon St. Clair information sheet, Ryerson and Burnham Libraries, Art Institute of Chicago, September 1918. Harlan Berk generously made this source available to me.
2. Weisenborn and Shiva were also members of the Palette and Chisel for a short time in the 1910s. See Marianne Richter, "The History of the Palette and Chisel Academy of Fine Arts," (graduate school paper, University of Illinois at Chicago, 2001), 11–17. Although most of Weisenborn's work from the teens was destroyed in a studio fire in the early 1920s, a surviving early painting called *The Dancer* employs pointillist style.
3. Frederic Paul Hull Thompson, "Twenty-Third Annual Exhibition of Chicago Artists," *Fine Arts Journal* 37, 3 (March 1919): 11.
4. St. Clair listed *Entrance to Xanadu* (called *In Xanadu*) as the first in a list of his most important works on the information sheet for the Ryerson and Burnham Libraries, Art Institute of Chicago, 1918.

WILLIAM SCHWARTZ
From Window #29

1. Manuel Chapman, *William S. Schwartz: A Study* (Chicago: L. M. Stein, 1930), 42.
2. William S. Schwartz, "An Artist's Love Affair with America," *Chicago Tribune Magazine* (5 April 1970): 64.

WILLIAM SCHWARTZ
Symphonic Forms No. 6

1. Manuel Chapman, *William S. Schwartz: A Study* (Chicago: L. M. Stein, 1930), 39.
2. William S. Schwartz, "An Artist's Love Affair with America," *Chicago Tribune Magazine* (5 April 1970): 64.
3. Douglas Dreishpoon, "Introduction," in *The Paintings, Drawings, and Lithographs of William S. Schwartz* (New York: Hirschl and Adler Galleries, 1984), 11.
4. Daniel Catton Rich, in an exhibition brochure for "Exhibition of Paintings and Lithographs by William S. Schwartz" (Chicago: Art Institute of Chicago, 1935). This brochure includes fourteen

examples of "symphonic forms," numbered between one and twenty-two.
5. Lawrence Lipton, "William S. Schwartz," in J. Z. Jacobson, *Art of Today: Chicago, 1933* (Chicago: L.M. Stein, 1932), 120.
6. Meyer Zolotareff, "Music Caught in Painting," *Chicago American*, 17 September 1931; as quoted in Dreishpoon "Introduction," 11.

RAMON SHIVA
Chicago MCMXXIV

1. *Exhibition of Paintings by Ramon Shiva* (Chicago: M. Knoedler and Co. Inc., 1930), n.p.
2. Lee Anna Shiva, typescript biography, n.d., made available to me by Lee Anna Halley, niece of the artist.

MITCHELL SIPORIN
Homeless

1. Siporin, "Statement," in Dorothy C. Miller (ed.), *Americans 1942: 18 Artists from 9 States* (New York: Museum of Modern Art, 1942), 112.

WILLARD GRAYSON SMYTHE
Abstraction

1. Lloyd C. Englebrecht, "Modernism and Design in Chicago," in *The Old Guard and the Avant-Garde*, ed. Sue Ann Prince (Chicago: University of Chicago Press, 1990), 128–29.
2. *Recent Acquisitions 1996* (Chicago: Robert Henry Adams Fine Art, 1996), n.p. According to his obituary, *Chicago Sun-Times*, 11 July 1995, Smythe was an instructor at the Art Institute until 1960, when he was promoted to professor.
3. *Recent Acquisitions 1996*.

FRANCES STRAIN
Four Saints in Three Acts, Introducing St. Ignatius

1. For Strain, see Susan S. Weininger, "Frances Strain Biesel," in *Women Building Chicago, 1790–1990*, ed. Rima Lunin Schultz and Adele Hast (Bloomington: Indiana University Press, 2001), 854–56.
2. Frances Strain, "Statement," in J. Z. Jacobson, *Art of Today: Chicago, 1933* (Chicago: L.M. Stein, 1932), 126.
3. Stein lectured at the University of Chicago in fall of 1934, at which time she so impressed Thornton Wilder, then teaching at the university, that he arranged for her to return again in winter of 1935, when she gave a series of lectures that required an invitation from Wilder to attend. Her lectures are collected in *Narration: Four Lectures* (Chicago: University of Chicago Press, 1935). For her visit, see Gilbert A. Harrison, *The Enthusiast: A Life of Thornton Wilder* (New Haven, Conn.: Ticknor and Fields, 1983), 136.
4. "Four Saints in Three Acts," OPERA *America's Encore Magazine*, n.d., http://www.opera america.org/encore/four_s.htm (accessed November 7, 2003).

SVEND SVENDSEN
Winter Sunset in Norway

1. See "Svend Svendsen," *The Arts* 4 (December 1895): 183.
2. "Art and Artists," *Chicago Post*, 18 March 1899.

3. See for example "Svend Svendsen," 183, and "Art," *Chicago Times-Herald*, 19 March 1899.

STANISLAUS SZUKALSKI
Rudolph Weisenborn

1. James Weber Linn, "Chicago Byways and Highways," *Chicago Herald and . . .* [cut off] (18 August 1923); in Rudolph Weisenborn Papers, Archives of American Art, Washington, D.C., roll 856, frame 1189.
2. Stanislaus Szukalski, *Projects in Design* (Chicago: University of Chicago Press, 1929), 33.

JULIA THECLA
Bunny Backstage

1. For Thecla, see Maureen A. McKenna, *Julia Thecla* (Springfield, Ill.: Illinois State Museum, 1984), which also includes personal reminiscences of Thecla by Katharine Kuh, David Porter, Parker Panttila, Phyllis Ford Choyke, and Harry Bouras.
2. Ibid, 9–10. See also *An Exhibition of Paintings and Drawings by Julia Thecla* (Chicago: Albert Roullier Art Galleries, 1941), in which the checklist for the exhibition includes at least eight paintings (of twenty-two) that have dance themes. Guggenheim was a painter and writer in addition to dancing professionally; some of her paintings echo Thecla's in their mottled flesh and use of decorative patterning. She exhibited a portrait in the 42nd Annual Exhibition of Artists of Chicago and Vicinity at the Art Institute in 1938.

MORRIS TOPCHEVSKY
Unemployed

1. C. J. Bulliet, "Artists of Chicago: Past and Present, No. 70: Morris Topchevsky," *Chicago Daily News*, 27 June 1936.
2. *Hull House Yearbook* (Chicago: Frederich Hildman Printing Co., 1929), 18. In "Artists of Chicago," Bulliet writes of Topchevsky: "He met and talked frequently with Rivera about both paint and social subjects. But he didn't make the mistake of becoming Diego's pupil, for he sensed so strong a personality in the Mexican that he would have to become either a little Rivera or battle with his master."
3. Morris Topchevsky, "Statement," in J. Z. Jacobson, *Art of Today: Chicago, 1933* (Chicago: L.M. Stein, 1932), 129.

WALTER UFER
Near the Waterhole

1. For a summary of the relationship between Chicago and painters in the Southwest see Judith A. Barter with contributions by Andrew J. Walker, *Window on the West: Chicago and the Art of the New Frontier 1890–1940* (Chicago: Art Institute of Chicago, in association with Hudson Hills Press, 2003), chap. 2.
2. Stephen L. Good, "Seven Paintings by Walter Ufer," *Artists of the Rockies and Golden West* 11 (Winter 1984): 50.
3. For the identification of the male rider, I am indebted to Dean Porter's essay on *Near the Waterhole* in *Union League Club of Chicago Art Collection* (Chicago: Union League Club of Chicago, 2003), 252.

FRANK R. WADSWORTH
A River Lavadero, Madrid

1. Newspaper clipping marked *Chicago Examiner*, 10 February 1906, in the Art Institute of Chicago Scrapbooks, vol. 21, Ryerson and Burnham Libraries, Art Institute of Chicago. A brief obituary of Wadsworth is given in *American Art News* 4, 3 (28 October 1905): [2].

RUDOLPH WEISENBORN
The Artist in the City (The Chicagoan)

1. Weisenborn as quoted in "Art War Flares, Moderns on Top," *Chicago News*, 24 October 1928. *Chicago* is now in the Collection of the Illinois State Museum, Springfield, Illinois.
2. Sam Putnam, "Foreword," in *Catalog of the Third Annual Chicago No-Jury Society of Artists Exhibition* (1924), n.p.
3. Rudolph Weisenborn, untitled typescript, Rudolph Weisenborn Papers, Archives of American Art, Washington, D.C., roll 856, frame 18.

CHARLES WHITE
Spiritual

1. White's three Chicago murals were *Five Great American Negroes* (1939), now at Howard University, Washington, D.C., and *History of the Negro Race* and *History of the Negro Press* (both 1940), present whereabouts unknown. *History of the Negro Race* was apparently a two-panel mural on canvas painted for the Chicago Public Library; for an illustration, see *Images of Dignity: The Drawings of Charles White* (Los Angeles: Ward Ritchie Press, 1967), 31. *History of the Negro Press* was painted for the American Negro Exposition in the summer of 1940; for an illustration, see idem, 32.

EXHIBITION CHECKLIST

Gertrude Abercrombie (1909–1977)
Self Portrait of My Sister, 1941
Oil on canvas, 27 x 22 in. (68.6 x 55.9 cm)
Powell and Barbara Bridges Collection

Jean Crawford Adams (1890–1972)
View from the Auditorium, c. 1935
Oil on canvas, 24¼ x 18½ inches (61.6 x 47 cm)
Chicago Historical Society, 1990.435

Ivan Le Lorraine Albright (1897–1983)
Into the World There Came a Soul Called Ida,
1929–30
Oil on canvas, 56¼ x 47 in. (142.9 x 119.4 cm)
The Art Institute of Chicago, Gift of Ivan Albright,
1977.34

George Ames Aldrich (1872–1941)
The Melting Pot, Chicago, c. 1926
Oil on canvas, 30 x 36 in. (76.2 x 91.4 cm)
Collection of Clifford Law Offices

Anthony Angarola (1893–1929)
Snow Birds, 1928
Oil on canvas, 44 x 36 in. (111.8 x 91.4 cm)
Davis Museum and Cultural Center, Wellesley
College, museum purchase, Wellesley College
Friends of Art

Emil Armin (1883–1971)
The Open Bridge, 1930
Oil on Masonite, 22 x 27 in. (55.9 x 68.6 cm)
Collection of the Illinois State Museum, Gift of
Susanna and Matthew Morgenthau in Memory of
their Mother, Irma Thorman Morgenthau, 1981.33

Henry Avery (1906–unknown)
Still Life with Grapes, c. 1940
Oil on canvas, 30 x 36 in. (76.2 x 91.4 cm)
South Side Community Art Center Collection

Belle (Goldschlager) Baranceanu (1905–1988)
Riverview Section, Chicago, 1926
Oil on canvas, 28 x 34 in. (71.1 x 86.4 cm)
Collection of the San Diego Historical Society,
Gift of Belle Baranceanu

Frederic Clay Bartlett (1873–1953)
Blue Rafters, c. 1916
Oil on canvas, 28 x 30¼ in. (71.1 x 76.8 cm)
The Art Institute of Chicago, Friends of American
Art Collection, 1919.107

Macena Barton (1901–1986)
Portrait of C. J. Bulliet, 1932
Oil on canvas, 47 x 41½ in. (119.4 x 105.4 cm)
Mr. and Mrs. Harlan J. Berk

Macena Barton
Salome, 1936
Oil on canvas, 76 x 50 in. (193 x 127 cm)
Collection of Jim Romano and Rick Strilky

Bernece Berkman (1911–1988)
Current News, 1937
Oil on board, 20 x 40 in. (50.8 x 101.6 cm)
Jim and Randi Williams, Nashville, Tennessee

Kathleen Blackshear (1897–1988)
A Boy Named Alligator, 1930
Oil on canvas, 22 x 18⅛ in. (55.9 x 46 cm)
The Art Institute of Chicago, Gift of Mr. and
Mrs. William J. Terrell, Sr., 1991.160

Aaron Bohrod (1907–1992)
Clark Street, Chicago, 1934
Oil on board, 23¹⁵⁄₁₆ x 31¾ in. (60.8 x 80.6 cm)
Barry and Merle K. Gross

Raymond Breinin (1910–2000)
At the Pier, 1941
Oil on canvas, 30 x 40 in. (76.2 x 101.6 cm)
Private collection

Edgar Britton (1901–1982)
untitled (mural study), 1938
Gouache on gessoed board, 8¾ x 15¾ in.
(22.2 x 40 cm)
Mr. and Mrs. Harlan J. Berk

Fritzi Brod (1900–1952)
Self-Portrait, 1934
Oil on board, 27½ x 20 in. (69.9 x 50.8 cm)
Mr. and Mrs. Harlan J. Berk

Claude Buck (1890–1974)
Labor, undated
Oil on canvas, 16 x 18 in. (40.6 x 45.7 cm)
Mr. and Mrs. Harlan J. Berk

Karl Albert Buehr (1866–1952)
News from Home, 1912
Oil on canvas laid down, 39½ x 32 in.
(100.3 x 81.3 cm)
Edenhurst Gallery, Los Angeles and
Palm Desert, California

Elbridge Ayer Burbank (1858–1949)
Portrait of a Woman, Munich, 1892
Oil on canvas, 37⅝ x 31⅞ in. (95.6 x 81 cm)
Courtesy of Rockford Art Museum

Francis Chapin (1899–1965)
White Tower, c. 1931
Oil on canvas, 31 x 38 in. (78.7 x 96.5 cm)
Private collection

Richard A. Chase (1892–1985)
The Palmolive Building, after 1929
Oil on Masonite, 24 x 24 in. (61 x 61 cm)
Chicago Historical Society, Gift of the Artist,
Richard Chase, 1980.195.7

Alson Skinner Clark (1876–1949)
The Coffee House, before 1906
Oil on canvas, 38 x 30 in. (96.5 x 76.2 cm)
The Art Institute of Chicago, Gift of Mr. and
Mrs. Alson S. Clark, 1915.256

Eldzier Cortor (born 1916)
Southern Landscape, c. 1938–40
Tempera and gesso on board, 20 x 34 in.
(50.8 x 86.4 cm)
Robert Henry Adams Fine Art, Chicago and
Greenwich Gallery of American Art, Greenwich,
Connecticut

Gustav Dalstrom (1893–1971)
Laundry, 1942
Oil on artist board, 27 x 30 in. (68.6 x 77.5 cm)
Collection of the Illinois State Museum, 1990.48

Charles V. Davis (1912–1967)
Newsboy (The Negro Boy), 1939
Oil on canvas, 36 x 30 in. (91.4 x 76.2 cm)
Howard University Gallery of Art

Manierre Dawson (1887–1969)
Prognostic (center panel), 1910
Oil on canvas, 33 ¾ x 35 ¾ in. (85.7 x 90.8 cm)
Milwaukee Art Museum, Purchase, M1967.78

Julio de Diego (1900–1979)
Vamda, 1937
Oil on canvas, 40 x 30 ¼ in. (101.6 x 76.8 cm)
Mr. and Mrs. Harlan J. Berk

Pauline Dohn (Rudolph) (1865–1934)
A Village Belle, 1899
Oil on canvas, 29 x 20 in. (73.7 x 50.8 cm)
Illinois Historical Art Project

Walter Ellison (1900–1977)
Train Station, 1935
Oil on cardboard, 8 x 14 in. (20.3 x 35.6 cm)
The Art Institute of Chicago, Charles M. Kurtz
Charitable Trust and Barbara Neff Smith and
Solomon Byron Smith funds; through prior gifts of
Florence Jane Adams, Mr. and Mrs. Carter H.
Harrison and estate of Celia Schmidt, 1990.134

William McKnight Farrow (1885–1967)
Paul Laurence Dunbar, 1934
Oil on canvas, 35 ¼ x 32 ⅛ in. (89.5 x 81.6 cm)
National Portrait Gallery, Smithsonian Institution,
NPG.93.86

Frances Foy (1890–1963)
The Cheese Vendor, 1928
Oil on Masonite, 27 ¾ x 24 in. (70.5 x 61 cm)
Powell and Barbara Bridges Collection

Rowena C. Fry (1895–1989)
Great Lakes Art Class, 1941–45
Oil on canvas, 24 x 30 in. (61 x 76.2 cm)
Mr. and Mrs. Harlan J. Berk

Frederick F. Fursman (1874–1943)
Maizie Under the Boughs, 1915
Oil on canvas, 40 x 30 in. (101.6 x 76.2 cm)
Powell and Barbara Bridges Collection

Leon Garland (1896–1941)
Unemployed Men in the Hull-House Courtyard,
c. 1930–31
Oil on canvas, 30 x 40 ⅟₁₆ in. (76.2 x 101.8 cm)
Jane Addams Hull-House Museum, University of
Illinois at Chicago

Todros Geller (1889–1949)
Strange Worlds, 1928
Oil on canvas, 28 ¼ x 26 ⅛ in. (71.8 x 66.4 cm)
The Art Institute of Chicago, Gift of Leon Garland
Foundation, 1949.27

J. Jeffrey Grant (1883–1960)
Michigan Avenue, c. 1934
Oil on canvas, 40 x 35 in. (101.6 x 88.9 cm)
Collection of Clifford Law Offices

Oliver Dennett Grover (1861–1927)
Midsummer, 1893
Oil on panel, 10 x 8 in. (25.4 x 20.3 cm)
Illinois Historical Art Project

Oliver Dennett Grover
On the Island, World's Columbian Exposition, 1893
Oil on panel, 10 x 7 in. (25.4 x 17.8 cm)
Mr. and Mrs. Kenneth Probst

Oliver Dennett Grover
A Windy Day, 1893
Oil on panel, 10 ⅛ x 8 ⅜ in. (25.7 x 21.3 cm)
Private collection

William Harper (1873–1910)
August in France, c. 1908–9
Oil on canvas, 36 ⅛ x 36 ⅛ in. (91.8 x 91.8 cm)
Tuskegee University Archives and Collection

Victor Higgins (1884–1949)
Circumferences, 1914–19
Oil on canvas, 51 ¼ x 57 in. (130.2 x 144.8 cm)
The Snite Museum of Art, University of Notre
Dame, Gift of Mr. and Mrs. John T. Higgins, 63.53.4

Samuel Himmelfarb (1904–1976)
Jackson Park, 1938
Oil on board, 23 ¾ x 29 ⅝ in. (60.3 x 75.2 cm)
Molly Day and John D. Himmelfarb

Carl Hoeckner (1883–1972)
The Yes Machine, undated
Oil on board, 33 ½ x 43 ¾ in. (85.1 x 111.1 cm)
Mr. and Mrs. Harlan J. Berk

Rudolph Ingerle (1879–1950)
Salt of the Earth, c. 1932
Oil on canvas, 52 ¼ x 48 ¼ in. (132.7 x 122.6 cm)
Courtesy of Rockford Art Museum

Raymond Jonson (1891–1982)
The Decree, 1918
Oil on canvas, 35 x 41 in. (88.9 x 104.1 cm)
Jonson Gallery Collection, University of New
Mexico Art Museum, Bequest of Raymond Jonson,
82.221.0072

George Josimovich (1894–1986)
Composition No. 2, 1922
Oil on canvas, 24 x 32 in. (61 x 81.3 cm)
Mr. and Mrs. Harlan J. Berk

A. Raymond Katz (1895–1974)
The Argument, 1938
Oil on canvas, 58 x 65 in. (147.3 x 165.1 cm)
Barry and Merle K. Gross

Paul Kelpe (1902–1985)
Construction Relief, 1927
Wood, metal, paint, and board, 17 x 13 x 4 ⅝ in.
(43.2 x 33 x 11.7 cm)
Kresge Art Museum Collection, Michigan State
University, MSU purchase, 73.25

Carl R. Krafft (1884–1938)
The Charms of the Ozarks, c. 1916
Oil on canvas, 45 x 50 in. (114.3 x 127 cm)
Collection of the Union League Club of Chicago,
UL1976.33

Herman Menzel (1904–1988)
Mexican Pool Room, S. Chicago #2 (with Bunting),
1927
Oil on canvas, 18 ⅜ x 25 ⅟₁₆ in. (46.7 x 65.2 cm)
Jeanne D. Lutz

Edward Millman (1907–1964)
Flop House, 1937
Tempera on fiber board, 23 x 29 ⅞ in.
(58.4 x 75.9 cm)
Smithsonian American Art Museum, Transfer from
The Museum of Modern Art

Archibald J. Motley Jr. (1891–1981)
The Plotters, 1933
Oil on canvas, 36 x 40 in (91.4 x 101.6 cm)
The Walter O. Evans Collection of African
American Art

James B. Needham (1850–1931)
*Chicago River, Chicago and Northwestern Railroad
Station*, 1902
Oil on canvas on board, 8 x 6 in. (20.3 x 15.2 cm)
Chicago Historical Society, Gift of Mrs. Joseph Du
Canto, 1986.768.8

James B. Needham
Chicago Waterfront, 1901
Oil on canvas on board, 5 ⅞ x 6 ½ in. (14.9 x 16.5 cm)
Chicago Historical Society, Gift of Mrs. Joseph Du
Canto, 1986.768.15

James B. Needham
Sailboat at Dusk, c. 1895–1915
Oil on canvas on board, 6 x 5 ¼ in. (15.2 x 13.3 cm)
Chicago Historical Society, Gift of Mrs. Joseph Du
Canto, 1986.768.5

James B. Needham
S.S. Seneca, 1903
Oil on canvas on board, 7 ⅞ x 6 ¼ in. (20 x 15.9 cm)
Chicago Historical Society, Gift of Mrs. Joseph Du
Canto, 1986.768.19

James B. Needham
Steamer at Dock, c. 1895–1915
Oil on canvas on board, 6 ⅝ x 8 ⅛ in. (16.8 x 20.6 cm)
Chicago Historical Society, Gift of Mrs. Joseph Du
Canto, 1986.768.4

James B. Needham
Tugboat, c. 1895–1915
Oil on canvas on board, 6 x 5 in. (15.2 x 12.7 cm)
Chicago Historical Society, Gift of Mrs. Joseph Du
Canto, 1986.768.14

James B. Needham
Tugboats, c. 1895–1915
Oil on canvas on board, 8 ⅛ x 12 ⅛ in. (20.6 x 30.8 cm)
Chicago Historical Society, Gift of Mrs. Joseph Du
Canto, 1986.768.1

James B. Needham
Waterfront at Dusk, 1907
Oil on canvas on board, 5 ½ x 6 ½ in. (14 x 16.5 cm)
Chicago Historical Society, Gift of Mrs. Joseph Du
Canto, 1986.768.9

(James) Harold Noecker (1912–2002)
The Genius?, c. 1942–43
Oil on canvas, 30 x 36 in. (76.2 x 91.4 cm)
Collection of Barton Faist

B. J. O. Nordfeldt (1878–1955)
Chicago, 1912
Oil on canvas, 41 ½ x 35 ¾ in. (105.4 x 90.8 cm)
Weatherspoon Art Museum, The University of
North Carolina at Greensboro, Gift of Mr. and Mrs.
W. S. Weatherspoon in memory of Elizabeth McIver
Weatherspoon, 1969, 1969.1638

John Warner Norton (1876–1934)
Study for *Ceres*, 1930
Oil on board, 40 ⅛ x 11 ½ in. (101.9 x 29.2 cm)
Private Collection of John Norton Garrett

Gregory Orloff (1890–1981)
Men on Hill Reading Newspapers, undated
Oil on canvas, 36 x 40 in. (91.4 x 101.6 cm)
Mr. and Mrs. Harlan J. Berk

George Demont Otis (1879–1962)
Grain Elevators, Goose Island, undated
Oil on canvas, 18 x 24 ³⁄₁₆ in. (45.7 x 61.4 cm)
Chicago Historical Society, 1970.153

Pauline Palmer (1865–1938)
The Morning Sun, c. 1920
Oil on canvas, 50 x 40 in. (127 x 101.6 cm)
Courtesy of Rockford Art Museum

Frank C. Peyraud (1858–1948)
Winter Light on the Farm, 1896
Oil on canvas, 12 x 18 in. (30.5 x 45.7 cm)
The Marshall Collection, Peoria, Illinois

Tunis Ponsen (1891–1968)
untitled (Century of Progress, World's Fair),
c. 1933–34
Oil on canvas, 24 x 30 in. (61 x 76.2 cm)
Collection of the Union League Club of Chicago,
UL2000.3

Harvey Gregory Prusheck (1887–1940)
Lunar Landscape, 1920
Oil on canvas, 36 ½ x 40 in. (92.7 x 101.6 cm)
Jonson Gallery Collection, University of New
Mexico Art Museum, Bequest of Raymond Jonson,
82.221.1197

Romolo Roberti (1896–1988)
Roofs (Tree Studios), 1934
Oil on canvas, 34 x 30 in. (86.4 x 76.2 cm)
Western Illinois University Art Gallery

Gordon St. Clair (1885–1962)
Entrance to Xanadu, c. 1915
Oil on canvas, 54 x 38 ½ in. (137.2 x 97.8 cm)
Mr. and Mrs. Harlan J. Berk

William Schwartz (1896–1977)
From Window #29, 1937
Oil on Masonite, 30 x 24 in. (76.2 x 61 cm)
The Keys Collection, Waterford, Michigan 010,
Courtesy of Richard Norton Gallery

William Schwartz
Symphonic Forms No. 6, c. 1932
Oil on canvas, 29 ½ x 26 in. (74.9 x 66 cm)
Collection of Clifford Law Offices

William Edouard Scott (1884–1964)
Traveling (Lead Kindly Light), 1918
Oil on canvas, 22 ⅛ x 18 in. (56.2 x 45.7 cm)
Huntington Museum of Art, Gift of Mrs. Virginia
Van Zandt (West Virginia)

Charles Sebree (1914–1985)
untitled (Seated Woman), 1938
Oil on canvas, 21 ⅞ x 25 ⅝ in. (55.6 x 65.1 cm)
Laurie and Alan Reinstein

Ramon Shiva (1893–1963)
Chicago MCMXXIV, 1924
Oil on canvas, 53 x 50 in. (134.6 x 127 cm)
Mr. and Mrs. Harlan J. Berk

Mitchell Siporin (1910–1976)
Homeless, 1939
Oil on canvas, 30 x 40 in. (76.2 x 101.6 cm)
Private collection

Willard Grayson Smythe (1906–1995)
Abstraction, 1943
Oil on canvas, 39 ⅜ x 28 ½ in. (100 x 72.4 cm)
Shane Qualls

Frances Strain (1898–1962)
*Four Saints in Three Acts, Introducing
St. Ignatius*, 1934
Oil on canvas, 36 x 30 in. (91.4 x 76.2 cm)
Courtesy of Michael Rosenfeld Gallery, New York

Svend Svendsen (1864–1934)
Winter Sunset in Norway, 1897
Oil on canvas, 43 x 32 ¾ in. (109.2 x 83.2 cm)
Collection of the Union League Club of Chicago,
UL1906.1

Stanislaus Szukalski (1895–1987)
Rudolph Weisenborn, 1919
Charcoal on paper, 23 ¼ x 18 ½ in. (59.1 x 47 cm)
Mr. and Mrs. Harlan J. Berk

Julia Thecla (1896–1973)
Bunny Backstage, 1939
Opaque watercolor on cardboard with gesso ground,
20 x 25 in. (50.8 x 63.5 cm)
Collection of the Illinois State Museum,
1943.16/912.11

Morris Topchevsky (1899–1947)
Unemployed, undated
Oil on canvas, 27 ½ x 29 ½ in. (69.9 x 74.9 cm)
Private collection

Walter Ufer (1876–1936)
Near the Waterhole, 1921
Oil on canvas, 36 ½ x 40 ½ in. (92.7 x 102.2 cm)
Collection of the Union League Club of Chicago,
UL1976.51

Frank R. Wadsworth (1874–1905)
A River Lavadero, Madrid, undated (c. 1905)
Oil on canvas, 30 ¼ x 36 ¼ in. (76.8 x 92.1 cm)
Collection of the Union League Club of Chicago,
Gift of the estate of Sarah F. Wadsworth,
UL1904A.4.2

Rudolph Weisenborn (1881–1974)
The Artist in the City (The Chicagoan), 1926–27
Oil on canvas, 72 x 47 ½ in. (182.9 x 120.7 cm)
West and Velma Weisenborn

Charles White (1918–1981)
Spiritual, 1941
Oil on canvas, 36 ¼ x 30 ⅛ in. (92.1 x 76.5 cm)
South Side Community Art Center Collection

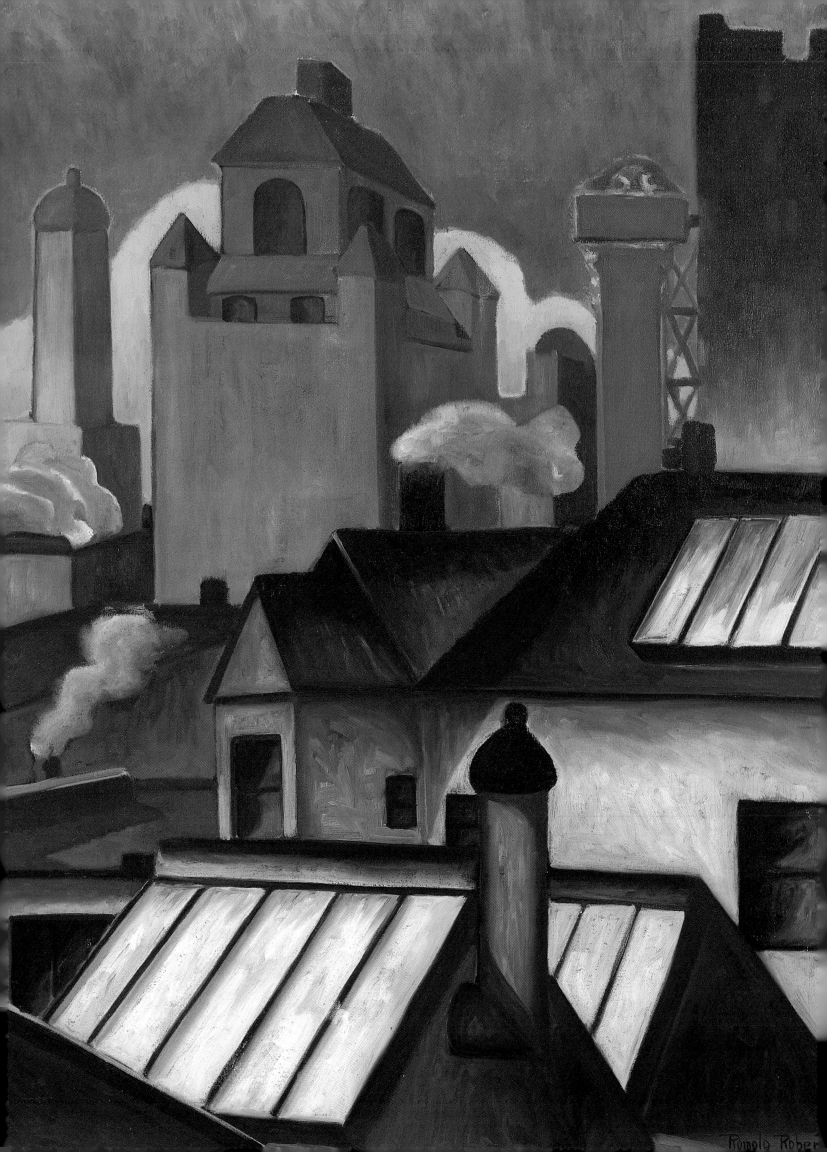

SELECTED BIBLIOGRAPHY

Adams, Henry, and Randy J. Ploog. *Manierre Dawson: American Pioneer of Abstract Art.* New York: Hollis Taggart Galleries, 1999.

"African Americans in Art: Selections from The Art Institute of Chicago." *The Art Institute of Chicago Museum Studies* 24, 2 (1999).

Barter, Judith A. *Window on the West: Chicago and the Art of the New Frontier, 1890–1940.* With contributions by Andrew J. Walker. Chicago: Art Institute of Chicago, in association with Hudson Hills Press, 2003.

Bearden, Romare, and Harry Henderson. *A History of African-American Artists: From 1792 to the Present.* New York: Pantheon Books, 1993.

Becker, Heather. *Art for the People: The Rediscovery and Preservation of Progressive- and EPA-Era Murals in the Chicago Public Schools, 1904–1943.* San Francisco: Chronicle Books, 2002.

Blum, Betty. *Art-Related Archival Materials in the Chicago Area.* Washington, D.C.: Archives of American Art, 1991.

Bohrod, Aaron. *A Decade of Still Life.* Madison: University of Wisconsin Press, 1966.

Bulliet, C. J. *Apples and Madonnas: Emotional Expression in Modern Art.* Chicago: Pascal Covici, 1927.

Capturing Sunlight: The Art of Tree Studios. Chicago: Chicago Department of Cultural Affairs, 1999.

"Chicago as an Art Center." Special issue, *Art & Archaeology* 12 (September/October 1921).

Donnell, Courtney, Susan Weininger, and Robert Cozzolino. *Ivan Albright.* Chicago: Art Institute of Chicago, distributed by Hudson Hills Press, 1997.

Drake, St. Clair, and Horace R. Cayton. *Black Metropolis: A Study of Negro Life in a Northern City.* Introduction by Richard Wright. 1945. Reprint, Chicago: University of Chicago Press, 1993.

Falk, Peter, ed. *The Annual Exhibition Record of The Art Institute of Chicago, 1888–1950.* Madison, Conn.: Sound View Press, 1990.

Garvey, Timothy J. *Public Sculptor: Lorado Taft and the Beautification of Chicago.* Urbana: University of Illinois Press, 1988.

Gerdts, William H. *American Impressionism.* New York: Abbeville Press, 1984.

———. *Art Across America: Two Centuries of Regional Painting, 1710–1920.* Vol. 2, *The South, Near Midwest.* New York: Abbeville Press, 1990.

———. *The Friedman Collection: Artists of Chicago.* New York: Spanierman Gallery, 2002.

———, et al. *The Lost Paintings of Tunis Ponsen (1891–1968).* Muskegon, Mich.: Muskegon Museum of Art, 1994.

Greenhouse, Wendy, and Susan S. Weininger. *Painting in Chicago 1895–1945: The Bridges Collection.* Urbana: University of Illinois Press, forthcoming 2004.

———. *A Rediscovered Regionalist: Herman Menzel.* Chicago: Chicago Historical Society, 1994.

Germer, Stefan. "Pictures at an Exhibition: The Art Market in Chicago 1870–1890." *Chicago History* 16 (Spring 1987): 4–21.

Goldstein, Leslie S. "Art in Chicago and the World's Columbian Exposition of 1893." M.A. thesis, University of Iowa, 1970.

Gray, Mary Lackritz. *A Guide to Chicago's Murals.* Chicago: University of Chicago Press, 2001.

Grossman, James R. *Land of Hope: Chicago, Black Southerners, and the Great Migration.* Chicago: University of Chicago Press, 1989.

Hammer, Ethel Joyce. "Attitudes Toward Art in the Nineteen Twenties in Chicago." Ph.D. diss., University of Chicago, 1975.

Hey, Kenneth R. "Five Artists and the Chicago Modernist Movement, 1909–1928." Ph.D. diss., Emory University, 1973.

Horowitz, Helen Lefkowitz. *Culture & the City: Cultural Philanthropy in Chicago from the 1880s to 1917.* 1976. Reprint, Chicago: University of Chicago Press, 1989.

Jacobson, J. Z. *Art of Today: Chicago, 1933.* Chicago: L.M. Stein, 1932.

Locke, Alain LeRoy, ed. *The Negro in Art: A Pictorial Record of the Negro Artist and of the Negro Theme in Art.* Washington, D.C.: Associates in Negro Folk Education, 1940.

Mavigliano, George J., and Richard A. Lawson. *The Federal Art Project in Illinois, 1935–1943.* Carbondale: Southern Illinois University Press, 1990.

Motley, Willard F. "Negro Art in Chicago." *Opportunity* 18, 1 (January 1940): 19–31.

The "New Woman" in Chicago: 1910–45: Paintings from Illinois Collections. Rockford, Ill.: Rockford College, 1993.

Prince, Sue Ann, ed. *The Old Guard and the Avant-Garde: Modernism in Chicago, 1910–1940.* Chicago: University of Chicago Press, 1990.

Reynolds, Gary A., and Beryl J. Wright. *Against the Odds: African-American Artists and the Harmon Foundation.* Newark, N. J.: Newark Museum, 1989.

Richter, Marianne, and Wendy Greenhouse. *Union League Club of Chicago Art Collection.* Chicago: Union League Club of Chicago, 2003.

Robinson, Jontyle Theresa and Wendy Greenhouse. *The Art of Archibald J. Motley, Jr.* Chicago: Chicago Historical Society, 1991.

Scanlan, Joseph, ed. *A History of the Renaissance Society: The First Seventy-Five Years.* Chicago: Renaissance Society at The University of Chicago, 1993.

Shaw, Sophia, ed. *The Arts Club of Chicago: The Collection 1916–1996.* Chicago: Arts Club of Chicago, 1997.

Sparks, Esther. "A Biographical Dictionary of Painters and Sculptors in Illinois, 1808–1945." Ph.D. diss., Northwestern University, 1971.

Weinberg, H. Barbara, Doreen Bolger, and David Park Curry. *American Impressionism and Realism: The Painting of Modern Life, 1885–1915.* New York: Metropolitan Museum of Art, distributed by Harry N. Abrams, 1994.

Weininger, Susan, and Kent Smith. *Gertrude Abercrombie.* Springfield: Illinois State Museum, 1991.

Weininger, Susan, ed. *BlockPoints: The Annual Journal and Report of the Mary and Leigh Block Museum of Art* 3/4 (1996/1998).

Whitridge, Eugenia Remelin. "Art in Chicago: The Structure of the Art World in a Metropolitan Community." Ph.D. diss., University of Chicago, 1946.

Wolfe, M. Melissa. *American Indian Portraits: Elbridge Ayer Burbank in the West (1897–1910).* Youngstown, Ohio: Butler Institute of American Art, 2000.

Yochim, Louise Dunn. *Role and Impact: The Chicago Society of Artists.* Chicago: Chicago Society of Artists, 1979.

Zimmer, Jim L., Cheryl Hahn, and Richard N. Murray. *John Warner Norton.* Springfield, Ill.: Illinois State Museum, 1993.

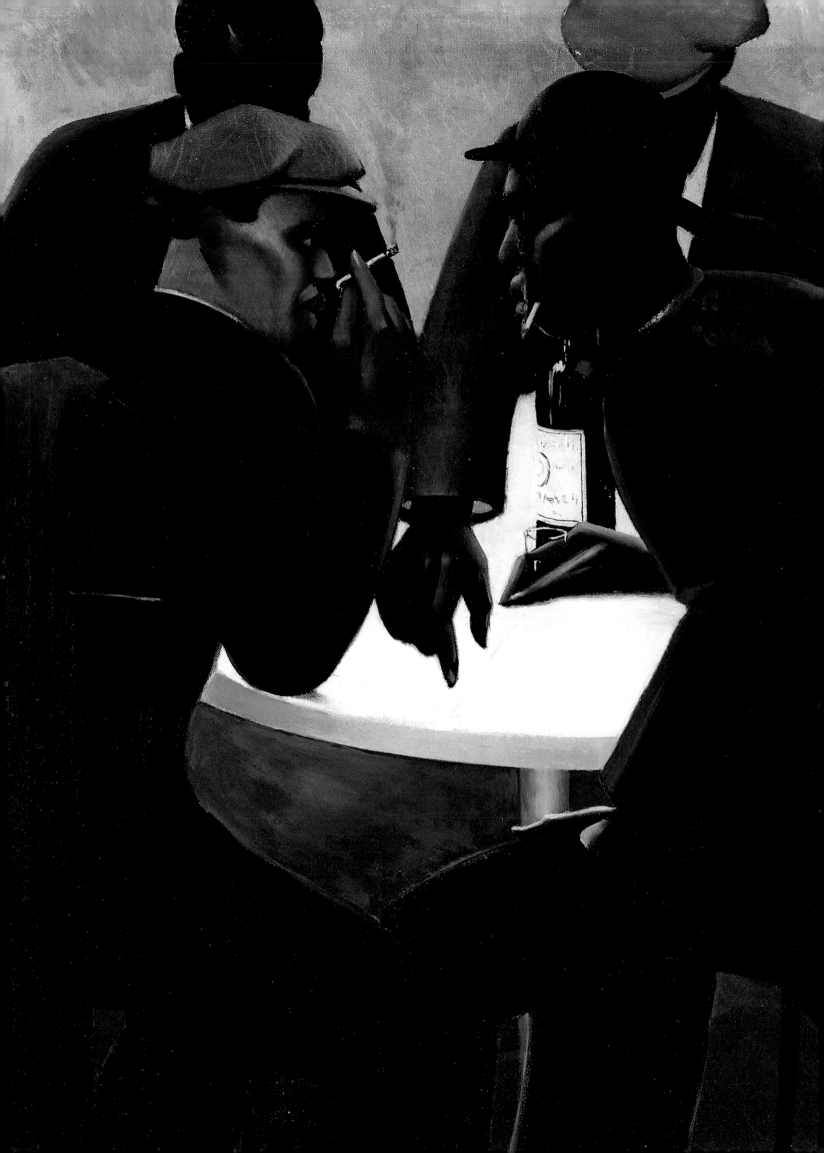

PHOTOGRAPHY CREDITS

Photographs of the works in the exhibition were in most cases provided by the institution or individual owning the work and are reproduced with permission. The following photography credits apply to all images for which separate or additional credit is due. Every effort has been made to trace individual copyright holders, and any omissions are unintentional.

Greenhouse, "Local Color: Impressionism Comes to Chicago"
Fig. 10: Courtesy of the Chicago Historical Society. Fig. 11: (Philip Mrozinski). Fig. 13: (Wheeler Cole)

Schulman, "'White City' and 'Black Metropolis': African American Painters in Chicago, 1893–1945"
Fig. 2, 6, 8: Photograph from the Charles C. Dawson Collection, DuSable Museum of African American History. A gift from Mrs. Mary R. Dawson, deceased. Courtesy of the DuSable Museum of African American History, Chicago (Gregory Williams). Fig. 4: Photograph courtesy Estate of Albert Krehbiel. Fig. 5: Photograph courtesy of Chicago Public Schools and Public Building Commission, photography by Sadin Photo Group, Ltd ©1992 (Don Du Broff). Fig. 7: Photograph courtesy Ohio Historical Society, Columbus, Ohio. Fig. 9: Photograph courtesy of The Art Institute of Chicago. Fig. 10: Courtesy George J. Mavigliano (John Walley Papers). Fig. 11: Photograph courtesy of Michael Rosenfeld Gallery, New York

Weininger, "Completing the Soul of Chicago: From Urban Realism to Social Concern, 1915–1945"
Fig. 1: © 1999, The Art Institute of Chicago, all rights reserved. Fig. 4: (Garry Henderson). Fig. 5, 10: Photograph courtesy of The Art Institute of Chicago. Fig. 6, 7: Photographs courtesy of ACA Galleries. Fig. 8: © T.H. Benton and R. P. Benton Testamentary Trusts/Licensed by VAGA, New York, NY (Robert E. Mates). Fig. 13–15: Photograph © Andrew Hemingway.

Weininger, "Fantasy in Chicago Painting: 'Real Crazy, Real Personal, and Real Real'"
Fig. 3, 5: Photographs courtesy of The Art Institute of Chicago. Fig. 10: Photograph © Museum of Contemporary Art, Chicago. Fig. 12: Photograph courtesy of Robert Henry Adams Fine Arts.

CATALOGUE

Cat. 6, 25, 83: (Gary Andrashko). Cat. 36: Photograph courtesy of The Art Institute of Chicago (Robert Hashimoto). Cat. 3, 9, 13, 23, 30: Photography courtesy of The Art Institute of Chicago. Cat. 16, 78: Photography courtesy of Robert Henry Adams Fine Art. Cat. 14: © Estate of Aaron Bohrod/Licensed by VAGA, New York, NY (Garry Henderson). Cat. 26: (Gregory R. Staley). Cat. 7, 11, 38, 40, 48, 51, 62, 68, 71, 73, 75, 84, 87, 88: Photography courtesy of the Terra Foundation for the Arts (Garry Henderson).

This book was published in conjunction with the exhibition *Chicago Modern, 1893–1945: Pursuit of the New* organized by the Terra Museum of American Art in Chicago where it was on view from July 17–October 31, 2004.

This exhibition and publication of the Terra Museum of American Art was made possible through the generous support of the Terra Foundation for the Arts. Additional funding was provided by LaSalle Bank; Thom Gianetto, Don Merrill, and Daniel Nicodemo of Edenhurst Gallery, Los Angeles and Palm Desert, California; and Mr. and Mrs. Harlan J. Berk of Chicago.

Project coordinated by Elizabeth Kennedy with the assistance of Shelly Roman
Production coordinated by Tom Wawzenek
Printing coordinated by Francesca Rose
Photography coordinated by Leo Kelly
Designed and typeset by Joan Sommers Design, Chicago
Color separations by Professional Graphics, Rockford, IL
Printed by Musumeci S.p.A.

Published by the Terra Foundation for the Arts.
Distributed by The University of Chicago Press, Chicago

ISBN: 0-932171-41-9

Library of Congress Cataloging-in-Publication Data

Chicago modern, 1893–1945: pursuit of the new / edited by Elizabeth Kennedy ; essays by Wendy Greenhouse, Daniel Schulman, and Susan S. Weininger.—1st ed.
 p. cm.
 Catalog of an exhibition at the Terra Museum of American Art, Chicago, July 17–Oct. 31, 2004.
 Includes bibliographical references and index.
 ISBN 0-932171-41-9
 1. Art, American—Illinois—Chicago—19th century—Exhibitions.
 2. Art, American—Illinois—Chicago—20th century—Exhibitions.
 I. Kennedy, Elizabeth, 1949– II. Greenhouse, Wendy, 1955–
 III. Schulman, Daniel. IV. Weininger, Susan S. V. Terra Museum of American Art.

N6535.C5C476 2004
709'.773'1107477311—dc22 2004000728

Printed and bound in Italy.

Front cover: Ramon Shiva, *Chicago MCMXXIV,* detail (cat. 77).
Back cover: Richard A. Chase, *The Palmolive Building* (cat. 22).

Frontispiece: Detail of cat. 63.
Contents: Detail of cat. 12.
Page 21: Detail of cat. 80.
Page 79: Detail of cat. 83.
Page 172: Detail of cat. 71.
Page 174: Detail of cat. 53.